Celebrity

Wendy Wick Reaves

Pie Friendly, Research Assistant

National Portrait Gallery, Smithsonian Institution
in association with Yale University Press
NEW HAVEN and LONDON

Caricature
IN AMERICA

This exhibition was made possible in part by the Smithsonian Institution Special Exhibition Fund, the Smithsonian Institution Scholarly Studies Fund, the Marpat Foundation, and the Max and Victoria Dreyfus Foundation, Inc.

An exhibition at the National Portrait Gallery,
Smithsonian Institution, Washington, D.C.,
April 10–August 23, 1998.

Designed by Lisa C. Tremaine
Set in Weiss and Nora type by Amy Storm
Index prepared by Barbara E. Cohen

Printed in Italy by Conti Tipocolor

Reaves, Wendy Wick, 1950–
 Celebrity caricature in America / Wendy Wick Reaves; Pie Friendly, research assistant.
 p. cm.
 Catalogue of an exhibition held at the National Portrait Gallery, Apr. 10–Aug. 23, 1998.
 Includes bibliographical references and index.
 ISBN 0-300-07463-8 (cloth : alk. paper)
 1. American wit and humor, Pictorial—New York (State)—New York—History—20th century—Exhibitions.
2. Celebrities—United States—Caricatures and cartoons—Exhibitions.
I. Friendly, Pie. II. National Portrait Gallery (Smithsonian Institution) III. Title.
 NC1426.R3 1998 97-46906
 741.5'074'753—dc21 CIP

A catalogue record for this book is available from the British Library.

The paper in this book meets the guidelines for permanence and durability of the Committee on Production Guidelines for Book Longevity of the Council on Library Resources.

10 9 8 7 6 5 4 3 2

Frontispiece: *Joseph Weber and Lew Fields* (1867–1942; 1867–1941) by Al Frueh. Linocut, c. 1922. Published in Frueh, *Stage Folk* (New York, 1922). National Portrait Gallery, Smithsonian Institution, Washington, D.C.; gift of the children of Al Frueh: Barbara Frueh Bornemann, Robert Frueh, and Alfred Frueh, Jr.

Contents

Director's Foreword

Too often, there is a grim earnestness to portraiture, with artist, subject, and viewer tending to regard the art of portrayal as a solemn ritual. There is a good reason for this, of course, since the passage of time erases knowledge of the living personality, leaving behind only such records as biographies, obituaries, and visual images as the precious records of the notables of past ages. This serious aspect of visual biography is the foundation of the collections and the exhibition program of the National Portrait Gallery, and many visitors to the gallery find that their appreciation of history is greatly enhanced by their sense of the people who contributed to it.

But there is another side to portraiture, involving a less reverent regard for the sitter. Political and social satires in visual form, known as caricatures and cartoons, have been around for several hundred years. Kings, presidents, prime ministers, and mayors all have suffered as their features and their pretensions were exaggerated and highlighted. The National Portrait Gallery has been attentive to the visual satirist, just as it has explored the more benevolent realm of formal portraiture. In evoking the past, it has often been revealing to learn about the social and political issues of a previous age, or to assess the personality of a public figure by examining the blend of hostility and ridicule that the caricaturist brings to him or her.

We turn now to yet another branch of comedic portraiture: the celebrity caricature, as it emerged in the United States toward the end of the nineteenth century and flourished until after the Second World War. Celebrity caricature is still alive in the pages of the *New York Review of Books*, the *New Yorker*, and a few other publications, but it is not as well as it was in days of the old *Vanity Fair*, the old *Life*, or the thriving theatrical centers around Broadway in the East and Hollywood Boulevard in the West.

This was a time when American society was undergoing considerable change, and the study of celebrity caricature helps to remind us of these developments. Theater was becoming more professionalized, more centralized, and more popular. Vaudeville and variety gave way to the Ziegfeld Follies and the Broadway musical. The arrival of the motion picture made a few actors and actresses into national idols. Other personalities gained fame through their regular appearances on the radio—a medium that came to reach all parts of the country and to involve all listeners in the same, shared experience. An increasingly literate, urban, and prosperous public supported new periodicals, including sophisticated, lavishly illustrated magazines. Americans once relied on locally generated amusements; as the twentieth century progressed, popular culture was brought to everyone, everywhere through the new media, and with increasingly convenient travel around the country.

Celebrity caricature reflected these trends and was in part created by them. The artists tended to be free of the suspicious unfriendliness of political satire, mocking well-known performers, writers, or society figures but not trying to destroy them. After all, the success of the celebrity caricaturist depended on the survival of the celebrities being caricatured. The whole process seemed to involve making the well known even better known, until instant recognition of the subject by the audience was possible without captions or labels. This was the measure of both true celebrity and successful celebrity caricature.

Best of all, American celebrity caricaturists of the early decades of this century included some of the most lively and capable artists of the time. Through international exhibitions and through increasing travel abroad, Americans became exposed to advanced European art movements of the early twentieth century

without much delay. While the general public found it difficult to accept cubism, futurism, or dada, many artists were energized by these trends. Many of the characteristics of the new visual arts that the public rejected in the sales gallery or museum were brilliantly incorporated into the work of the caricaturists of the time (some of whom were "serious" artists, actually working with the innovators), and in this form the new art styles met no public resistance at all.

Despite Condé Nast's improvements in printing technology in the 1930s, for the majority of publications the processes of the time could impart only a hint of the brilliance and quality of the original paintings and drawings on which the reproductions were based. Moreover, caricatures were often used in other places, some of them surprising. They appeared on theater curtains, on cigarette cases, and on at least one dress fabric. There were sculpted caricatures and animated cartoons using caricatures of living actors. In this collection of superbly chosen examples, we have the unique opportunity to experience the drawings, paintings, and sculpture of the golden age of celebrity caricature.

The sharp eyes, undaunting persistence, and tireless ingenuity of Wendy Wick Reaves, along with Pie Friendly and their Portrait Gallery colleagues, have brought this remarkable body of work together for our delectation and enlightenment. Their diligence, persuasiveness, and stealth have brought many of the finest examples shown here into the collections of the Gallery to be enjoyed by future generations; when acquisitions were impossible, they persuaded lenders to share their treasures with us, so that the story could be told as completely and meaningfully as possible.

Alan Fern
Director, National Portrait Gallery

Preface

"Celebrity Caricature in America" has been a project driven by the joy of discovery. My first introduction to these portraits came from a chronological search through the old *Vanity Fair* magazine on an unrelated quest. Focused as we are at the National Portrait Gallery on images of the famous, I immediately noticed the lively india ink caricatures capering through the issues from the 1920s. After weeks of research, I was stunned, much as the magazine's original readers must have been, by the breathtaking switch to color in the 1930s. Caricature now dazzled, brilliant-hued, on full-page frontispieces and covers, conveying sophisticated, emblematic representations of twentieth-century notables. Both the black ink and the color images possessed an aesthetic sophistication not necessarily predictable in magazine humor. In addition, they radiated an infectiously irreverent comic spirit and a celebratory evocation of urban style.

These charming portraits also posed baffling questions. The problematic word "caricature" itself is imprecise and replete with negative meaning. Within the tradition of satiric drawing, caricature could imply either a general category of satiric cartooning or figural distortion. It had a destructive purpose, tearing away the false public front to expose underlying hypocrisy, vanity, and corruption. The same word, often used with the modifier "mere," suggests instead a cheap, meretricious literary or visual depiction, constructed with little thought or artistry. It implies a shallow abbreviation that misses the true nature of the original. The caricature I was encountering, however, was both clearly defined and upbeat. Artists, editors, and critics at the time used the word in reference to a stylized form of portraiture distinctly differentiated from editorial cartoons and other forms of social and political satire. They recognized these likenesses as a new type of caricature, updated with a contemporary look and a fresh

significance. The pictures mocked their subjects, to be sure, but with an emphasis on wit and style rather than corrective judgment. And hidden within those stylish distortions was a complimentary sense of deserving notability. As Arthur Miller once said about a Hirschfeld drawing, a caricature could locate "a wit in your miserable features that may yet lend you a style and a dash you were never aware of in yourself."

Caricature of the era began to make sense only after I realized its connection to the newly evolved, mass-media generated celebrity culture. These pictures did not address human frailty—a traditional subject for satiric portraiture—so much as they probed the nature of fame itself in an age of mass communication. Faces and mannerisms had become so well known that they could be cleverly stylized or abbreviated, drawing upon the vocabulary of modernism while mocking the extremes of radical art movements. Witty distortions did not expose hidden, inner qualities; they summarized those weaknesses and quirks already well publicized in the press. This caricature thus often reinforced rather than challenged established reputations.

It seemed I had stumbled across a prime Portrait Gallery topic: an unknown but obviously once-popular form of portraiture related to modern design that explored the roots of twentieth-century celebrity. Who were these artists? Where were their original drawings? Why did they become so popular? With the help of my indefatigable research assistant, Pie Friendly, I began to investigate the artists and contact their descendants. Finding, much to my delight, that original material existed for all the major caricaturists of the era, I began to develop our own collection. In addition to drawings, we located intriguing objects inspired by the caricature trend: a dress, a puppet, a doll, sculpture, a folding screen. As we launched an extensive search through artists' papers and contempo-

rary periodicals, we discovered many other outlets for this prevalent art form. Indeed, it permeated the press and enjoyed a vogue in New York City in the first half of the century that captivated everyone from the mass audience of the metropolitan newspapers to the artistic avant-garde. The discovery of so many little-known drawings and objects, as well as rich evidence of how they were received, confirmed my initial resolve to reintroduce these portraits in an exhibition and a book.

From the beginning I thought of this material as a form of portraiture, closely related at first to the fine arts and evolving into a prevalent popular art form. In my role as curator of prints and drawings at the National Portrait Gallery, I have long been intrigued by the dissemination of famous faces. The twentieth-century caricature vogue, I came to believe, added one more element to the complex development of the portrait tradition in a mass-media age. Far from being a pyramidal industry with great artists and prominent sitters at the top, American portraiture after the decline of the "grand manner" became a multidimensional, less hierarchical activity, often lacking clear artistic leadership. The iconic images of early twentieth-century America do not necessarily come from traditional categories of fine art. Memorable likenesses from movies, posters, photography, cartoons, and advertising affected the perception of public figures through powerful and innovative image making. Portraiture of this era cannot be assessed without considering the renegotiation of high and low culture boundaries, and these shifting visual priorities cannot be understood without an awareness of prevalent popular art forms, including caricature.

Early twentieth-century popular culture hardly seemed like an unplowed field. But most of the dozens of artists I had identified were little known; in some cases, we had to ferret out the most basic biographical facts. Few of the hundreds of drawings we located had received any extensive critical scrutiny; many had never been publicly exhibited. Why did this caricature have a resonance that promoted it into a fad? What comic strains influenced its tone? How were these drawings marketed and published? Of the hundreds of subjects represented, did any record a reaction to the relentless distortions to which they were subjected? How did this rather sophisticated popular genre intersect with the fine arts and the avant-garde? Who was the targeted audience?

I could assume on the part of my readers no more familiarity with this unknown terrain than I had myself. My purpose was therefore necessarily introductory, and answering the questions I had posed would necessitate extensive documentation. I hoped in this volume to define the genre in the words of its proponents; identify the roles of makers, purchasers, and consumers in the caricature industry; reveal the response of art critics and the public; and suggest the attitude of the "victims" themselves to the process. Although I had plenty of evidence, the breadth and unfamiliarity of my subject caused organizational and methodological dilemmas. In the end I concluded that a narrative approach would best accommodate both the questions I wished to address and the quantity of new material I had to present. There was a compelling tale here to be told: when, how, and why did the celebrity caricature vogue wax and wane?

The details of my larger story emerged from the smaller vignettes: the successful careers of the leading artists, the concerns of the publishers or editors who disseminated their work, and the efforts of the critics to define what they saw as a new art form. I have consciously chosen, therefore, a rather traditional approach: tracing the caricature phenomenon through individuals and tying my narrative closely to the artwork itself. The resulting biographical emphasis in much of the text permitted me to suggest the atmosphere within which caricature would thrive, while maintaining my overall, loosely chronological narrative structure. The images themselves invite a variety of interpretations. But speculation can go seriously awry unless grounded in an understanding of the pictures' place in the visual culture, so I wanted to locate this new genre within the fluctuating pictorial marketplace of the period. The portraits introduced here deserve further analysis. They could profitably be examined, for instance, within a social and political context or each celebrity's management of image portrayal. They could also yield many intriguing comparisons with other types of art. The number of pictures in this volume—nearly three hundred—precluded much in-depth analysis here. I hope that the present volume will inspire further investigation and the pursuit of different methodologies.

This turned out to be a New York story. The era's great masters of caricature converged upon the city from Kansas City, Saint Louis, Paris, Mexico City, or Rome, attracted by its prominence in art and publishing.

Popular magazines disseminated their work throughout the country, inspiring caricature on the entertainment pages of many metropolitan newspapers. But I have not attempted here to assess that national impact, and this study is in no way an inclusive survey of American caricature of the period. My files are overflowing with artists whose work and stories have not found a place in this chronicle. I have focused on the genesis and first flowering of celebrity caricature, and, despite a brief nod to Hollywood, I have located the principal elements of the tale in New York City. There was little room to speculate on how American media and celebrity cultures contributed to differences between these portraits and caricature traditions that developed elsewhere. All these areas warrant continued investigation.

Furthermore, in any work based on a large body of research, errors are bound to occur. I have noted a regrettable tendency for my fingers to type inventive fiction when my mind thinks it is dictating documentable truth. I have tried to list all my sources so my inevitable mistakes can be recognized and corrected by others.

Popular art forms emerge and subside slowly, frustrating the historian's urge to pin down tidy beginnings and endings. Promising precedents predate the starting point; new careers are launched when the trend seems clearly past. I will argue here that this type of portraiture flourished in the first half of the century, along with the growth of the mass media, and reached its peak between the two world wars. Caricature did not vanish after World War II, but this form of it—focused on personality and fame rather than social and political satire—diminished or changed its emphasis. I hasten to point out, however, that the late twentieth century may well be experiencing a rebirth of this temporarily latent art form. Magazines like *Rolling Stone* led the trend, publishing mildly mocking portraits as comments on national stardom. As mainstream periodicals of the 1990s compete for celebrity coverage, accompanied by caricature, talented young artists are encouraged again to draw the faces of the famous. So there may yet be other chapters to this unfolding tale. Still yearning for role models and grappling once more with explosive changes in communications, we modern Americans, like our predecessors early in the century, may well need caricature's refreshing corrective to our ongoing obsession with fame.

Acknowledgments

Large research projects and exhibitions are as highly collaborative as theatrical productions. My principal partner in this endeavor has been research assistant extraordinaire Pie Friendly. With a usefully unforgettable name highly descriptive of her personality, Pie has reinvented the telephone as a research tool, secured us valuable friends everywhere we have gone, organized our research trips from Hollywood to Seville, Spain, and tracked down information on a wide variety of subjects. No long lost object or buried biographical fact is safe from her dogged pursuit. She found things in people's attics they never knew they had, blanketed the country with letters that sometimes yielded results years later, and exercised her skills in promotional and fundraising activities when required. Of the many debts I owe her, none is greater than this: despite the inevitable tedium of research—and the dreaded microfilm machine has certainly appeared in our dreams—no team has ever had more fun on a long-term project. I thank her for her skill, her friendship, and several glorious years of adventure pursuing our subject.

Michael Kammen and Karal Ann Marling have aided my enterprise more perhaps than they know by reading the manuscript and supporting the project through several stages. Their endorsement has opened many doors for me, and I am immensely grateful for their advocacy and advice. Rick Marschall has also commented on the manuscript with beneficial results.

The National Portrait Gallery has provided me with incalculable support over the past five years. Director Alan Fern, a keen student of caricature himself, has been an enthusiastic proponent from the beginning. Deputy Director Carolyn Carr has been invariably helpful and understanding, honoring my requests, accepting my acquisitions, offering constant advice and support. Two other crucial readers, Lillian Miller and Brandon Fortune, invested considerable time on thorough and thoughtful reviews of the manuscript, a generous and valuable gift to any colleague. I greatly regret that Lillian did not live to receive her copy of the book or sufficient thanks from me; I shall miss her wise counsel. Amy Henderson gave critical advice at an early stage; Mary Panzer, Fred Voss, and others commented on portions of the text. I am grateful to them all. I felt especially privileged to have access to the superb library we have here; we hope Cecilia Chin, Pat Lynagh, and the rest of the library's marvelous staff recognize our gratitude. In our publications office Frances Stevenson and Dru Dowdy have performed many services with consummate skill. Photography for this book was a major undertaking: Rolland White and Marianne Gurley deserve our undying gratitude for their extra efforts to accommodate us. Curator of Exhibitions Beverly Cox and designers Nello Marconi and Al Elkins and their staff brought the exhibition to life in their nearly magical way. The competent hands of Claire Kelly and Liza Karvellas, as well as the entire staff of the registrar's office under Sue Jenkins, juggled the endless details involved in any large exhibition. I have relied greatly on conservators Rosemary Fallon and Emily Klayman; their insights have benefited me as much as their meticulous work has. Mary Hewes has labored hard on my behalf, as has the staff of the Education Department, particularly Leni Buff and Jewell Robinson. Development officer Deborah Berman deserves special thanks, not only for her accomplishments but for her unquenchable enthusiasm and support.

In my own office, Ann Wagner, LuLen Walker, Thom Minner, Ann Shumard, and Rebecca Szekely have contributed in ways too numerous to mention. LuLen has shepherded many new drawings through the acquisition process and Ann Wagner has been an endlessly patient assistant in charge of a myriad of details. More than anything else, I owe to this remarkable group the creation of

an atmosphere of friendship and support that allowed me to focus on the tasks at hand. I am fully aware of how lucky I am to have had this advantage. Over the years, numerous interns and volunteers have also helped with aspects of the research. I am indebted to Emily Hage, Andrea Howell, Dorothy Moss, Francis Fletcher, Katie Sevier, Sarah Goldfrank, Rosario Ramirez, Adriana Hopper, Lee Gray, Marjorie White, and Olivia Cowdrill. I hope all those not mentioned by name will realize how much I have appreciated their contributions.

Our research has taken us far afield and our obligations are many. The children of Al Frueh—Barbara Bornemann, Mike Frueh, and Robert Frueh—were exceptionally gracious, generous, and informative. Their gift of drawings and an invaluable archive of personal papers will have lasting value. Joe Grant showed equal generosity in donating caricature and describing his career. Rodrigo de Zayas welcomed us to Seville with great hospitality and was especially forthcoming in helping us research his father's work. Al Hirschfeld and his wife, Louise Kerz, offered friendship and assistance. Karl and Maybelle Klein, Bruce Kellner, and Ellen Goheen bent over backwards to inform us about Ralph Barton. Erwin Vollmer donated caricature and helped us research Aline Fruhauf's career. Heywood Hale Broun, Philip Hamburger, Anthony Adams, Peter Benchley, Ward Kimball, and Friz Freleng have broadened our understanding of the period in their various ways. Stu and Miriam Reisbord have donated drawings and tutored us on the subject of animation.

We owe thanks to many institutions and to the staff who have guided our way through theri collections. At the risk of inadvertently omitting important colleagues, I will mention specifically Marty Jacobs at the Museum of the City of New York; Robert Taylor, Brian O'Connell, Roberta Waddell, Nancy Finley, and Stuart Bodner at the New York Public Library; Ida Balboul and Marjorie Shelley at the Metropolitan Museum of Art; Wendy Shadwell at the New-York Historical Society; Bernard Reilly, Harry Katz, Jane Van Nimmen, Linda Ayres, Walter Zvonchenko, and Madeleine Mets at the Library of Congress; David Kiehl at the Whitney Museum; Brooks McNamara at the Shubert Archives; Jeanne T. Newlin and Annette Fern at the Harvard Theatre Collection; Geraldine Duclow at the Philadelphia Free Library; Iris Snyder at the Delaware Art Museum; Barbara R. Ross at the Princeton Art Museum; Meg Grasselli at the National Gallery; Marie Odile Gigou at the Bibliothèque Historique de la Ville de Paris; Cheryl Leibold at the Pennsylvania Academy of the Fine Arts; Domingo Rodriquez at the Theatre Development Fund; Samuel Gill and Margaret Herrick at the Motion Picture Academy Library; Kay Salz and David Smith at Disney; Maxine Flexner Ducey at the Wisconsin Film Archive; Ned Comstock at the USC Cinema Library; Melissa Miller at the Humanities Research Center; Paul Koda at George Mason University Library; Bart Ryckbosch at the Art Institute of Chicago; Ray Wemmlinger at the Players.

The exhibition could not have happened without our sponsors and lenders, whom I thank not only for their generosity but for their enthusiasm. We have also been overwhelmed by the generosity of many individuals with whom we have consulted. I am grateful to Tom Kunkel, Sylvia Morris, Judith Wechsler, Mike Barrier, Donald Crafton, John Canemaker, Nancy McClellan, Douglas Hyland, Francis Naumann, Richard West, David Leopold, Mark Samuels Lasner, Barbara Novak, David Tatham, Draper Hill, Keith Melder, Chuck Sachs, Harry Lunn, Richard Merkin, Art Wood, Steve Schneider, Tom Engelhardt, Katharine Graham, Steven Heller, Ed Sorel, Gabriel Laderman, Alan Buchman, Liz Hylton, Claude Bernés, Ralph Esmerian, Penny Proddow, Marion Fasel, Vincent Sardi, Jr., Jeff Lotman, Reggie Birks, Alex Miller, Robert Freedman, Hari Rorlich, Ray Kinstler, Bette Weed, Diana Franz, Dwight Bowers, Ruth Selig, Barbara Schneider, Walt Reed, and Roger Reed.

Judy Metro, Heidi Downey, Mary Mayer, and Lisa Tremaine at Yale University Press deserve my acknowledgment for seeing some value in the reams of paper I sent them and wrestling it into its present form.

Finally, I want to tip my hat to Rosanah Bennett, Emily Ennis, Mary Carpenter, Sarah Hall, and Anna Brooke for their ability to listen, encourage, and advise. My lowest bow, however, is reserved for Paul, Caroline, and John Daniel Reaves for providing a welcome daily distraction from my obsession. John Daniel's wit and imagination, reminiscent of the effervescent personalities I was studying, sustained me throughout with delightful doses of fresh perspective. This book is dedicated to him.

Lenders to the Exhibition

Anne and Ronald Abramson

Archives of American Art, Smithsonian Institution,
Washington, D.C.

The Beinecke Rare Book and Manuscript Library,
Yale University, New Haven, Connecticut

Nathaniel Robert Benchley

Mr. and Mrs. Paul A. Bonner

Brooklyn Museum of Art Library Collection,
New York

The Coffee House, New York City

Tom Engelhardt

Katharine Graham

Philip Hamburger

Harry Ransom Humanities Research Center,
The University of Texas at Austin

Sarah and Draper Hill

Al Hirschfeld

Patricia Ross Honcoop

The Houghton Library, Harvard University,
Cambridge, Massachusetts

The Mike Kaplan Collection

Mr. and Mrs. Karl H. Klein

Library of Congress, Washington, D.C.

Library of the National Portrait Gallery and National
Museum of American Art, Smithsonian
Institution, Washington, D.C.

Jeff and Thérèse Lotman

Harry H. Lunn, Jr.

The Metropolitan Museum of Art, New York City

Anne Meyer

Sarah Jane Morthland

Museum of the City of New York, New York

National Portrait Gallery, Smithsonian Institution,
Washington, D.C.

Margery Nelson and William Link

The New York Public Library, New York City

The New York Public Library for the Performing Arts,
New York City

Penguin USA Library, New York City

The Hampden-Booth Theatre Library at The Players,
New York City

Private collections

Sardi's Restaurant, New York City

The Steve Schneider Collection

Sally Sloan

Syracuse University Art Collection, New York

Part 1 Introduction

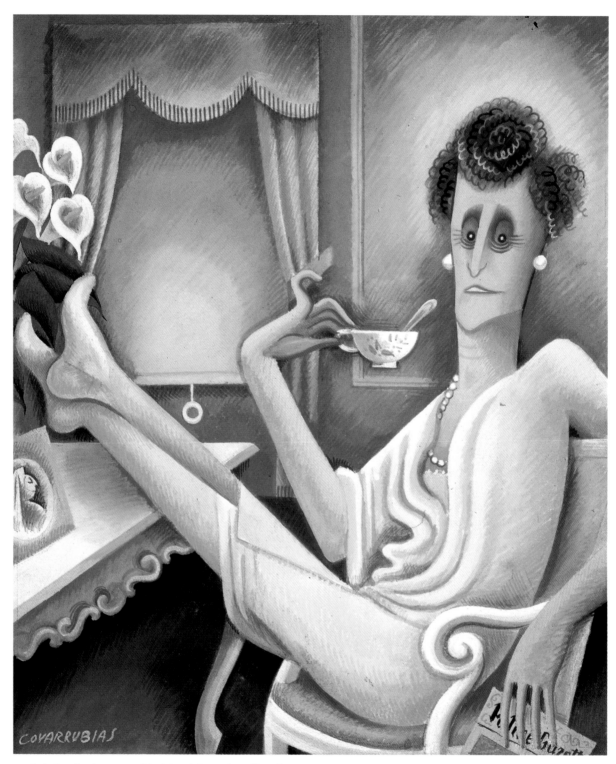

1.1 *Emily Price Post* (1873–1960) by Miguel Covarrubias. Gouache on paper, 29.3 x 24.1 cm (11⁹/₁₆ x 9¹/₂ in.), 1933. Original illustration for *Vanity Fair*, December 1933. Prints and Photographs Division, Library of Congress, Washington, D.C.

A Vivid Interpretation

Between modern caricature and modern "straight" portraiture there is only a thin and vague line of demarcation. Both are psychological in their way of seeing a subject, exaggerating the salient and significant features . . . , and rendering the summary impression by the quickest and most arbitrary strokes.
—Henry Tyrrell

We prefer caricatures of international figures to photographs of them simply because we seek some vivid interpretation.
—Vanity Fair, 1932

M iguel Covarrubias's caricature portrait of Mrs. Emily Price Post, published in the December 1933 issue of *Vanity Fair,* appalled her loyal friends and supporters (fig. 1.1). The doyenne of taste, widely admired for her books on etiquette and home decoration, her syndicated columns, and her radio broadcasts, appeared with bare feet propped on a table and the lurid *Police Gazette* dangling from one hand. The portrait stripped her of glamour, dignity, and good manners, contrasting provocatively with her public image. In letters to the editor, her friends complained. One was "shocked" at the "very vulgar caricature." Another was "surprised and disgusted," noting sourly that "it is not a good caricature, it has no meaning and it isn't funny. It is in bad taste and will . . . alienate from your paper many of her friends, among them myself." A third writer, however, was "currazy" about the portrait. This correspondent resented Post's ever-present advice and enjoyed seeing her sit with her feet up on the table, which, she noted, "is just what I bet the old horror does."

The editors of *Vanity Fair* had no need to worry about the mixed opinions; the fourth letter brought a perky endorsement from Post herself. "I think the caricature of me is too giggle-making for words," she gushed, "calla lilies, Queen Victoria, the shade pulled down and the spoon in the tea cup, and you don't know *how* funny the hair is! That's just the way it looks if allowed for so much as a minute to go its own way. Anyway, many many thanks for the delicious 'publicity.'"[1]

Delicious? The victim of this attack sounds positively charmed. What had happened to caricature's power to cause public figures to writhe in torment? What is the point of figural distortion if it is not relentless in serving the purpose of satire? The unflattering portrait certainly entertained its audience at Mrs. Post's expense. But the impeccably bred divorcée, required to support herself and her children, had learned the benefits of such publicity. The celebrity gained from syndication and radio promoted her reputation and sold her books. Covarrubias's portrayal, emphasizing fame, style, and wit rather than wounding criticism, also enhanced that necessary familiarity. It was a twentieth-century form of caricature, quite distinct from traditional graphic satire. More affectionate than damning despite their distortions, these portraits actually celebrated their victims, suggesting the attainment of an exalted level of public recognition.

Emily Post was not alone in understanding the value of this humorous, impudently mocking form of publicity. Few subjects appreciated their own portrayals at first glance, observed caricaturist William Auerbach-Levy in a 1925 newspaper interview, but many eventually changed their minds. George Gershwin's response to Auerbach-Levy's drawing (fig. 1.2) was typical. "Well, er," Gershwin reportedly muttered, "say, Bill, couldn't you just remove that cigar — it's so undignified stuck in the mouth at that angle." After the image was published, Auerbach-Levy noted, "cigar, angle, and all," Gershwin called to report, "everyone's crazy about that caricature you made of me. I think it's a peach. It's the best one ever made of me and I've been the victim of them all."[2] He asked for the original. Such publicity-savvy celebrities as the Algonquin Round Table writers, relentlessly caricatured, came to love the artists' distortions of their own features (fig. 1.3). They advocated a similar mocking wit and understood the compliment of being among the chosen victims.

Modern caricature, as it was sometimes called by artists and critics, was a form of portraiture that devel-

oped in America in the early twentieth century and peaked between the two world wars. Like previous forms of caricature, it used exaggeration and distortion to reinterpret the human figure in a sharp or humorous light. But these portraits of the interwar years had an updated style, tone, and significance. Although related to the satiric likenesses of editorial cartooning as well as the comic stereotypes of much magazine humor, they developed distinct characteristics. Like Al Frueh's *George Arliss* (fig. 1.4), they were frequently drawn from life, cleverly abbreviated rather than maliciously distorted, and focused on the fashionably famous. Caricature of the period carried a message quite different from the political or social satire of the day because

it grew directly out of a mass media–generated celebrity industry. These intensified summaries of personality, transformed by a modern aesthetic and a detached, sophisticated wit, appealed to an audience hungry for emblems of the emerging urban culture.

The magazines and newspapers that published this caricature considered it fresh and innovative. Condé Nast's *Vanity Fair*, one of the leading proponents of the humorous, stylized portrait, provided the best definition. Responding to a letter complaining about Covarrubias's October 1932 cover portrait of Mussolini, the editors felt compelled to state their policy. "The magazine regards a conspicuous caricature . . . as an acknowledgment of world importance, rather than as an insult.

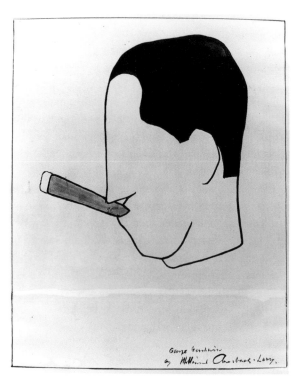

1.2 *George Gershwin* (1898–1937) by William Auerbach-Levy. India ink on paper, 36.8 x 29.2 cm (14½ x 11½ in.), c. 1925. Original illustration for *New York World*, February 22, 1925. Museum of the City of New York, New York; gift of Arthur Gershwin.

1.4 *George Arliss* (1868–1949) by Al Frueh. India ink and white gouache on board 49.5 x 35.5 cm (19½ x 11¼ in.), c. 1911. National Portrait Gallery, Smithsonian Institution, Washington, D.C.; gift of the children of Al Frueh: Barbara Frueh Bornemann, Robert Frueh, and Alfred Frueh, Jr.

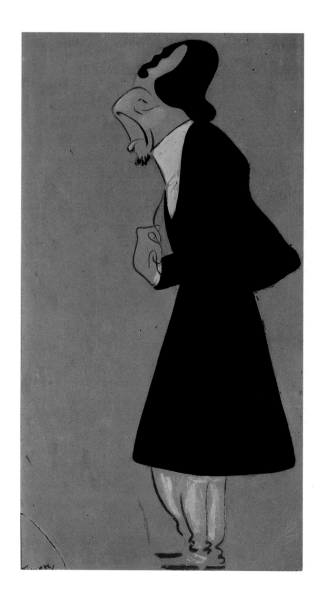

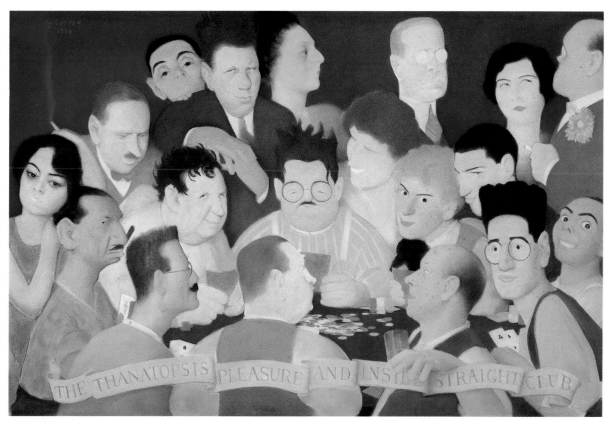

1.3 *The Thanatopsis Pleasure and Inside Straight Club* by Will Cotton. Pastel on paper, 65.4 x 99.1 cm (25³/4 x 39 in.), 1929. Mr. and Mrs. Paul A. Bonner.

Figures like Gandhi, Hindenburg, Macdonald, Hoover, and Roosevelt are given attention because of their great interest as personalities; not because *Vanity Fair* wishes to analyze or criticize their characters. . . . We prefer caricatures of international figures to photographs of them simply because we seek some vivid interpretation."[3]

Key words in *Vanity Fair*'s statement provide important clues about the significance of these portrayals. The editors preferred caricature because it provided a *vivid* portrayal, which implied a lively, bold, dynamic look derived from modern design. Furthermore, they viewed caricature as an expression of *personality*, not an analysis of *character*, terms that suggest a newly evolved concept of fame. Even when the subjects were presidents, prime ministers, society leaders, and business tycoons—all traditional subjects for ridicule and criticism—these images were irreverent rather than judgmental, a fresh, modern-looking portrayal of exterior characteristics.

To achieve the vitality of a "vivid interpretation," caricaturists strove for a figure immediately recognizable, eye-catching, and amusing. William Sharp's *Fanny Brice* (fig. 1.5) and Will Cotton's *Alfred Lunt and Lynn Fontanne* (fig. 1.6) exploit attenuated shapes, exaggerated expressions, and color to heighten the impact. Brice's ridiculous features contrast with the slim, elegant line of her figure. Fontanne, as Queen Elizabeth, fairly sizzles with brilliant hues. These images startled a public accustomed to predictable charcoal portraits and grainy photographs of the famous in newspapers and magazines. Cleverly abbreviated distortions, wild juxtapositions of colors, and witty references to well-known traits converged for the viewer into a sharp jolt of celebrity recognition.

The response to this new form differed from the traditional reading of figural distortion. A glance back at the history of caricature reveals that although the exaggerated portrait began with the more benign purpose of simple amusement, in the eighteenth and nineteenth

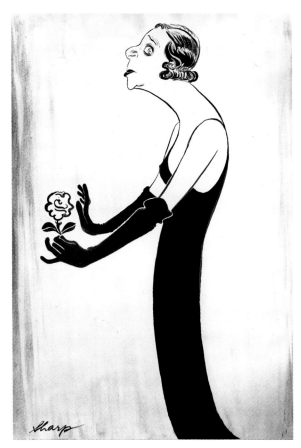

1.5 *Fanny Brice* (1891–1951) by William Sharp. India ink on board, 40.6 x 35.5 cm (16 x 13¹⁵/₁₆ in.), c. 1940–41. National Portrait Gallery, Smithsonian Institution, Washington, D.C.

care, meaning to load or exaggerate. The terms *ritrattini carichi* and *caricatura* began to spread as other artists imitated their informal sketches. The famous Baroque sculptor Gian Lorenzo Bernini was one of many who continued the tradition, sketching caricatures virtually all his life. His rapidly drawn portraits (fig. 1.7) always portrayed specific people rather than types; they were witty characterizations meant for the immediate amusement of the subject and his friends.[5] Bernini developed a reputation for his skill at conveying a likeness in a humorous form.

By the early eighteenth century, the Italians' distorted likenesses became well known through engravings, but caricature was expanding beyond the bounds of portraiture. In England, the popularity of satirical cartoons, combining Italian caricature with Dutch political allegories, helped to launch an extensive print industry for producing, marketing, and exporting graphic images. The human condition, rather than the human figure, provided the subject matter for these engravings. Their function was not just to amuse but to criticize the foibles of society and to protest the abuses of political power. Artists probed beneath appearances to expose disreputable character traits. The distortions of the figure played a role, providing the parody of a well-known likeness or establishing a comic type for ridicule, but the actual portrait was secondary to the satiric message of the cartoon. In the hands of such artists as William Hogarth, Thomas Rowlandson, and James Gillray, the meaning of the word "caricature" expanded to encompass a range of social and political satire.

The English artists produced separately published engravings, which were marketed to the public through printsellers. In mid-nineteenth-century France the publications of Charles Philipon—such as *Le Charivari*—linked the art of cartooning and social protest to journalism. His stable of cartoonists, dominated by the brilliantly able Honoré Daumier, turned out thousands of lithographic images for the satiric papers ridiculing King Louis-Philippe and his weak regime. Attempts at censorship brought more attention to their relentless attacks. In Daumier's *Baissez le rideau, la farce est jouée* (fig. 1.8), the king is a ridiculous Pierrot figure, dissolving the sleepy legislature with the clown's closing line "Ring down the curtain, the farce is over." Most famous of all were Philipon's caricatures of the pear-shaped head of Louis-Philippe. Arrested for one antiroyal image, he defended himself in court by

centuries it became inseparably linked with ridicule and social protest. It was no wonder that Emily Post's loyal friends were intuitively offended.

Comic drawing has existed throughout the history of art. Humorous deviations from concepts of ideal beauty can be traced to the ancient Greeks, for instance. The medieval world abounded with depictions of the fantastic and the grotesque, often with meticulous distortions of face and figure or the conflation of human and animal characteristics. But the beginnings of modern caricature are usually associated with the brothers Annibale and Agostino Carracci in late-sixteenth-century Italy.[4] Their quickly sketched outline portraits exaggerated certain aspects of the figure or face while maintaining a recognizable likeness or individual expression. The Carraccis were said to have even coined the word caricature, derived from the verb *cari-*

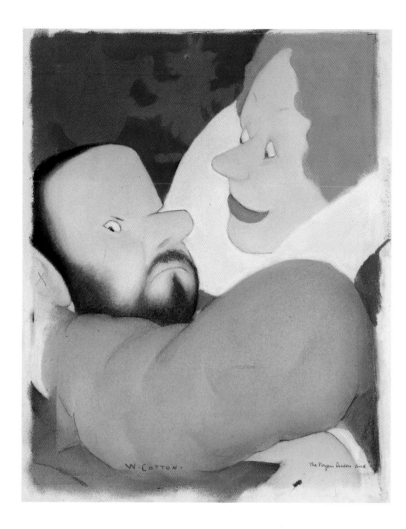

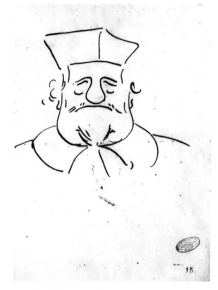

1.7 *Cardinal Scipione Borghese* (?–1633) by
Gian Lorenzo Bernini. Brown ink on paper,
before 1633. Biblioteca Apostolica Vaticana,
Vatican City, Italy.

1.6 *Alfred Lunt and Lynn Fontanne* (1893–1977;
1887–1983) by Will Cotton. Pastel on board,
48.2 x 35.6 cm (19 x 14 in.), c. 1930. National
Portrait Gallery, Smithsonian Institution,
Washington, D.C.

showing the judges how logically the head could be
transformed into the fruit (fig. 1.9). Since the French
word for pear also means "fathead," and suppression of
Philipon's publication of the drawing created even
more publicity, the drawing instantly became famous.[6]
By the end of the century, the success of Philipon's
comic papers stimulated a proliferation of satirical jour-
nals throughout the western world, while the editorial
cartoon became a standard feature of the daily news-
paper.

America had its own tradition of graphic satire. From
the allegorical cartoons of the American Revolution to
the mid-nineteenth-century political prints issued by
Currier and Ives and other lithographic companies,
cartoon and caricature most often served to expose and
ridicule.[7] In the 1870s, Thomas Nast's bloated and
grotesque characterizations of New York's corrupt offi-
cial, William Marcy Tweed (fig. 1.10), were nearly as
effective as Philipon's infamous pear. Published as
wood engravings in *Harper's Weekly*, Nast's pictures of
Boss Tweed helped to advertise the notoriety of the
Tammany politician and bring about his downfall. *Puck*
and *Judge* and other partisan humor journals of the late
nineteenth century reproduced full-page chromolitho-
graphic cartoons satirizing political figures. This tradi-
tion of graphic satire would continue into the twenti-
eth century and develop new forms. Social activism of
the Progressive era would find an effective voice in
daily editorial cartoons and new publications, such as
The Masses, which featured cartoons too radical for the
general press.

Lighter forms of humor had also developed in the
nineteenth century. The "gag" cartoon, meant solely to
amuse, became a staple of illustrated magazines, and the

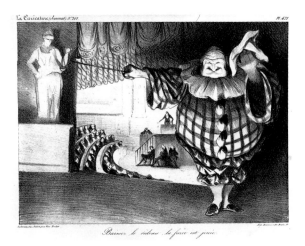

1.8 *Baissez le rideau, la farce est jouée* by Honoré Daumier. Lithograph, 19.9 x 27.7 cm (7¹³/₁₆ x 10⁷/₈), 1834. Rosenwald Collection, © 1997 Board of Trustees, National Gallery of Art, Washington, D.C.

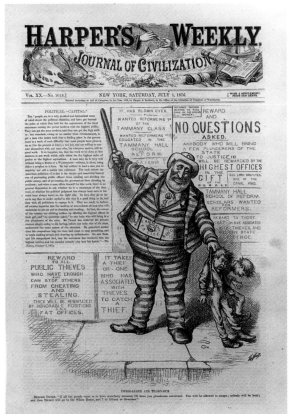

1.10 *Tweed-le-Dee and Tilden-dum* (William Marcy Tweed) (1823–78) by Thomas Nast. Wood engraving, 40.5 x 28 cm (15¹⁵/₁₆ x 11 in.), 1876. Published in *Harper's Weekly*, July 1, 1876. National Portrait Gallery, Smithsonian Institution, Washington, D.C.

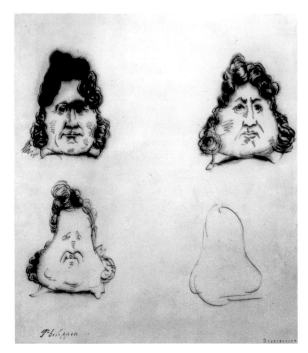

1.9 *The Metamorphosis of King Louis-Philippe into a Pear* by Charles Philipon. Bister ink on paper, 24.7 x 21.7 cm (9³/₄ x 8⁹/₁₆ in.), 1831. Bibliothèque Nationale de France, Paris.

multipaneled comic strip had begun to evolve. In England, the editors of *Punch* generally avoided bitter satire in the cartoons, indulging instead in a polite ribbing that upheld rather than mocked the Establishment.[8] Similarly, caricature likenesses in London's *Vanity Fair* were often nothing more than casual, informal portraits. Nonetheless, the public still associated caricature with criticism and ridicule. Exaggerated and distorted figures had been the handmaiden of social and political cartooning for nearly two centuries. Such portraits were supposed to probe and analyze; their distortions were meant to expose weaknesses and character flaws.

While the savage attack still suited the needs of social and political satirists, however, a young generation of caricaturists deployed a new approach in the years before World War I. They chose for their subjects the colorful rather than the corrupt figures of the day. However unflattering the distortions, these artists did not analyze, correct, or provoke. In strong, inked lines or bright, dazzling colors they uplifted the spirit with their lightly mocking appraisals of fame. The urban audience appreciated their leavening wit. By the

1920s, the vogue for caricature had turned into a craze. In New York City, amusing portraits were hung at Sardi's Restaurant, painted on café walls, printed on fabrics, featured on the intermission curtain of a popular musical revue, modeled into puppets like Al Frueh's *John Drew* (fig. 1.11), and engraved onto cigarette cases like Sem's *Cole Porter* and Frueh's *The Man Who Came to Dinner* (figs. 1.12, 1.13). Caricature permeated the press, particularly on the entertainment pages, where it was removed from an editorial context. In the process, the range of subjects expanded and the satiric intent began to diminish.

Writer and caricaturist Fornaro was one of the first critics in the American press to differentiate the caricaturist's art from the cartoon distortions of the editorial page. Defining a cartoon as an allegory of a political situation, he described a caricature, in contrast, as an "epigrammatic portrait of a personality," a concise evo-

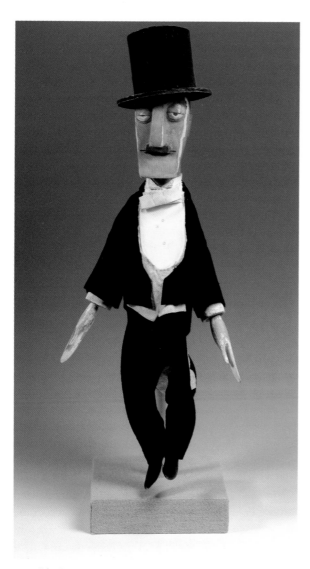

1.12 *Cole Porter* (1892–1964) by Georges Goursat [Sem]. Gold cigarette case, 1.6 x 8.7 x 7.6 cm ($^5/_8$ x $^7/_{16}$ x 3 in.), 1934. Made by Cartier for opening of *Adios Argentina*. Billy Rose Theatre Collection, New York Public Library for the Performing Arts, New York, Astor, Lenox, and Tilden Foundations.

1.11 *John Drew* (1853–1927) by Al Frueh. Wood, paint, cardboard, felt, fabric, and wire, 40.6 x 15.2 x 7.7 cm (16 x 6 x 3 in.), c. 1915–25. National Portrait Gallery, Smithsonian Institution, Washington, D.C.; gift of the children of Al Frueh: Barbara Frueh Bornemann, Robert Frueh, and Alfred Frueh, Jr.

1.13 *The Man Who Came to Dinner* (Monty Woolley, John Hoyt, Moss Hart, and George S. Kaufman) by Al Frueh. Silver, gold, and enamel cigarette case, 1.6 x 14.6 x 8.9 cm ($^5/_8$ x 5$^3/_4$ x 3$^1/_2$ in.), 1939. Made by Fulco di Verdura. Private collection.

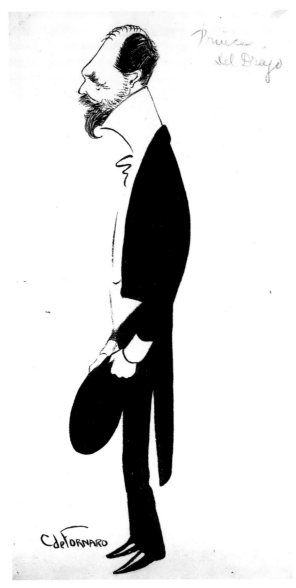

1.14 *Prince Giovanni del Drago* (1860–1956) by Carlo de Fornaro. India ink on paper, 37.8 x 20 cm (14⅞ x 7⅞ in.), c. 1910. © 1997 Board of Trustees, National Gallery of Art, Washington, D.C.; gift of John O'Brien.

cation of the subject's essence.[9] His words, and his own abbreviated, Parisian-style drawings (fig. 1.14) introduced the critical debate over definitions and implications of modern caricature that would last throughout the next generation.

Such cryptic renderings of personalities as Miguel Covarrubias's *Harpo Marx* (fig. 1.15) had little in common with the comic deformities of the editorial page. *Vanity Fair* editor Frank Crowninshield recognized that

these images were from a genre separate from the cartoon: distorted portraits assembled from similar components but with an independent aesthetic and internal logic. In a 1927 introduction to one of Covarrubias's books, Crowninshield offered his explanation of the difference between cartoon and caricature: "Our pen-and-ink newspaper humorists, remarkable as they undoubtedly are, would find themselves in a serious quandary save for three befriending expedients—the device of exaggeration, of clever legends, and of subjects which *in themselves* are farcical . . . subjects, in short, which, even without a drawing, automatically superinduce laughter. Take the best men in the American newspaper field today . . . deny them these three expedients and see how almost impossible their task would become." Covarrubias, on the other hand, worked with "only a chemist's trace of exaggeration" and no need for captions or farcical situations. "Our laughter derives," Crowninshield pointed out, "wholly and absolutely from the draftsmanship itself; from the artist's grasp of character, his clairvoyant vision, his sensitive misdirection of line, or his deft and almost imperceptible misplacement of muscle, shadow or plane."[10]

Caricature portraits, in the hands of these artists, departed from comic conventions and evoked the vitality of the new century by borrowing the vocabulary of avant-garde design. Although American caricature encompassed a variety of styles, it generally expressed a diluted form of modern art, derived not only from the artistic avant-garde but from contemporary graphic design, fashion, theater, and the popular arts. At about the turn of the century, through the influence of numerous movements and workshops from Vienna to Glasgow to Berlin, craftsmen, architects, and artists began to emphasize the importance of aesthetic design in the decorative and applied arts. The compelling desire to integrate and purify all form and ornament in everyday life profoundly influenced commercial, industrial, fashion, and graphic designers.

The new art movements of the period encompassed unprecedented experimentation with color, structure, perspective, cultural references, and symbolic and abstract representation. The controversy generated by these radical departures from visual realism left many critics and much of the public firmly opposed to a modernist viewpoint, but it did bring urgency and innovation to all design concepts. As designers attempted to express the modern era, they borrowed

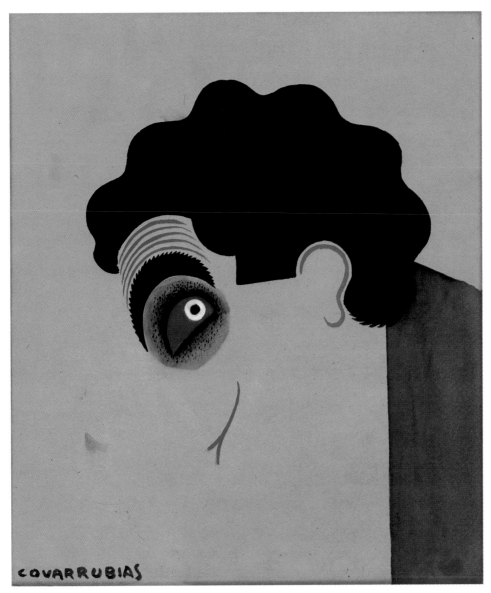

COVARRUBIAS

1.15 *Harpo Marx* (1893–1964) by Miguel Covarrubias. Watercolor and tempera on paper, 35.6 x 30.5 cm (14 x 12 in.), c. 1930–35. National Portrait Gallery, Smithsonian Institution, Washington, D.C.

elements from the fine arts. Forms became simplified, elongated, geometricized, abstracted, fragmented, or distorted, evoking a new, contemporary look. Thus, through books, magazines, posters, advertisements, postcards, packaging, stage sets, clothes, and so forth, basic elements of modern style entered daily life. Most of the theoretical underpinnings of the various art movements were left behind in the process. Nonetheless, this bold and simplified look implied newness and vitality.

Modern design evoked two themes that seemed to summarize the spirit of the times: a preoccupation with style and a fascination with fast-paced urban culture. In his study of American advertising in this period, Roland Marchand discusses how promotional campaigns borrowed fine art imagery to create an aura of urbanity. Pictures could convey the image of fashionable contemporaneity when words could not, giving an added value to almost any product. By the mid-1920s,

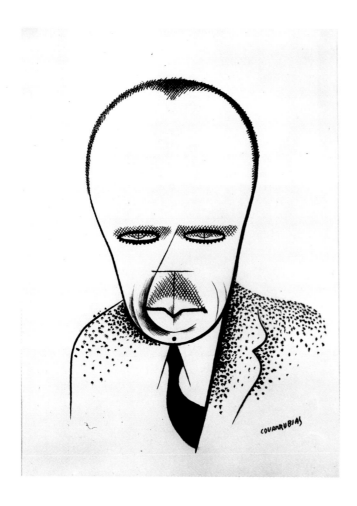

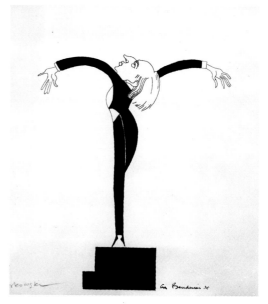

1.17 *Leopold Stokowski* (1882–1977) by Alfred Bendiner. India ink and pencil on paper, 35.8 x 28.9 cm (14^1/$_{16}$ x 11^3/$_8$ in.), c. 1940. National Portrait Gallery, Smithsonian Institution, Washington, D.C.

1.16 *James Weldon Johnson* (1871–1938) by Miguel Covarrubias. India ink on paper, 27.7 x 19.7 cm (10^7/$_8$ x 7^3/$_4$ in.), c. 1928. The Yale Collection of American Literature, Beinecke Rare Book and Manuscript Library, Yale University, New Haven, Connecticut.

advertisers competed for visual attention by using such components of modernism as diagonal lines, asymmetrical layouts, fragmentation, expressive distortion, and simplified composition. Consumers, they felt, would equate such visual signals with sophistication.[11]

Advertisers firmly believed that their work, often derived from modernist design, reflected American culture at its best. Historians could reconstruct a picture of 1926, boasted advertising agency N. W. Ayer and Son, simply by perusing newspapers and magazines, for daily advertising faithfully records the "action, color, variety, dignity, and aspirations of the American Scene."[12] The rhetoric of the day leaves no question that that scene was an urban one. The tempo, energy, newness, and polish of the city underlay all claims. "Every age finds its own mode of expression," trumpeted the Stehlisilks Corporation in a promotional pamphlet for a new series of fabrics by American designers. "And out of our restless and vigorous civilization has grown a robustly original form of art. There is nothing restful about our skyscrapers—their beauty lies in their clean sweep of line and their buoyant energy. Modern American art is the expression of a virile civilization; it is exciting, energetic, colorful."[13]

Caricature, like advertising art, borrowed from contemporary aesthetic trends to convey dynamic energy and sophistication. Never had style seemed so important for comic drawing. Humor itself was secondary to a stylish manipulation of line and form. By using simplified, elongated figures, abbreviated features, geometric patterns, and streamlined precision, caricature artists evoked the fashionable modernity of urban life. Ultimately their stylish mockery would be fueled by the abstractions, collage techniques, color dissonances, and unex-

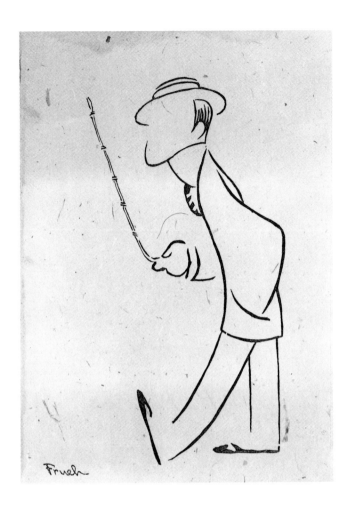

1.18 *George M. Cohan* (1878–1942) by Al Frueh. Linocut, 31.9 x 21.7 cm (12⁹/₁₆ x 8⁹/₁₆ in.), c. 1915–22. Published in Frueh, *Stage Folk* (New York, 1922). National Portrait Gallery, Smithsonian Institution, Washington, D.C.

pected conflations of cubism, fauvism, and surrealism.

Distortion and provocation had long been elements of caricature and cartoons. But in the early twentieth century, these were also aspects of much artistic innovation. Thus, exaggerated or stylized features in caricature of this period suggested a sophisticated, experimental approach to portraiture. Miguel Covarrubias organized his image of Harlem Renaissance author and poet James Weldon Johnson into an exacting geometric scheme (fig. 1.16). With a delicate cross hatching he suggests the dark skin tone. He leaves much of the face unmodeled, however, to heighten the impact of the powerful brow and jaw, suggesting intelligence and strength of character. Despite his symmetrical precision, however, he manages to retain a convincing likeness, moderating distortion through familiarity.

These isolated portraits, removed from distracting backgrounds, dialogue lines, and captions, catch the eye with an assertive simplicity. Such images as Alfred Bendiner's *Leopold Stokowski* (fig. 1.17) enliven the page, conveying the drama and movement of live performance. The controlled lines and condensed forms have a totemic power. Al Frueh's caricature of George M. Cohan (fig. 1.18), drawn in fluid contours, eliminate facial features altogether, distilling the image to the shape of the chin, the tilt of the hat, and the jaunty and distinctive stance. It seems to express the exuberance, theatricality, and wit of the age.

The vitality of modern style alone, however, does not explain the prevalence of these portrayals. If this type of caricature lacked the sharpness and bite that has invigorated political commentary and social satire for centuries, we must find another reason for its extraordinary popularity. The extra element, of

1.19 *George S. Kaufman* (1880–1961) by William Auerbach-Levy. India ink on paper, 26 x 14.6 cm (10¼ x 5¾ in.), c. 1925–30. National Portrait Gallery, Smithsonian Institution, Washington, D.C.

course, is the relationship of caricature to the twenti-eth-century form of celebrity. The instantly recogniz-able caricature could function as a sort of trademark or logo advertising the subject's fame. William Auerbach-Levy used bold contours and barely sug-gested features to create an emblematic summary of personality in such images as *George S. Kaufman* (fig. 1.19). Columnist Franklin P. Adams, or F. P. A., as he was known, played poker with cards that featured dif-ferent caricature portraits of himself (fig. 1.20); critic

Alexander Woollcott had his own image printed on stationery and announcements.[14]

According to *Vanity Fair's* caricature policy, subjects were chosen "because of their great interest as *personali-ties,*" not because of a desire "to analyze or criticize their *characters.*" These are the same words used by historian Warren Susman as he charts the change from a culture of character in the nineteenth century to a culture of personality in the twentieth.[15] This type of caricature became popular because it responded to a new preoc-

cupation with the fashionably famous. The nature of fame had changed profoundly in just a few generations. Notability was no longer based solely on achievement, heroism, villainy, or "character." Accomplishment became less important than the extended publicity or reputation generated from it. In addition, by the early twentieth century fame was no longer tied to traditional forms of accomplishment. The baseball hero, the striptease star, and the mother of quintuplets could compete with the warrior prince and the theologian in the pantheon of the famous.

The evolution toward modern celebrity can best be understood by tracing its roots to the nineteenth century. In many respects the distribution of inexpensive prints and photographs and the growth of illustration in the press—what Daniel Boorstin calls the Graphic Revolution—established the communication system through which twentieth-century celebrity evolved.[16] Concurrently, the components of fame were beginning to change. In postrevolutionary America, the famous were often judged by standards of civic virtue and public service. The *Grand Masquerade Ball* (fig. 1.21), an 1866 *Harper's Weekly* newspaper cartoon by Thomas Nast, depicted a series of recognizable images of prominent people representing the life-size caricatures that Nast had created for a New York opera ball.[17] The presence of the showman P. T. Barnum as well as Nast himself in this entourage suggests the evolution toward a publicity-driven type of celebrity. The remaining subjects, however, are historians, poets, clergymen, editors, presidents, statesmen, and classical musicians.

By the end of the nineteenth century, the focus had shifted to individual, self-made success, spotlighting those who had acquired material wealth or attracted a popular following. A public audience became a necessary component of fame. As Leo Braudy has pointed out, "the theater of public life that before had been so scorned, attacked, or cautiously embraced became an essential part of the equipment of everyone who aspired to popular recognition."[18] As figures like Barnum had already discovered, to succeed in this public sphere one had to attract the attention of the press. The theatrical star system that emerged in the late nineteenth century, dependent on publicity and advertising, reflected these developments. Major figures of the New York, Paris, and London stage made well-publicized tours of the country. Their adoring fans put local stock companies out of business.

Such changes signaled a shift in the history of fame. Celebrity in its modern form, however, was propelled by the development of the mass media at the beginning of the twentieth century. The technological innovations and efficiencies of scale that were brought to bear on the national system of communications had a profound effect in disseminating information about the famous. Motion pictures and recordings brought stars to a national public. Newsreels publicized war heroes and athletic champions in all corners of the country. Radio popularized new commentators and entertainment personalities from the low and high ends of the spectrum.

A phenomenal growth in newspaper and magazine circulation in the late nineteenth century had already brought the traditional press into the era of the mass

1.20 *Franklin P. Adams* (1881–1960) by Rea Irvin. Halftone on paper, 8.9 x 5.7 cm (3$\frac{1}{2}$ x 2$\frac{1}{4}$ in.), c. 1930. National Portrait Gallery, Smithsonian Institution, Washington, D.C.; gift of Anthony Adams.

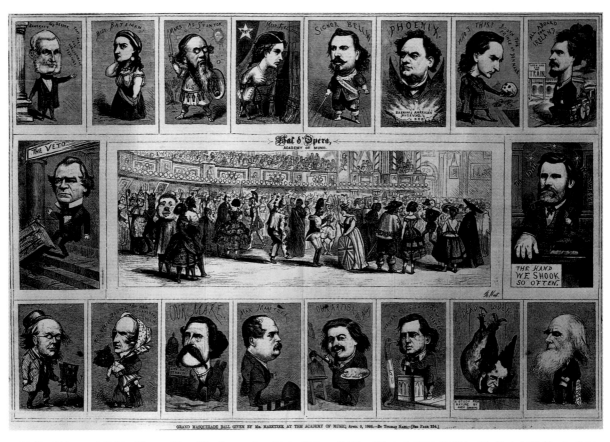

1.21 *Grand Masquerade Ball* by Thomas Nast. Wood engraving, 34.4 x 52.2 cm (13¼ x 8⁹⁄₁₆ in.), 1866. Published in *Harper's Weekly*, April 14, 1866. National Portrait Gallery, Smithsonian Institution, Washington, D.C.

audience. As the new century unfolded, however, information about the famous became increasingly standardized. Newspapers, for instance, consolidating or merging into chains like Hearst, Scripps-Howard, and Gannett, lost some of their individual character. Editors relied increasingly on syndication services, especially for features.[19] One writer growing up in the Midwest in the early 1930s remembered avidly reading the syndicated columns in the local Hearst paper and the "loads of King Features Syndicate stories about glamorous folk of every ilk."[20] Just as Americans throughout the country heard the same recordings and watched the same movies, they read identical celebrity anecdotes illustrated with the same intimate, candid pictures.

What the syndication services did not provide, press agents and public relations experts did. The field of celebrity promotion expanded dramatically along with

all other forms of advertising. Eager publicists pumped out "news" of their own making and fresh glamour photos, simultaneously creating and feeding increased demand. The extra coverage stimulated new outlets: tabloids, fan magazines, newsmagazines with cover portraits, and greatly expanded Sunday magazines in the large city papers. Even small-town newspapers felt the effects of the urban mass media. William Allen White's *Emporia (Kan.) Gazette*, for example, so renowned for its individual character, was by the 1920s devoting more space to the latest celebrity photographs and features "now distributed in mats with stylish layout and headlines already provided."[21]

The vast machinery that developed to support Hollywood's star system set new standards of promotion. The combined resources of the trade press, fan magazines, newspapers, posters, public appearances, and films themselves produced a narrow set of distinct char-

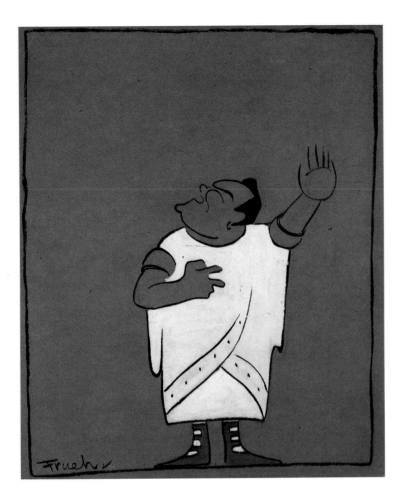

1.22 *Enrico Caruso* (1873–1921) by Al Frueh. Ink, gouache, and watercolor on board, 38 x 28.7 cm (14⁵/₁₆ x 11⁵/₁₆ in.), c. 1910. National Portrait Gallery, Smithsonian Institution, Washington, D.C.

acter traits (often fictional or exaggerated) that distinguished one star from another. Studios and press agents made sure that no information contradicting that constructed identity entered the public sphere.[22] The rest of the celebrity industry evolved along similar lines, producing simplified, glamorized identities for other public figures. Neither producers nor consumers wished to crack open these exaggerated celebrity images and reveal more realistic human traits. The hints of peccadilloes that were dropped in the early Broadway gossip columns, for instance, and the endless information about the private lives (generally love lives) of the famous usually tantalized readers without truly reversing reputations. Everyone wanted to laugh at eccentricities and flaws, but no one wanted to destroy their larger-than-life heroes, geniuses, bad boys, and ingenues.

Out of this familiarity grew besotted fans, marketable fads, and unprecedented renown. Pajamas, per-

fume, soap, and cigars were named after Broadway beauty Billie Burke (see fig. 5.9), and stores sold copies of her slim-fitting gowns and red-gold curls. The new stars of the era learned how to exploit new media technologies to promote themselves and capture expanding audiences. Operatic tenor Enrico Caruso (fig. 1.22) made his first recordings in 1902. The managing director of the Metropolitan Opera, along with many of Caruso's fans, heard his legendary voice for the first time through the phonograph. Many actors moved from the Broadway or vaudeville stage to film studios; some even survived the transition from silent movies to sound. Cowboy performer Will Rogers parlayed his wisecracking vaudeville act into a career that encompassed Broadway, syndicated columns, magazine articles, movies, books, and radio broadcasts. "Us Birds that try to keep before and interest the public have various ways of doing it," he wrote. "The more you do

anything that don't look like advertising the better advertising it is."[23]

The mass media thus completed the change in the definition of notability. For most of the nineteenth century, fame related to lasting accomplishment in traditional fields; popular writers and lecturers praised the virtues of statesmen, clergymen, authors, military heroes, and business leaders for the public to emulate. In the twentieth century the focus had shifted. According to a study cited by cultural critic Dwight Macdonald, for instance, the entertainment world increasingly provided the subjects for biographical articles in popular magazines. The emphasis on achievement from business, professional, and political fields correspondingly declined. Even the word "celebrity" took on new connotations. By the 1920s and '30s, the implication of serious, lasting accomplishment had disappeared. In his introduction for the *International Celebrity Register* (1959), Cleveland Amory defined what the word had come to signify in the twentieth century: "It often means simply accomplishment in the sense of popular, or highly publicized, temporary success."[24]

Caricature, closely connected to the growing celebrity industry, reflects these changes in the popular concept of fame. Books of collected caricature from the 1920s reveal an expanded field of talents and accomplishments. Covarrubias's 1925 volume *The Prince of Wales and Other Famous Americans* appropriated the handsome British prince along with a range of indigenous subjects.

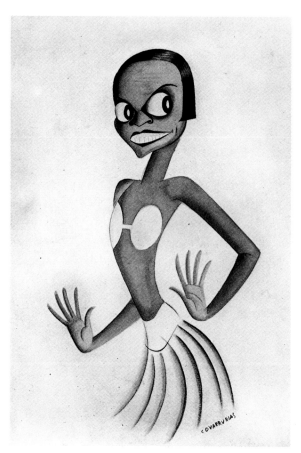

1.23 *Florence Mills* (1895–1927) by Miguel Covarrubias. Printed illustration. Published in Covarrubias, *The Prince of Wales* (New York, 1925). Library of the National Portrait Gallery and the National Museum of American Art, Smithsonian Institution, Washington, D.C.

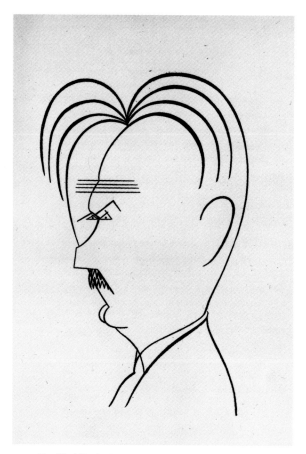

1.24 *Van Wyck Brooks* (1886–1963) by Eva Herrmann. Printed illustration. Published in Herrmann, *On Parade* (New York: Coward-McCann, 1929). Library of the National Portrait Gallery and the National Museum of American Art, Smithsonian Institution, Washington, D.C.

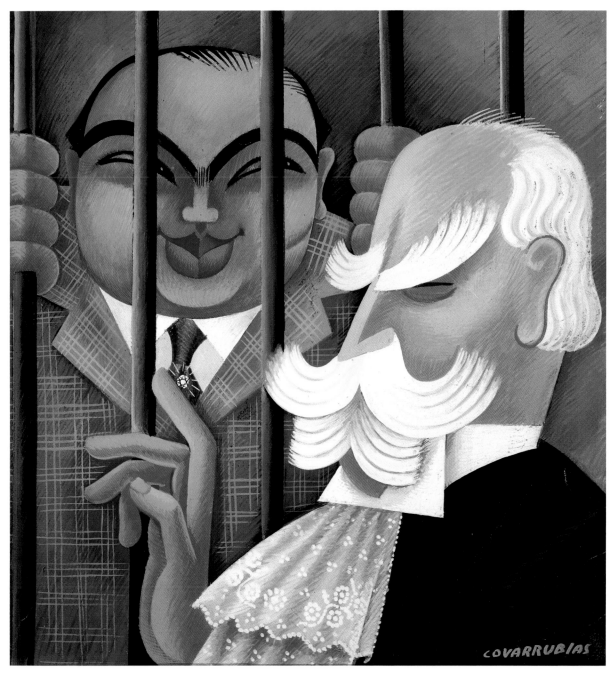

1.25 *Al Capone and Chief Justice Charles Evans Hughes* (1899–1947; 1862–1948) by Miguel Covarrubias. Gouache on paper, 32.7 x 27.5 cm (12 7/8 x 10 13/16 in.), 1932. Original illustration for *Vanity Fair*, October 1932. Art Collection, Harry Ransom Humanities Research Center, The University of Texas at Austin.

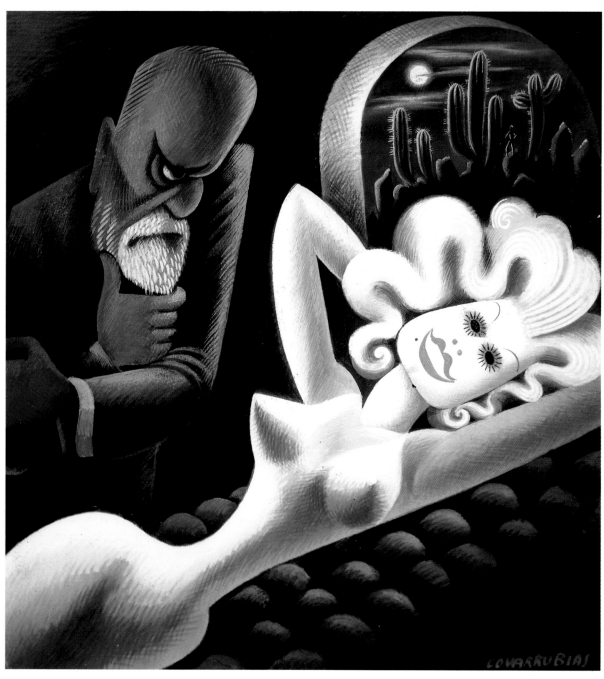

1.26 *Sigmund Freud and Jean Harlow (1888–1939; 1911–37)* by Miguel Covarrubias. Gouache on paper, 35.2 x 29.2 cm (13⁷/₈ x 11¹/₂ in.), 1935. Original illustration for *Vanity Fair*, May 1935. Prints and Photographs Division, Library of Congress, Washington, D.C.

Sports heroes, film stars, follies girls, radio personalities, and syndicated columnists joined the traditional statesmen and bankers in this book of stylized portraits. The same humorous irreverence underlies the presentation of dancer Florence Mills (fig. 1.23) and President Calvin Coolidge (see fig. 7.23). It was not so much a lack of respect as an equal level of admiration accorded to each subject for attaining a requisite level of fame.

Of course the caricaturists still lampooned statesmen, authors, merchant princes, and other subjects from more traditional fields of accomplishment, but these depictions carry a different meaning from that of the nineteenth-century portraits—or cartoons—of "great men." Eva Herrmann, in On Parade of 1929, focused on literary figures. Her images of writers gave famous names and faces a new twist. Unlike pictures of the famous from an earlier age, the depiction of the face did not automatically refer to the subject's accomplishments. Caricature portraits bristling with wit, sharp lines, geometric shapes, and a modern approach distracted the viewer from the underlying reasons for fame. Detailed familiarity with the author's writing was less important than an immediate recognition of his face and reputation. The parallel lines above the eyes of Herrmann's Van Wyck Brooks (fig. 1.24), for instance, evoked more than a furrowed forehead. They referred as well to Brooks's anxiety about what he called highbrow and lowbrow, well-known terms that he used to describe the cultural divergences in American life.

Critics like Brooks worried about the marked distinction between high and low elements of the culture that had emerged at the end of the nineteenth century, with templelike museums and symphonic halls paying homage to imported culture while seedy burlesque houses pandered to baser tastes.[25] Opera and Shakespearean plays, for instance, once popular art forms that attracted the entire social structure from the heckling pit to the kid-gloved boxes, were produced primarily for a wealthy, educated elite by the end of the century. Vaudeville, burlesque, and the early moving pictures provided more popular fare. Van Wyck Brooks deplored the irreconcilable difference between a derivative high culture divorced from any authentic life experience and a shallow, unintellectual low culture providing only a momentary respite from materialistic competition.

"Certainly no true social revolution will ever be possible," he wrote in the accompanying paragraph in Herrmann's book, "till a race of artists, profound and sincere, have brought us face to face with our own experience and set working in that experience the leaven of the highest culture." He longed for a "genial middle ground" based on a common American heritage.[26]

Technological changes in media communications in the early twentieth century would soon hasten a unified national culture, although critics would have to contend with its distinctly middlebrow sensibilities.[27] The emerging media industries rapidly undermined cultural polarities, popularizing the more sophisticated entertainments and refining the less genteel for a mass audience. With high moral purpose, for instance, the broadcast and recording industries wrest highbrow music from the hands of the elite in an attempt to elevate and educate. If a general audience felt excluded from elaborate symphonic halls and opera houses where top hats and propriety were expected, anyone could marvel over Caruso's recordings. When Arturo Toscanini, renowned conductor of the Metropolitan Opera and the New York Philharmonic, began conducting the NBC radio orchestra in regular broadcast concerts, a Fortune magazine survey found that of the nearly 40% of all Americans who had heard of Toscanini's name, "no less than 71% can identify him as an orchestral conductor." His was "certainly a mass audience," the magazine concluded.[28]

But great entertainment talents also emerged from the vital, so-called low end of the spectrum. Composer Irving Berlin, drawing inspiration from the amalgamation of immigrant cultures in New York's Lower East Side, wrote songs that seemed to define the American spirit. Enormously successful on Broadway and in recordings and films, Berlin created a musical legacy that seemed to touch virtually every American.

This merging of high and low elements of the culture provided an ideal opportunity for caricature. Both mocking and exploiting the new mix of famous figures provided by the celebrity industry, caricature could deflate the serious accomplishments of some while elevating the peripheral or temporary impact of others. Covarrubias's popular "Impossible Interview" series for Vanity Fair in the 1930s, for instance, explores the lev-

eling nature of twentieth-century fame for its humorous implications. The seemingly illogical pairings of gangster Al Capone with Chief Justice Charles Evans Hughes (fig. 1.25), Albert Einstein with astrologist Evangeline Adams, or Sigmund Freud and Jean Harlow (fig. 1.26) epitomized—and lampooned—the equalizing effects of modern celebrity.[29] These pictures gave the criminal and the justice, the brilliant scientist and the fortune teller, the psychoanalytical theorist and the sex goddess the equal focus and status that they received in the public mind. We can discount any divergence on moral or intellectual grounds: as celebrities, these figures share a more or less equivalent rank. The humorous incongruity hints at the possible implications of this nonhierarchical perception of prominence.

Covarrubias's "Interview" between modern choreographer Martha Graham and fan dancer Sally Rand, published in *Vanity Fair* in December 1934 (fig. 1.27), aptly conveys this theme. A hilarious series of contrasts define the pairing in this drawing: Graham, intense, avant-garde, and creative, is depicted with sharp angles and a harsh, brilliant red; Rand, sensuous and alluring, is rendered in smooth curves and candy-sweet pink. The accompanying dialogue, however, written by Corey Ford, emphasizes the underlying similarities between the two subjects:

> SALLY: *Hello, Martha. Still doing the same old intellectual strip-tease?* MARTHA: *I beg your pardon, Miss Rand, I do not think we have anything in common*—SALLY: *Forget it, kid, we're in the same racket, ain't we? Just a couple of little girls trying to wriggle along.* MARTHA: *But my dancing is modern—classical—imaginative. If you leave anything to a customer's imagination, it's because he's near-sighted.* SALLY: *Sure, I come right out in the open. I put my best points forward.* MARTHA (*haughtily*): *You should learn to bare your soul.* SALLY: *Say, I got to keep something covered.* MARTHA: *In your dancing, you should seek to interpret*—SALLY: *That's where you're wrong. I always let 'em put on their own interpretation. They like to read between my lines.* MARTHA: *I don't know what they see in you.* SALLY: *Neither do they. They only think they do. That's why I'm always surrounded by so many fans.* MARTHA: *I'm sure you'd be frowned on in the ladies' clubs.* SALLY: *And you'd be a flop in a cooch concession, kid. From now on, we'd better split fifty-fifty. You take the ladies, and I'll take the men*—MARTHA (*enviously*): *For plenty.*[30]

This repartee gently mocks Graham's modernism for its seriousness while endowing Rand's playful allure with a certain legitimacy. Nothing about the fan dancer suggests immorality or even bad taste; she comes across as feisty, funny, and talented. In other words, high art and low, popular culture and the avant-garde merge in an expression of the new preoccupation with the talented and famous.

Much of this caricature's satire was aimed not at the individuals themselves but the celebrity system that produced them. The famous had learned how to maintain a public persona through new channels of publicity. But many eventually recognized the damaging effects of the modern media spotlight. Enrico Caruso, always ready to talk to reporters or give a charity concert, acknowledged that this willingness affected his health. "If I had known the high price of celebrity," he once confided, "I would have gladly become a member of the chorus." The urbane British playwright and actor Noel Coward found himself in great demand during his many Broadway appearances. "The press fall over themselves to say nice things about me," he once exulted after another successful opening, "and I'm altogether New York's white haired boy." But Coward was keenly aware that his public persona was as much a charming, artificial creation as those he invented for the stage. "It's all a question of masks, really," he wrote about celebrity like his own, "brittle, painted masks. We all wear them as a form of protection; modern life forces us to. We must have some means of shielding our timid, shrinking souls from the glare of civilization."[31]

Caricature spoofed those celebrity masks rather than the individuals behind them, even though its humor depended upon the recognition that publicity provided. Most readers would have recognized violinist Fritz Kreisler immediately in Paolo Garretto's witty depiction (fig. 1.28) drawn on a thin piece of wood veneer against a brilliant, air-brushed blue background. Garretto published this drawing on a *Vanity Fair* page called the "Olympians of the Musical Sphere" (fig. 1.29) which also featured Paderewski, Stravinsky, and Toscanini. The varied color backgrounds pull the page together in a patchwork of geometric faces, all recognizable to even tone-deaf Americans.

Familiarity creates an illusion of intimacy between the famous and their public, as Leo Braudy and Richard Schickel have suggested.[32] The irreverence of a carica-

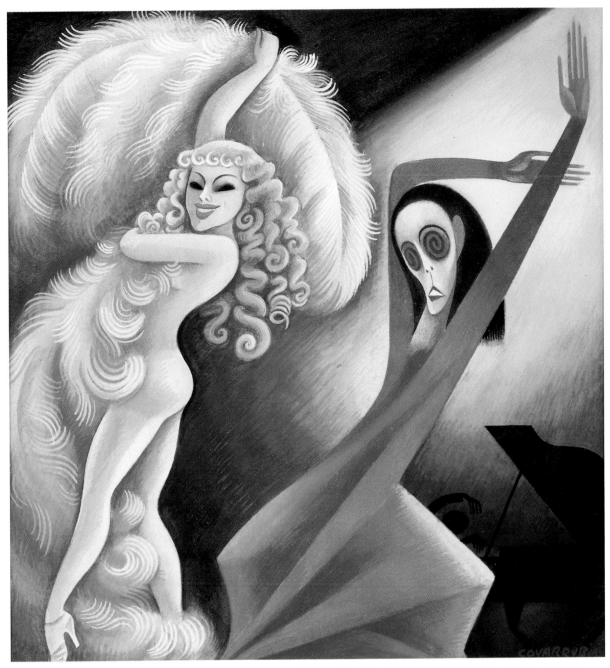

1.27 *Sally Rand and Martha Graham* (1904–79; 1894–1991) by Miguel Covarrubias. Gouache on paper, 31.7 x 29.8 cm (12½ x 11¾ in.), 1934. Original illustration for *Vanity Fair*, December 1934. Private collection.

1.28 *Fritz Kreisler* (1875–1962) by Paolo Garretto. Collage with wood laminate, airbrushed gouache, and black crayon on board, 30.8 x 23.8 cm (12¹/₈ x 9³/₈ in.), 1933. Original illustration for *Vanity Fair*, March 1934. National Portrait Gallery, Smithsonian Institution, Washington, D.C.

ture portrait, like Covarrubias's 1933 drawing of Emily Post, removed the personal distance one senses from a stranger. The etiquette she advocated may have implied an exclusive, aristocratic background, but as a celebrity she was accessible to everyone. Humor underscored this feeling of intimacy. Any threat of inferiority to Emily Post or Martha Graham or Van Wyck Brooks disappears as we smile at the caricaturist's distillation of their reputations.

The fandom created by the mass media, Braudy has pointed out, "caricatures the famous" through a process of simplification, reduction, and distortion.[33] His choice of words suggests the confluence of this type of popular portraiture and the new twentieth-century version of fame. The celebrity image of a public figure often became a simplified, exaggerated construction in the public imagination that was far removed from the reality of the individual. Many of the characteristics of the caricature portrait—the celebratory irreverence, the broad outlines and featureless faces, the exaggeration and stylization, the focus on particular details to the exclusion of others, the suggestion of intimate familiarity—also summarize the public perception of the celebrity heroes of a modern society.

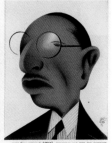
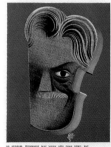

1.29 *Olympians of the Musical Sphere* by Paolo Garretto. Printed illustration. Published in *Vanity Fair*, March 1934. Library of the National Portrait Gallery and the National Museum of American Art, Smithsonian Institution, Washington, D.C.

The Spirit of Caricature

Humour is more to us than a mere mood. It is the pith of the swift, electric atmosphere that is so distinctively our own. . . .
It is a thing as wide as a city street, as free as a prairie, as vivid as an incandescent sign.
—Louis Baury

American artists, journalist Louis Baury noted in a January 1915 article for *The Bookman*, had an ebullient humor quintessentially their own, a spirit that "craves only the privilege of . . . pelting impartially with its own gay, inimitable, irreverent confetti every head that bobs up in the carnival of civilisation." Artists needed more outlets than just the comic pages, he wrote, for their humor was "too thoroughly American to be consigned always to the lighter, more ephemeral pictorial avenues." He suggested that Americans form their own version of the Salon des Humoristes, established in Paris in 1907 to exhibit comic works of art. He concluded with an inspiring endorsement of humor in art, equating it unmistakably

with modernity in America: "Humour is more to us than a mere mood. It is the pith of the swift, electric atmosphere that is so distinctively our own, that capitalisation of the moment which serves us in lieu of the tradition that is Europe's. It is a thing as wide as a city street, as free as a prairie, as vivid as an incandescent sign. It is as impudent as a skyscraper, as warm as a hand-clasp, as true as the shifting crowds that give rise to it while they dream and love and laugh and die."[1]

Baury's words struck a chord, and their author immediately found himself organizing an "American Salon of Humorists" exhibition, which opened at the Folsom Galleries in New York in April 1915.[2] Twenty-five prominent artists, including the ash can painters and

2.1 *Art Exhibit with a Neat Barnyard Side Show* by Herb Roth. Printed illustration. Published in *New York World*, April 25, 1915. National Portrait Gallery, Smithsonian Institution, Washington, D.C.

2.2 *Noel Coward* (1899–1973) by William Auerbach-Levy. Watercolor on paper, 57.8 x 45.7 cm (22³/₄ x 18 in.), c. 1930. The Hampden-Booth Theatre Library at The Players, New York City.

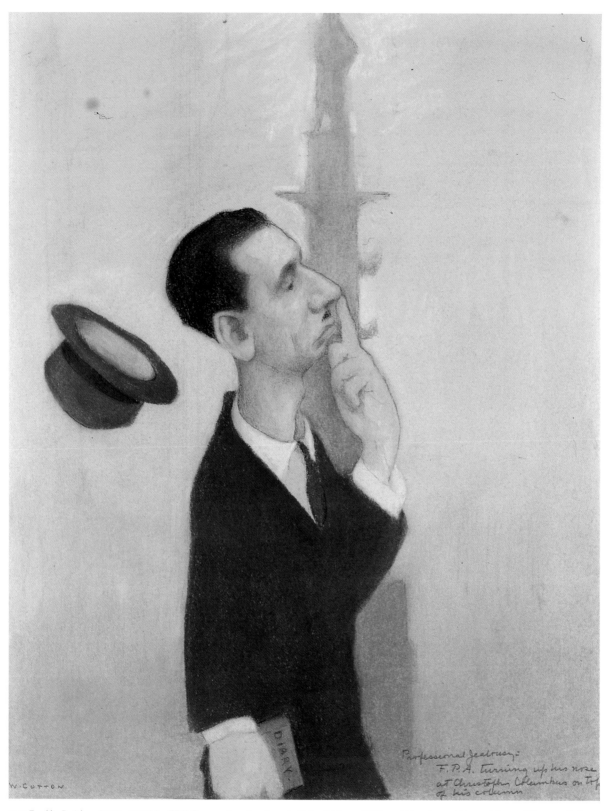

2.3 *Franklin P. Adams* (1881–1960) by Will Cotton. Pastel on board, 43.8 x 34.3 cm (17¼ x 13½ in.), c. 1930–35. National Portrait Gallery, Smithsonian Institution, Washington, D.C.

contributors to the magazine *The Masses*, exhibited 175 paintings, drawings, prints, and sculptures. All the New York papers covered the show. Many critics liked the vitality of the work, but some, like the reviewer for *New York World*, were disappointed. The *World* illustration portrayed the opening-night revelers looking distinctly glum (fig. 2.1). The exhibition ignored two critical events that were changing the atmosphere of the New York art world. Little of the graphic satire reflected the increasingly threatening European war, even though many of the *Masses* artists were staunch isolationists. And the show barely acknowledged the more radical modern art movements introduced at the controversial 1913 art exhibition, popularly known as the Armory Show. Despite considerable enthusiasm, the notion of an annual salon of American humorists collapsed, a victim of poor timing. Commentators, however, widely endorsed Baury's premise, stated in the foreword to the catalogue: "If our art is to expand we have got to bring the highest, sincerest artistry in the market to minister to the fantastic, the extravagant, the bizarre, the witty, the ironic, the mocking, in short, humor in all its multi-hued phases."[3]

Baury's words, and the response to them, suggest how enthusiastically artists, intellectuals, and urban sophisticates of the first quarter of the twentieth century embraced a new comic spirit that emphasized irreverence, wit, wordplay, and parody. For a generation reacting to explosive change, old styles of humor seemed stale. The complexities of a modern metropolis demanded fresh expression. While this playful, impudent approach did not replace stronger, darker forms of satire, it did become an increasingly prominent part of the mix of comic offerings. On the Broadway stage, Tin Pan Alley, and the vaudeville circuit, in magazine verses and newspaper columns, at annual clubhouse dinners and Greenwich Village balls, the vogue for wit and light parody flourished. New York's evolving café society adored Noel Coward (fig. 2.2) and his latest comedy, Cole Porter and his recent songs, columnist Franklin P. Adams (fig. 2.3) and his timely quips.

The many forms of comedy and satire, which covered an emotional range from carefree wit to moral outrage, played an important cultural role during this period. As always, humor could be an entertaining escape or a protest against convention, but it was often much more. It could imply an intellectual attitude, a vitalizing approach to life, a sign of modernity, a com-

2.4 *Max Beerbohm* (1872–1956) by Max Beerbohm. Ink and wash on paper, 20.2 x 15.2 cm (11½ x 6 in.) (sight), c. 1900. Mark Samuels Lasner. © the Estate of Max Beerbohm, reprinted by permission of London Management.

ponent of the bohemian lifestyle, or the mark of gentlemanly refinement. One might admit to having no sense of beauty, the dapper English writer and caricaturist Max Beerbohm would argue in 1902, but no one would ever admit to having no sense of humor (fig. 2.4).[4] To a greater extent than at any other time, humor defined sophistication and discriminating taste.

Although comic forms always seemed a stepchild to more serious achievement in literature and art—as humorists then and now frequently complain—critics and scholars nonetheless began to recognize a new authenticity and value in humor. An increasing number of psychological studies on the comic impulse stimulated scientific and philosophical debate. Max Eastman, for instance—writer, critic, editor of *The Masses*, and Village personality—took a serious, analytical interest. In his 1921 volume *The Sense of Humor*, the first of his two books on the subject, he traced the history of humor studies from Plato through Henri Bergson, the French philosopher whose 1911 essay *Le Rire* was widely quoted and translated into several languages. Noting Sigmund Freud's association of the comic impulse with the unconscious and other psychological theories published in French, German, and English, Eastman summarized conflicting analyses and outlined his own theory of humor as an elemental human instinct.[5]

Historians and literary scholars also started to scrutinize comic traditions. The vernacular humor of the nineteenth century, featuring colorful, rural folk characters with eccentric spelling, local dialect, and unschooled wisdom, had remained outside the respectable literary mainstream. Much of that humor was published in the popular regional press and largely ignored by critics. By the end of the century, however, more sophisticated writers, such as Bret Harte and Mark Twain, were plumbing this tradition, dissolving the boundaries between comic writing and fine literature. Cultural historians, meanwhile, studied the folk elements of this humor. Assessments of nineteenth-century American comic writing began as early as 1901 with two retrospective magazine articles. Intellectuals of the post–World War I era, as Kenneth Lynn has pointed out, turned to the history of vernacular humor in an effort to discover what critic Van Wyck Brooks had called a "usable past." By the 1920s and '30s such scholars as Jeannette Tandy, Constance Rourke, and Walter Blair were publishing critical studies and anthologies of American humor. Just as naïve painting, sculpture, and crafts were newly respectable areas of art collecting, literary folk humor could be studied for its contribution to authentic American culture.[6]

While scholars, psychologists, and historians dissected these traditions, the general public remained captivated by the present, particularly by the new technologies producing experimental forms of humor.

Comedy played an essential role in the developing motion picture industry, for instance, constituting a large proportion of the output of films. A new crop of raucous, outrageous slapstick heroes, not all that different from the native folk characters of earlier literary humor, rose to the fore.[7] The boisterous, fast-paced hilarity of Mack Sennett's Keystone comedies and the more sophisticated humor of Charlie Chaplin's little tramp crossed class boundaries and even language barriers, helping to propel the motion picture into broader-based, middle-class popularity. The newspapers' color supplements, featuring such inventive comic strip artists as George Herriman and Winsor McCay, intrigued adults and children alike. In the late 1890s, Richard Outcault's enormously popular cartoon "The Yellow Kid," a colorful strip about a feisty street urchin, led to such a frenzied competition between press magnates William Randolph Hearst and Joseph Pulitzer—who routinely stole each others' artists and cartoon ideas—that the name "yellow journalism" came to symbolize a whole approach to circulation-building newspaper publishing. The advent of animated cartooning would stimulate equal fascination a generation later.

The major outlet for humor was the popular press. Newspapers and magazines published humorous pictures, poems, and essays, providing daily comic fare for an expanding mass audience. A large number of New York City's writers and artists helped supply material to meet the incessant demand. George Luks, for instance, drew the Yellow Kid for the *New York World* when Outcault moved to the *Journal*. The well-established journals *Puck* and *Judge* specialized in comic offerings, as did *Life*, a beloved magazine of humor long before its reincarnation as an exemplar of photojournalism. More general magazines as well as the expanding newspaper supplements encouraged the trend. Periodicals from England, France, Italy, and Germany supplemented local fare.[8] The English *Vanity Fair* offered portraits of the leading celebrities by Beerbohm, "Spy" (Sir Leslie Ward), and "Ape" (Carlo Pellegrini). The German journals, such as *Jugend* or *Simplicissimus*, introduced stronger, bolder draftsmanship and a heavier, satiric tone (fig. 2.5). The French and Italian magazines, such as *Le Rire*, *L'Assiette au Beurre*, or *L'Asino* took a lighter, wittier stance with caricatures of condensed, abbreviated lines.

Even those magazines not specializing in humor emphasized their comic and satiric elements. The rad-

ical magazine *The Masses*, for instance, founded in 1911 with serious, propagandistic purposes, announced on its masthead that it was a "Magazine with a Sense of Humor and no Respect for the Respectable; Frank; Arrogant; Impertinent; searching for the True Causes; a Magazine directed against Rigidity and Dogma wherever it is found."[9] *The Masses* was a collective enterprise; a large group of artists and writers gathered monthly to argue, debate, and vote on contributions in sessions described by one participant as "witty, colorful and brilliantly lively."[10] The artists, frustrated by the restrictions of the commercial magazines, submitted their drawings as independent works of art, ranging from political and social satire to light-hearted depictions of the urban scene. When Max Eastman took over as editor in 1912, *The Masses* became more focused and revolutionary, seeking "radical art" and lively writing comparable to that in the foreign journals. But Eastman considered the humorous component of his publication critical. When a later chronicler described the process of bringing out the magazine as a struggle between "hilarious laughter" and "serious work for socialism," Eastman reacted strongly to the implied disparagement of humor. "Humor has a higher place in America than in other national cultures," he insisted, "and *The Masses*, notwithstanding its internationalism, was in that respect constitutionally and very fervently American. We would give anything for a good laugh except our principles." Eastman and Baury were not alone in considering this spirit particularly American. "Humor is an important part of American life," George Gershwin insisted when discussing his own *Porgy and Bess*, "and an American opera without humor could not possibly run the gamut of American expression."[11]

Within the range of abundant comic offerings, this new mode—detached, clever, and impudent—took a prominent position. It was not truly indigenous, of course, but an American variant of European precedents, formulated by entertainment and publishing cultures that were increasingly global. Through two events of the mid-1890s—a spoof on George du Maurier's bohemian novel *Trilby* and Max Beerbohm's visit to America—we can trace the primarily French and English influences that inspired this vogue for sophisticated parody, which, as it permeated New York in the prewar period, proved a fertile breeding ground for caricature of the famous.

2.5 *Simplicissimus.* Printed cover illustration, December 9, 1912. From the Periodyssey/Richard Samuel West Collection.

On December 29, 1894, the young illustrator John Sloan found his artistic talents temporarily eclipsed by his theatrical triumph as the heroine of a musical farce entitled *Twillbe*. This production, also starring Sloan's artist friends Robert Henri, William Glackens, and Everett Shinn, was written and staged in Philadelphia by students at the Pennsylvania Academy of the Fine Arts and their friends. The play lampooned Du Maurier's recent novel, the tale of a young bohemian model with exquisite feet and her relationship with three British artists living in Paris. Sloan served as both scene designer and title character, costumed for the latter in hideous, oversized stuffed feet and a dress that imitated the frontispiece illustration of the heroine (fig. 2.6). "I had enormous false feet," Sloan later recalled, "and a Burne-Jones wig. Sang 'Sweet Alice Ben Bolt' in my best falsetto. My sister Marianna had made a dress for me with a Watteau pleat to mark the front, which I

2.6 *John Sloan as Twillbe* (1871–1951) by unidentified photographer. Photograph, 1894. Delaware Art Museum, Wilmington, Helen Farr Sloan Library Archives.

got on backwards and tripped over all the time."[12]

Reports in the Philadelphia newspapers the next day recounted the success of the production. The spoof worked because of the audience's familiarity with both Du Maurier's tale, first published serially in *Harper's Magazine* in 1894, and the bohemian life the story describes. Even since Henri Murger's *Scènes de la Vie Bohème* of 1845, stories about the artistic life of poverty, creativity, freedom, and boisterous high spirits were commonplace, culminating in Giacomo Puccini's opera *La Bohème* of 1896 and Du Maurier's novel. Soon after its publication, *Trilby* garnered additional publicity from the feud that erupted when James McNeill Whistler took offense at the character modeled after himself and

threatened to sue Du Maurier for libel. The uproar helped fuel a *Trilby* craze. The dramatization of the book succeeded on stages around the country; products from hats to shoes to bunion cream bore Trilby's name, and Broadway caterers sold ice cream molds of her feet.[13]

At the Pennsylvania Academy, the traditional spoofing of paintings—students had once staged a mocking tableau of Thomas Eakins' famous canvas *The Gross Clinic*—had become increasingly refined and elaborate by the end of the century. During the Academy's 1894 Annual Exhibition the students mounted a companion show lampooning the paintings, issuing tickets and awarding juried prizes. *Ellen Terrified as Lady Macbeth*, for instance, satirizing John Singer Sargent's painting of actress Ellen Terry, substituted an upturned soup bowl for the crown held over her head and depicted soup flowing over her shoulders in place of her red hair. After this triumph, acclaimed in the newspapers, caricature shows spoofing the paintings became, for a time, a regular offshoot of the Annual Exhibition.[14] The spirit of these endeavors was far from malicious. A poem by Sloan best expressed the prevailing mood:

> *Take heart ye noble works of art held up to mockery*
> *For naught is safe from satire but mediocrity*
> *And as the learned Jury have weeded out the bad*
> *The fact that ye are singled out should make your*
> * authors glad.*[15]

Mockery and caricature, in the hands of these young men, represented a Parisian-bred spirit of levity and rebellion that was related to new notions about art and the artist's relationship to his environment. The *Twillbe* cast, part of a group of like-minded art instructors, students, and newspaper sketch artists coalescing around Robert Henri and John Sloan in the mid-1890s, exemplified this spirit.[16] Several of them had recently returned from studying in Paris, and their camaraderie reflected a philosophy of life prevalent among the artistic communities of Montmartre and the Latin Quarter. Gathering weekly at Henri's studio, the young men shared serious discussions of art, drama, music, and literature regularly interspersed with uproarious parties and comic theatricals.

A self-consciously playful exuberance permeated this bohemian culture. Its participants were expected to appreciate café nightlife, the vitality of an urban social mix, and a sense of irreverence and humor. In the fifty years since Murger's *Scènes de la Vie Bohème*, this spirit had

been commodified into a salable image of "gay Par-ee," relentlessly promoted by nineteenth-century guide-books and tourist literature. The emphasis on pleasure and levity took on nationalistic tones, as Charles Rearick has pointed out, because the French viewed it as a Gallic tradition in distinct contrast to English prudery and German pessimism. "Gaiety is the distinguishing char-acteristic of the French," noted Jules Lévy, who, along with other bohemians, also saw it as a rebellion against a conservative moral order and staid artistic traditions.[17]

In the 1880s, Lévy and others, calling themselves the Incoherents, had organized satirical exhibitions with such entries as oil paintings on emery paper and sculp-tures in breadcrumbs and held outrageous costume balls in defiant mockery of formal galas and bourgeois restrictions. Other members of the young, rambunc-tious avant-garde imitated these events. Annual fêtes, like the notorious Bal des Quat' z' Arts, where seminu-dity was a popular costume, scandalized the Parisian establishment, to the delight of many participants.[18] Press accounts publicized such instances of high-spirit-ed rebellion. Meanwhile, the fictionalized versions of the artist's life, including Puccini's opera and Du Maurier's novel, romanticized notions of bohemian culture and humor in the public imagination. In the process, the rebellious fury of the movement was changed into impudence and its scandalous reputation evolved into fashionable notoriety.

The lighter side of the Sloan-Henri circle reflected the influence of "all this Bohemian flapdoodle," as cari-caturist Ralph Barton called it. Everett Shinn's room-mate, George Luks, an artist with vaudevillian flair, could put on hilarious boxing displays and imitate every man in the room. He could cook Welsh rarebit over a gas jet in the ceiling by standing on a box on top of a chair perched on a table and flinging the gourmet results down to upheld plates.[19] The comic songs, poems, and dramas they performed—no less than the impassioned discussions of art and literature—expressed the bonhomie of a group of young men who did not take life too seriously but took innovation, tal-ent, and wit very seriously indeed.

Underlying this spirit of bohemian levity were new ideas about the role of the artist within the urban envi-ronment. For many, the sentimental and allegorical art of the academies seemed artificial and lifeless; these artists wanted to infuse a new liveliness and humanity into their art by focusing on the vivid details of urban

life. The concepts of a modern approach to art, first codified by Charles Baudelaire in his 1863 essay "Painter of Modern Life," influenced their generation deeply. In this seminal work Baudelaire described the artist who finds a timeless relevance in the incidental circumstances of everyday life. Much like the philoso-pher, poet, novelist, or moralist, Baudelaire's artist used carefully observed details of his contemporary world to evoke the human condition. In the crowded streets of the city he sensed a "river of vitality in all its majesty and brilliance."[20] Baudelaire's artistic urban observer, the *flâneur*, was a refined and discriminating sophisticate who strolled the boulevards with a heightened aware-ness, passionately committed to both life and art.

Vitality was a critical component of this ethos. For many young artists, humor, mockery, and wit provided that enlivening element. The impulse to sketch carica-ture portraits of friends and colleagues emerged from such ideas. In Du Maurier's story, the youngest of the three artists, Little Billee, arrives at his teacher's atelier to find the walls "adorned with endless caricature—*des charges*—in charcoal and white chalk."[21] The Philadelphia group, much like French art students, translated their companionable, teasing friendships into amusing portrait sketches. Sloan, Glackens, Shinn, and Luks all worked as sketch artists for the Philadelphia newspapers during this time, shuttling between the *Public Ledger*, the *Inquirer*, the *Record*, and the *Press*. Sloan's description of the *Press* art department, a frequent gathering spot for the four, sounds much like a scene from *Trilby*: "It is not hard to recall the *Press* 'art department': a dusty room with windows on Chestnut and Seventh Streets—walls plastered with caricatures of our friends and ourselves, a worn board floor, old chairs and tables close together, 'no smoking' signs and a heavy odor of tobacco, and Democrats (as the roaches were called in this Republican stronghold) crawling everywhere. But we were as happy a group as could be found and the fun we had there took the place of college for me. Like most newspaper men of those days we knew nothing of world troubles; a care-free life such as the birds lead."[22]

One of the pieces that hung for years in the *Press* art department was George Luks's sketch of William Glackens (fig. 2.7), created in 1895 on the occasion of a party launching the young artist on a visit to Paris. The ever poetic John Sloan furnished the verse, which was inscribed at the top of the drawing. "He goes from

2.7 *William Glackens* (1870–1938) by George Luks. Ink on paper, 66.2 x 52.7 cm (26⅛ x 20¾ in.), 1895. Delaware Art Museum, Wilmington; gift of Helen Farr Sloan.

2.8 *George Luks* (1867–1933) by William Glackens. Pencil on paper, 36 x 28.4 cm (14⅜ x 11⅜ in.), c. 1895. Delaware Art Museum, Wilmington; gift of Helen Farr Sloan.

amongst us oh brothers," it began, "the chaste one the little one leaves us." Together, the poem and the ink sketch suggest the youth, delicacy, and artistic sensibility of the traveler, their own Philadelphia version of Little Billee.[23] Most victims of such teasing could not match Sloan's attempts at poetry, but all of them could, and did, retaliate with pencil and pen. Glackens's caricature of Luks, entitled *Dink in His Studio* (fig. 2.8), features two of the latter's well-known propensities: heavy drinking and flashy clothes. The usually active Luks is temporarily sedated, with a bleary smile, half-shut eyes, and a large glass of wine at his elbow. His unusual vest added a distinctive, sartorial flair. According to Shinn, it was made of "cream-colored corduroy, like doormats laid out in strips of a hawser's thickness, or bark-stripped logs on a frontier fort stockade."[24]

The worn edges and tears of a Sloan drawing of Shinn (fig. 2.9) indicate that it too was posted and admired on a studio wall. Entitled *Ever at Rest*, it depicts the ambitious young man tied to a chair that is bolted

to the floor as he rushes, against deadline, to finish his illustration with red, "yeller," and "blu." Shinn, only eighteen when he joined the *Twillbe* cast, was one of the youngest of the group and was promptly nicknamed the Kid. Here he is called "Our Yeller Kid" in honor of the comic strip character. The nickname also implies Shinn's progress from black and white newspaper work to more colorful and lucrative commissions from the magazines and Sunday supplements.

Glackens, Luks, Henri, and Shinn all moved to New York in the late 1890s, with Sloan finally following in 1904. Joining other artists, intellectuals, and free-spirited radicals, they gravitated toward Washington Square and Greenwich Village, which was becoming an epicenter of bohemian life. As they began peddling their drawings to various newspapers, magazines, and humor journals, they competed with such artists as Charles Dana Gibson, Howard Chandler Christy, and James Montgomery Flagg, whose highly finished, pen and ink "pretty girls" dominated the field of illustration

2.10 *The Weaker Sex* by Charles Dana Gibson. Pen and ink on paper, 58.4 x 74.3 cm (23 x 29¼ in.), n.d. Original illustration for *Collier's Weekly*, July 4, 1903. Prints and Photographs Division, Library of Congress, Washington, D.C.

2.9 *Everett Shinn* (1876–1953) by John Sloan. Ink, pencil, and watercolor on paper, 34.5 x 30 cm (13⅝ x 11¾ in.), c. 1897. Delaware Art Museum, Wilmington, Helen Farr Sloan Library Archives.

(fig. 2.10). The vigorous drawings of the Philadelphia artists, in contrast, reveal their training as newspaper sketch artists, a profession that required keen observation, total recall, and the ability to draw selectively and rapidly.

Inspired by Gibson's decision, in 1905, to give up pen and ink and concentrate on oil painting, William Glackens envisioned the successful illustrator as an impoverished painter in patched pants and sandals (fig. 2.11). The drawing reveals a sketch artist's intuitive selection, emphasizing the salient and dramatic points through carefully chosen details. Using a vigorous, quickly rendered pencil line, Glackens created an immediate likeness and sense of setting. The balding, squarish head is instantly recognizable; one small patch of peeling plaster serves to describe an artist's garret; a squiggling contour line suggests ill-fitting pants and general untidiness. Glackens's friends would also have snickered at the reference to a famous painting at the Pennsylvania Academy, William Sidney Mount's 1838

2.11 *Charles Dana Gibson* (1867–1944) by William Glackens. Pencil on paper, 27.7 x 33 cm (10⁷/₈ x 12¹⁵/₁₆ in.), 1905. Original illustration for *New York World*, October 22, 1905. National Portrait Gallery, Smithsonian Institution, Washington, D.C.

canvas *The Painter's Triumph*. Posed in the same stance as Mount's painter, Gibson aims his dripping brush at the world's smallest canvas.

Teasing caricatures continued to be a leitmotif of the ongoing friendships of the five friends from Philadelphia and their widening circle.[25] "I have just come from Henris it is *1:30 A.M.*," Sloan wrote to his wife Dolly, "we have been 'drawerin' each other etc fancy two things like this drawing 'caricatures' of each other as tho' the Lord had not done the two jobs long before" (fig. 2.12). Robert Henri often signed his letters with his own image or drew it on a picture postcard instead of writing a note. Although never an illustrator or sketch artist himself, Henri, like the others, considered the rapid, unlabored sketch an integral part of his

approach to art, and he emphasized it in his teaching. His caricature images fairly burst with the spontaneity that he preached when he urged his students and fellow artists to record their life experiences directly on the canvas. Another sketching companion of Henri's was George Bellows. After a day of hard work the two would occasionally go out to play pool or attend a prize fight, returning home afterward to sketch caricatures.[26]

Passionate commitments to causes and defiant reactions to outmoded convention underlay the playful tone of this humor. Henri, angered by the National Academy's rejection of his friends' work, led the battle toward nonjuried, independent exhibitions that included a wider variety of styles and subjects. He invested his caricature sketches with his dismissive attitude

toward the art establishment, creating parodies of artistic pretension. A 1904 self-portrait depicts a pot-bellied, spindly-legged creature with a paintbrush that looks like a pitchfork and hair tousled into devil's horns (fig. 2.13). The serious side of John Sloan was dedicated to socialist causes. He worked tirelessly for *The Masses*, serving as its unofficial art editor from 1912–14. Often he persuaded his friends to donate drawings, and he contributed many himself, including some bitterly satiric political pictures.

Nonetheless, the lighter spirit of the group's caricatures and comic theatricals remained a critical component of their approach to life, and it exemplified the new strain of humor that was pervading New York City. The Greenwich Villagers often set the tone. Max Eastman expressed a credo shared by many when he noted, "I have always had a strong and shameless interest in hav-

ing a good time. . . . I never could see why people with a zeal for improving life should be indifferent to the living of it. Why cannot one be young-hearted, gay, laughing, audacious, full of animal spirits, and yet also use his brains?" In the spirit of similar Parisian endeavors, the artists and writers of *The Masses* held costume balls to raise money for the magazine.[27] For some, it was an excuse to arrive scantily clad; for others, it was a competition for self-mocking wit. At one of these popular events, reported in several New York newspapers, a Village poet, usually described as "unkempt Harry Kemp" came "disguised as a poet," producing verses to order on a small typewriter. Max Eastman came as a "child of the Amazons," in reference to his recently published book of poetry by that name. Two male artists arrived as a pair of Degas's dancers, dressed in tutus and intending to spend most of the evening "at

2.12 *Robert Henri and John Sloan* (1865–1929; 1871–1951) by John Sloan. Ink on paper, 22.6 x 15.9 cm (8⁷/₈ x 6¹/₄ in.), c. 1903. Delaware Art Museum, Wilmington, Helen Farr Sloan Library Archives.

2.13 *Robert Henri* (1865–1929) by Robert Henri. Crayon on paper, 27.8 x 21.4 cm (10¹⁵/₁₆ x 8⁷/₁₆ in.), 1904. National Portrait Gallery, Smithsonian Institution, Washington, D.C.

2.14 *Aubrey Beardsley* (1872–98) by Max Beerbohm. Printed illustration. Published in Beerbohm, *Caricatures of Twenty-Five Gentlemen* (London, 1896). Mark Samuels Lasner. © the Estate of Max Beerbohm, reprinted by permission of London Management.

the bar."[28] Costume balls became a regular part of Village life, attracting many uptown tourists and considerable publicity. The popular press loved to report on Greenwich Village exploits; the latest advocates of free love, dress reform, or nudity always made good copy. These stories disguised the darker side of Village life—the underlying anxiety, alienation, and alcoholism that fueled many colorful, hedonistic events—by a prevailing sense of youthful innocence, talent, and fun.

This light vein of humor, however, had influences other than the Village-bred, bohemian spirit. A generation before Noel Coward, Max Beerbohm introduced a refined British sensibility that would have enormous impact. In 1895, not long after the *Trilby* spoof, the young Englishman arrived in America for a well-publicized three-month visit. "Max," as he was popularly known, had come to assist his half-brother, the actor-manager Herbert Beerbohm Tree, on a theatrical tour to New York, Chicago, Boston, Philadelphia, and Washington. This was long enough for the young man to be interviewed by various newspapers, publish some essays and caricatures, and establish himself as a personality. His self-portrait depicts an impeccably tailored dandy with a quizzical, mildly critical air (see fig. 2.4). A friend of Oscar Wilde and Aubrey Beardsley, Max represented to many Americans the cultivated decadence of the British Aesthetic movement. The thin line and limp, boneless figures of such caricatures as the portrait of Beardsley, published in his 1896 volume *Caricatures of Twenty-Five Gentlemen*, reinforced the notion (fig. 2.14).[29]

Beerbohm had mastered the art of provoking just enough controversy to gain attention. He criticized American speech and decried the taste that made the dramatization of *Trilby* such a success. A reporter from the *Boston Herald* took him to task for his acerbic observations. "Bostonians speak English," he grumbled, "though Mr. Beerbohm possibly thought they spoke Choctaw."[30] Nonetheless, the publicity established Max's popularity in America, and he made many important contacts. In New York, he received a card to the Players, an elegant clubhouse where he could meet renowned American theatrical figures. The Players still owns his drawing of the acclaimed playwright Clyde Fitch, with whom Beerbohm developed a close friendship during the tour. Before he left America he arranged to have a series of caricatures published in the little magazine *Chap-Book*, issued by Stone and Kimball in Chicago. Drawings like that of William Archer staring at a bust of Henrik Ibsen, whose works he had translated for the London stage, introduced a refined sensibility to the art of caricature. Only an audience aware of the work of both men could fully appreciate the reverent fawning of one and the grumpy arrogance of the other (fig. 2.15). The viewer must bring his own intelligence to the image in order to infer the critical meaning.[31] Despite the small size and poor quality of the *Chap-Book* reproductions, images such as a lumpy George Bernard Shaw captured Max's inimitable tone and style (fig. 2.16).

Beerbohm's popularity in America grew steadily in the ensuing years. His books of caricatures and literary

MR. G. BERNARD SHAW.—Drawn by MAX BEERBOHM.
November 1, 1896.

2.15 *William Archer* (1856–1924) by Max Beerbohm. Ink and watercolor on paper, 36.4 x 21.6 cm (14⁵/₁₆ x 8¹/₂ in.) (sight), c. 1896. Original illustration for *The Chap-Book*, October 1, 1896. Mark Samuels Lasner. © the Estate of Max Beerbohm, reprinted by permission of London Management.

2.16 *George Bernard Shaw* (1856–1950) by Max Beerbohm. Printed illustration. Published in *The Chap-Book*, November 1, 1896. From the Periodyssey/Richard Samuel West Collection. © the Estate of Max Beerbohm, reprinted by permission of London Management.

parodies, often republished in American editions, sold briskly, and the frequent excerpts of his essays and reviews in the press prompted humorist Finley Peter Dunne to observe that "English literature was suffering from the Beerbohmic plague." By the 1920s, art critic Willard Huntington Wright pointed out that the frenzied collecting of Beerbohm editions and original drawings amounted "almost to a fad"; such discriminating trendsetters as artist A. E. Gallatin, art patron John Quinn, humorist Christopher Morley, caricaturist Will Cotton, and writer Carl Van Vechten succumbed.[32]

Not everyone approved of Beerbohm's drawing style, which contrasted dramatically with the vigorous

sketching of the ash can artists. When asked his assessment of the Englishman's work, artist Boardman Robinson bluntly retorted, "As drawings, bags of wind. Purely literary. He depends on his captions." To some, Beerbohm's line seemed weak, his coloring pale, his figures torpid and listless. Wright claimed that Beerbohm's reputation "rests almost entirely upon his intellectual and temperamental capacities. His most ardent defenders have never held a brief for his craftsmanship. His drawing, in fact, is at times amateurish." For most, however, restrained lines and pale tints only heightened extraordinarily apt allusions, such as his image of Whistler biographer Joseph Pennell, *Thinking*

of the Old 'Un, from the 1913 volume *Fifty Caricatures* (fig. 2.17). With a portrait of Whistler in the background, Beerbohm depicted Pennell in the pose of Whistler's famed portraits of his mother and of Thomas Carlyle.[33]

Beerbohm selected his subjects from the celebrity ranks of the literary, entertainment, or political worlds. Despite his personal acquaintance with most of these subjects, his caricatures depended on the public reputation or perception of each figure. This concept of reassembling the components of fame into something exquisite as well as characteristic would lead modern caricature away from traditional cartooning toward a new satiric art form. In his essay "The Spirit of Caricature" (1901), Beerbohm helped define the modern version of distorted likenesses. "The most perfect caricature," he wrote, "is that which, on a small surface, with the simplest means, most accurately exaggerates, to the highest point, the peculiarities of a human being, at his most characteristic moment, in the most beautiful manner." Caricature implies no moral judgment, he insisted, but it must capture every aspect of the subject, exaggerating some points, diminishing others: "The whole man must be melted down, as in a crucible, and then, as from the solution, be fashioned anew. He must emerge with not one particle of himself lost, yet with not a particle of himself as it was before."[34]

Beerbohm conveyed to his audience an attitude of superiority and detachment. Such a stance had great appeal to the iconoclastic American critic Benjamin de Casseres, who would become a spirited advocate of new forms of caricature. "A born caricaturist," De Casseres wrote in a 1906 article about Beerbohm, "must detach himself from his environment. My intellect versus this outside world; my native perception, ether clear, standing impregnable against the waves that beat against it from those external illusions, that must always be his formula."[35] The modern caricaturist, in other words, did not indulge in the eye-gouging, corrective attitudes of the critical satirist. He remained above the fray.

Beerbohm avoided the messy business of direct confrontation. Despite the keenness of his wit, he had what critic Bohun Lynch described as a "daintiness" of imagination. From his aloof and superior position he commented on his contemporary world with irony but without contempt. Instead of drawing his portraits from life, he employed, as he once confided to Edmund

Gosse, "no pen, no notebook, merely a mild attentive gaze." Baudelaire's flâneur, strolling incognito through the crowd, observed life with similar detachment. Like the dandy he caught so perfectly in his drawings, Baudelaire's modern artist had "this lightness of carriage, this sureness of manner, this simplicity in the air of domination" that set him apart as a superior being.[36] Beerbohm had honed these qualities of lightness, sureness, and domination to a fine art. In his hands, style and fashion became as important in humor as vitality.

Dandified refinement and detachment were compatible with the emphasis on more polite and cultivated humor in American publishing at the turn of the century. And yet this new strain of humor abhorred the sentiment of the genteel. The tone of Beerbohm's portraits and parodies—fresh, observant, and intellectual—set the groundwork for the flowering of irreverent wit. It added a note of restraint and urbanity to the unbridled bohemian levity that had become, by the second decade of the century, nearly a cliché.

This sense of sophistication accelerated the spread of the spirited comic mode beyond the eccentric lifestyles of Greenwich Village. Indeed, a discriminating wit was becoming a required attribute for the gentleman—or, more precisely, the urban sophisticate—just at the point before the war when definitions of social leadership were changing rapidly. The traditional upper class, epitomized by Mrs. Astor's famous Four Hundred, was losing its autocratic control over social life in New York. Rebelling against the formal social rituals of exclusive clubs and private mansions, a new generation turned toward public meeting places and entertainments. The light fare of drawing room stage comedies, newly respectable moving pictures, vaudeville shows, and sporting events attracted audiences of mixed sex and class. New Broadway restaurants, elegantly decorated and romantically lit with electric lights, proliferated in the theater district. By installing dance floors or providing informal entertainment, these establishments extended the theatrical fantasies of the Great White Way late into the night. Debutantes mingled with showgirls; the wealthy and well-bred joined artists, intellectuals, and middle-class professionals of all types in sampling the unrestricted freedom of the lobster palaces, cabarets, and roof garden restaurants.[37]

Public amusements played a critical role in this emerging urban culture. They epitomized for many the

2.17 *Joseph Pennell* (1860–1926) by Max Beerbohm. Printed illustration. Published in Beerbohm, *Fifty Caricatures* (London, 1913). Mark Samuels Lasner. © the Estate of Max Beerbohm, reprinted by permission of London Management.

erosion of barriers between fine and popular art, high and low culture, audience and performer, upper- and lower-middle classes, male and female spheres. The glittering nightlife of dining and performance helped define the allure of New York City, embodying those qualities of creativity, innovation, and vitality that had become so important. All the participants within its orbit benefited from the reflected glamour, particularly the three intersecting groups who produced, promoted, and sampled this feast of entertainment. The theatrical profession encompassed not only film and stage

performers but the directors, playwrights, composers, musicians, set designers, and others who supported them. The journalistic industry that covered the theater district involved editors, press agents, drama critics, columnists, fashion arbiters, society reporters, and illustrators. The fashionable audiences included almost anyone with enough talent, beauty, fame, or personality to be noticed.

This was a wide cross section of New York's upper and middle classes. Out of this tantalizing mix emerged the new café society that would flower after the war, a

2.18 *Frank Crowninshield* (1872–1947) by Irma Selz. Ink on paper, 32.4 x 26.7 cm (12³/₄ x 10¹/₂ in.), c. 1932. Tom Engelhardt.

social elite defined by publicity and celebrity rather than pedigree. The term was reportedly invented by society editor Maury Paul after dining at the Ritz one night in 1919. "Society isn't staying home and entertaining any more," he pointed out. "Society is going out to dinner, out to night life, and letting down the barriers."[38] The stars of this amalgam of metropolitan life would become the celebrities of postwar New York.

Frank Crowninshield and Condé Nast, editor and publisher of *Vanity Fair* magazine, which started in 1913, exemplified the integrating forces behind the rise of café society. Crowninshield, the charming, debonair editor with an impeccable New England genealogy, had been educated in Paris and Rome. For all his social connections and cosmopolitan gentleman's breeding, however, he was a champion of the new in art, entertainment, and humor. Crowninshield was a frequent visitor to the controversial 1913 Armory Show of modern painting. Still working for the *Century* at the time, he was embarrassed by the negative review his magazine was about to publish and apologized to the show's organizer, Walt Kuhn, about the lack of enthusiasm for

"our movement."[39] From then on, although he avoided radical extremes, he was an enthusiastic promoter and collector of modern art. An inveterate clubman, a connoisseur, and a tireless participant in New York's theatrical nightlife, he was at the forefront of cultural changes in New York City.

The gracious, debonair, and infectiously enthusiastic Crowninshield loved to encourage budding talent. "To Irma Selz," he wrote at the bottom of one young caricaturist's portrayal of him (fig. 2.18), "full of youth, talent, promise, and charm! From her 60 year old admirer." The amiable editor seemed to know everyone worth knowing. "In any quarter of the globe," Robert Benchley wrote, "you are likely to run into a personal friend of Frank Crowninshield's. They are like Eastman kodaks or McCormick reapers." This vast circle of friends ranged, Geoffrey Hellman noted in a *New Yorker* profile, from the refined Mrs. William Astor to the elegant stripper Gypsy Rose Lee. "Crownie has introduced everyone in this country who has ever been introduced," Hellman reported, "and in many cases he has introduced them to each other."[40]

Crowninshield's friend Condé Nast, wealthy and socially ambitious, had a similar interest in fostering the new stars of café society. Invited to lavish parties in his fabulous penthouse at 1040 Park Avenue was a spicy mixture of Manhattan personalities representing society, the arts, the press, and show business. "Around 1922," Nast modestly noted later, "I got a little money and decided to give a party. I thought, 'My God, I can't give a party; my friends are too mixed. I can't leave out George Gershwin and I can't leave out Mrs. Vanderbilt and I can't have them together.' But I did, and to my surprise, everyone liked it."[41] In *Vanity Fair*, Nast and Crowninshield developed a vehicle to define sophisticated, cosmopolitan taste in a rapidly changing urban world. The magazine appealed to those who had this savoir-faire and to those who wanted it.

For urbanites attracted to this emerging culture, wit signified an escape from boring conventionality. In New York social clubs, for instance, this effervescent spirit flourished, often resulting in comic theatricals and caricature portraits. The elegant Gramercy Square clubhouse of the Players, grandly renovated by Stanford White, looked like a traditional gentlemen's club. Indeed, it had been founded by Edwin Booth to raise the prestige of the theatrical profession. But Mark Twain, Thomas Nast, Oliver Herford, and other pro-

fessional humorists were honored members at the turn of the century, and humor was celebrated.[42] The annual Pipe Night at the Players, which started as a boisterous evening of beery bawdiness, soon became a more formal affair, organized by a specially selected "Pipemaster" and featuring comic songs, recitations, and skits. Hand-drawn posters, such as the 1911 example featuring chairman John Drew (fig. 2.19), advertised the event. Caricature would flourish in this atmosphere. Over the years the downstairs grill was hung with amusing portraits of famous members and visitors: Will Cotton's pastel of theatrical producer Jed Harris (fig. 2.20), William Auerbach-Levy's languid Noel Coward (see fig. 2.2), Ralph Barton's image of two stars from the play *Strictly Dishonourable*.

Many of the newer clubs resisted the traditions of upper-class gentlemen's institutions, bypassing dreary businessmen and socialites to recruit lively, café society stars from the theatrical and journalistic worlds. Frank Crowninshield decided to start the Coffee House Club in 1914 after meeting a fellow member of the staid Knickerbocker Club for lunch. Weary of the "brass-buttoned flunkies, silver duck presses, and gold-plated table conversation" of their renowned old institution, they decided to found an intimate dining club that had "no sympathy with wealth or business." The Coffee House Club would gather together a group of actors, writers, artists, musicians, and other entertaining conversationalists—Cole Porter, Robert Benchley, and Douglas Fairbanks were early members—who would dine at a communal table in the interests of conviviality.[43]

A drawing by the visiting Cuban caricaturist Conrado Massaguer (fig. 2.21) captures Condé Nast (the smiling figure in the center) basking in the glow of talent, fame, and beauty at a Coffee House Club play reading. Author Jesse Lynch Williams reads at a small table, surrounded by such luminaries as critic Heywood Broun, actors Alla Nazimova, John Drew, Tallulah Bankhead, musicians Arthur Rubinstein and Jascha Heifetz, humorist Irvin Cobb, artist Charles Dana Gibson, designer Léon Bakst, and photographer Arnold Genthe. Most of these figures are assembled with the playwright himself on the narrow, cramped stage, and Condé Nast is standing in the midst of them all. Massaguer, whose drawing appeared in *Vanity Fair*, was gently satirizing Nast's social ambitions by giving him such a prominent position among the group.[44] But Nast, arguably, deserved his place on the stage with

2.19 *John Drew* (1853–1927) by unidentified artist. Ink and gouache on paper, 58.4 x 33 cm (23 x 13 in.), 1911. The Hampden-Booth Theatre Library at The Players, New York City.

the others. The star attraction of the evening was not the playwright but the celebrity audience, and Nast, as publisher of café society glamour, deserved credit as impresario.

Elaborate comic theatricals, written with a light tone of parody and performed by their members, became a staple of many clubs. The annual "Gambols" of the Lambs Club included lampoons of current plays and comic

2.20 *Jed Harris* (1900–79) by Will Cotton. Pastel on paper, 50.2 x 34.9 cm (19¾ x 14¾ in.), c. 1930–35. Robert A. Freedman.

2.22 *The Solemn, Sepulchural Seance Scene at the Dutch Treat Club's Ides of March Show* by Samuel Cahan. Printed illustration. Published in *New York World*, March 21, 1920. National Portrait Gallery, Smithsonian Institution, Washington, D.C.

2.21 *An Evening at the Coffee House* by Conrado Massaguer. Ink on paper, 61 x 45.7 cm (24 x 18 in.), 1923. The Coffee House, New York City.

portrayals of famous entertainers.[45] The Dutch Treat Club was also renowned for its annual performance, often reported in the newspaper along with a caricature drawing. The *New York World* illustrated a séance scene from one show (fig. 2.22), for instance, depicting Robert Benchley as Adam, attired in fig leaves and spats, and illustrator Rea Irvin as "John Barleycorn," wearing a long robe, laurel wreath, and halo and imitating John Barrymore's dramatic profile pose.[46]

Prominent illustrator James Montgomery Flagg, a founding member and onetime president of the Dutch Treat Club, wrote many of the annual shows, "all lampooning the artistic professions and the magazines."[47] In addition to his images of beautiful young women and broad-shouldered men so sought after by magazine editors, Flagg produced comic and satiric books and drew clever portraits of his famous friends. The caricatures, he noted, in his 1914 volume *The Well-Knowns as Seen by James Montgomery Flagg*, "unlike the serious portraits, are not intended to be offensive." And, indeed, although genuinely funny, portraits like the image of famed tenor Enrico Caruso as Pagliacci (also published in *Harper's Weekly*, April 25, 1914), are brimming with good humor (fig. 2.23). Much like the teasing portraits of the Henri-Sloan circle, Flagg's caricatures suggest jocular, familiar intimacy, as if he were

drawing fellow members of the Dutch Treat Club during one of their annual performances. Caruso was himself a talented caricaturist, publishing his sketches of the music world in the Italian-language newspaper *La Follia di New York*.[48] Amateur comic theatricals, witty after-dinner entertainment, burlesques of plays, the roasting of prominent citizens, costume balls, and witty caricature portraits had a similar buoyant tone.

As historians Walter Blair and Hamlin Hill point out, the period before the war saw a shift from predominantly rustic to more urbane humor; and beginning about 1915, most major humorists were born in cities.[49] Urban humorists, such as John Kendrick Bangs and Oliver Herford, favorite after-dinner speakers at the Players, produced books that appealed to sophisticated, educated audiences. New York magazines and newspapers soon adopted this refined vein of nonsense, wit, and fantasy. Both Bangs and Herford contributed to *Smart Set*, a magazine founded in 1900 that was intended, according to the *New York Times*, "to entertain and amuse rather than instruct or edify." In the years before its famous editorial team H. L. Mencken and George Jean Nathan took over, *Smart Set* had already acquired a reputation for "its sunny way of clever dialogue and incident in prose and out." Newspaper publishers also understood the appeal of this approach.

2.23 *Enrico Caruso* (1873–1921) by James Montgomery Flagg. Ink, opaque white, and watercolor over pencil on board, 59.2 x 37.6 cm (23⁵/₁₆ x 14¹³/₁₆ in.), 1914. Original illustration for *Harper's Weekly*, April 25, 1914, and *The Well-Knowns as Seen by James Montgomery Flagg* (New York, 1914). Sarah and Draper Hill.

"Do, do," beseeched Ralph Pulitzer, publisher of the *New York World*, "take all the heavy stuff and boil it down. Look out for the things that are distinctive, original, dramatic, romantic, thrilling. Also whatever is curious, unique, odd, and humorous, but without offending good taste."⁵⁰

Newspaper columns featured clever quips and musings about the details and personalities of New York life. In 1904, F. P. A. moved from Chicago to New

York to establish his column, at the *New York Evening Mail*. Eventually entitled "The Conning Tower" when he moved to the *New York Tribune* and then the *New York World*, it established a precedent for literary wit. Encouraging light verse, puns, punch lines, parodies, and jokes of all kinds in response to his own erudite observations, Adams was swamped by contributions. Once a week, his column became "The Diary of Our Own Samuel Pepys," surveying the activities of his own

immediate circle. More than anyone else, F. Scott Fitzgerald recalled, "F. P. A. guessed the pulse of the individual and the crowd, but shyly, as one watching from a window." Adams was only the first of many New York columnists—Don Marquis, Heywood Broun, and others followed—who captured new strains of humor, and, through syndication, published them in newspapers throughout the country.[51]

Editors became influential advocates of urbane humor. In 1913, when Condé Nast consulted Crowninshield about his new magazine, originally entitled *Dress and Vanity Fair*, the latter had ready advice. "Your magazine should cover the things people talk about," he told Nast as they discussed the future of the publication, "parties, the arts, sports, theatre, humor, and so forth."[52] Sensing that Crowninshield could add much-needed focus and definition, Nast hired him to run the magazine. The new editor insisted on shortening the title to *Vanity Fair* and deemphasizing women's fashion to distinguish the magazine from its sister publication *Vogue*. Bringing his own keen wit, genteel polish, enthusiasm for the avant-garde, and fascination with new forms of popular entertainment to the enterprise, he set an immediately distinctive tone.

Crowninshield's editorial creed emphasized liveliness, vitality, and polite but spirited humor. In the March 1914 issue he promised to chronicle the progress of American life entertainingly. He had noticed, he told his readers, an "increased devotion to pleasure, to happiness, to dancing, to sport . . . , to the delights of the country, to laughter, and to all forms of cheerfulness." This was a good sign, he argued, a realization of the need for a "fair measure of pluck and for great good humor." *Vanity Fair*, he continued, "means to be as cheerful as anybody. It will print much humor, it will look at the stage, at the arts, at the world of letters, at sport, and at the highly vitalized, electric, and diversified life of our day from the frankly cheerful angle of the optimist, or, which is much the same thing, from the mock-cheerful angle of the satirist."[53]

Cheerful, or even mock-cheerful, optimism in 1914 seems in retrospect to be an inappropriate rudder with which to steer the magazine through a wartime era. But the humor of *Vanity Fair* was not as relentlessly sunny as the ebullient editor's words imply. Crowninshield himself was a renowned, discriminating wit, bored by sentimental formulas. He planned, according to his editorial statement, to wean American authors and artists away

from their "tight," academic technique and "stiff, unyielding ways." Following the example of the French humor magazines, he would urge his contributors to be "a trifle more fluent, fantastic, or even absurd."[54]

As Cynthia Ward has argued, Crowninshield's early patronage of such writers as Dorothy Parker and Robert Benchley in the late 1910s influenced the modern voices of urban humor that emerged after the war. His insistence on light rather than heavy-handed satire and refined diction rather than dialect or slang—"correct Crowninshield dinner English," Ring Lardner once disparagingly called it—encouraged a polished prose that added to their aura of urbanity. Rejecting lower-class dialect, they used their own educated voices to critique middle-class mores. The refined tone lent an elegant irony to their self-mocking comments on contemporary life. Parker often introduced her most outrageous critiques, for instance, with demure, polite apologies. Benchley aptly summarized Crowninshield's policy as a "willingness for any writer who writes entertainingly, to say practically anything he wants to say in *Vanity Fair*—so long as he says it in evening clothes." Many culturally radical ideas and attitudes found their way into the magazine in an urbane disguise. Both Parker and Benchley were editors at *Vanity Fair* by 1919, and although their stay was brief, Crowninshield's deft touch had left its mark.[55]

Although wartime horror and homefront deprivations crushed some of the breezy frivolity of this urban humor, a tone of irreverent mockery revived after the conflict. Indeed, the profoundly destabilizing events of World War I gave a sometimes desperate urgency to pleasure-seeking gaiety and sharp quips. Converging on New York was a group of town wits that included F. P. A., Parker, Benchley, Robert Sherwood, Alexander Woollcott, Harold Ross, and George S. Kaufman. They found jobs at the newspapers and at those journals that would be called collectively the "smart" magazines: *Life*, *Judge*, *Vanity Fair*, and, ultimately, the *New Yorker*. From their prominent positions as columnists, essayists, and drama critics, they cultivated a piquant, mocking tone most frequently aimed at the city's best known personalities, among whom they counted themselves. For many they epitomized New York's comic spirit. Critic Carl Van Doren considered F. P. A., for instance, the "very quintessence of Manhattan," publishing in his column "the most edged, the most stinging, the most impudent annotations upon the minor

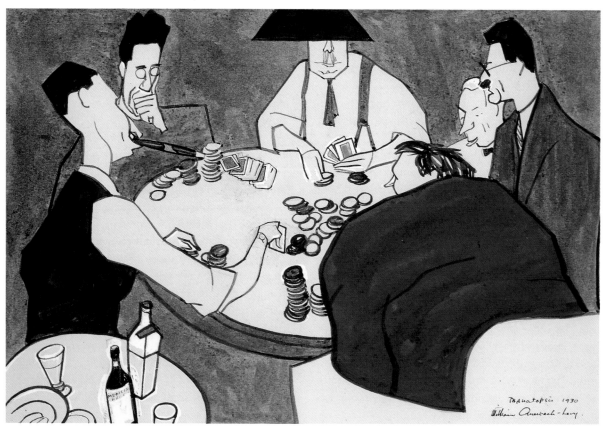

2.24 *The Thanatopsis Literary and Inside Straight Club* by William Auerbach-Levy. Watercolor, india ink, and gouache over pencil on paper, 35.7 x 48.3 cm (14 x 19 in.), 1930. National Portrait Gallery, Smithsonian Institution, Washington, D.C.

occurrences of the day." Adams's rejoinders, Van Doren noted, were appreciated by his followers for their dexterity, insouciance, and "gyroscopic balance."[56]

A core element of this group knew each other in Paris during the war. F. P. A., Woollcott, Ross, and John Winterich were all writer-editors of the *Stars and Stripes*, the newspaper of the American Expeditionary Forces. The card-playing, wisecracking camaraderie of Ross and fellow newspapermen—civilian reporters such as Heywood Broun also joined their regular poker game at a Montmartre café—was the genesis of the friendships that revived after the war as the soldier-scribes gravitated to New York. Most of this contingent attended a luncheon in the summer of 1919 at the Algonquin Hotel in mocking honor of Alexander Woollcott. Two theatrical press agents, John Peter Toohey and Murdock Pemberton, dreamed up the event as a practical joke on the pompous raconteur. A

press release announced twelve speakers of wartime reminiscences, each of which was a misspelling of Woollcott's name. The effort to deflate the self-importance of the honoree ended in failure—Woollcott relished the attention—but the wisecracking pranksters had so much fun that a small core of them decided to lunch regularly at the hotel.

In addition to the *Stars and Stripes* crowd, Crowninshield, Parker, Benchley, and Sherwood, a fellow *Vanity Fair* editor, dropped in frequently at the Algonquin luncheons; so did aspiring playwrights Edna Ferber, George S. Kaufman, and Marc Connelly. Press agents, actors, artists, and various invited guests joined the writers in an ever-fluctuating gathering at their round table in the Algonquin Rose Room. F. P. A., Ross, Kaufman, Broun, Woollcott, Harpo Marx, and others also met on Saturday nights for a poker game, dubbed by Adams the Thanatopsis Literary and Inside Straight

Club in reference to Sinclair Lewis's novel *Main Street* (fig. 2.24). With so many clever wordsmiths among them, this "vicious circle," as they called themselves, soon became famous for its ingenious puns and insults, which would appear immediately in print in someone's column, generally F. P. A.'s or Heywood Broun's.[57]

As Ann Douglas has argued, the modernists of the 1920s wanted to strip away artifice and sentimentality to reveal, and revel in, "fearful," "terrible" honesty. Motivated in part by a Freudian self-consciousness, they confronted unpleasant truths about themselves and their surroundings with an obsessive exactitude. Humor was one means of pinpointing the truth with dexterous acuity. Much comedic writing, along with other popular arts that flourished in the 1920s, had "a precision of pitch, a deftly antiseptic sting" that was new in American entertainment. That quick, light, deft assault, precisely aimed to puncture but not obliterate its target, characterized this generation's approach. "Truth may be light or dark," Douglas points out. "It is accuracy of perception not solemnity of tone that counts."[58]

Not all humorists of the period shared a place on the playful end of comedy's emotional continuum. No note of gaiety enlivened the more abusive examples of H. L. Mencken's legendary wit, for example, and the comments of Parker, Woollcott, and other Algonquin Round Table writers often revealed a bitter undercurrent. None-theless, a fashionable gloss of sophisticated restraint generally disguised the neuroses and psychological preoccupations that would characterize humor later in the century. By mid-century this strain of humor had lost much of its meaning; its refined detachment seemed weak and outdated. In the first decades of the century, however, this pungent spirit had fresh resonance.

New York City thus provided a fertile ground in which a witty form of celebrity caricature could take root. The pencil sketches of the Henri-Sloan circle, the delicate lines and tones of Beerbohm, and the charcoal drawings and watercolors of Flagg, however, adapted poorly to printed reproduction and standards of modern graphic design. Caricature would flourish in the press when artists turned instead to the bold, elegant lines and abbreviated forms developed by French and Italian caricaturists. Their stylized figural forms were introduced in America by such cosmopolitan personalities as the Swiss-Italian artist Carlo de Fornaro and the Mexican artist Marius de Zayas. The Americans, Al Frueh, who made periodic trips abroad, and Ralph Barton, who lived much of his life in France, would follow in their footsteps. As the press gradually began to feature new styles of caricature, avant-garde artists and critics began to see in them a symbolic summation of personality congenial to their search for innovative visual expression.

Part 2 The Pioneers

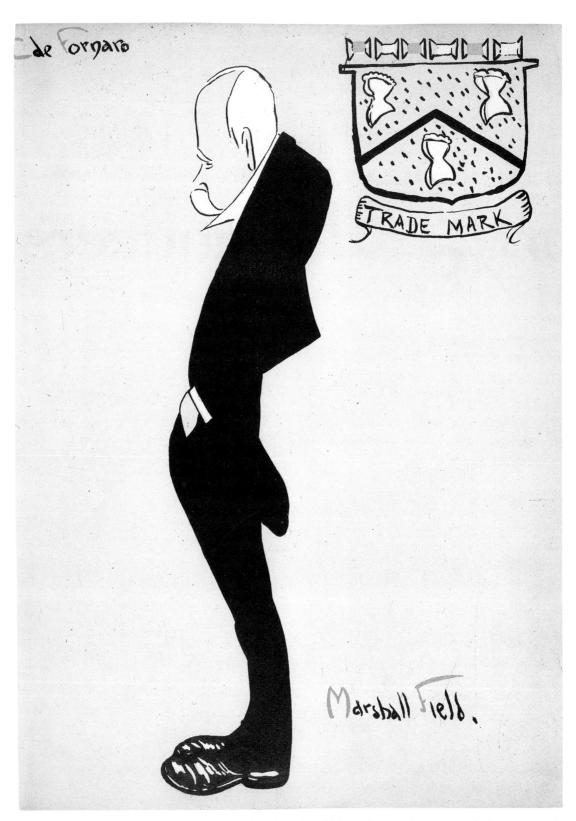

3.2 *Marshall Field* (1835–1906) by Carlo de Fornaro. Color lithograph. Published in Fornaro, *Chicago's Anointed* (Chicago, c. 1898). Chicago Historical Society.

CHAPTER THREE

Carlo de Fornaro: *Introducing the Intelligent Line*

The Japanese were masters in the use of the intelligent line, which is the basis of modern caricature.
—Paul Haviland

Directly a man is stereotyped as . . . well known . . . , he provokes caricature, he is legitimate prey, and should be forced to assume a less shop-worn, a more piquant guise.
—The Critic, 1900

Just as the spirit of light parody was permeating New York, the cosmopolitan young artist Carlo de Fornaro (1871–1949) arrived in Chicago for a brief, ill-considered foray into the mercantile profession (fig. 3.1). Although he is little remembered today, Fornaro introduced a Parisian style of attenuated portraiture that would take root in the American press. A writer and critic as well, he articulated for an American audience the substantial differences between modern caricature and other comic forms.

Born in Calcutta, the Swiss-Italian Fornaro, as he was generally called in America, had visited Paris and studied architecture and engineering in Zurich and painting in Munich. Succumbing to familial pressure after several failed attempts to establish a livelihood, Fornaro arrived in Chicago in the mid-1890s, hoping to launch a business career by working for hardware merchants. Despite his best efforts, working for one employer who was short and stout and another who was tall and slim was too much for his artistic impulses. "My connection with the establishment ceased," he told an interviewer, "upon a day when I could not resist the temptation to draw caricatures of the two proprietors. . . . The drawing was such a success that my resignation was asked for immediately."[1]

Fornaro spent the next year drawing caricatures of prominent city figures for the *Chicago Times-Herald*. The response was encouraging. Chicago's new caricaturist, reported the *Sunday Chronicle*, was adept "at discovering the weak side of the characters of the great, and [he] produces them in a good-natured way with his pen."[2] In 1898 Fornaro made sixteen lithographic prints of his portraits and published them in a slim, unbound portfolio entitled *Chicago's Anointed*. Reducing each full-length figure to a stylized black shape that stands out boldly on the page, he accentuated a slovenly slouch in

3.1 *Carlo de Fornaro (1871–1949)* by unidentified photographer. Printed illustration. Published in *Arts and Decoration*, April 1923. Library of the National Portrait Gallery and the National Museum of American Art, Smithsonian Institution, Washington, D.C.

the case of department store magnate Marshall Field (fig. 3.2) and a ridiculous rotundity in the portrait of meat-packing mogul Philip D. Armour (fig. 3.3). Attributes for each of the subjects were condensed into a comic coat of arms, a device that dates back to Charles Philipon and the French caricaturists of the 1830s.[3] Field's heraldic device, for instance, sports

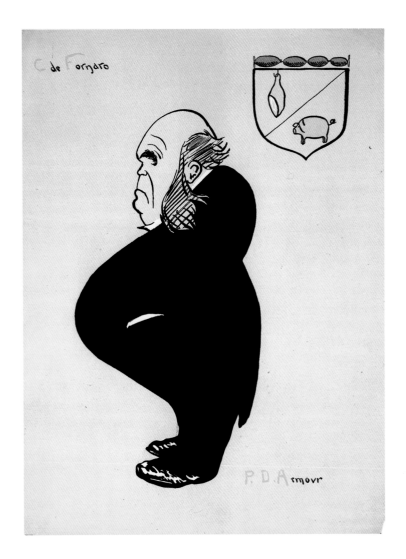

3.3 *Philip D. Armour* (1832–1901) by Carlo de Fornaro. Color lithograph, 33.2 x 25.4 cm (13¹/₂ x 10 in.), 1898. Published in Fornaro, *Chicago's Anointed* (Chicago, c. 1898). National Portrait Gallery, Smithsonian Institution, Washington, D.C.; gift of Gabriel Laderman.

corsets, spools of thread, and the motto "Trade Mark." The only text, removed to the facing page, briefly lists the subject's "confessions," revealing favorite hero, animal, book, and so forth—in Armour's case, for instance, Buffalo Bill, the hog, and "What to Eat."

Fornaro's subjects also appeared in the editorial cartoons of the newspapers. The allusive imagery and captions, however, focusing on specific issues of the day, distracted from the portrait itself. In his brief preface to *Chicago's Anointed*, Fornaro distinguished between cartoon satire and his witty portrayals: "Caricatures may be divided roughly into two classes," he wrote, "those whose purpose it is to hurt or correct, and those who[se] purpose it is to amuse. These caricatures were

made with only the latter aim in view, and if they give offence to anybody they exceed both their authority and the artist's intentions." Lacking the cartoon's topical specificity, these images were focused summarizations of each individual.

To the extent that it targeted illustrious local citizens, Fornaro's album resembled the volumes of caricature portraits that proliferated in America from the 1890s through the first quarter of the twentieth century. These volumes, issued by newspaper cartoonists and carrying such titles as *Cartoons of the Nodaway County Boys* (1906) and *Club Men of Dayton in Caricature* (1912), saluted civic leaders with pleasant, cartoonish portrayals and short, respectful biographies. *Representative Men*

of the West (1904), published by *American Cartoonist* magazine, typifies the genre. Its subjects were primarily businessmen, such as Denver "bond man" Ralph W. Smith (fig. 3.4), who was, according to the accompanying paragraph, a vice-president of the National Surety Company, a sports fan, and a member of the Denver Club, the Masons, and the Elks. Such brief, amiable biographies bore a rags-to-riches slant whenever possible. The stiff little figures in the illustrations, placed within a background alluding to their profession, generally had undistorted heads copied from photographs and small, cartoon bodies.

These books of eminent citizens belong to a tradition of collected, illustrated biographies that began in the early nineteenth century. Inspired by a rising nationalism and a search for American heroes, the biography mania of the age resulted in such multivolume works as Joseph Delaplaine's *Repository of the Lives and Portraits of Distinguished Americans* (1816–18) and Longacre and Herring's *National Portrait Gallery of Distinguished Americans* (1833–39).[4] These large, ambitious projects required the coordinated efforts of subjects, portraitists, engravers, and biographers. Both images and texts set forth the moral character and civic virtue of great men for lesser citizens to admire and emulate. Instead of satirizing this tradition, the cartoon volumes merely indicated its decline. Although mild homage was paid in the text and portrait, neither was meant to exemplify greatness. The portraits were generally devoid of either wit or satire, and they even lacked the immediacy of the daily editorial cartoon. Each subject was a potential purchaser of the volume and was thus targeted as an affluent consumer rather than as someone deserving of either emulation or disparagement.

But Fornaro's volume did satirize this tradition, as well as introduce a new approach to caricature. Each cleverly drawn figure in his set of handsomely printed lithographs stands alone on the page, identified only by a name. The parodic coat of arms converts biographical content into a visual joke. Furthermore, despite its assertion of amiability, Fornaro dedicated *Chicago's Anointed* to the "best looking man in this book," taking a mischievous swing at the vanity of his subjects. The city's leading citizens could not have been flattered by their hilarious paunches, wrinkles, and scowls. Each undignified figure, while clearly recognizable, is transformed from his photographic likeness.

RALPH W. SMITH,
DENVER.

3.4 *Ralph W. Smith* (1870–?) by J. J. Moynahan and Francis Gallup. Wood engraving, c. 1904. Published in *Representative Men of the West in Caricature* (Denver, 1904). Library of the National Portrait Gallery and the National Museum of American Art, Smithsonian Institution, Washington, D.C.

Fornaro keeps the satiric impulse in check by avoiding overt reference to rapacious business practices or bloated tycoons. Nonetheless, each portrait countered, with pungent irreverence, the flattering eulogies that successful businessmen generally received in the popular press. Introducing a new style and tone, *Chicago's Anointed* gleefully mocked the notion that a portrait of a great man could inspire his fellow citizens.

The raised eyebrow rather than the clenched fist characterized this new form of caricature. In distinguishing his art from other forms of satire, Fornaro implied that the more corrective, judgmental approach was tainted by the vulgarity of partisan passion. The modern caricaturist, avoiding prejudiced outrage on

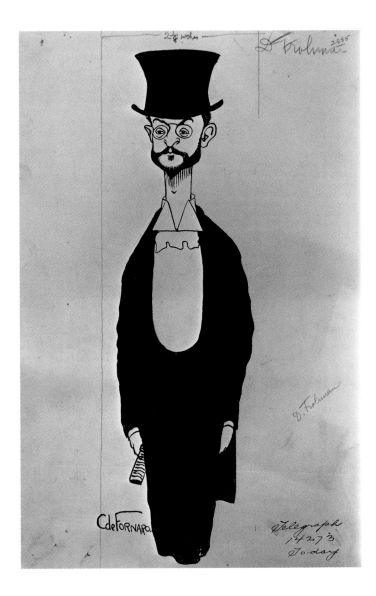

3.5 *Daniel Frohman* (1851–1940) by Carlo de Fornaro. Ink on paper, 38.1 x 25.4 cm (15 x 10 in.), c. 1900. Theatre Arts Collection, Harry Ransom Humanities Research Center, The University of Texas at Austin.

the one hand and obsequious respect on the other, offered instead a detached appraisal of his subject. His audience could share in this preeminent, critical stance. As Charles Baudelaire had explained in his essay on the comic impulse, the viewer's laughter often derived from "a joy in [one's] own superiority."[5] The milder critique that this satiric portraiture offered revealed not a less intense regard but an Olympian detachment that was empowering. This attitude, as much as the bold stylizations, distinguished modern caricature from its predecessors.

There is no evidence that *Chicago's Anointed*, which was published by Fornaro himself, brought windfall profits

to the young artist. But shortly after its publication he managed to move to New York City and soon began publishing a series of celebrities in the color pages of the *New York Herald*. A critic for Leslie's *Illustrated American* was the first to recognize his talent. In the field of personal (as opposed to political) caricature, the author pointed out, America had been deficient; of the various artists portraying public figures, only Fornaro had a pronounced gift for the "satire of portraiture." He compared him favorably with Otto Toaspern, then publishing a series of amusing portraits in *Life* magazine, calling the latter "merely an expert distorter of photographs." He concluded that Fornaro, like Charles Léandre in France

3.6 *William Clyde Fitch* (1865–1909) by Carlo de Fornaro. Ink on paper, 41.7 x 26.8 cm (16⅝ x 10⁹/₁₆ in.), 1902. Original illustration for *New York Telegraph*, November 9, 1902. Harry Ransom Humanities Research Center, The University of Texas at Austin.

and Max Beerbohm in England, was doing some of the best work in the field.[6]

After this auspicious beginning, the editors of the *Dramatic Mirror* engaged Fornaro to portray eminent theatrical figures. Announcing the series in the January 1899 issue, they published an interview with the artist in which he defined modern caricature. Americans little understood the art "in its highest form," Fornaro explained. "We have cartoons—most of them political and many of them brutal—but the real caricature, that exhibits by a few simple lines the habitual expression of a face, is not yet greatly in vogue on this side." It was best appreciated, he noted, in France and Italy.[7]

Caricature need not be offensive, Fornaro insisted. He had drawn statesmen and military officers on a trip to Washington and had found that a true caricature was usually as pleasing as a good portrait. Public figures presumably could stand the heat of the spotlight better than hardware merchants. Fornaro did occasionally offend his subjects, but he discovered that officials and theatrical celebrities were accustomed to general scrutiny and were generally less sensitive to mockery. His drawing of theatrical producer Daniel Frohman (fig. 3.5) typifies his style. His vivid black india ink portrait depicts a stiff, long-necked bowling pin of a figure. The simplicity of the undetailed body focuses attention on the head, where the pointed goatee, the alert and intelligent eyes, and the Mad Hatter–sized top hat all give the sense of a distinct, intriguing character. This image was impertinent but more likely to appeal to Frohman's friends than to his enemies.

According to the *Mirror*'s interview, Fornaro was not quite so bold as to ask for a sitting when he drew a portrait. Instead, he studied his subject surreptitiously, trying to form a distinct mental image. The face and figure of the caricature grew gradually in his imagination, with the strongest features becoming more prominent while the weaker ones faded. "By the time I am ready to put the image on paper," he explained, "there are only the boldest lines left. It is largely an art of leaving things out, and a caricature is often most valuable and artistic because of the lines that are not there."[8] In his drawing of popular playwright Clyde Fitch (fig. 3.6), for instance, published in the Sunday *Telegraph*, the squinting eyes are barely suggested, and the mouth is hidden entirely behind a self-satisfied mustache. Articulated only by a contour of bulging wrinkles, the folds and details of the clothing merge into a single shape, as the figure performs a characteristically slight, stiff bow. The black and white contrasts and simplified shape impart an insistent, eye-catching quality to the portrayal.[9]

Well-known figures like Frohman and Fitch could hardly be offended at Fornaro's depictions. Comments in the press suggest a dawning realization that it was the subject's renown rather than his misdeeds that occasioned this mild mockery, and that the price of such fame was public consumption of his image. In July 1900, the literary monthly *The Critic*, which often featured satiric artists, published Fornaro's portrayal of Ernest Seton-Thompson, a popular Canadian author of animal stories. According to the accompanying text,

3.7 *Elsa Maxwell* (1883–1963) by Georges Goursat [Sem]. Watercolor on paper, 50.2 x 33 cm (19³/₄ x 13 in.), c. 1920–30. Original illustration for *Le Grande Monde a L'Envers*. Print Collection, Miriam and Ira D. Wallach Division of Art, Prints and Photographs, New York Public Library, New York, Astor, Lenox and Tilden Foundations.

the editors considered caricature a "wholesome thing," and they planned to publish on occasion "fanciful versions of those unhappy beings who have become commodities—literary column commodities." After a man has achieved some literary fame, they explained, "he provokes caricature, he is legitimate prey, and should be forced to assume a less shop-worn, a more piquant guise."[10] This form of caricature, in other words, was based on a celebrity that engendered so much publicity that the subject lost all claim to ownership of his own likeness or reputation. His image was in the hands of the populace, legitimate prey for journalists and artists. The public, as consumer, deserved a bright, fresh package for such a product, and the caricaturist provided it.

In spite of the efforts of the editors at *The Critic*, few Americans fully understood this art, Fornaro felt, so he continued to articulate the difference between cartoon and caricature in an October 1900 article for *The Criterion* magazine. The artistic caricature is the "quintessence of wit in art" he contended, while the cartoon is only a political weapon, a murderous ax in comparison with the "graceful but penetrating foil." He complained about the big head–dwarfish body formula used by many cartoonists, and he cited Beerbohm, Oliver Herford, and Leonetto Cappiello as eminent practitioners of the new art. A caricature, he declared, "must contain more than a likeness of the person caricatured—it must suggest the character, the soul, the inmost being. . . . A caricature is an epigrammatic portrait of a personality; a cartoon is a composition of . . . portraits of political men, with accessories depicting a political situation; it is, as it were, an allegory." Fornaro argued that modern caricature resembled other forms of portraiture more than other types of humorous drawing. The caricaturist, as opposed to the cartoonist, was an artist.[11]

Although Fornaro had studied art in Germany, he did not advocate the powerful draftsmanship and heavily satiric tone made famous by the caricaturists of *Jugend, Simplicissimus,* and other German magazines. He had also lived, at least briefly, in Paris, and he modeled his own style after the lighter, wittier work appearing in such Parisian satirical journals as *Le Rire* and *L'Assiette au Beurre.* The popularity of these stylish, clever portraits led to the publication of portfolios of prints featuring the fashionable circles of the theater, the beach, the race track, and other society gathering spots. Caricature albums by Georges Goursat, known as "Sem," and by the Italian-born artist Leonetto Cappiello became the rage of Paris around the turn of the century, about when Fornaro was issuing *Chicago's Anointed.*[12] Since it was fashionable to be included, the celebrity victims learned to tolerate the most unflattering distortions. Sem's slightly later drawing of visiting American socialite Elsa Maxwell (fig. 3.7), for instance, depicted from behind as she attempted to dance the Charleston, is deliciously wicked, even though its zestful gaiety keeps it from being wholly malicious.

The critic Christian Brinton considered Fornaro's work comparable to the caricatures of Sem and Cappiello. He featured all three artists in a December 1904 article for *The Critic,* in which he further defined

the new type of attenuated caricature. To be ridiculed by Sem, the current "pet of Paris" was an "index of smartness," Brinton pointed out, for the artist carried to the limit the prevailing trend toward simplification. He illustrated one of Sem's prints, a soirée of socialites transformed into a cleverly choreographed performance of ridiculous nods, bows, and gestures (fig. 3.8). Like Fornaro, Sem used the entire figure to convey the character of his subjects, varying the stance, stature, and expression of each. This abbreviated stylization conveyed a modern feeling, Brinton emphasized, and yet suggested, in its simplicity, ancient art forms. Cappiello's geometric caricatures, he noted, have the "primitive directness of hieroglyphics. The formula is absolutely concise; facial characteristics and conformation of figure are reduced to their slenderest terms; nothing superlative is admitted and nothing essential is omitted. It is a new art and yet old, it is pantomime on paper."[13]

Fornaro, struggling to support himself as a caricaturist and writer in New York, must have been flattered to receive equal billing with two artists who had attained prominence in Paris. His own art encompassed the same fluid lines, attenuated forms, and silhouetted poses as, for example, Cappiello's *Marthe Mellot* from the 1899 album, *Nos Actrices* (fig. 3.9). The *Critic* article reproduced Fornaro's caricature of the internationally acclaimed actress Eleanora Duse. Depicting the great star in a most untheatrical slump with a bouquet dragging at one side and a bored expression, he playfully mocks both her celebrity and her renowned stage presence (fig. 3.10).

The sharp outlines, simplifications, and reductions of this caricature style were aesthetic elements that the

3.8 *Soirée* by Georges Goursat [Sem]. Color lithograph, c. 1900. Published in *Album Vert*, c. 1900. © The Frick Collection, New York.

Parisian caricaturists shared with contemporary poster artists. The large, colorful advertisements proliferating in the streets of Paris in the last third of the nineteenth century, drawn by such artists as Jules Chéret (fig. 3.11) and Henri de Toulouse-Lautrec, had introduced a dramatic graphic intensity. Their prominence in the urban setting inspired all designers and illustrators to forge forceful, clearly legible styles. Indeed, the poster craze spread these visual ideas throughout the western world. By the end of the century all aspects of graphic design, including advertising, publishing, and illustration, had begun to adopt a new simplicity and boldness.

If, as Alan Fern has claimed, poster artists had discovered through caricature how to evoke aspects of personality and likeness through abbreviated line and gesture, the influence was equally strong in the opposite direction.[14] Like the poster commanding attention on the busy street, caricature functioned in an environment of competing words and images and in a newspaper or magazine needed to attract the eye in an dramatic,

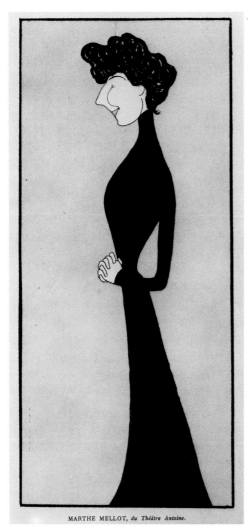

MARTHE MELLOT, *du Théâtre Antoine.*

3.9 *Marthe Mellott* by Leonetto Cappiello (1875–1942). Color lithograph, c. 1899. Published in Cappiello, *Nos Actrices* (Paris, 1899). Rare Books; Southwest Collection/ Special Collections Library, Texas Tech University, Lubbock.

formation which has always been the despair of his less favored associates. Having exhausted the possibilities of Pisa he settled in Florence, and later in Zürich, where he devoted himself to mathematics and engineering preparatory to entering the Polytechnic.

The somewhat rigid vista of life as a civil engineer did not prove a source of unmixed joy to the future satirist, who was, indeed, fonder of Swiss field sports than of quadratic equations or the binomial theorem. On the fatal day when he was to have gone up for his examinations, he suffered an entirely heroic revulsion of feeling against his prospective calling and adroitly stepped on a train which whirled him southward toward Florence. Paternal authority now loomed large upon the horizon, and the youth who so narrowly escaped becoming a sturdy builder of railways and bridges was taken to India and installed as Assistant Manager of a tea plantation in Assam, near the Tibetan frontier. It would naturally have been unbecoming if the new Assistant Manager had not fully realized the possibilities of his position, so he quickly proceeded to surround himself with a numerous suite and become the Rajah of the district. The tea plant eventually proved less absorbing than the wild oats of oriental extravagance, with the result that the Assistant Manager was precipitately removed from his high estate by a father who quite humanly showed a certain distaste for paying his son's debts. Sadly but philosophically the ex-Assistant Manager took his last look at the white, soaring crests of the Himalayas, and listened pensively to the music of the soft-flowing Brahmaputra.

Though facts seem to prove the contrary, the future caricaturist had really been moving all the while along the somewhat irregular curves of evolution toward his true goal. Once back in Calcutta, he entered a local art school and began drawing vigorously from the cast in company with a number of ambitious Baboos. So pronounced were his achievements that his preceptor, who, though an Englishman, was a man of accurate æsthetic intuitions, and advised him to leave Cal-

SIGNORA DUSE À LA FORNARO

3.10 *Eleanora Duse* (1858–1924) by Carlo de Fornaro. Printed illustration. Published in *The Critic*, December 1904. Library of Congress, Washington, D.C.

3.11 *Loïe Fuller* (1862–1928) by Jules Chéret. Color lithographic poster, 111.1 x 82.4 cm (43³/₄ x 32⁷/₁₆ in.), 1893. National Portrait Gallery, Smithsonian Institution, Washington, D.C.

3.12 *Folies Bergère* by Leonetto Cappiello. Poster, 129 x 94 cm (50⁷/₁₆ x 37¹/₈ in.), 1900. Prints and Photographs Division, Library of Congress, Washington, D.C.

assertive fashion. Graphic humorists began to employ a posterlike, insistent boldness to convey their ideas.

The work of Cappiello, who both designed posters and drew caricatures, suggests the connections between these forms of figural art. In his 1900 poster for the Folies Bergère (fig. 3.12), the flattened image of the dancer is outlined with a sinuous black contour line highlighted against a vivid yellow background, while the features of the unmodeled face are barely suggested. The spirited movement of the contour line captures the attention, adding vivacity to the image. A similar flatness, simplification, and linear energy characterize his caricatures, giving them a fashionable, contemporary gloss. Cappiello's style, as Christian Brinton concluded, appeared "so acute in its modernity and so precise in its contour."[15] In contrast with the sketchy, long-caption humor drawing and the issue-oriented editorial cartoon, the new form of caricature was a

high-impact, attention-getting form. The likeness had to be instantly recognizable and its humor immediate. The graphic clarity of strong dark contours, simplified masses of color, and fluid, curving ink lines helped caricature, like poster art, compete in a complex visual forum.

The Parisian vogue for Japanese woodblock prints had inspired poster and caricature artists alike. The simplified linearity of these prints was particularly suitable for caricature, which did not incorporate words into the visual image. American critic Paul Haviland, one of the editors of the journal *Camera Work*, recognized this emphasis on line as a critical element of the new form of caricature. "The Japanese were masters in the use of the intelligent line," he noted, "which is the basis of modern caricature as evolved by Sem, Capiello [*sic*], Fornaro and [Marius] de Zayas."[16] Because the number of stokes of the pen or brush were so limited, each line became more significant to the whole, more "intelligent."

As satirical journals proliferated throughout the western world in the late nineteenth century, so did stylized, amusing portraiture of the famous. Not all caricaturists took the linear approach of the French. The English *Vanity Fair* magazine, for instance, still published many fleshed-out figures with distorted faces. By the end of the century, however, caricature portraits were frequently drawn in the fluid, sinuous lines of the prevailing Art Nouveau aesthetic. New Yorkers got a glimpse of this international vogue at a caricature exhibition that opened at the Fifth Avenue Bookshop in 1904. The *New York World* on February 21 gave prominent coverage to the show (fig. 3.13), publishing two pages of illustrations under the headline "International Figures Drawn from Life by the Leading Caricaturists of the World." The array of images, drawn by Fornaro, Sem, Cappiello, Max Beerbohm, and a little-known artist named Saccetto, included depictions of Theodore Roosevelt, King Edward, the Duke and Duchess of Marlborough, Rudyard Kipling, Ignace Paderewski, J. Pierpont Morgan, Clyde Fitch, and Sarah Bernhardt. The light tone and linear qualities of all the portraits make it clear that Fornaro's art belonged to an international trend, despite regional differences and stylistic variations.

To Americans, Max Beerbohm was by far the best known of the artists represented. His prankish sense of the comic is especially distinctive in the *World* illustration of an attenuated Duchess of Marlborough (the former American Consuelo Vanderbilt), endowed with all the grace of a praying mantis as she strolls along with her dwarfish little Duke. The few drawings that sold at the 1904 exhibition were all Beerbohm's, according to the American critic Benjamin de Casseres, who preferred the work of Sem, Cappiello, and Fornaro. Five years later he was still griping about Beerbohm's precedence over other, more linear caricaturists. It was probably, he complained with his scornful attitude toward the American audience, because "Beerbohm's 'art' comes nearer the comic Valentine stage than any one else's. And the comic Valentine is still confounded with caricature in this country."[17] Despite this disparaging opinion, Beerbohm could claim a strong American following, and his dry, superior tone had a great influence on urban forms of humor. But Beerbohm's wit was almost impossible to match, and his drawing style, which varied dramatically from one subject to the next, was difficult to emulate. His portraits often depended

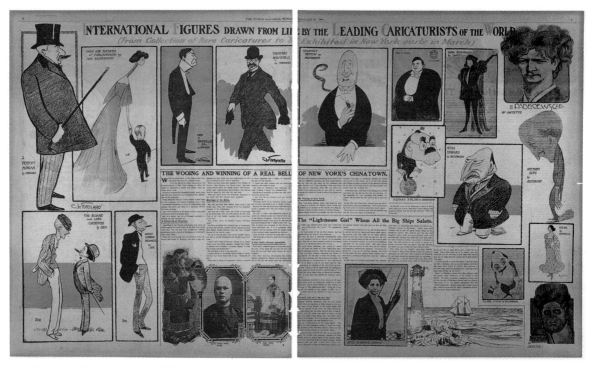

3.13 *International Figures Drawn from Life by the Leading Caricaturists of the World* by various artists. Printed illustration. Published in *New York World*, February 21, 1904. National Portrait Gallery, Smithsonian Institution, Washington, D.C.

on a lightly sketched line or on subtle color tones not easily reproduced. The sharp, precise French version of this style would thus become the dominant approach to caricature in America.

By the time of the 1904 exhibition Fornaro was successfully introducing this style in numerous New York publications and enjoying a growing reputation.[18] His drawings had appeared in *The Criterion*, *Everybody's*, *The Critic*, the *Dramatic Mirror*, and various newspapers, and he had issued another portfolio of caricatures. *Millionaires of America*, published in 1902, was received with "vast pleasure" by society, according to the *New York Evening Journal*, entertaining its victims as well as their friends. The twelve lithographic portraits—three of which were drawn by a little-known collaborator named Max Cramer de Pourtales—each sported a comic heraldic device and a Latin motto. One reviewer called the caricatures of J. P. Morgan, John J. Hill, and William C. Whitney masterpieces. "He uses very few lines," he wrote about Fornaro, "but the few are fraught with portentous significance. Every stroke tells, even every dot. . . . There is about Mr. de Fornaro's work no buffoonery, no horse play, no vulgarity—elements that are found in the work of many American caricaturists who have never crossed the Seine. And if there is . . . any underlying malice it is well hidden under a masterful technic [sic]."[19]

Fornaro had no intention of flattering his subjects, however. The portfolio cover stated his theme with biblical authority—"they have made them a molten calf, and have worshipped it"—and judicious touches of gold throughout the album serve as constant reminders of the obsessive pursuit of wealth. The portrait of financier J. Pierpont Morgan seems, at first, decidedly malicious (fig. 3.14). Morgan appears as a powerful, bellicose presence, "glowering moodily into space," one reviewer wrote, "as if seeking more worlds to Morganize."[20] Fornaro used color sparingly and effectively on the black and white figure. Touches of gold glitter on a ring, a watch chain, and pince-nez, while bright red glows on a small stickpin and, most cruelly, on the bulbous nose, disfigured by a skin disease. But Morgan was a controversial figure, accustomed to both vilification and effusive praise. He had made enemies with his heavy-handed business techniques, and he was a regular target of the cartoonists, who always emphasized his nose. Furthermore, public outrage toward the giant trusts and the men who created them was growing. In

the fall of 1902, the year that *Millionaires of America* appeared, Ida Tarbell published in *McClure's* magazine the first of her essays exposing the business abuses of John D. Rockefeller, Sr., ushering in a new muckraking era. In this light, Fornaro's depiction seems less judgmental, detached from the bruising publicity warfare.

Fornaro's *Millionaires* album charted a new course between the fawning paeans of the popular magazine writers and the exposés of the muckrakers. He mocked the library endowments of the diminutive Andrew Carnegie by showing him raised in his chair on a pile of books (fig. 3.15). Philanthropy, in Fornaro's conception, could always elevate the stature of the successful businessman. John Jacob Astor IV, puffed with vanity, appears as a gangly, weak, frivolous descendant of the founder of the family fortune. But the press, increasingly critical of unscrupulous greed and ostentatious inherited wealth, had emphasized exactly such characteristics in each of Fornaro's victims. Although he mocked their foibles, he did not expose them. Instead, he summarized external traits well known to the public. His underlying theme was not the wealth of his high society subjects but the celebrity reputations that money had brought them.

Millionaires of America brought Fornaro to the attention of Joseph Pulitzer's *New York World* newspaper, where a brief review and four of the caricatures were published on January 4, 1903. His timing was perfect; the *World* staff was about to introduce an updated format for the Sunday edition, and Fornaro's brand of caricature had just the tone they were seeking.[21] The new Metropolitan Section would focus not on the business of the working world but on personalities, entertainment, social events, and the vibrant nightlife of the city, appealing to the increased leisure interests of urban dwellers. The new section was one more refinement of Pulitzer's efforts to reach a mass audience. With its mix of sensationalized reporting, human interest stories, large headlines, sports, fashion, and entertainment, the *World* already had soared in circulation, attracting more female, lower-class, and immigrant readers. Despite intense competition, it was the most widely read newspaper in the country.[22]

Illustration had always been a prominent part of Pulitzer's formula, and he was innovative in two important areas: the use of portraiture and the emphasis on pictures used primarily to entertain. Not long after he bought the paper in 1883, he later explained, he decid-

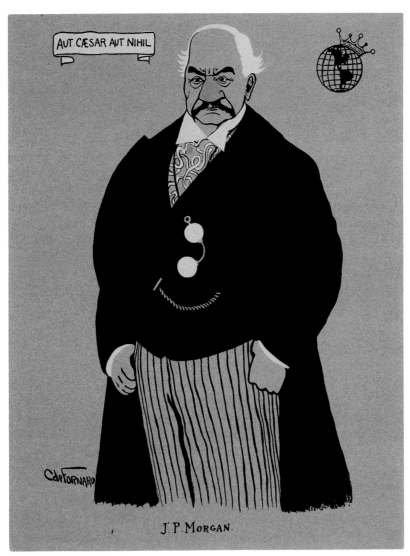

AUT CÆSAR AUT NIHIL

CARLO FORNARO

J. P. MORGAN.

3.14 *J. Pierpont Morgan* (1837–1913) by Carlo de Fornaro. Color relief print on paper, 34.3 x 21.7 cm (13½ x 8⁹/₁₆ in.), 1902. Published in Fornaro, *Millionaires of America* (New York: Medusa, 1902). National Portrait Gallery, Smithsonian Institution, Washington, D.C.; gift of Gabriel Laderman.

ed to feature more portraits to help attract additional readers: "They called me the father of illustrated journalism. What folly! I never thought of any such thing. I had a small paper which had been dead for years, and I was trying in every way I could think of to build up its circulation. I wanted to put into each issue something that would arouse curiosity and make people want to buy the paper. What could I use for bait? A picture, of course . . . a picture of someone prominent in the news.

. . . Circulation grew by the thousands."[23] Images of New Yorkers predominated, not only famous people but many of merely local prominence, including firefighters, police officers, journalists, merchants, brides, or anyone to whom a human interest story could be attached.

Part of Pulitzer's instinct for circulation building was his understanding of the entertainment value of pictures.[24] Particularly in the Sunday edition, the paper

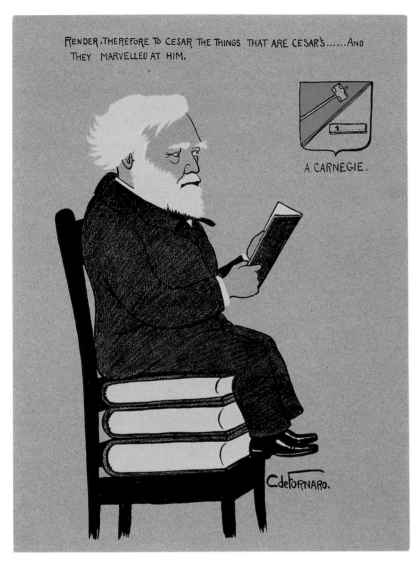

RENDER, THEREFORE TO CESAR THE THINGS THAT ARE CESAR'S......AND THEY MARVELLED AT HIM.

A. CARNEGIE.

CdeFORNARO.

3.15 *Andrew Carnegie* (1835–1919) by Carlo de Fornaro. Color relief print on paper, 34 x 22.1 cm (13³/₈ x 8¹¹/₁₆ in.), 1902. Published in Fornaro, *Millionaires of America* (New York: Medusa, 1902). National Portrait Gallery, Smithsonian Institution, Washington, D.C.; gift of Gabriel Laderman.

was sprinkled with images meant primarily to amuse and intrigue the reader rather than to elucidate an article or give visual details about the news. Often these illustrations would be unconnected to any of the text on the page. Pictures would soon become, according to one historian, the "most important single element in the Sunday edition."[25] The Metropolitan Section built on and refined these traditions. The depictions of policemen and storekeepers were replaced by images

of celebrity figures. With a light, humorous tone, the new Sunday section focused on the people and events that gave New York its style and flair.

By offering a sense of community and an almost familial connection to prominent public figures, the Metropolitan Section counteracted the sense of alienation that resulted from rapid urbanization and increased immigration. As historian Jib Fowles has pointed out, identification with celebrities often

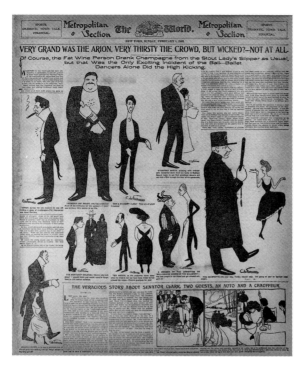

3.16 *Very Grand Was the Arion, Very Thirsty the Crowd* by Carlo de Fornaro. Printed illustration. Published in *New York World*, February 8, 1903. National Portrait Gallery, Smithsonian Institution, Washington, D.C.

helped restore an emotional grounding for those moving from a small, cohesive community to a metropolis. Establishing one's identity within a diverse urban population was difficult, but the media provided an enticing choice of role models, people who seemed to have reached the pinnacle of personal and public success.[26] Comfortable in the knowledge of where to go, what to see, how to dress, and whom to gossip about, the reader of the Sunday paper could relate to New York as a more manageable and less threatening town.

When the Metropolitan Section began, Fornaro was given a prominent role. Pulitzer's emphasis on portraiture and on pictures for entertainment had led almost inevitably to caricature. From 1903 to 1906, Fornaro's caricatures enlivened the front page weekly and often appeared on the second or third page as well. In his drawings of the Arion Ball on February 8, 1903 (fig. 3.16), for instance, readers could enjoy the depictions of such celebrities as architect Stanford White, flashy playboy "Diamond Jim" Brady, millionaire's son Joseph Leiter, and theatrical producer Sam Shubert. Every

reader could share vicariously in the enjoyment of the evening, for these famous figures did not seem to be distant, glamorous creatures from an unattainably aristocratic social circle. Their positions were as often self-made as inherited, and because one knew so much about their lives and reputations they seemed like close acquaintances. Caricature took this process of simplifying and exaggerating the public image one step further, giving visual form to well-known traits. The addition of humor made the connection to the famous even more intimate. One could hardly stand in awe of Fornaro's lively, ridiculous figures. The affectionate familiarity achieved through recognition and distortion made every famous name a part of the urban family. Each celebrity seemed to belong to the metropolis, and, by extension, to the readers of the Metropolitan Section. This sense of connection and ownership, so much a part of celebrity's addictive attraction, gave caricature much of its appeal.

Fornaro frequently worked with writer Roy L. McCardell on features for the Sunday paper. Together they invented the "Metropolitan Section's Geographical Survey" to examine various aspects of New York life. Led by a fictional figure named Fogarty, the adventurous Survey team explored the subway, still under construction, solved traffic problems on the Brooklyn Bridge, lectured to visiting delegations, and generally turned up wherever interesting things were happening. By using real people, places, and events, McCardell turned out an entertaining mix of humor, fiction, and local color, providing Fornaro with ample opportunity to depict recognizable individuals and prominent visitors. Adding to the sense of authenticity, the bearded Fogarty frequently appeared among the famous, along with the figures of Fornaro and McCardell themselves. Like the fictional Mr. Dooley, Finley Peter Dunne's uneducated but insightful comic philosopher whose musings appeared elsewhere in the Sunday edition, the Survey team was just trying to make sense of the complexities of urban life, and it did so with an entertaining and irreverent wit.

Fornaro continued to cover the glamorous nightlife of New York, especially dinners, balls, and theatrical openings. His drawing of all the New York newspaper drama critics (fig. 3.17), which appeared in the *World* on January 10, 1904 (and was republished with slight changes in *The Critic* in March), was captioned "Remember, Ladies and Gentlemen, You Must Not

Annoy Them!" Spread out along the page, the critics represent a formidable phalanx of unsmiling, judgmental figures. The drawing mocks the arrogant, cynical pomposity of these arbiters of talent while acknowledging their collective power. In the growth of public nightlife in the first quarter of the twentieth century, the press and its critics would have increasing influence in directing the leisure hours of urban dwellers. For many young, middle-class men and women in New York, it was in the dazzling nightlife of the city rather than in the workplace or the home that they sought their identity and status. In the process, the critics themselves became local celebrities, as Fornaro's drawing suggests. Where they dined after the show, and with whom, could be as important as their opinion of the performance.

The large number of critics in the drawing, each identified by name and publication, is a reminder that New York supported a great many newspapers during this period. Most employed their own teams of illustrators and cartoonists, so Fornaro's work at the *World* should not be overstated. He also published in the *Evening Sun*, the *Herald*, and the *Telegraph*. Given Fornaro's high-profile position with the preeminent *World* and appearance in other publications, he was noticed by publishers, critics, and illustrators. Slim Parisian-style caricature figures began to appear in the work of other newspaper artists.[27]

By early 1906, Fornaro had left the paper to begin a new chapter of his life. With the American critic Benjamin de Casseres he went to Mexico City and started a daily newspaper called *El Diario*, serving as the Sunday editor and contributing caricatures. Deeply politicized by his experience, he returned to New York in November 1908 and published *Diaz, Czar of Mexico* the following year. His book, which exposed the tyranny and corruption of the Mexican dictator, was translated into Spanish and widely distributed in Mexico, despite government efforts to suppress it. The dictator's agents were more effective in the American courts. In a virtually unprecedented case, Fornaro was arrested for criminal libel against an official of a foreign government. To the horror of the press, he was tried and sentenced to prison for a year.[28] Afterward, Fornaro's career began to veer away from illustration, and by the time of his death in New York in 1949 he was probably better known as a writer and journalist. His artistic endeavors, which included painting, theater design, advertising, a 1925 cover for the *New Yorker*, and a series of theatrical posters, were so diverse that he failed to secure a lasting reputation in any one area.[29]

Nonetheless, Fornaro did make a few more contributions to the newly developing art of caricature. From 1912 to 1914 the *New York Evening Sun* published his caricature series "Seeing New York with Fornaro." He

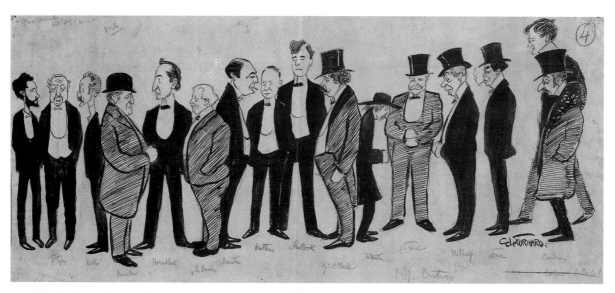

3.17 *New York Drama Critics* by Carlo de Fornaro. Ink, pencil, and Chinese white on paper, 33 x 76.2 cm (13 x 30 in.), 1904. Published in *New York World*, January 10, 1904. The Harvard Theatre Collection, the Houghton Library, Harvard University, Cambridge, Massachusetts.

3.18 *Seeing New York with Fornaro: Rivals!* by Carlo de Fornaro. Printed illustration. Published in *New York Evening Sun*, December 22, 1913. National Portrait Gallery, Smithsonian Institution, Washington, D.C.

3.19 *Seeing New York with Fornaro in Picture-Puzzle Land* by Carlo de Fornaro. Printed illustration. Published in *New York Evening Sun*, February 9, 1914. National Portrait Gallery, Smithsonian Institution, Washington, D.C.

3.20 *John D. Rockefeller, Sr.* (1839–1937) by Carlo de Fornaro. Printed illustration. Published in Fornaro, *Mortals and Immortals* (New York: Hornet, 1911). National Portrait Gallery, Smithsonian Institution, Washington, D.C.

covered such events as a horse show, a tea dance, and an opening at the Academy of Design (fig. 3.18). In one of his amusing pictures he spoofed the extremes of modern art, depicting Walter Pach, Walt Kuhn, Arthur B. Davies, and Joseph Stella at a Montrose Gallery exhibition of futurists, cubists, and post-impressionists (fig. 3.19).

Fornaro also issued one more volume of caricatures. *Mortals and Immortals*, published in 1911, was a book of illustrations rather than a portfolio of lithographic prints. It featured on its cover an image of Diogenes

searching for an honest man. It was, of course, really the artist conducting the search among the sixty-eight portraits within, depicting mostly American public figures, with a few Mexican and Canadian names. A literary quote accompanied each caricature, and Fornaro varied his characteristic dark ink image with such quickly sketched outline figures as John D. Rockefeller, Sr. (fig. 3.20), or portraits enlivened by patterns of hatched lines. The reviews of the book were mixed. *La Follia*, New York's leading Italian-language newspaper, reproduced the images, one by one, in a weekly series

that lasted more than a year. But several critics thought the pictures were uneven, ranging from the "pointed and palpable" to the drawing of little merit. Some sketches seemed to exist as a "parade of stunts," in the opinion of F. E. A. Curley of the *Dramatic Mirror*, who thought Fornaro lacked the "zeal of an artist deeply moved."[30]

Although Fornaro's drawings varied in quality, *Mortals and Immortals* was a milestone for the nascent art of modern caricature. No one could ignore, for instance, the two prefaces for the volume written by De Casseres, the most spirited advocate of the art form. Ever railing against "paunchy, heavy-mammelled Complacency" and the "sleazy bourgeois mind," De Casseres could be great fun to read. "Like the rainbow playing above the Yosemite gorge," mocked one critic, "is the irised fabric of his words atremble above the gulf of a terrible philosophy." If his overblown rhetoric was sometimes difficult to fathom, his dramatic images and iconoclastic views always surfaced. The critic who mocked him admitted that he delighted in De Casseres's style even when he disagreed with him; like most other reviewers, he could not resist a long quote.[31]

De Casseres insisted that caricature was a cold, intellectual art designed to appeal only to those who could recognize the fantastic absurdity of the mundane. "All those who see life as a mixture of diabolistic humor and mystical vaudeville are caricaturists," he wrote, "whether their names be Shakespeare, Cervantes, Heine, Fornaro, Sem, De Zayas, or Anatole France." The caricaturist must have a certain satanic spirit, De Casseres noted; he carries in his soul a "fatal smile" and in his brain a sigh that "will sparkle like a diamond—and cut like one."[32] By championing caricature at this formative period De Casseres gave an intellectual validity to the humorous stylization of the human figure that provided it an aura of sophistication, linking it to the visual experimentation of the avant-garde. The reviewers' quotes from De Casseres's remarks undoubtedly brought the volume to the attention of many who might have otherwise ignored it.

In addition, Fornaro, although not as deeply committed to modernism as De Casseres, introduced in *Mortals and Immortals* recent developments in art and design. A new geometric shaping and patterning, emanating from workshops in Glasgow and Vienna, was augmenting the sinuous, curving lines of Art Nouveau styles. In such portraits as his image of Senator Jonathan Bourne, Jr. (fig. 3.21), Fornaro varied his undulating line with sharp geometric angles and shapes.

In his image of Theodore Roosevelt (fig. 3.22) Fornaro carried his tendency toward geometric form to an abstract extreme. Entitled "The Square Deal," it was a visual pun on the president's 1904 campaign slogan. Although the hat and coat are legible enough, the human features are completely reduced to rectangles, squares, and parallel lines. Sophisticated New Yorkers would have recognized more than a campaign slogan in the picture and its title. Fornaro's square was a reference to the cube, a timely spoof on the extremes of cubism, particularly the recent work by Pablo Picasso. De Casseres, who thought the Roosevelt image an extraordinary piece of work, missed the joke. "Fornaro and Picasso," he effused, "have found the secret of the straight line, the poetry of logic."

Both Fornaro and De Casseres were friends of the Mexican caricaturist Marius de Zayas, who had worked with them on *El Diario* and subsequently moved to New York. De Zayas, intrigued by the new art he saw on a visit to Paris, organized an exhibition of Picasso's drawings and watercolors for Alfred Stieglitz's 291 Gallery. The show opened in March 1911, shortly before the publication of *Mortals and Immortals*. In the April–July issue of Stieglitz's magazine, *Camera Work*, De Zayas wrote about the "New Art in Paris," including cubism, presenting some of Picasso's views.[33] Fornaro certainly knew about the Picasso exhibition and De Zayas's article. Although he unquestionably spoofed the cubists in his image of Roosevelt, he nonetheless introduced a radically stylized image that successfully portrayed an individual in abstracted form.

De Casseres, for all his insight, was wrong about the direction that caricature would take in America. Its evolution depended on its appeal to the many, not the few, and a truly satanic spirit would not thrive in America in the post–World War I era. Although De Casseres saw the sophisticated wit in Fornaro's work he did not recognize its broad comic potential. Most Americans would miss the reference to the new theories of cubism in the Roosevelt portrait, but of all the pictures in the book, that one would have been the most recognizable and probably the most humorous. The combination of subject and style pointed in a new direction for caricature. What made the image so successful for the average viewer was that Roosevelt was such a vivid and well-known entity, embodying the new notion of "personality" more than any other figure

J.BOURNE JR.

I WOULD APPLAUD THEE TO THE VERY ECHO. — MACBETH

5

3.21 *Senator Jonathan Bourne, Jr.* (1855–1940) by Carlo de Fornaro. Printed illustration. Published in Fornaro, *Mortals and Immortals* (New York: Hornet, 1911). National Portrait Gallery, Smithsonian Institution, Washington, D.C.

of the day. He was a man of titanic energy, vitality, and enthusiasm whose passions for history, literature, natural history, hunting, exploring, and writing easily matched his interest in politics, and he dominated his era like no president ever had. "So strong was this young Roosevelt," wrote William Allen White, "hard-muscled, hard-voiced . . . with hard wriggling jaw muscles, and snapping teeth . . . , so completely did the personality of this man overcome me that I made no protest and accepted his dictum as my creed."[34]

Becoming a recognized personality, of course,

required the attention of the press, and Roosevelt had an instinct for publicity. His Wild West hunting exploits and his charge up San Juan Hill during the Spanish-American War quickly became part of American lore. He invariably offered a quotable comment, a dramatic gesture, or a charming photo of life at the White House, with its multitude of pets and children. As a result, the president was embraced by the press. He was also relentlessly cartooned. Albert Shaw compiled 630 contemporary cartoons for his *Cartoon History of Roosevelt's Career* (1910), pointing out that "no

3.22 *Theodore Roosevelt* (1858–1919) by Carlo de Fornaro. Printed illustration. Published in
Fornaro, *Mortals and Immortals* (New York: Hornet, 1911). National Portrait Gallery,
Smithsonian Institution, Washington, D.C.

one in recent years has figured as frequently as Mr.
Roosevelt" in comic art.[35] From coast to coast the exag-
geration of the famous spectacles and toothy grin
became a standard visual joke, a way to capture his
magnetic presence.

Fornaro's depiction extended and transformed these
comic images. Divorced from the captions and issues
of the editorial page, his witty stylization had a clarity
and precision that raised it above cartoon mockery.
His face and his character were so well known that
they could be completely abstracted yet remain recog-

nizable. Although the Roosevelt portrait was unusual in
Fornaro's work, in its extreme reduction and sim-
plification, its summarization of character, and its focus
on celebrity it exemplified the characteristics of the
new art form. Fornaro's brand of caricature would suc-
ceed because of its simultaneous appeal to intellectuals
and modernists like De Casseres and to the mass audi-
ence of the urban newspaper. After Fornaro's abrupt
departure for Mexico in 1906, this task was taken up by
Marius de Zayas, who would further establish carica-
ture as a visual interpretation of personality.

Marius de Zayas: *Spotlight on Personality*

Personality is the most important thing to an actress's success . . . , the glitter that sends your little gleam across the foot-lights and the orchestra pit into that big black space where the audience is.
—Mae West

He loves to choose for subject a face and form that is at war or is on fire with some forbidden idea.
—Benjamin de Casseres

"Everybody may not be picturesque," announced the "Prologue" of the magazine *As Others See Us: A Semi-Monthly of Comment and Caricature*, on January 1, 1908, "but everybody is, willy-nilly, a picture." Focusing on "society folks that are, society folks that would be, actors, and artists—in fact, all who frame themselves in superiority and exhibit themselves in the salon of life," this new journal intended to show people what sort of picture they were. By carefully selecting a fashionable figure—generally female—analyzing her personality, and critiquing her style, the editors hoped to reveal the "finer tones of American life." Behind this flimsy excuse for a magazine was a more substantial motivation: the arrival in New York City of the urbane Mexican caricaturist Marius de Zayas (1880–1961) (fig. 4.1). There will be caricatures, promised the prologue, "that for artistry and authenticity rival the work of the famous Sem, Beerbohm and Cappiello in Europe."[1]

Gracing the cover of the first issue was the nearly full-length figure of Consuelo, Duchess of Marlborough (fig. 4.2), nearly crushed beneath an oversized hat. Her profile is defined by the sharp corners of a pointed nose and chin, while the dress is reduced to a slight, bowed arc. De Zayas's drawing shows considerably more sophistication than the mild commentary within, which called the American-born beauty the "perfection of exquisite helplessness" with a "figure that is and is not . . . , a perky little uptilt to the nose, and the half-afraid voice and smile."[2] Like Sem, Cappiello, and Fornaro, De Zayas used the entire figure to convey his subject, even as he reduced it to a slim, elegant contour. But De Zayas often added an unsettling edge to his caricatures, such as the unpleasantly sharp angles of the subject's profile and bent-back, bony-fingered hand. The latter is a small but dis-

4.1 *Marius de Zayas* (1880–1961) by Alfred Stieglitz. Photograph, 1914. De Zayas Archives, Seville, Spain.

cordant detail, subtly recalling the skeletal *calavera* imagery of Mexican popular prints and suggesting the fleeting nature of youth and beauty. The caricature was not biting, corrective satire any more than the "critique" within was a probing analysis, but those distinctive touches added spice to the amiable tone and elegant line. The sharpness drew one's attention away from the wealth, social status, and feminine grace that the Duchess shared with many in her class and suggested instead a distinct personality. The figure is not a generalized type but a sharply defined individual.

The new caricaturist was the son of the prominent Mexican poet, author, and lawyer Raphael de Zayas y Enriquez, who owned two influential newspapers in Veracruz.[3] Because of their opposition to the Diaz government, the De Zayas family was forced to leave Mexico. They settled in New York early in 1907. Marius, still in his twenties, had already traveled in Europe and studied art in France and Spain. His caricatures had been published by Carlo de Fornaro and Benjamin de Casseres in *El Diario* in Mexico City, and his New York career shows the influence of both. Caricature was only one chapter in De Zayas's productive life. As a writer on cubist and African art, as one of Alfred Stieglitz's chief lieutenants at his 291 Gallery, and as a gallery proprietor in his own right, De Zayas would spend much of his life advancing the cause of modern art in America.

4.2 *Consuelo, Duchess of Marlborough* (1877–1964) by Marius de Zayas. Printed illustration. Published in *As Others See Us* (New York), January 1, 1908. De Zayas Archives, Seville, Spain.

Although he was a caricaturist in America for less than a decade, De Zayas made several important contributions to the field. Honing and refining a reductive, ink line style, De Zayas took up where Fornaro left off, further establishing the Parisian version of caricature in the popular press. At the same time, however, he brought caricature to the attention of the artistic avant-garde. In addition to his black ink illustrations, he had a subtle, dark-background, charcoal technique that intrigued the artists and critics associated with Stieglitz. The three exhibitions of his drawings at the 291 Gallery helped to affirm caricature as a more sophisticated and intellectual art form than previously thought. De Zayas, in other words, was working on two fronts, developing an interest in caricature portraits in both popular audiences and avant-garde artistic circles.

De Zayas's distinctive caricatures made an immediate impression on New York audiences. Fornaro had laid the groundwork for the growth of caricature in the popular press, and De Zayas soon found himself in demand for newspaper illustration. Not long after his arrival he started working for Fornaro's old employer, the *New York World*, publishing in the *Evening World* during the week and the Metropolitan Section on Sundays. Although he drew a number of political cartoons for the *World*, it was his stylized portraits, usually drawn in the reductive Parisian mode, that attracted notice. He drew Theodore P. Shonts, head of the New York subway system, for instance, dressed in a garish plaid suit and musing from his swivel chair on the crowded condition of the subway car depicted above him (fig. 4.3). De Zayas's caricatures of the famous appeared in other New York City periodicals as well: *Lillian Russell* and *John Drew* in the Spanish-language magazine *América*, for example, and the actress *Mlle. Delapierre* in the Italian-language newspaper *La Follia di New York* (fig. 4.4).[4] The range of his publications shows De Zayas's ability to appeal to a variety of urban audiences, from the frivolous social set of *As Others See Us* to the mass audience of the *World* to the not-quite-assimilated newcomers reading about famous New Yorkers in native-language publications.

Within months of his arrival in New York, De Zayas was established in the popular press and had connected with literary intellectuals and the artistic avant-garde. Benjamin de Casseres, also recently arrived from Mexico, undoubtedly helped to introduce De Zayas in literary and publishing circles. For instance, the young

4.3 *Theodore P. Shonts* (1856–1919) by Marius de Zayas. India ink on paper, 53.98 x 35.7 cm (21¼ x 14 in.), 1907. Original illustration for *New York World*, March 10, 1907. De Zayas Archives, Seville, Spain.

4.4 *Mlle. Delapierre* (?–?) by Marius de Zayas. Printed illustration. Published in *La Follia di New York*, September 8, 1912. De Zayas Archives, Seville, Spain.

artist joined the Vagabonds, a "literary lunch-club" of writers, editors, and artists to which De Casseres belonged.[5] The opportunity to associate with such members as Theodore Dreiser and the editors of *Judge* and *Literary Digest* was undoubtedly useful to a newly arrived artist-illustrator hoping to publish his drawings. Through the Vagabonds, De Zayas also met a number of photographers and began to draw their portraits.[6] The members of his circle appreciated De Zayas's incisive portrayals. Their own small magazine, *The Bang*, featured the new "beloved" member on October 28, 1907, describing him as "racially Spanish, natally Mexican, residentially American, temperamentally universal." The author, artist Leon Dabo, classified De Zayas with such great epic draftsmen as Goya. De Zayas had learned to leave out the nonessential lines of a drawing, Dabo asserted, refining a "meager absolutism" that revealed the strengths and weaknesses of

his subject. Although his friends considered him good-natured and modest, De Zayas's self-portrait suggested, according to the article, a "reserved, somewhat haughty aristocrat—a thinker—a man neither approved nor intimidated by the problems surrounding us—not a mystic, but a dreamer of logical forms, who revolves the masks with which humanity hides its real self in his inexorable crucible, to emerge therefrom as a synthesis of the soul—drawn with a few strokes of sledge hammer directness and power—masterly and final."[7]

Not many New Yorkers read *The Bang*, but the more mainstream periodical *Current Literature* introduced De Zayas to a wider public in March 1908, featuring his drawings and quoting Dabo's remarks. Also commenting on De Zayas's art was the one critic who took caricature more seriously than anyone, his friend De Casseres. Since he viewed caricature as an intellectual branch of the arts—the visual image "furthest removed

from emotion and the pretty, kittenish tricks of contemporary art"—De Casseres found it logical to compare it to poetry, science, and religion. "To the poet man is a wonder-thing," De Casseres wrote; "to the scientist man is a mechanical experiment; to the devotee man is God's great sin; to De Zayas man is the last expression of nature's mirth." Spurning conventionality and mediocrity, De Casseres noted, De Zayas "loves to choose for subject a face and form that is at war or is on fire with some forbidden idea."[8]

Ever the iconoclast, ranting against the banality of American audiences and conventional art, the passionate De Casseres himself was on fire with forbidden ideas and had a tendency to view everything in revolutionary terms. Nonetheless, his assessment of De Zayas was insightful. The caricaturist did seem to prefer subjects animated with energy, flair, intelligence, and commitment, those who had defined a role for themselves where they could have some impact. For both the mass audience of the newspapers and the specialized one of the art exhibitions, De Zayas's work sharpened the focus on celebrity personality. Even more than Fornaro, De Zayas gravitated instinctively toward those subjects whose reputations could enliven a drawing before it was begun, and whose distinctive, recognizable traits could be summarized in a stylized visual form.

As historian Warren Susman has pointed out, the popular press and the self-improvement manuals of the period frequently promoted the notion that "personality" was central to success in life. Henri Laurent's 1916 *Personality and How To Build It*, one of Funk and Wagnalls's series on "mental efficiency," emphasized the value of developing one's personal talents in order to become a distinct and significant individual. Although everyone theoretically had a unique combination of behavioral traits that could be called personality, the word had come to connote a colorful, original combination of attributes which "forces itself upon the attention of the mass and which emerges from the level of the average multitude." A compelling theatricality that commanded attention was the principal manifestation of this heightened quality of distinction, the "glitter that sends your little gleam across the footlights," Mae West once called it.[9] In the popular press the term "a personality" usually referred not to behavioral traits in general but to a specific person endowed with this dynamic attribute.

Theodore Dreiser, writing in the popular press, disagreed with the self-improvement theory that anyone could develop personality, claiming that nature provided this rare quality at birth to a select few. Old-time virtues, such as honesty, fairness, and intellect, did not suffice; magnetism, courage, and assurance were also required. In addition to innate talents, one needed the "vital energy to apply them or the hypnotic power of attracting attention to them."[10] Pure achievement, without the ability to summon publicity, Dreiser pointed out, would go unnoticed. The artist, scientist, journalist, or socialite—like the performer—had to strut a bit upon his stage.

Such notions of dramatic personality were already inspiring mockery. The artist Everett Shinn, for instance, joked about the expectation of artistic temperament in a 1907 illustrated note to John Sloan shortly before the exhibition of "The Eight" at the MacBeth Gallery (fig. 4.5). In preparation for the show, the artists had all had their photographs taken by Gertrude Käsebier, and Shinn was reporting on the experience. Half-hidden under the camera cloth, the photographer looks like a cartoon hausfrau, while Shinn, with hat, cane, and cigarette, poses with studied affectation. "Was up to be photographed to day," he scribbled on the sheet, "great fun. being an artist. with temperament." Shinn understood that he had to play a role for the press. Although he satirized the hackneyed notion of an artistic temperament, he knew that publicity required a certain amount of theatrical posing.

Marius de Zayas seemed to have an instinctive understanding of that vital, animating quality of "being some-

4.5 *Gertrude Käsebier Photographing Everett Shinn* by Everett Shinn. Ink and watercolor on board, 13.3 x 19.7 cm (5¼ x 7¾ in.), 1907. Delaware Art Museum, Wilmington; gift of Helen Farr Sloan.

4.6 *Alla Nazimova* (1879–1945) by Marius de Zayas. Ink and watercolor on paper, 63.5 x 50.8 cm (25 x 20 in.) (sight), 1910. De Zayas Archives, Seville, Spain.

body," and he was particularly drawn to subjects who could attract attention in a vivid and dramatic way. He drew a series of *World* illustrations of Alla Nazimova, for instance, the petite, dark-haired Russian actress who had captivated New York with her portrayals of Henrik Ibsen's characters. Critics raved about her talents; the Shubert brothers built a theater for her. "Her veins are charged with that special sort of electricity which is known as theatricality," one commentator wrote.[11] For De Zayas, the bone-defying poses of her body communicated that emotional intensity on stage. In his drawing of Nazimova as Rita Allmers in *Little Eyolf* (fig. 4.6), her hunched shoulders and head thrown back in anguish immediately evoked her distinctive interpretation.

The Croatian-born inventor Nikola Tesla attracted an equal level of celebrity. De Zayas depicted him in profile seated in an armchair for an illustration in *As Others See Us* (fig. 4.7). An impossibly long-legged creature, he leans intently forward.[12] Although expensively dressed in a fur-trimmed coat, Tesla looks uncomfortable in his club-like chair, as if he does not quite fit into a social setting of wealth and ease. The holder of hundreds of patents for electrical inventions, Tesla was internationally celebrated for such feats as introducing alternating-current electricity, lighting the 1893 Chicago Exposition, harnessing and generating power from Niagara Falls, and predicting wireless broadcasting. But he was more than a traditional hero-inventor. He was also a showman whose electrical demonstrations dazzled both scientific and popular audiences; he was a dandified member of society who dined in evening clothes at the fashionable Delmonico's before going back to his laboratory; and he was an eccentric, visionary genius with startling and perhaps mad prophecies for the future.

Perhaps because of these unusual and contradictory personality traits, Tesla intrigued the celebrity press. He must have fascinated De Zayas as well, for he also drew a much more studied portrait of the inventor (fig. 4.8). In this large charcoal image Tesla's shadowy figure emerges from a dense, dark background. De Zayas repeated the narrow, Sem-like figure and sharp profile from the illustration but achieved a quite different effect by trading the crisp clarity of black against white for the ambiguous mystery of varying tones of gray. Portraying Tesla as a nearly full-length figure striding forward, the drawing made the most of the inventor's extraordinary physique. According to contemporary descriptions, Tesla was over six feet tall and extremely slender, with black hair, piercing blue eyes, and a chin "as pointed as an ice-pick."[13] The charcoal depicts Tesla in a coat and hat as if walking along a dark street. But this is no boulevardier out for a leisurely stroll. With head thrust forward and shoulders pulled back, there is an impassioned intensity to his stride that hints at both his brilliance and that eccentric, unbalanced streak that was already apparent in Tesla's character.

Tesla, in other words, was more than an easily exaggerated member of a glittering social circle. He was a prototype of the larger-than-life personality that would come to dominate the celebrity industry. Such figures were not just the well-known attendees of balls and

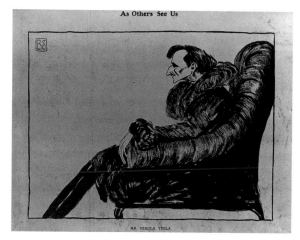

4.7 *Nikola Tesla* (1856–1943) by Marius de Zayas. Printed illustration. Published in *As Others See Us* (New York), March 1, 1908. De Zayas Archives, Seville, Spain.

dinners that Fornaro had caricatured but those who had reached a spectacular pinnacle of success, generating unprecedented publicity. In some ways Tesla exemplified the change from nineteenth- to twentieth-century fame. His celebrity, which glorified his flamboyance more than his substantial achievements, proved ephemeral. As he became increasingly unstable in his later years, he was largely ignored, his work all but forgotten. Only in the late twentieth century would his brilliance be widely recognized and his reputation revived. At the time De Zayas drew him, however, Tesla was still a captivating and revered subject. In both of his portraits De Zayas added that sharp, slightly disturbing element that implies distinctive traits of character, temperament, and behavior.

Drawn to strong personalities and artistic innovation, De Zayas was bound to gravitate toward the self-styled ringleader of the artistic avant-garde, Alfred Stieglitz. Although De Zayas was already well connected, his meeting with Stieglitz in 1907, as related by Stieglitz biographer Dorothy Norman, was a fateful encounter. According to Norman, De Zayas recalled that Stieglitz had come to visit him on the advice of an art critic: "I had a studio in New York. I wanted to be alone. I was not attempting to get into contact with anyone in order to have my work exhibited or bought. But then, one day in 1907, a man entered my studio and stood looking at my work. He simply walked in. He did not introduce himself. . . . I was working for the

New York Evening World, also making other pictures for myself. The man asked me about what I was doing— did I wish to sell or exhibit?' I replied, 'I make what you see here for myself. Just that.' 'Would you like to exhibit?" the man repeated. I said, 'No.'"[14]

This account suggests that De Zayas had two stylistic approaches to caricature, one commercial and the other—discovered and promoted by Stieglitz—more artistic and creative. Although it is tempting to assign his ink drawings and charcoal portraits to these different categories, the dichotomy is not so obvious. De Zayas did publish both simultaneously in the magazines, and most critics did not differentiate between them. Rather, it was the time and effort put into his drawings that distinguished between hasty work for the press and the thoughtful portraits of friends and associates.

Stieglitz was particularly attracted to De Zayas's charcoal drawings, however, which bear a clear relationship to the pictorialist photography that he and like-minded Photo-Secessionists had been promoting. De Zayas's charcoal of Stieglitz (fig. 4.9), for instance, with its dark background and soft focus, is strikingly similar to photographs like Heinrich Kühn's image of Edward Steichen (fig. 4.10). In both, the brightly lit face and hands suggest the cerebral intimacy of the creative personality, while the figures are barely discernible against the shadowy background. Stieglitz's concentration on an autochrome carefully held out toward the light heightens that effect.[15] In comparison with the even illumination and realistic depiction of much photography and illustration at the time, these pictures were startlingly different, evoking the enigmatic mysteries of symbolist art. Stieglitz had been working to elevate photography from the realm of commercial illustration to the realm of fine art. To his eye, De Zayas was doing the same with caricature.

The avant-garde artists of Stieglitz's circle would also have seen the resemblance of De Zayas's images to the charcoal "noirs" of Odilon Redon. The drawings of this visionary French artist, made in the 1870s and 1880s, were greatly admired and often exhibited after they appeared on the market at the turn of the century. Redon meant the ghostly ambiguity of his darkened surface to evoke the mystical or spiritual unconscious. He considered charcoal used in this way to be an agent of elemental truth and the struggle to create form out of the chaotic darkness cathartic.[16] De Zayas, adding touches of conte or litho crayon, achieved effects that ranged from delicate tones to deep, rich darkness. Although he did not strive for Redon's emotional resonance, De Zayas used the charcoal background to heighten a sense of mystery. The sharp profiles, elegant bodies, and background obscurity of these drawings convey a psychological dissonance that moved beyond traditional comic drawing. Despite the caricatured figures, there was a subjective, synthetic quality to De Zayas's charcoal drawings that related them to symbolist art.

But De Zayas's *Stieglitz* does not lack humor. The artist depicts the familiar profile—large head, mustache, and mop of hair—with an entertaining touch of exaggeration. He obscures the eyes, which traditionally provide a window to the intellect, substituting Stieglitz's well-known spectacles. The reduced, undetailed figure has its own role to play in the characterization. Simultaneously leaning back and thrusting forward, it adds to the sense of energetic engagement with the work being studied. Clever reductions and humorous exaggerations, therefore, summarize as much as satirize the Stieglitz persona, exploiting superficial physical features to suggest more profound motivations and characteristics.

De Zayas must have found the atmosphere around Stieglitz congenial and stimulating compared with the lonely drudgery of daily newspaper work. In 1905, Stieglitz had opened his exhibition space, the Little Galleries of the Photo-Secession, at 291 Fifth Avenue, as part of his campaign to promote pictorialist photographers and establish their work in the context of fine art. Assisted by Edward Steichen, he founded the magazine *Camera Work* to promote his ideas. At 291, as the gallery was usually called, he began to gather around him a group of intellectuals who met frequently to debate new ideas in art and plan exhibitions. Agnes Ernst was a young reporter for the *New York Sun* in 1908 when she was first sent to interview Stieglitz. She was immediately inspired by the "gusto for life and beauty" that she found at the Little Galleries. "Thereafter," she recalled in her memoirs, "if life seemed too dull or too discouraging, I would repair to '291' to refresh my spirits with discussion of the battle that Steichen and Stieglitz had begun to wage against the academic smugness then prevalent."[17]

De Zayas had already joined the battle, lunching regularly at 291 and becoming an influential member of the group. Stieglitz appreciated De Zayas's wit, intelli-

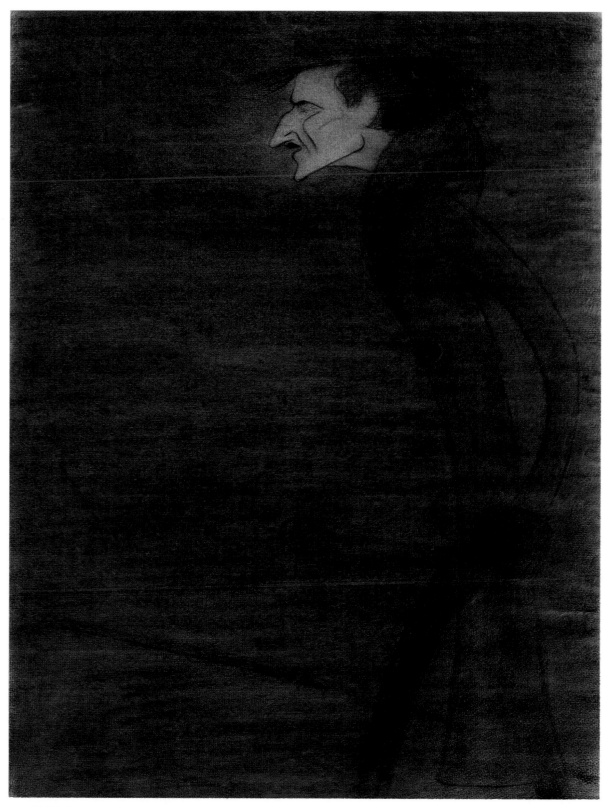

4.8 *Nikola Tesla* (1856–1943) by Marius de Zayas. Charcoal on paper, 62.3 x 48.3 cm (24¹/₂ x 19 in.), c. 1908. National Portrait Gallery, Smithsonian Institution, Washington, D.C.

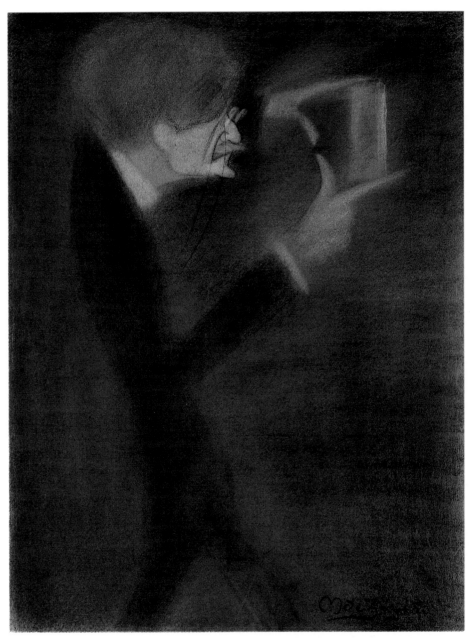

4.9 *Alfred Stieglitz* (1864–1946) by Marius de Zayas. Charcoal on paper, 63.5 x 48.2 cm (25 x 19 in.), c. 1909. Katharine Graham.

gence, and knowledge of art, and the two became close friends. Stieglitz, who was himself frequently the subject of the young artist's caricatures, encouraged De Zayas's work. Along with Steichen, the collector and photographer Paul Haviland, and Agnes Ernst Meyer (who became a major patron of the gallery after her marriage to Eugene Meyer in 1910), De Zayas became a principal member of the inner circle at 291, contributing articles to *Camera Work* and helping to organize exhibitions.

De Zayas's friendships with the Stieglitz circle inspired a series of caricatures. In one ink-and-watercolor drawing he captured the high-spirited, playful side of the group, depicting his 291 companions

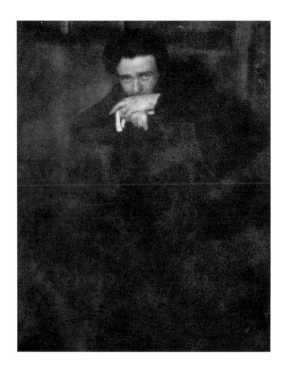

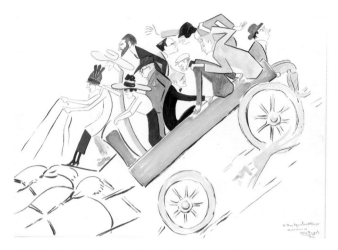

4.11 *The Picnic* by Marius de Zayas. Ink and watercolor on paper, 55.7 x 78.1 cm (21⁹/₁₆ x 30³/₄ in.), 1912. Katharine Graham.

4.10 *Edward Steichen* (1879–1973) by Heinrich Kühn. Photograph–waxed bromoil print, 28.9 x 22.9 cm (11³/₈ x 9 in.) , c. 1907. National Portrait Gallery, Smithsonian Institution, Washington, D.C.

careening downhill on a haywagon at a forty-five-degree angle (fig. 4.11). De Zayas made the drawing on one of those occasions when the group assembled for a picnic at Seven Springs, the Meyers' farm near Mount Kisco, New York. In addition to the young artist Katherine Rhoades in the driver's seat, Agnes directly behind, and Eugene in the rear, the figures include Stieglitz, his wife, some critics, John Marin, Paul Haviland, and De Zayas himself (in a beret). Drawn with bold ink outlines, the image is enlivened by geometric forms and vivid colors, but there are unsettling aspects to this image of a seemingly joyous occasion. Although the golden-colored arcs of Agnes' body on one end and Marin's on the other pull the circle together, the bright blue accents of a skirt, an elbow, and an arm all point outward, as if threatening to explode the compact group. And, although the setting, the bright colors, and the tangle of caricatured figures connote gaiety and frivolity, some of the subjects are clutching the wagon in terror. De Zayas suggests both the zestful camaraderie and the tensions the group shared.

Some of De Zayas's ink drawings of his 291 associates, such as his portraits of Alvin Langdon Coburn and John Marin (figs. 4.12 and 4.13), have a small gilt sun in one corner of the sheet, a symbol of the illuminating creativity of the avant-garde.[18] His dark background charcoal technique produced more radical interpretations of personality. The image of Agnes Meyer (fig. 4.14), for instance, had none of the academic prettiness she deplored. De Zayas suggested her wealth and status by depicting her with an ermine-trimmed hat and an enormous matching muff. But despite the expensive outfit, he distorts her face, renowned for its beauty, into a sharp, almost ugly, profile. Although hardly flattering in conventional terms, the portrait focuses attention on her spirited energy and intellect, qualities far more essential to her character than feminine beauty. She owned the drawing for the rest of her life.

In another charcoal, De Zayas explored the relationship of Edward Steichen to Auguste Rodin (fig. 4.15). Steichen, who met Rodin in 1901, had spent months studying him at work in his studio and had made a series of photographic portraits. The aging artist became his hero. Returning to Paris in 1906, Steichen began working on an exhibition of Rodin's drawings, which he had suggested as the first nonphotographic show at the Photo-Secession Galleries.[19] Placing the

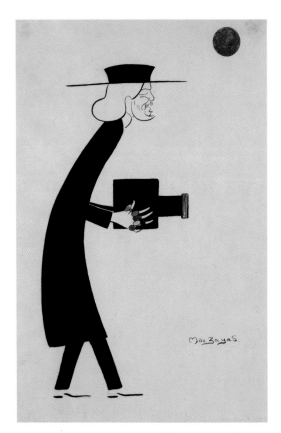

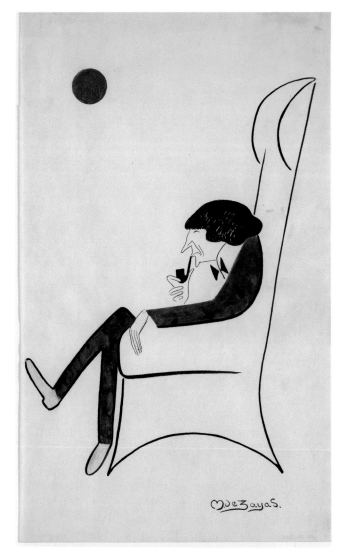

4.12 *Alvin Langdon Coburn* (1882–1966) by Marius de Zayas. Ink, watercolor, and gold paint, 44.5 x 28.6 cm (17¹/₂ x 11¹/₄ in.), c. 1910. The Metropolitan Museum of Art, New York; Alfred Stieglitz Collection.

4.13 *John Marin* (1870–1953) by Marius de Zayas. Pencil, ink, watercolor, and gold paint on paper, 44.1 x 26.5 cm (17¹/₄ x 10¹/₂ in.), c. 1910. The Metropolitan Museum of Art, New York; Alfred Stieglitz Collection.

grinning young photographer deferentially in the background, dominated by the massive bulk of the master, De Zayas suggests their respective positions in the art world. Exuberant line enlivens solid form throughout. A series of wavy strokes animate the columnar shape of Rodin's beard like an archaic Greek sculpture; sharp angles radiate from the center of his face defining eyes, brows, and cheeks; the swirling circle of the hand connotes the speed and energy of his draftsmanship.

Stieglitz had wanted to exhibit these portraits from the time he met De Zayas. Finally, in January 1909, he mounted an exhibition of twenty-five charcoal drawings at 291, along with a show of autochromes by J.

Nilsen Laurvik. It included De Zayas's portrait of Tesla, one of De Casseres, and the image of Stieglitz looking at one of Laurvik's autochromes. The charcoals were divided into three sections based on subject categories, according to Paul Haviland's description in *Camera Work* the following April. Portraits of members of New York's social set, such as Mrs. Clarence Mackay (fig. 4.16), had the "place of honor" on the main wall, flanked by actors and actresses on one side and Photo-Secessionists like Clarence White on the other (fig. 4.17). "The limelight of caricature was thrown with a curiously subtle discrimination," Haviland noted, but he insisted that the depictions were without malice and that no one could resent his or her portrayal with good reason.[20]

4.14 *Agnes Meyer* (1887–1970) by Marius de Zayas. Charcoal on paper, 60.7 x 48 cm (24 x 18⁷/₈ in.), c. 1908. Katharine Graham.

4.15 *Edward Steichen and Auguste Rodin* (1879–1973; 1840–1917) by Marius de Zayas. Charcoal on paper, 61.9 x 47.6 cm (24³/₈ x 18³/₄ in.), c. 1910. Katharine Graham.

Art critics at this time were beginning to recognize that caricature had changed from the satiric distortions of the nineteenth century, and they searched for new definitions and relationships. Benjamin de Casseres considered caricature an intellectual, elite art form— comparable to a novel, poem, painting, or sculpture— examining the human condition in its own way and understandable only to discerning minds. Writing for the April 1909 issue of *Camera Work*, he complained that caricature exhibitions were poorly attended, remembering the little-noticed 1904 New York exhibition of caricature featuring works by Beerbohm, Sem, Cappiello, and Fornaro. The average New York viewer, whom he scathingly referred to as the "Candy Kid,"

could not appreciate the remorseless logic of good caricature, seeing it only as ugly and "missing entirely the intellectual principle, the ironic twinkle."[21]

De Casseres thought only in terms of the passionate and savage attack. But others felt that modern caricature deserved a higher status than before because it was nonjudgmental, creative, and constructive rather than merely destructive. The caricaturist, noted Guy Pène de Bois, like the editorial writer or essayist, must never descend to pettiness, gossip, or personal venom: "He is arbiter of customs, of morals; judge of the sins, mistakes, virtues of his time. He should be an impassive onlooker, unmoved by prejudices and absolutely without malice."[22] Caricature, many commentators observed, had become less vicious, sometimes even "kindly." This did not suggest a less keen and critical analysis but a detached, unprejudiced summary more likely to reveal the truth.

All of the critics saw a contrast between De Zayas's drawings and other cartoonists' primitive exaggerations of physical features. They recognized in him a subtle, intuitive understanding and an insight into mental or emotional characteristics. A caricaturist such as De Zayas, noted a writer for *The Craftsman* in 1908, was not cynical and bitter, focused only on attack, but had a higher purpose—to create "unerringly exact psychological studies." In describing De Zayas's ability to reveal inner traits many commentators spoke of reaching the soul of his subject. One of his Vagabond friends wrote enthusiastically in *The Bang* for January 25, 1909, that De Zayas was the "exposer of the soul." Others called him a "cartoonist of the soul," described his approach as a "synthesis of the soul," or spoke of his attempt to write "monographs of human souls."[23]

The use of the word "soul" emphasized De Zayas's more profound analysis in comparison with much comic drawing. The French philosopher Henri Bergson, author of the influential 1911 study *Laughter: An Essay on the Meaning of the Comic*, saw the soul as a supple, vital, animating human quality in opposition to the rigid, resistant matter of the body. The critics admired De Zayas's ability to probe beyond appearance to suggest what Bergson called the "very flame of life, kindled within us by a higher principle." This quality related his caricature more closely to the fine arts. The critic Henry Tyrrell, writing about De Zayas's 291 exhibition for the *New York Evening World*, saw little difference between "modern caricature" and "modern 'straight' portraiture." "Both are psychological in their way of seeing a subject, exaggerating the salient and significant features . . . and rendering the summary impression by the quickest and most arbitrary strokes."[24]

After De Zayas's 1909 exhibition the editors of *Camera Work* wanted to reproduce his innovative charcoals, even though their subtle tonalities made the process difficult. Four photogravure plates of the drawings appeared in the January 1910 issue of *Camera Work*, one year after the exhibition. The editors had carefully considered their choice of subjects, ultimately reproducing the drawings of De Casseres (fig. 4.18), dancer Ruth St. Denis, and actresses Madame Hanako and Mrs. Brown-Potter. With the exception of De Casseres, the pieces all depict stage performers. "Since the American public is still a little sensitive to caricature," the editors noted, "and we wish to avoid any suggestions of undue personality, we have selected on this occasion examples only of admittedly professional public characters."[25]

This comment sounds a surprisingly cautious note from the rebellious spirits behind *Camera Work*. The editors had consciously avoided the other two categories of subjects from the show: members of the Photo-Secession and social leaders. Perhaps they were concerned about alienating more photographers, for many of Stieglitz's initial supporters already disapproved of the nonphotographic, modern art that 291 and *Camera Work* promoted. Socialites, on the other hand, presumably trained to value privacy and avoid public display, might be the most sensitive to suggestions of "undue personality." This notion of understated, upper-class discretion would of course soon be overwhelmed by a publicity-savvy café society; by the 1920s, the idea that one could have "too much" personality would be unthinkable. Despite its cautious tone, however, the editors' note in *Camera Work* was an important statement, a clear recognition of the conjunction between caricature and performance. The people who would not be offended by this focused emphasis on personality were those most actively involved in creating it—stage performers.

In their search for publicly recognized personalities, De Zayas and the newspaper caricaturists who followed him turned increasingly to the theater and performing arts. For it was here—at the intersection of an expanding media demanding fresh material and a vibrant world of entertainment brimming with colorful

4.16 *Mrs. Clarence Mackay* (1879–1930) by Marius de Zayas. Charcoal on paper, 62.2 x 41.6 cm (24¹/₂ x 18⁷/₈ in.), c. 1909. The Metropolitan Museum of Art, New York; Alfred Stieglitz Collection.

4.17 *Clarence White* (1871–1925) by Marius de Zayas. Pastel on paper, 56.5 x 41.6 cm (22¹/₄ x 16³/₈ in.), c. 1909. The Metropolitan Museum of Art, New York; Alfred Stieglitz Collection.

4.18 *Benjamin de Casseres* (1873–1945) by Marius de Zayas. Photogravure, c. 1907. Published in *Camera Work*, no. 29, January 1910. Smithsonian Institution Libraries, Washington, D.C.

newcomers—that the celebrity industry was evolving. Actresses and dancers like Madame Hanako, Mrs. Brown-Potter, and Ruth St. Denis, who made a profession of being public figures with recognizable characteristics, could be expected to survive the limelight of caricature. From this point on, modern caricature would be intimately connected to the theater and performance world.

De Zayas's own deep interest in the theater positioned him squarely in the center of this development. Studying in Paris at the turn of the century undoubtedly stimulated this fascination. For art students of his generation, the vitality of Parisian nightlife helped to define the bohemian culture. An appreciation for diverse entertainment forms was an expected and often integral part of communal life as companionable groups gathered at the cafés and cabarets. Artists and intellectuals naturally gravitated toward the vibrant

creativity of performance, where innovation and rebellion met, pushing at the boundaries of tradition and decorum. For poster artists and caricaturists, especially, the theatrical milieu provided fertile ground for subject matter. Here were subjects with personality who could generate the drama, excitement, notoriety, and recognition necessary for a vivid portrayal.

The contemporary theater in America—as well as opera, vaudeville, and silent films—offered a rich selection of character types, which were already simplified and exaggerated. The caricaturist need only add that zestful, dynamic quality that made each individual seem unique. From the beginning of De Zayas's New York career the theater was a regular part of his life. Every morning he met with his editor at the *Evening World* to decide which event to cover. Illustrating the articles written by critic Charles Darnton, he attended performances regularly, customarily sitting in the front row, close to the powerful footlights.[26] His incisive portrayals of these figures suggested a natural affinity between the actor portraying a memorable role and the caricature conveying a vivid personality. At about this time he even made a mock-up for a volume of theater-related caricatures, hand-lettering the title "Actresses, Managers, & First Nighters" on the cover and drawing portraits of Alfred G. Vanderbilt and the brothers Lee and J. J. Shubert on facing pages inside (fig. 4.19). Unfortunately, the book was never published.[27]

For all his reputed ability to probe beneath the surface and capture the soul of his subject, De Zayas himself had the instincts of a showman. Despite his aesthetic sophistication he did not sacrifice the instantaneous summary and humor that made caricature so accessible. He added to his drawings a focused element of vibrancy, glamour, wit, or mystery that would instantly convey the requisite magnetism. His collaboration with Caroline Caffin on the book *Vaudeville* (1914) suggests his own instincts for reaching a broad audience. The newly respectable vaudeville show was reaching its peak at about this time, with a varied format of short acts providing tasteful entertainment for a middle-class audience that included women and children. As De Zayas understood, the vaudeville performance—much like the poster and the caricature—had to make an immediate impression. There was no time for subtle emotions or a gradual development of character. Each act had to convey a vibrant, instantly distinguishing quality.

Caffin acknowledged this facet of vaudeville performance by including a chapter on personality. Simple competence, a pretty face, or a sweet voice did not suffice, she pointed out. "It is ever the strong personality and the ability to get it across the footlights and impress it upon the audience that distinguish the popular performer." Gertrude Vanderbilt, for example, was "breezy, daring, and buoyant," succeeding because of her high spirits, energy, and infectious good humor rather than her singing or dancing. De Zayas matched his illustration ingeniously to the author's description (fig. 4.20). Vanderbilt's long, supple limbs "swirl in quite surprising orbits," Caffin gushed. "The sinuous figure bends and turns and skims over the ground, bounding with long, boyish strides, carefree, laughing, joyous."[28] De Zayas reduced the dancer's arms, hand, and costume to simple curling lines conveying the spirit of exuberant but graceful movement.

Although such ink drawings often lack the subtlety of the charcoal portraits, they astutely summarize the traits that made a star noticeable on stage. De Zayas also caricatured for the book the veteran stage performers Lillian Russell and Sarah Bernhardt (fig. 4.21), both of whom were occasionally lured to the vaudeville theater. Russell's elegant costume and glittering jewels evoke the operetta heroines she traditionally played; Bernhardt's tense pose translates her dramatic monologues into a set of straining muscles. De Zayas presents them here in the roles the popular audience expected, capitalizing on their well-known, distinctive attributes. Focusing his own spotlight on one aspect of a performer, eliminating and reducing everything else, De Zayas too could capture the attention of a broad and varied audience. While intriguing intellectuals and the artistic avant-garde he was also packaging personality for mass consumption by evoking the theatricality

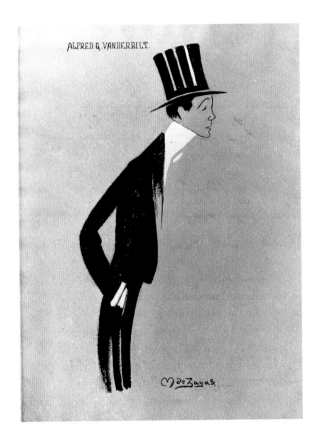 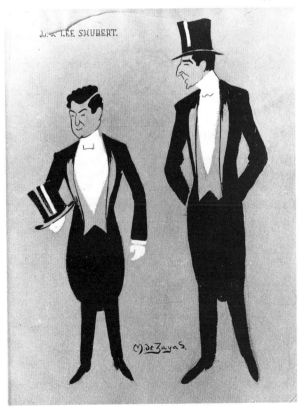

4.19 *Alfred G. Vanderbilt (1877–1915)* and *Levi Lee Shubert and Jacob J. Shubert (1875–1953; 1880?–1963)* by Marius de Zayas. India ink, white gouache on paper, c. 1910. Bound into unpublished volume entitled *Actresses, Managers, and First Nighters* (1909). De Zayas Archives, Seville, Spain.

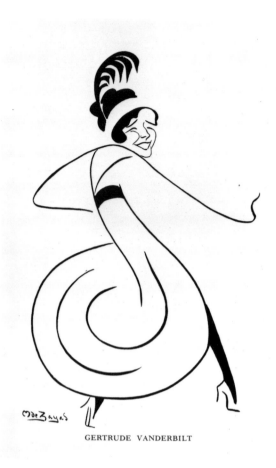

GERTRUDE VANDERBILT

4.20 *Gertrude Vanderbilt* (c. 1899–1960) by Marius de Zayas. Printed illustration. Published in Caroline Caffin, *Vaudeville* (New York, 1914). Dartmouth College Library, Hanover, New Hampshire.

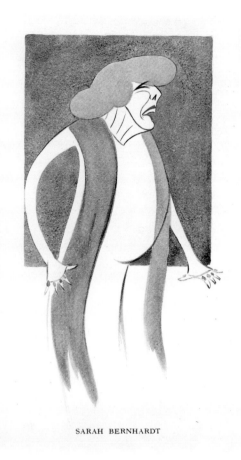

SARAH BERNHARDT

4.21 *Sarah Bernhardt* (1844–1923) by Marius de Zayas. Printed illustration. Published in Caroline Caffin, *Vaudeville* (New York, 1914). Dartmouth College Library, Hanover, New Hampshire.

of the contemporary stage. Caricature would proliferate because of this mass appeal.

Even De Zayas's charcoal drawings suggest this sensibility. In his image of New Orleans-born actress Mrs. Brown-Potter (Cora Urquhart Potter) (fig. 4.22)—one of the subjects reproduced in *Camera Work*—he combines subtlety with dramatic presentation. The low vantage point and use of light in this image reveal his preference for sitting very close to the footlights. The powerful lighting emphasizes the actress's large head and plumed hat, accentuating her strong chin and casting her heavily lidded eyes in dramatic shadow. Reflected light on the bottom of her dress completes the fluid arc of her figure, and subtle highlights suggest

the sheer fabric draped over her arm and the rich embroidery of her bodice. The slim fingers of a nearly skeletal hand emerge from the darkness, adding a slightly sinister note to the characterization of this elegant, dramatic figure.

De Zayas's charcoal drawings of nontheatrical subjects often evoke a similar sense of staged performance. In the portrait of his close friend Paul Haviland (fig. 4.23), more than just the low vantage point and the spotlit head suggest the stage. In his dramatic stance, the tripod supports and Haviland's legs, arms, and torso all emanate from the center of the body. Holding the bulb for the shutter release in his right hand and a stopwatch in his left and frowning in concentration, he

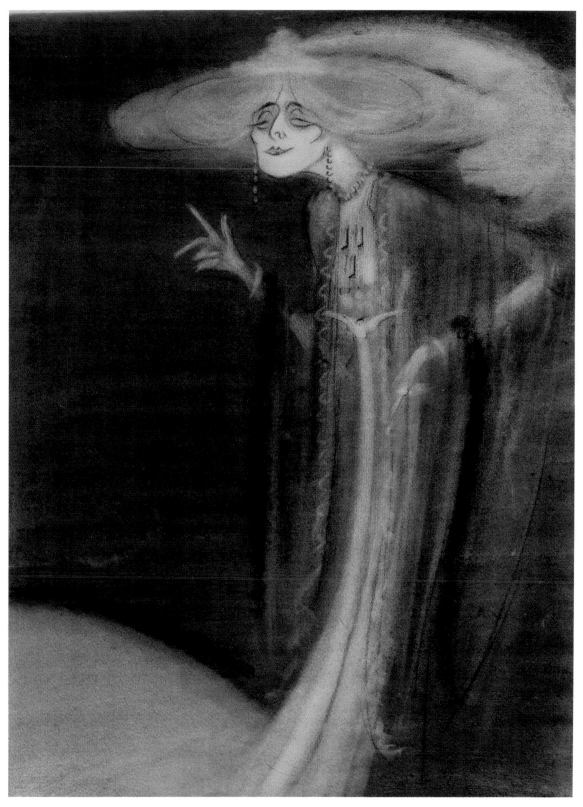

4.22 *Cora Urquhart Brown-Potter* (1857–1936) by Marius de Zayas. Charcoal on paper, 61.6 x 47.7 cm (24¹/₄ x 18³/₄ in.), c. 1908. Original illustration for *Camera Work*, no. 29, January 1910. The Metropolitan Museum of Art, New York; Alfred Stieglitz Collection.

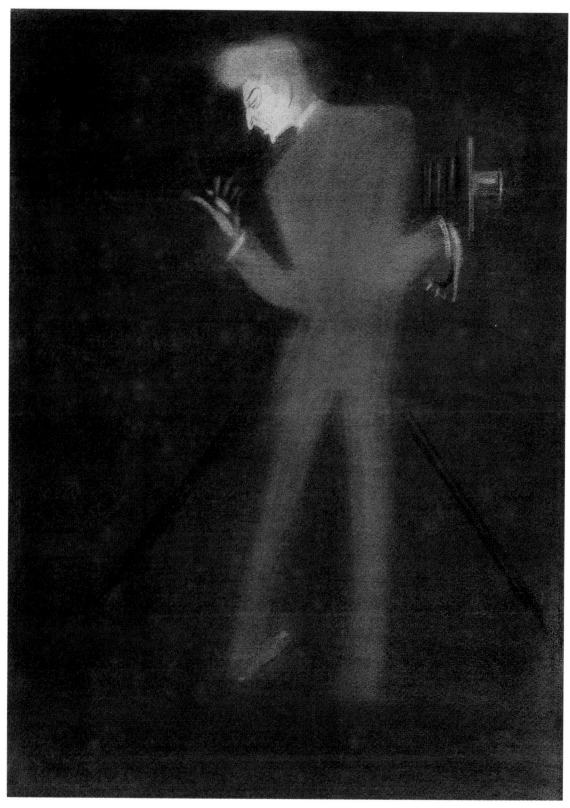

4.23 *Paul Haviland* (1880–1950) by Marius de Zayas. Charcoal on paper, 56.8 x 40.6 cm (22³/₈ x 16 in.), c. 1910. National Portrait Gallery, Smithsonian Institution, Washington, D.C.; gift of Mr. and Mrs. Harry H. Lunn, Jr.

4.24 *"Boulevardiers" of New York Shown in Caricature* by Marius de Zayas. Printed illustration. Published in *New York Times*, May 1, 1910. National Portrait Gallery, Smithsonian Institution, Washington, D.C.

twists his head around in an unnatural profile. It is a back-to-the-audience pose with face and stopwatch clearly visible, as if the significance of the action had to reach the back row. De Zayas did not produce a candid image of a photographer at work but a dramatic, staged depiction of the artistic quest.

On April 26, 1910, Stieglitz opened a second De Zayas exhibition at 291, a very successful installation that remained on view into December. Entitled "Up and Down Fifth Avenue," the show integrated caricature and theater more forcefully than ever. De Zayas created a small stage in the gallery, nine feet wide and fifteen feet long, with a painted backdrop of Fifth Avenue in front of the Plaza Hotel. On it he arranged dozens of cardboard pieces backed with wooden supports. Each piece, six to twelve inches tall, depicted an individual or a group in caricature. Walking on foot or riding in hansom cabs and carriages, the famous New

Yorkers that De Zayas had delineated on the newspaper page came together to enact their daily drama. All that remains of this elaborate panorama are a few reproductions. The *New York Times* illustrated it in its magazine of May 1, 1910, with the title "'Boulevardiers' of New York Shown in Caricature" (fig. 4.24). De Zayas had assembled an enormous cast of notables, including the young millionaire Alfred Vanderbilt, whose carriage contained half a dozen theatrical stars, Teddy Roosevelt raising his hat to an impervious crowd, "Diamond Jim" Brady, Paul Haviland, John Jacob Astor, and J. Pierpont Morgan. The *Times* appreciated the effect of many small vignettes: artist William Merritt Chase nearly bumping into socialite Mrs. Clarence Mackay as she emerges from a taxi, for instance, and Ethel Barrymore pushing a perambulator. Every lively little figure is going somewhere, doing something, and each gesture and expression helped to convey

Marius de Zayas 93

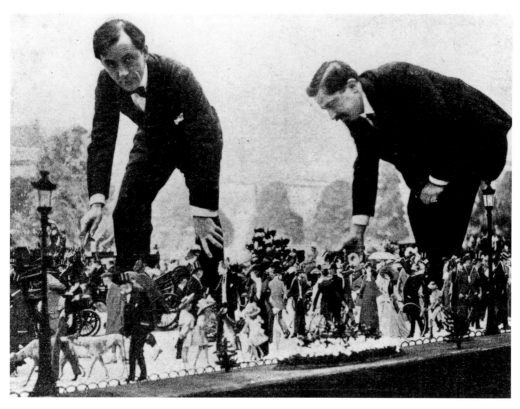

4.25 *"La Grande Saison" in the Bois de Boulogne* by unidentified photographer. Photograph, 1909. Courtesy of Bibliothèque Historique de la Ville de Paris, France.

the "bustle and rush of the avenue." As Henry Tyrrell of the *Evening World* pointed out, there was the usual collection of celebrity figures: actors, producers, socialites, politicians, artists, journalists, and critics. "All the old familiar human landmarks are here," Tyrrell noted, "together with many new candidates for notoriety."[29]

Most of the critics identified the miniature panorama as a French idea. And, indeed, the caricaturist Sem, along with the illustrator Auguste Jean-Baptiste Roubille, had assembled a similar exhibition in Paris in 1909. Entitled "La Grande Saison," it comprised cut-out profiles of the carriages, horses, and personalities passing by on the Bois de Boulogne (fig. 4.25).[30] But De Zayas's audience probably experienced his adaptation of this idea with a slightly different frame of reference. The Parisian boulevards provided city dwellers with a form of open-air recreation that had a well-developed culture and tradition all its own. For all the prominence of

Fifth Avenue, the streets of New York City were not used for urban promenading to the same degree. Instead, New Yorkers related De Zayas's panorama specifically to the theater.[31] Sadakichi Hartmann, writing for *Camera Work*, called it a "strange little play" and a puppet show. The *New York Times* referred to the "stage setting" and the "action of the play." James Huneker of the *New York Sun* also mentioned puppets and stage settings. Henry Tyrrell of the *Evening World* coined the witty phrase "panoramic motionless picture."[32]

Through the caricature portraits, in other words, personality was interpreted as a performance. Abbreviated silhouettes and exaggerated gestures conveyed the likeness and characteristics of each celebrity on the little stage. Every figure portrayed a role, much like an actor or vaudeville star would, defining a distinct character. The theater becomes a metaphor for urban life in De Zayas's conception. New York City

was the stage; its celebrities played the starring roles; the press provided the plot; the local public was the audience. De Zayas summarized the dramatic allusion in visual form. In taking caricature off the page and putting it on the stage, he assembled a captivating show. At the same time, he presented caricature as a contemporary portrait form.

Everyone responded to "Up and Down Fifth Avenue" with enthusiasm. "It looks like a first-night crush at any hour of the day just now at 291," remarked Acton Davies, covering the exhibit in his "News of the Theatres" column for the *Evening Sun*. All the celebrities depicted crammed into the Little Galleries to laugh at De Zayas's whimsical creation. But some critics took it seriously. "In the harmless form of a puppet show," Sadakichi Hartmann noted in his *Camera Work* review, "he unrolls a whole épopée [epic poem], every page a human life told in a swift and summary way, a protest against the smug and egalitarian organization of life, against the monstrous stupidity of conventions, parades and badges, and the hypocrisy of morals—a wonderful synthesis of the grandeur and shame of the large city." To achieve this, Hartmann realized, the caricaturist had to capture the critical, external characteristic of each individual subject.[33]

Although the Stieglitz circle did not consider caricature a major art form, De Zayas had expanded their appreciation of its subtleties. His friendships among the avant-garde also encouraged him to continue his explorations of the boundaries between caricature and art. In October 1910, while visitors were still swarming to see "Up and Down Fifth Avenue," De Zayas left for Paris. During the following year he sought out the most experimental contemporary art and struggled toward an understanding of cubism and African sculpture. His mentor was Pablo Picasso, who shared his interest in caricature and enjoyed sketching amusing portraits of his companions.[34] De Zayas later told his son that he and Picasso once had a square-wheeled bicycle constructed so that they could place it against a wall near a bistro and make caricatures of gawking passersby.[35]

But Picasso also inspired De Zayas's serious study of cubist and primitive forms. From Paris, De Zayas arranged a show of eighty-three of Picasso's works for 291 that opened in April 1911. He also began to work on an exhibition of African sculpture.[36] His evolving perceptions of avant-garde trends in art appeared over the next few years in essays, published mostly in *Camera*

4.26 *Charles Frohman and Alla Nazimova* (1860–1915; 1879–1945) by Marius de Zayas. Ink on paper, 38 x 28 cm (15 x 11 in.), c. 1915. Original illustration for *Puck*, April 3, 1915. National Portrait Gallery, Smithsonian Institution, Washington, D.C.

Work, in which he analyzed the intellectual precepts behind the radical experiments in visual form. His books—*A Study of the Modern Evolution of Plastic Expression* (1913), written with Paul Haviland, and *African Negro Art: Its Influence on Modern Art* (1916)—were among the first analytical writings on cubist and African aesthetics to be published in America. While he continued to draw caricature portraits, sometimes called "Dezayagraphs," for *Puck* in 1914 and 1915 (fig. 4.26), his exposure to Parisian art inspired him to experiment in a different direction.

Influenced by his study of ancient and modern stylization, De Zayas began to evolve a theory of abstract caricature, using geometric shapes and mathematical formulas as symbolic substitutes for representational form. Picasso, he had explained in *Camera Work*, "receives a direct impression from external nature, he analyzes, develops, and translates it . . . with the inten-

4.27 *Alfred Stieglitz* (1864–1946) by Marius de Zayas (1880–1961). Charcoal on paper, 61.6 x 47.7 cm (24¹/₄ x 18⁵/₈ in.), 1912–13. Original illustration for *Camera Work*, no. 46, April 1914 (issued October 1914). The Metropolitan Museum of Art, New York; Alfred Stieglitz Collection.

tion that the picture should be the pictorial equivalent of the emotion produced by nature." De Zayas felt that a similar theory could be applied to caricature. Since he had always pushed beyond physical appearance in his search for the essence of an individual, abstraction was the next logical step in the stylization of form. The emotional element, what he called "the spirit," that was missing from representational caricature could be achieved by finding the "pictorial equivalent."[37]

In a series of drawings, such as his charcoal of Alfred Stieglitz (fig. 4.27), De Zayas experimented with caricature abstraction. Geometrical shapes represented the physical self—paired circles connoting spectacles and a triangular shape suggesting the mustache—while the mathematical signs symbolized the spirit. Already influenced by African sculpture and Aztec art, he searched for nonrepresentational, symbolic form. He credits his discovery of an ethnological object at the British Museum during a brief 1911 trip to London as the inspiration for his Stieglitz portrait and a critical moment in the development of his theory of caricature:

> Studying the ethnographical collection at the British Museum, I was impressed by an object invented by an artist from Pukapuka or Danger Island in the Pacific. It consisted of a wooden stick to which a few circles made of some vegetal material were fixed by pairs right and left to the stick. It impressed me particularly because it reminded me of the physical appearance of Stieglitz. I say "physical" because the resemblance was also spiritual. The object, said the catalogue, was built as a trap for catching souls. The portrait was complete, and it caught my soul, because from it I developed a theory of abstract caricature, theory which I exposed together with a few caricatures called "abstract" together with a few others which were of the "concrete" style. Some of the critics took my theory of abstract caricatures seriously; others didn't.[38]

De Zayas combined the symbolic power of the soul catcher with an algebraic equation in his Stieglitz portrait, synthesizing the emotive quality of the primitive with the scientific authority of the modern.

De Zayas's abstract caricature was introduced to the American public in 1913, the same year as the controversial Armory Show. The third De Zayas exhibit, appearing at 291 from April 8 to May 20, comprised eighteen portraits in both his abstract and traditional styles. In his catalogue essay he differentiated between the two and explained the theory behind his abstractions. He referred to pictures like his double portraits

of Rodin and Steichen as his "relative" or "concrete" style. Abstract drawings, such as the image of Alfred Stieglitz, he termed "absolute" caricatures.

The handsome and accomplished Agnes Meyer became one of the subjects of De Zayas's abstraction (fig. 4.28). Curving lines and ovoid shapes in the drawing imply physical form, as can be seen by comparing it with a Steichen photograph (fig. 4.29).[39] Like the photograph, the central image seems posed in profile with the face turned forward. Elegant, curving lines— the last vestige of Sem-like contours—define her slim, graceful figure, dominated by the head with its broad brow and prominent chin. A complex algebraic formula implies intelligence. Centered on a vertical axis that extends beyond the edge of the image, the figural form generates a sense of balance, composure, and classical beauty. These static elements are counteracted, however, by straight and curving diagonal lines sweeping upward toward the right, which animate the drawing with a feeling of motion and speed, suggesting Agnes Meyer's dynamic progression through life. De Zayas called this element an "initial force" or trajectory and considered it an important component of his caricature theory.

De Zayas's juxtaposition of the material and immaterial, bound together by the trajectory of the individual, was undoubtedly influenced by the contrasting elements of body and soul in Henri Bergson's essay on laughter. During his career as a caricaturist, De Zayas wrote in his catalogue essay (reprinted twice in *Camera Work*), he had concluded that the face and figure of a man reveal only his habits, not his psychological self or his "specific value, place or significance in relation to existing things." Matter, he felt, cannot exist without the spirit, but the spirit cannot be represented as a material entity. By using algebraic signs as "abstract equivalents," however, the psychological or metaphysical can be represented. His new technique of caricature, therefore, consisted of representing "the spirit of man by algebraic formulas," his "material self by geometrical equivalents," and his "initial force by trajectories."[40]

De Zayas's caricature theory intrigued the Parisian avant-garde, as well as his American friends. French artist Francis Picabia, wrote a critic for the *American Art News*, considered De Zayas the most innovative creator of "graphical and plastic synthesis of the analysis of individuals." In 1914, when De Zayas returned to Paris, Picabia introduced him to French poet Guillaume

4.29 *Agnes Meyer* (1887–1970) by Edward Steichen. Photograph, 1908. The Metropolitan Museum of Art, New York. Reprinted with permission of Joanna T. Steichen.

4.28 *Agnes Meyer* (1887–1970) by Marius de Zayas. Charcoal on paper, 62.2 x 47 cm (24¹/₂ x 18¹/₂ in.), 1914. Original illustration for *Camera Work*, no. 46, April 1914 (issued October 1914). Anne Meyer.

Apollinaire, who conveyed his enthusiasm for De Zayas's work in the *Paris-Journal*. De Zayas's caricatures, Apollinaire wrote, "employing some very new techniques, are in accord with the art of the most audacious contemporary painters. . . . They are incredibly powerful."[41]

Outside of the avant-garde and his own circle, however, the abstract caricatures baffled American art critics. "And now Marius de Zayas has got it," wrote William B. McCormick in the *New York Press*," quite the worst case on record. By this we mean an attack of the prevailing disease for the fantastically obscure in art." J. Edgar Chamberlin at the *New York Mail* concluded that the whole thing was a joke, that De Zayas was spoofing cubism and futurism and that his theory was merely a great bluff. The *New York Tribune*'s conservative critic Royal Cortissoz called it a "sort of postscript to

the freakish side of the recent Armory Show, an affair of bizarre absurdity." The "relative" caricatures were cleverly amusing, he wrote, but the "'absolute' performances suggest the disordered dreams of some Cubist mathematician." Samuel Swift from the *New York Sun*, equally perplexed, described the portrait of Theodore Roosevelt (fig. 4.30) as an "enticing affair that might be the detail drawing of a sort of electric wired bear trap with rows of sharp triangular shapes like shark teeth."[42]

Four of De Zayas's traditional caricatures from the exhibition and six abstract images appeared as photogravures in the April 1914 issue of *Camera Work*, along with his essay from the catalogue.[43] In the same issue a listing of upcoming 291 exhibits for the 1914–15 season indicated that another show of De Zayas's caricatures was being planned. But it was not to be. Two new interests began to demand his time and

attention and eventually led to a break in his friendship with Stieglitz. De Zayas, along with Agnes Meyer and Paul Haviland, was growing discouraged with the lethargy of 291 during wartime and Stieglitz's lack of initiative. Hoping to revitalize the modern movement, they started another magazine and planned to open a gallery with a more commercial emphasis.

In March 1915 they published the first issue of their innovative journal. With Stieglitz's support, they named it *291*. Bolder in both design and content than the declining *Camera Work*, the new magazine was infused with a cosmopolitan, iconoclastic spirit. The young editors published typographical experiments, modern artworks, and progressive poetry and criticism. Inspired by Apollinaire's poems and ideograms, De

Zayas, Agnes Meyer, and Katherine Rhoades experimented with "psychotypes," interspersing words, shapes, and images on the page to suggest personalities. When Francis Picabia arrived in New York and joined the group after the publication of the first issue, he took the notion of abstraction in a new direction. On the cover of the July–August 1915 issue was the first of his machine portraits, an image of Alfred Stieglitz (fig. 4.31). Compared with De Zayas's Stieglitz cover, on the first issue (fig. 4.32), Picabia's conception was far more innovative: he portrays Stieglitz as a symbolic camera with a hand brake pulled up and a gear shift stalled in neutral, stretching toward but never reaching the ideal.[44] Picabia also helped the group launch the Modern Gallery, which, under De

4.30 *Theodore Roosevelt* (1858–1919) by Marius de Zayas. Photogravure, 19.9 x 15.3 cm (7⁷/₈ x 6¹/₁₆ in.), 1914. Published in *Camera Work*, no. 46, April 1914 (issued October 1914). National Portrait Gallery, Smithsonian Institution, Washington, D.C.

4.31 *Alfred Stieglitz* (1864–1946) by Francis Picabia. Commercial relief print on paper, 38 x 22.8 cm (15 x 9 in.), 1915. Published in *291*, July–August 1915. National Portrait Gallery, Smithsonian Institution, Washington, D.C.; gift of Katharine Graham.

Zayas's direction, showed modern American and European art as well as African and pre-Columbian works. As his new activities began to consume his time and interests, De Zayas stopped making caricatures altogether.

The forefront of the avant-garde was shifting away from Stieglitz and the 291 Gallery. The circle of artists that congregated in the home of Louise and Walter Arensberg generated a new energy and more radical experimentation. At their regular, informal evenings,

the Arensbergs played hosts to artists and intellectuals such as Picabia, Man Ray, and Marcel Duchamp, the celebrated French painter of the Armory Show's most vilified work, *Nude Descending a Staircase*. The Arensberg circle encouraged the iconoclastic behavior and anarchistic attitudes that were later identified with the dada movement. De Zayas, who became a friend and an adviser to Walter Arensberg as proprietor of the Modern Gallery, was the bridge between the Stieglitz group and the Arensberg circle. His *Camera Work*

4.32 *Alfred Stieglitz* (1864–1946) by Marius de Zayas. Ink and wash on paper, 69.8 x 53.3 cm (27¹/₂ x 21 in.), 1915. Published in *291*, March 1915 cover. The Metropolitan Museum of Art, New York; Alfred Stieglitz Collection.

essays—along with those of De Casseres—were the first, according to one critic, to "launch a full-scale attack on the canons of art and morality and to define the attitudes later known as Dada."[45] Contemporary art historians agree that with his absolute caricatures De Zayas created some of the most highly abstracted and audacious works of art produced in America at that time.[46] Picabia, especially, was influenced by his interaction with De Zayas, and other members of the Arensberg circle eventually took up the concept of

abstract portraiture that the two had pioneered. Man Ray, Marsden Hartley, Charles Demuth, Charles Sheeler, and Arthur Dove, among others, all experimented with abstracted and symbolic images of personality.[47] Dada humor and wit abound in these images, although they sometimes lack the accessibility generally associated with caricature. De Zayas's concept of abstract portraiture would be influential, in other words, but his theory of absolute caricature spawned no followers. Nonetheless, he had strength-

ened the role of humor and caricature in both the Stieglitz circle and in the Arensberg group. This engagement with avant-garde movements helped to advance caricature in popular art venues.

Carlo de Fornaro had initiated a refined Parisian line and the first discussions of a new approach to satiric distortion. But Marius de Zayas introduced two critical elements that would characterize American caricature between the wars. In his hands, caricature moved closer to the entertainment world. In his choice of subjects, his staging of "Up and Down Fifth Avenue," and the dramatic posing of his compositions, De Zayas explored in his caricatures the intricate relationship of performance and celebrity. In addition, he distilled publicity-generating personality into concentrated form, focusing on recognizable surface traits. Although his charcoal drawings suggest psychological depths that made some critics speak of exposing the soul, oth-ers understood his skill at external synopsis. "Each man has some external characteristic, an appearance, gesture, attitude, which reveals the essence of his personality," Sadakichi Hartmann wrote in *Camera Work*. "The interest of the caricaturist is not in the actor but in the role the particular Thespian plays."[48] Hartmann was referring not just to those subjects who were stage performers but to all the stars of the celebrity world, each playing his or her own self-constructed role for the public and the press. The caricaturist, in other words, was not unmasking his subject but satirizing the mask itself by heightening its effect. "As Others See Us" was not a bad title for the short-lived, frivolous magazine that De Zayas illustrated when he first came to New York, for shallow public perception of the famous fueled his wit. The themes of celebrity performance and publicity that De Zayas engaged were ultimately incorporated into the definition of modern caricature.

Al Frueh: *The Quintessential Summary*

Nothing superlative is admitted and nothing essential is omitted. It is a new art and yet old, it is pantomime on paper.
—Christian Brinton

He works with a rigid economy of means, and he can construct a vivid portrait of a person with a few telling strokes. He deals in salients almost exclusively; and so keen is his observation that he is able to sum up a personality in a single feature or lineament.
—Willard Huntington Wright

Caricaturist Alfred J. Frueh was a man of such intriguing dimensions that his literary colleagues often resorted to liberal doses of humor and exaggeration just to describe him. "Frueh gives you the impression," *New York World* writer Joseph Van Raalte once noted in an article illustrated by the artist's self-portrait caricature (fig. 5.1), "of having blown [in] from one of his own drawings. . . . He is only a few yards over six feet in length, constructed on the plans and specifications of a cross between an installment house bed slat and the late afternoon shadow of a closely rolled umbrella." Even the name Alfred J. Frueh seemed a humorous deception, since he was always called Al and the surname was pronounced, as he once explained, "like free in free lunch (that was)."[1]

To his many friends and admirers, Frueh embodied the perfect synthesis of sophistication and simplicity, and his contradictions were part of his charm. The center of a wide circle of artistic and literary friends, he was taciturn and fond of solitude. An artist closely in touch with the emerging avant-garde, he himself focused on traditionally non–fine art forms: children's toys, ingenious folded paper animals, and distinctive caricature drawings. An interpreter of the stylish urban milieu, he preferred the primitive life on his Connecticut farm (fig. 5.2). "On his visits to New York," wrote Brendan Gill of the *New Yorker*, "he wore with relish the mask of a bumpkin; this was a device more subtle than it looked at first glance, for behind the mask was a person authentically rural, though as little a bumpkin as Thomas Jefferson."[2] This ingenious, independent observer of urban life would influence a whole generation of caricaturists.

Frueh (1880–1968) was born in Lima, Ohio, graduated from a local business school, and tried farming and the brewery business. He had experimented with caricature in his youth, Frueh told Van Raalte, when a boring course in Pitman shorthand inspired him to transform the symbols into recognizable likenesses: "I can never repay the debt I owe Ike Pitman—or it may have been his brother Ben. Whichever of the two it was gave me my first start in drawing."[3] After a visit to the St. Louis World's Fair in 1904 his drawing skills led toward a career. While there, his uncle introduced him to a friend at the *St. Louis Post-Dispatch*, where he landed a lowly job in the art department. But he advanced quickly and was publishing his own illustrations and sports cartoons in the paper by late 1904. Not all of this work was distinctive; much of it reflected styles and ideas picked up from other illustrators and cartoonists on the paper. In later years Frueh recognized the experience as part of his art education, noting that he had "percolated through the St. Louis Post-Dispatch School of Newspaper Art."[4]

Nonetheless, the strength of Frueh's draftsmanship and his ability to capture a likeness often lifted his drawings above those of his peers. For instance, his image of William Cave, manager of the Century Theater (fig. 5.3), resembles the work appearing in German or French satirical journals more than the other cartoons in the *Post-Dispatch*. With deft, elegant arcs, the profile of the nose extends into the brow and the cheekbone curves into the chin, giving the effect of a supercilious expression with a minimum of lines. This elimination of detail, which would become a defining aspect of his style, attracted attention at the earliest stages of his career. William Marion Reedy, for instance, editor of the nationally known journal the *St. Louis Mirror*, immediately recognized the vigor of his drawing. "If I mistake not, that new picture-maker,

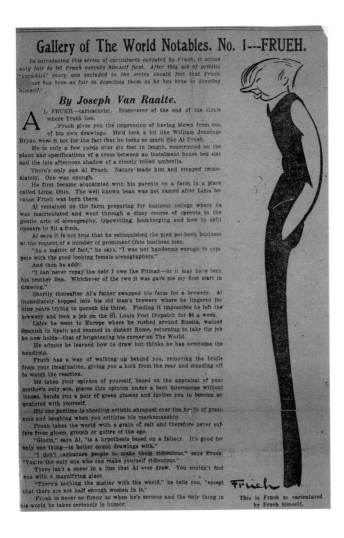

5.2 *Al Frueh* (1880–1968) by unidentified photographer. Photograph, n.d. Alfred J. Frueh Papers, Archives of American Art, Smithsonian Institution, Washington, D.C.; gift of the children of Al Frueh: Barbara Frueh Bornemann, Robert Frueh, and Alfred Frueh, Jr.

5.1 *Al Frueh* (1880–1968) by Al Frueh. Printed illustration. Published in *New York World*, January 23, 1921. Alfred J. Frueh Papers, Archives of American Art, Smithsonian Institution, Washington, D.C.; gift of the children of Al Frueh: Barbara Frueh Bornemann, Robert Frueh, and Alfred Frueh, Jr.

Frueh, on the *Post-Dispatch*, is destined to great sardonic, ironic, cruelly cynical work in art," he wrote in the November 9, 1905, issue of the *Mirror*. "He has the immense, raw crudity of strength which makes his technical deficiencies negligible. His work reminds one of the savage strength of the German caricaturists in *Jugend*, *Simplicissimus*, and *Wahr Jacob*."[5]

Al Frueh's love for theater unquestionably advanced his career. As soon as he arrived in St. Louis he partook of all the local offerings, adding to his repertoire of skills the ability to sketch performers. Stock companies had given way to seasonal touring companies by this time, and many of the idols of the New York and London stage came through St. Louis. Frueh's portraits of these actors soon began appearing regularly in the *Post-Dispatch*. Instead of sketching in the theater, he

relied on memory and first impressions. Habitually sitting in about the eighth row back on the side, he studied the performer moving about on stage, focusing on his or her interpretation of the role. Back at home after the show he developed the caricature on sheets of brown paper, first capturing a likeness and then refining his line, sharpening distortions, and eliminating details. In later years he would sometimes take a week to finish a seemingly spontaneous caricature, drawing as many as thirty sketches before arriving at the final image.[6]

While struggling for recognition among the other picture-makers, Frueh was delighted when his caricature of Austrian-born singer Fritzi Scheff (fig. 5.4), published in the *Post-Dispatch* on January 8, 1907, enraged its subject. He depicted the petite but fiery

actress, then starring in Victor Herbert's *Mlle. Modiste*, as a stiff, arrogant little figure with an elongated, doglike snout. Scheff reportedly screamed in fury when she saw the picture and immediately canceled that evening's performance. "It was very nearly the making of me," Frueh told an interviewer years later. "No one likes not to be noticed, and all at once I was famous."[7]

In general, however, the wit and fun rather than the malice of Frueh's drawings enhanced his reputation. William Marion Reedy recognized this quality in his next comment about the young caricaturist. Although Reedy still compared him with the German caricaturists, he no longer saw a cruel cynicism in the young man's work, commenting instead on his imaginative merriment. "He can give a portraiture and summarize a character in one fantastic curlacue [*sic*]. His fun is deliciously uncomplicated. It is never malicious. It is frankly boyish in its outlandishness."[8] Frueh's 1907 drawing of Eddie Foy (fig. 5.5), for instance, portraying the comedian with a chinless, cigar-shaped head, outlandish costume, and oversized feet, captivates the eye with its effervescent energy. Caricatures of comedians, of course, owe much of their humor to the actor rather than the artist; Foy, for instance, was renowned for his clownlike makeup, eccentric roles, and outrageous costumes. But Frueh went beyond the white face and funny clothes. Honing the shape of the head, defining the swing and bulge of the costume, and rendering the plodding heaviness of the feet, he added his own distinctive humor and style.

Of all the drawings Frueh made for the *Post-Dispatch*, critics recognized his caricature of John Drew as the most innovative (fig. 5.6). Though composed of planes and sharp angles as if hewn from planks of wood, it achieved a startlingly keen likeness (fig. 5.7). Drew, the uncle of the famous Barrymore siblings and himself one of the leading actors of the American stage, was appearing with Billie Burke in *My Wife*. Often referred to as "the first gentleman of the stage" and praised for the coolness and grace of his acting, he had set the standards for polite, drawing-room comedies of the time. A man of strong features, with heavy-lidded eyes and a long nose, he kept his face quite immobile, according to critics, using his body to interpret his role.[9] Frueh evoked the wooden immobility of those features in his caricature, published on February 18, 1908. Like other cartoon likenesses, the first level of humor was the recognition of well-known features and

5.3 *William Cave* (?–?) by Al Frueh. Ink with pencil on cut-out paper, 29.9 x 12.7 cm (11¾ x 5 in.), 1907. National Portrait Gallery, Smithsonian Institution, Washington, D.C.; gift of the children of Al Frueh: Barbara Frueh Bornemann, Robert Frueh, and Alfred Frueh, Jr.

traits, cleverly transformed. At the same time, the image broke the rules of cartoon exaggeration by converting the head into a witty sculptural form alluding to Drew's distinctive stage presence.

The drawing provoked an immediate, appreciative response. Within ten days the *St. Louis Dramatic News* had reproduced the image with the caption, "What Frueh handed Drew when Frueh drew Drew free-handed." *The St. Louis Mirror* was enthusiastic: "The wooden lineaments of the ligneous comedian, John Drew, as Frueh drew them in the *Post-Dispatch* . . . were the cheering sign of an otherwise uneventful day. Oh for a pencil like Frueh's to split more such blocks into kindling wood amid Homeric laughter!" Inspired by the drawing's success, Frueh made a plaster sculpture based on it and a wooden-headed puppet (see fig. 1.11). By March 7,

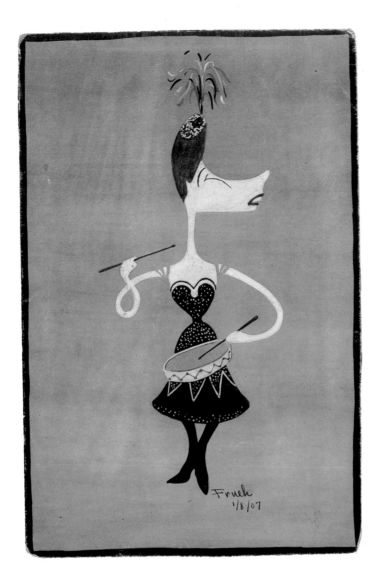

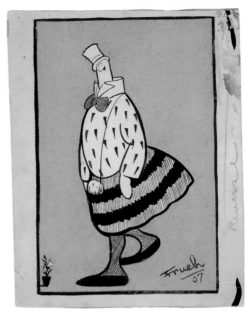

5.5 *Eddie Foy* (1856–1928) by Al Frueh. Ink on paper, 28.4 x 22.8 cm (11 1/8 x 9 in.), 1907. Original illustration for *St. Louis Post-Dispatch*, November 11, 1907. National Portrait Gallery, Smithsonian Institution, Washington, D.C.; gift of the children of Al Frueh: Barbara Frueh Bornemann, Robert Frueh, and Alfred Frueh, Jr.

5.4 *Fritzi Scheff* (1878–1954) by Al Frueh. Ink and gouache on paper, 27.3 x 18.3 cm (10 3/4 x 7 1/4 in.), 1907. Original illustration for *St. Louis Post-Dispatch*, January 8, 1907. National Portrait Gallery, Smithsonian Institution, Washington, D.C.; gift of the children of Al Frueh: Barbara Frueh Bornemann, Robert Frueh, and Alfred Frueh, Jr.

1908, just a few weeks after its initial publication, the drawing appeared in the New York *Dramatic Mirror*, and Frueh's name and wit were introduced for the first time in Manhattan.[10]

Frueh would eventually follow his reputation to New York. In the fall of 1908, however, he left for Europe to continue his art studies. "Loafed in Paris, London, Munich, Berlin, Rome and Madrid in 1909," he later explained, feigning idleness. In fact, he looked at art wherever he traveled and found time to study for a brief period with Henri Matisse in Paris. "Frueh's most individual traits have been developed," wrote his friend Henry Tyrrell a few years later, "or at least sharpened,

by his having 'passed through'—however casually—the studio school of Matisse in Paris." Frueh never acknowledged much about this association, or, indeed, any of his artistic training. "He admits he learned how to draw," Van Raalte reported about him, "but thinks he has overcome the handicap."[11]

Meanwhile Frueh had not been forgotten in St. Louis. In a whimsical test of his reputation he sent a postcard from Paris to one of his regular victims, former Governor Joseph Folk, addressed with a caricature head instead of a name. Beneath the grinning face, the words "St. Louis, Mo. U.S.A." completed the address. The St. Louis postmen, obviously readers of the *Post-*

Dispatch, needed no further identification. Without any apparent difficulty they delivered the card to Folk's law offices. Soon after, the drawing appeared in the newspaper. But Frueh did not go back to St. Louis after his travels. When he returned to the United States in the fall of 1909 he was lured to New York by a former *Post-Dispatch* editor now at Pulitzer's *New York World*. By December, Frueh had moved to New York to do various assignments for the *World*, and he finally signed a contract on July 1, 1910, for $100 a week, reserving the right to freelance for other journals and papers.[12]

In the *World's* Metropolitan Section traditional definitions of high culture, high society, and fame continued to be eroded by irreverent humor and caricatures of new celebrities. Writer Roy McCardell's December 11, 1910, coverage of the "dear old Dodos" of the American Academy of Arts and Letters, for instance, exemplified this trend. He suggested that such venerable immortals of the "thirty-five cent magazine crowd" as author William Dean Howells, sculptor Daniel Chester French, and academic Nicholas Murray Butler had little influence in contemporary life. It was the "fif-

5.7 *John Drew* (1853–1927) by Napoleon Sarony. Photograph, n.d. Theatre Collection, Free Library of Philadelphia.

5.6 *John Drew* (1853–1927) by Al Frueh. Ink with pencil on paper, 29.2 x 15.5 cm (11½ x 6⅛ in.), 1908. Original illustration for *St. Louis Post-Dispatch*, February 18, 1908. National Portrait Gallery, Smithsonian Institution, Washington, D.C.; gift of the children of Al Frueh: Barbara Frueh Bornemann, Robert Frueh, and Alfred Frueh, Jr.

5.8 *Joseph Weber and Lew Fields* (1867–1942; 1867–1941) by Al Frueh. India ink and gouache with pencil on board, 42.7 x 33 cm (16 13/16 x 12 in.), c. 1912. National Portrait Gallery, Smithsonian Institution, Washington, D.C.; gift of the children of Al Frueh: Barbara Frueh Bornemann, Robert Frueh, and Alfred Frueh, Jr.

teen-centers," he insisted, able to "assassinate the reputation of a half hundred hitherto respectable Captains of Industry," who could make circulation jump. McCardell's own tongue-in-cheek list of candidates for the Academy included "Diamond Jim" Brady, Lydia Pinkham of patent medicine fame, Sarah Bernhardt's brother Sam, "Eat-Em-Alive" Jack Abernathy, Carlo de Fornaro, and, of course, himself. He illustrated his article with caricatures by *World* artist Herb Roth, who adhered to a conventional cartoon style emphasizing large heads on small bodies.[13] With De Zayas still contributing illustrations—including scenes sent back from Paris—and Roth ensconced as a caricaturist, the newspaper did not initially feature Frueh's portraits.

Although small, identifiable figures sometimes appeared as he covered polo games, yachting parties, or evening entertainments, most of his early work for the *World* consisted of gag cartoons and comic strips.

Frueh continued to go the theater, however, and could not resist the temptation to make caricatures when he got home. Like many other sophisticated New Yorkers, his tastes were catholic, ranging from high opera to vaudeville. No one missed seeing Enrico Caruso sing his acclaimed Radames in Verdi's *Aida*, a role the famed tenor would perform sixty-four times at the Metropolitan Opera. Frueh's caricature proves that he too attended (see fig. 1.22). But he also enjoyed the 1912 reunion of the famous comic vaudeville team Joe

Weber and Lew Fields, who had split up in 1904 (fig. 5.8). Bending the tall figure of Fields over the short, portly Weber, Frueh depicts the partners "squaring off" with geometric precision. Erased lines between the figures indicate that he had originally drawn Fields pointing an accusatory finger in Weber's face. Frueh habitually edited his drawings, however, simplifying and strengthening them by removing unnecessary details. In this case he discarded the extraneous hand; Fields's stern countenance and Weber's spiral-eyed look of alarm sufficed to suggest their comic bullying routine.

Frueh's wit was inherent, and his talent for capturing a likeness was well developed from his St. Louis newspaper work, but he had brought home from his travels stylistic traits derived from Parisian poster artists and caricaturists. His caricature of Billie Burke (fig. 5.9), for instance, recalls the work of Leonetto Cappiello in the slim abbreviated figure, bold lines, and use of color. Like the image of Marcelle Lender from Cappiello's caricature album *Nos Actrices* (fig. 5.10), Frueh's Burke is drawn with strong, black contours, a sharp profile, and a slim, simplified figural shape. In both drawings,

5.9 *Billie Burke* (1886–1970) by Al Frueh. Ink, gouache, and pencil with watercolor on paper and board, 48 x 27 cm (18⅞ x 10⅝ in.), c. 1910–12. National Portrait Gallery, Smithsonian Institution, Washington, D.C.; gift of the children of Al Frueh: Barbara Frueh Bornemann, Robert Frueh, and Alfred Frueh, Jr.

5.10 *Marcelle Lender* (1862–1926) by Leonetto Cappiello. Color lithograph, 1899. Published in Cappiello, *Nos Actrices* (Paris, 1899). Rare Books; Southwest Collection/Special Collections Library, Texas Tech University, Lubbock.

touches of vivid, dense color enliven the neutral gray of the dress. Cappiello used bright accents of gold and red on hair, purse, and bow tie to sharpen the focus on the figure. Frueh achieved a similar effect with eye-catching, mountainous curls of red hair. But although Frueh's work reflected his exposure to Parisian styles, it also showed the cultural influences of New York. At first glance, Frueh's caricature of Alla Nazimova (fig. 5.11) resembles some of Cappiello's dark, inked images silhouetted against a light ground (see fig. 3.9). But in its extreme reduction of the figure, the strained pose, and the bony fingers of the hand it relates more directly to the drawings of Marius de Zayas (see fig. 4.6).

Frueh, like De Zayas, found dynamic subjects for caricature in the theatrical world. But more than any of his predecessors he could pinpoint the quintessential characteristics that distinguished one performer from another. He went beyond the variances of face and feature to emphasize each star's unique combination of perceived traits. Frueh synthesized, in other words, a likeness, a reputation, and a specific role into a coherent image. Because of this specificity his theatrical portraits did not evoke an urban nighttime world the way the Parisian posters implied the gaiety and weary vulnerability of the demimonde. His portrait of Billie Burke does not inform us about the theater of that period so much as describe her role within that milieu. So acutely did he capture her vivacious, animated, tirelessly perky stage presence that one critic was moved to call the caricature an "animated dimple."[14] In the wooden immobility of John Drew's face and the emotional pose of Nazimova's body he had wielded his satire with a similar precision.

Behind these concise lines and keen observations lay a comic persona of considerable sophistication. Frueh's illustrated letters from a second trip to Europe in 1912 and 1913 reveal a sense of humor both whimsical and ironic, inspired by literary sources (fig. 5.12). His evident enthusiasm for the trip was tempered by his separation from Giuliette Fanciulli, the daughter of the renowned musician, band leader, and composer Francesco Fanciulli. Though he relished his adventures in Italy, Switzerland, Belgium, Holland, Scotland, Ireland, England, and France, he found her absence unbearable. He finally persuaded Giuliette to join him in London, where they were married on June 12, 1913. Frueh illustrated his frequent letters to her with a remarkable series of caricature self-portraits as he

chronicled his travels in a bemused, humorous tone.

Letters from Italy after his arrival in late July 1912 showed the young traveler popping out of Vesuvius, crossing the River Styx, and wearing an actual wreath of laurel, a small sprig stuck through the paper to turn the caricature head into a crowned classical bust. Although much fonder of hiking in the country than of sightseeing in the city, he visited all the obligatory tourist spots, complaining humorously. From Venice he commented on the size of the mosquitoes, putting the relationship of the Old World and the New in irreverent perspective. They were, he noted, "great big Italian Jersey mosqueeters whose ancestors followed Christopher Columbus here when he came back from America. They haven't invented screens for the windows over here yet, but my bed is dressed up like if it was going to First Communion."[15]

Writing about Switzerland and Holland, Frueh adorned his self-portrait first with edelweiss and then with bloomers and wooden shoes. By mid-October he had reached Scotland. "Hoot, Bonny Birn," he addressed Giuliette in a Scottish brogue, depicting his long-legged self vainly trying to pull a kilt down over chilly knees. "I hae a mind to gay to Dancin' school and learn how to Highland Fling," he wrote with a drawing of how he might look in the attempt, "but I hae me doots whither I kin Larn it." From London, Frueh's caricature appeared first as a tall, slim figure attired in British tweeds, cap, and spats, and, after a visit to Hyde Park, as a bomb-tossing soap-box orator brandishing the sign "Votes for Pretty Women." In Paris he transformed his self-image from a top-hatted, prize-winning French Academician to a long-haired bohemian from the Latin Quarter. "Saw a dandy looking artist on the street today," he wrote. "No hat and no Sox—Sandals on his feet and its winter here too. Guess I'll dress the same and get great quicker."[16]

After months of traveling he settled in Paris to do some work, collaborating with Irwin Leslie Gordon on a comic journal called *The Log of the Ark*. His labors did not keep him from observing the Parisian art world, however. In March 1913 he wrote to Giuliette about visiting the Salon des Indépendants to look at the cubist pictures. "We've got a show here too with pictures in Geometry by artists who look at things through a sausage grinder. . . . I remember when I was a kid . . . I *tried* to ride down the Court house steps on a bicycle. I'm sure every time I hit one of the stone steps

5.11 *Alla Nazimova* (1879–1945) by Al Frueh. Ink and gouache on board, 44.6 x 29.6 cm (17 $^9/_{16}$ x 11$^5/_8$ in.), c. 1910–12. National Portrait Gallery, Smithsonian Institution, Washington, D.C.; gift of the children of Al Frueh: Barbara Frueh Bornemann, Robert Frueh, and Alfred Frueh, Jr.

on my way down I saw a couple of these same canvases. That was 15 years ago. and they say they are doing something new." A few days later he was back at the exhibition, explaining to Giuliette that every time he went there he got inspired. "About 2 more times and I'll be able to hide what I'm trying to do just as well as the next one." And to prove his point, he drew cubist watercolor portraits of them both. "I'm getting better lookin every minute," he wrote as a caption to the faceted likeness of himself.[17]

Frueh's letters and comic self-portraits reveal much about his approach to humor and caricature. Even his expressions of affection for his fiancée are couched in humorous terms. "Gee I can't think of anything unless you gotta mix in it," he complained in one letter, "and wherever I think, there you are. Same way with whenever."[18] Throughout the correspondence he mocks himself as an artist, as a tourist, and as a romantic lover, and in the process he develops the ironic detachment to analyze his experiences. Far from being the awestruck provincial visiting the great capitals of western civilization, he portrays himself as an American folk character whose apparent lack of sophistication and experience qualify him to comment with fresh insight on European history, art, and manners. In appropriating the stereotypes and costumes of each

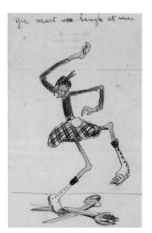

country in his caricature self-portraits, he absorbs cultural influences without discarding his own background and identity. Anything truly remarkable is subverted through his comic lens. Thus, enormous Italian mosquitoes must have been imported by Christopher Columbus from New Jersey, and cubism was the invention of a boy from Lima, Ohio, riding his bike down the courthouse steps.

Frueh's approach in these letters, particularly his intentional bad grammar, dialect, and slang, recall the essays of Finley Peter Dunne's comic saloonkeeper "Mr. Dooley," or Artemus Ward's uneducated country characters. By depicting himself as unsophisticated and rural, Frueh had a similar opportunity to lampoon others. It was a disguise that would suit him particularly well in dealing with the editors, publishers, and emerging celebrities of New York. This "mask of a bumpkin," as Brendan Gill called it, appears in Frueh's drawings in the "golly gee" sense of wonder that they impart. But the bumpkin's awe is tempered by the sophisticate's irreverence as each subject's most notable characteristic is neatly and satirically summarized in high Parisian style. This duality had its roots in the tradition of the American comic folk hero, but it is invested with Frueh's own acute insights into modern urban celebrity.

Alfred Stieglitz, who had already mounted two popular and successful De Zayas shows, was bound to appreciate the keen wit of Frueh's theater caricatures. After Frueh left for Europe, Stieglitz opened his 1912 fall season at 291 with an exhibition of more than fifty of his drawings, shown from November 20 to December 12. On the walls of the Little Galleries hung the images that Frueh had been creating over the past several years, including Scheff, Drew, Weber and Fields, and Burke. When Stieglitz ran out of space on the walls he added more pieces in a case.

In an article for the *New York Sun*, later reprinted in *Camera Work*, art critic Samuel Swift explained how the exhibition came about in a story that fits the Stieglitz mythology suspiciously well. Frueh, Swift related, was not satisfied with the work he was making for publication, so he made caricatures just to please himself. A friend of his brought these drawings to the attention of Stieglitz. Recounting a scenario almost identical to the one De Zayas reputedly experienced, Swift relates a conversation between Stieglitz and Frueh: "You have done these drawings in order to sell them? No. Do you want them to be published? No. You did them only for your own interest and satisfaction? Yes."[19]

Although this conversation probably never took place, the story has grains of truth. According to Giuliette's biographical notes, Frueh left his drawings with his friend Homer Croy, a writer who had begun his career at the *St. Louis Post-Dispatch* before moving to New York. While Frueh was in Europe, Croy persuaded Stieglitz to mount the drawings in his gallery.[20] There is no evidence that Frueh had intended these drawings for publication, but he obviously did lavish time and attention on them. On a number of caricatures, such as the vivid portrayal of comedian Frank McIntyre in "Snobs" (fig. 5.13), Frueh cut around the figure with a knife, laboriously scraping away the

5.12 *Al Frueh* (1880–1968) by Al Frueh. Letters to Giuliette Fanciulli. Ink on paper, 1912–13 Alfred J. Frueh Papers, Archives of American Art, Smithsonian Institution, Washington, D.C.; gift of the children of Al Frueh: Barbara Frueh Bornemann, Robert Frueh, and Alfred Frueh, Jr.

smooth surface paper in the background to reveal the gray, pulpy center of the illustration board. The stout figure of McIntyre, attired in wild checks, green spats, and matching ascot, is thus set off against the rough texture and neutral color of the background. The technique gives the effect of actual relief, as if the actor is taking a final bow on a narrow stage.[21]

The appeal of such caricature to the avant-garde circle at 291 serves as a reminder that wit and whimsy were an integral part of the modernist aesthetic, one frequently overlooked by latter-day historians. Frueh's portraits hardly seem the radical approach to style that 291 visitors had seen in exhibitions of Matisse's work or in the shows of such American artists as John Marin, Marsden Hartley, or Arthur Dove. And, indeed, these caricatures, according to a notice in *Camera Work*, were not intended to be "considered as a contribution to the advancement of modern art." But they were chosen because they revealed a "fresh and independent point of view."[22] Stieglitz, who loved satiric art, was undoubtedly struck by Frueh's innovative approach to subject matter.

For his image of John Barrymore, for instance, Frueh honed a spare image with an awkward, angular profile (fig. 5.14). The handsome young actor had opened in September 1909 to great acclaim in *The Fortune Hunter*, a popular comedy about a city slicker's attempt to marry wealth in a small town. In Frueh's caricature the clenched fist, bowed head, mouthless, glowering profile, and squiggled line of a sophisticated mustache summarize the brooding young failure before he is

transformed by small-town values. Portraying Barrymore as darkly handsome and intense, Frueh caught much of his appeal in the part that first launched him as a matinee idol. Like most of his portraits, this powerful distillation depicted not just the actor but that individual's unique interpretation of his role.

Such incisive portrayals of well-known theatrical figures captured the imagination of New Yorkers. Stieglitz sent Frueh a copy of the printed brochure. "Opened with this show," he scrawled on it in pencil. "Looks magnificent. Great success. Wish you could see it. It would please you immensely. A lot of people price'd things. Were told the things were not for sale. Hope you will publish series, the people say." In the corner he noted that he had added a few pieces to the forty-nine caricatures listed, including a drawing of a bicycle race and portraits of Johnston Forbes-Robertson and Margaret Anglin. "I trust you are making the best of your opportunities in Europe," Stieglitz commented encouragingly at the end of his note, "& are having a great time seeing & studying things." He wrote more formally a few days later, addressing his correspondent as "My dear Mr. Frueh" and thanking him for sending a catalogue from London. "Your show is arousing much interest," he repeated. "It is both a popular and artistic success. . . . I may extend the time of the exhibition another week. . . . I am sorry you cannot see the 'Little Room' as it looks. It has been entirely redecorated and I doubt whether your work will ever be shown to such advantage again."[23]

Stieglitz mentioned that *World* art critic Henry

5.13 *Frank McIntyre* (1877–1949) by Al Frueh. Ink and gouache on board, 45.1 x 30.3 cm (17 3/4 x 13 1/8 in.), 1911. National Portrait Gallery, Smithsonian Institution, Washington, D.C.; gift of the children of Al Frueh: Barbara Frueh Bornemann, Robert Frueh, and Alfred Frueh, Jr.

Tyrrell had stopped by to see the exhibit. Frueh's colleague and good friend was impressed by the show. Although their newspaper had not published Frueh's individual caricature portraits, the exhibition prompted Tyrrell's feature article in the *World*'s magazine section on January 5, 1913. The half page of eleven illustrations, colorfully printed in black, green, and orange, included images of vaudevillian Donald Brian (fig. 5.15), Lillian Russell, and Scottish performer Harry Lauder with his signature kilt and walking stick (fig. 5.16). A large picture of the wooden John Drew dominated the others. Tyrrell described the image as a

5.15 *Donald Brian* (c. 1875–1948) by Al Frueh. Ink on paper on board, 43.2 x 27.2 cm (17 x 10¹¹/₁₆ in.), c. 1911. National Portrait Gallery, Smithsonian Institution, Washington, D.C.; gift of the children of Al Frueh: Barbara Frueh Bornemann, Robert Frueh, and Alfred Frueh, Jr.

5.14 *John Barrymore* (1882–1942) by Al Frueh. Ink with wash on board, 47.8 x 22.5 cm (18¹³/₁₆ x 8⁷/₈ in.), c. 1909. National Portrait Gallery, Smithsonian Institution, Washington, D.C.; gift of the children of Al Frueh: Barbara Frueh Bornemann, Robert Frueh, and Alfred Frueh, Jr.

"hatchet-hewn Alaskan totem pole," acknowledging that it sounded far-fetched when described in words but was "absurdly like him." "Technically, Frueh's drawings have novelty and interest, in their extreme economy of line," Tyrrell explained, "which amounts practically to a pictorial short-hand. It is what the art critics call 'synthetic' drawing. That is, it summarizes a complete object or action in a single line, curve or angle. Shading or modelling there is none."[24]

Other critics would seize on this notion of external summary as a defining characteristic of Frueh's work. No one wrote about exposing the soul. Tyrrell had praised De Zayas for his ability to render a "summary impression," but Frueh's work seemed even more clearly related to surface characteristics because of his economy of line. In the extensive publicity that followed the exhibition, everyone commented on his astonishing stylistic spareness. "They're all there," noted the critic for the New York Evening Sun, "all the headliners on the theatrical playbills, done with five to fifteen strokes and the help of a little vermillion, cobalt or emerald green."[25] The portrait of Johnston Forbes-Robertson (fig. 5.17), Tyrrell had noticed, was composed of "just nine pen strokes and a big black silhouette with two white spots in it for hands."

A couple of reviewers thought Frueh's distortions excessive in some drawings. The Morning Telegraph felt that "the peculiarities of the face, figure, gesture or that indescribable something, the personality, that has made the subject a paying feature of the box office . . . , is manifest in delicate doses—sometimes not quite so delicate." Samuel Swift, in the New York Sun, agreed that Frueh occasionally went too far in his distortions. "Mannerisms, characteristic poses, pronounced features, favorite costumes, have been seized upon with skill and audacity, sometimes a bit too violently," he noted.

The image of a less than youthful Julia Marlowe as Juliet (fig. 5.18) may have been one that these critics had in mind. Frueh probably made the drawing in February 1910, when the seasoned Shakespearean duo Marlowe and Edward H. Southern, both then in middle age, once again performed their acclaimed Romeo and Juliet. Frueh depicted Marlowe in a dramatic black and white profile against a vivid green ground. Although girlish long hair cascades over her shoulders, set off by Juliet's pert red cap, her ample figure nonetheless suggests her age. The drawing, the Telegraph's critic noticed, depicted a Juliet "who appears well up in her lines, but a little careless in physique, sounding but not looking the part." The writer for the Evening Sun joked about the incongruity. Marlowe, he wrote, "with her red Juliet cap, her raven locks and uncolored gown, suggest[ed] Snow White but for an adorable gently rippling triple chin with which she is blessed by the artist." Frueh himself seems to have reacted to the comment. Although the image reproduced in the New York World shows unmistakable bulges under the chin, Frueh gave the drawing a deft face lift at some point, scratching out the offending curves for a tauter profile.[26]

Complaints of this type were rare, however. Most critics commented on the humor and merriment of the show. The critic from the Evening Sun was amused by the drawing of Fritzi Scheff (see fig. 5.4) "with arms like the neck of a flamingo, beating a tattoo on her *petite* little drum with her *bien* saucy little face *en avant*." Tyrrell, who knew Frueh well, described the artist's youth, gentle disposition, and "graphic eye" and discussed his humor in terms similar to those used by William Marion Reedy. "The irresistible boy spirit," he noted, "still dominates the varied and inimitable work that this joyful individualist puts into circulation today."[27] Words evoking freshness, youth, energy, and independence often described Frueh's approach to caricature. But these qualities of boyish independence disguised a seasoned sophistication and acute awareness of developing trends in art.

Frueh's focus on the theater undoubtedly helped to fuel his success. The theatrical world of the 1910s was expanding rapidly, nearing the peak of its impact on urban life. Within a decade New York would be producing an average of 225 new plays each year, a rate not equaled since. For Frueh's generation the theater embodied glamorous, fast-paced urban culture; dramatic performance seemed analogous to living life to the fullest. Indeed, establishing one's reputation in any field demanded a degree of theatricality. As Ann Douglas recognized in her study of the 1920s, well-known New Yorkers all tended to be actors, "not so much professionals earning their living on the stage as amateurs given to theatricalizing their lives at every turn."[28] Frueh's subject matter alone added an urbane aura to his drawings. The vaudevillians, opera stars, and dramatic leads he limned were both fashionable celebrities and role models. His caricatures, therefore, seemed all the more emblematic of contemporary life.

After the triumphant showing at 291, the exhibition

5.16 *Harry Lauder* (1870–1950) by Al Frueh. India ink, gouache, and watercolor on board, 45.7 x 31.6 cm (18 x 12⁷/₁₆ in.), c. 1910. National Portrait Gallery, Smithsonian Institution, Washington, D.C.; gift of the children of Al Frueh: Barbara Frueh Bornemann, Robert Frueh, and Alfred Frueh, Jr.

5.17 *Johnston Forbes-Robertson* (1853–1937) by Al Frueh. India ink with white gouache on board, 50.5 x 29.2 cm (19⅞ x 11½ in.), c. 1910. National Portrait Gallery, Smithsonian Institution, Washington, D.C.; gift of the children of Al Frueh: Barbara Frueh Bornemann, Robert Frueh, and Alfred Frueh, Jr.

of Frueh's drawings traveled to St. Louis and then to Boston. Following Frueh's instructions, Stieglitz shipped the drawings to the J. C. Strauss studio in St. Louis, where they were exhibited from January 22 to February 12, 1913. "'My caricature circus' has been moved to St. Louis and is probably going on now," he informed Giuliette. A few weeks later he wrote to tell her that he had a request from a Boston photographer named Henry Havelock Pierce who had seen the

exhibit in St. Louis and wanted to show it at his own studio.[29] Frueh gave his permission, and the caricatures were displayed at Pierce's studio from April 3 to April 17, 1913. For St. Louis and Boston the exhibition was expanded to include pieces that Stieglitz had not been able to fit into his gallery. Again the critics praised the astonishing effects of his minimal lines.[30]

Although Giuliette's letters to Frueh in Europe no longer exist, his comments indicate that she was keeping him informed of events in the New York art world. She had asked him whether he remembered seeing any of John Marin's work and sent him clippings about De Zayas's 1913 exhibition and the Armory Show. Always intrigued by the latest developments of avant-garde art, Frueh urged her not to miss the latter. Giuliette also sent to Paris all the notices about Frueh's own show in the New York papers. "I've got an awful swelled head," he acknowledged about the publicity, "haven't hair enough to go around. That's the reason it looks so thin."[31]

After their marriage in London, Al and Giuliette moved to Paris, where their first child was born in 1914. They had hoped to travel in Italy, but the threat of war made life increasingly difficult. In September 1914 they took a poorly provisioned, overcrowded ship back to New York.[32] After all the publicity from Frueh's 291 exhibition, the *World* was happy to welcome him back. With some interruptions he continued to draw pictorial humor for the paper for the next ten years, particularly comic strips and cartoons. In 1920 he went to Chicago to cover the Republican presidential convention for the *World*. Four years later the Democrats met in New York City, and he drew a special feature called "At the Convention with Frueh." Political caricature never became a specialty, however; his satiric approach worked best with the vibrant personalities of the theater.

The art world also welcomed Frueh back from Paris. Having survived the seismic tremors of the Armory Show and absorbed an influx of avant-garde expatriate artists after the outbreak of war, New York exhibited a growing enthusiasm for artistic experimentation. Frueh's whimsical world view and multifaceted talent appealed to many restless souls fleeing wartime chaos. For a community that encouraged such maverick creative talents as the recently repatriated Stettheimer sisters, Frueh seemed another example of free-spirited originality. He began to show regularly in art exhibi-

5.18 *Julia Marlowe* (1866–1950) by Al Frueh. India ink and gouache on board, 37.6 x 31.7 cm (14¹³/₁₆ x 12¹/₂ in.), c. 1910. National Portrait Gallery, Smithsonian Institution, Washington, D.C.; gift of the children of Al Frueh: Barbara Frueh Bornemann, Robert Frueh, and Alfred Frueh, Jr.

tions throughout the city, reaching a much broader audience than the narrow circle of loyalists who frequented Stieglitz's 291 Gallery. In addition to his theatrical drawings, he could offer free-standing, folded paper sculptures of cranes, poodles, dachshunds, and fighting cocks. *Vanity Fair* reproduced some examples in February 1915, commenting that each was a "true work of art."³³ Critics admired the ingenious craftsmanship of his origami. Like the caricatures, these images summarized their subjects with a humorous stylization and a crisp geometry.

Frueh had developed another talent that proved intriguing. His linocut versions of his caricature portraits coincided with a growing interest in the color print among American artists. Frueh had learned the art of cutting relief prints in Paris, inspired by the Japanese woodblock images to which all art students were exposed. Stieglitz's comment that 291 visitors wanted

5.19 *John Drew* (1853–1927) by Al Frueh.
Linocut, 29.8 x 18.9 cm (11³/₄ x 7⁷/₁₆ in.),
1915. Published in Frueh, *Stage Folk* (New York,
1922). National Portrait Gallery, Smithsonian
Institution, Washington, D.C.; gift of the chil-
dren of Al Frueh: Barbara Frueh Bornemann,
Robert Frueh, and Alfred Frueh, Jr.

him to publish his caricatures undoubtedly encouraged
his interest, and after his return to New York he started
translating his theatrical drawings onto linoleum
blocks. At about the same time, a group of printmakers,
primarily centered at the artists' colony in Province-
town, Massachusetts, were mastering the techniques of
Japanese-inspired color woodcuts. The movement
undoubtedly added extra appeal to Frueh's linocuts,
many of which were printed with color.³⁴

Frueh showed four of his prints at the 1915 Salon of
American Humorists exhibition along with some of his
drawings and paper animals. His now famous *John Drew*
appeared even more dramatic in the linocut version,
printed in bright green (fig. 5.19). The critic from the
New York American loved the exhibition, particularly
Frueh's caricatures. "For here," he noted, "is evidence of
an intellectualizing process that not only regulates the
style but also nerves the humor with ironic vim." The *New*

York Times admired the ease with which Frueh achieved his economy of line—"the apparently inevitable arrival at the quintessential without any indication of the process of elimination." Some critics, disappointed with the show, singled out Frueh as an exception to the general mediocrity. "He can do various stunts with the curve and with the angle, devoting almost too much of his extraordinary ingenuity to just nonsense," noted one writer, who acknowledged that Frueh was probably the most original artist in the exhibition.[35]

The color linocuts also appeared in the *World* as part of a series of four features on Frueh and his technique. In the first series, published on January 27, 1918, the editor introduced the artist by explaining his background. A year in Paris spent "unlearning something" in one "revolutionary" studio after another, he noted, "freed him from any undue respect for respectable conventionality, and he is now emerging an untrammeled expressionist, something like the Japanese print masters of the Ukiyo-e school." The artist was still young in years, the editor commented, "and a kid in animal spirits. But if there is any other rapid-fire artist in America who has as much of the original Hiroshige in him as Alfred Frueh, that artist has hitherto been thwarted of publicity."[36] The series finally convinced the editors of Frueh's special talent for caricature. The *World* began publishing Frueh's portraits regularly in the 1920s.

The seeming spontaneity of line in Frueh's prints belied the considerable labor and revision involved. Frueh's first print of Raymond Hitchcock (fig. 5.20), for instance, based on his 291 drawing, repeated the black and white checked suit, the red tie, and the bright yellow shock of hair. Over the top of the small black squares of the suit he printed thin, intersecting lines of yellow and red for a dazzling effect of color and texture. When he published a print of Hitchcock with Leon Errol in the *World* magazine, however, he simplified the caricature considerably, substituting for the checked suit the dark silhouette of formal dress, tipping the head down toward the shorter figure of Errol and focusing the humor on the greater distortion of the chin, nose, and bulging eye.

When the Society of Independent Artists started organizing exhibitions in 1917, Frueh participated regularly and was frequently mentioned by the critics. Some considered his work a welcome relief from modernist extremes. "That master of satirical comedy, A. J.

5.20 *Raymond Hitchcock* (1865–1929) by Al Frueh. Linocut, 40.6 x 25.4 cm (15 11/16 x 9 7/8 in.), c. 1915–22. National Portrait Gallery, Smithsonian Institution, Washington, D.C.; gift of the children of Al Frueh: Barbara Frueh Bornemann, Robert Frueh, and Alfred Frueh, Jr.

Frueh," James Huneker wrote in 1920 after a visit to the Society of Independent Artists exhibition, "is an oasis in this desert of repulsive degeneracy dubbed 'independent' art."[37]

Nonetheless, the attitude of a modernist lay behind Frueh's accessible humor. There was a discernible anti-art stance to his exhibition submissions that was related to the budding dada movement. When Marcel Duchamp, Beatrice Wood, and Henri Pierre Roché

5.21 *Frueh Christmas Card* by Al Frueh. Relief print with watercolor on paper, 36.8 x 25.2 cm (14¹/₂ x 9¹⁵/₁₆ in.), 1928. National Portrait Gallery, Smithsonian Institution, Washington, D.C.; gift of the children of Al Frueh: Barbara Frueh Bornemann, Robert Frueh, and Alfred Frueh, Jr.

published the first issue of their magazine *The Blind Man* on April 10, 1917, Frueh provided the cover illustration: a sightless man with dog and cane walking past a framed picture. The association suggests a certain sympathy with the attempt to subvert conventional notions of art. Exhibiting mechanical toys, folded paper sculpture, and silhouetted animals cut from metal along with his caricatures, Frueh himself challenged the distinctions between art and non-art, adult and childish sensibilities. At the third annual Independents exhibit in 1919 Frueh submitted a "singing sculpture" and a lampshade carved in the shape of a traffic cop. Critics particularly admired his baby's cradle on wheels, painted with overlapping planes of Mother Goose imagery. "It was in the highest degree modern," noted the *New York Times*. "It put the adult spectator at once in the wondering and

curious mood of the infant."[38] Frueh lacked the anarchic militancy of the dada artists, but his brief association with them bolstered his independent stance. Alexander Calder would employ a similar ingenuity and whimsical charm in experimenting with his famous circus a few years later. Both defied traditional artistic categories, materials, and themes, to the surprised delight of their audience.

For most critics, Frueh's unusual work had a contemporary resonance. In 1921 the Pennsylvania Academy of the Fine Arts included some of his drawings in an exhibition of modern "tendencies" in American art, and the National Arts Club chose his caricatures, paper animals, and singing wooden figure for a humorists show. So regular were his contributions to the art exhibits that the *World* began to use him in its advertising. "Yearly exhibits of these Frueh caricatures at the art galleries always draw a throng," it trumpeted in a notice titled "Why the World is the Best," which stressed that Frueh's growing reputation was international. "Even in Europe," the ad noted immodestly, "he is recognized as America's greatest caricaturist. Lots of Americans who visited France and Spain this summer found circulating there postcards of Frueh's funny drawings."[39]

Ardent admirers of Frueh's work could be found in various New York artistic and literary circles. At their Greenwich Village house on Perry Street, where caricatures hung on the wall, Al and the extroverted Giuliette entertained frequently. Their correspondence files overflow with evidence of their diverse social activities. Benjamin de Casseres wrote to apologize for missing a Frueh invitation, as did actress Helen Hayes. Writers Hendrik Van Loon and Eugene O'Neill (along with his wife, Carlotta Monterey) were lifelong friends. Frueh corresponded with many artists who admired his work, including Robert Henri, Gaston Lachaise, William Gropper, Walter Pach, Fornaro, and Conrado Massaguer. Many others sent Christmas cards in response to Frueh's own end-of-the-year greeting, which always included caricatures of himself and Giuliette. *Vanity Fair* editor Frank Crowninshield wrote to congratulate him on one of these cards (fig. 5.21): "It is a masterpiece, one of the cleverest and most original cards I have ever seen."[40]

In the fall of 1922, a decade after Stieglitz had suggested it, Frueh published a portfolio of the caricatures that he had been exhibiting for years. Issued by Lieber

and Lewis with the title *Stage Folk*, it consisted of thirty-seven linocut prints, depicting forty-one performers. On the cover of the album he portrayed himself as the grinning puppet figure Punch.[41] Although he based many of the prints on the drawings from his 1912–13 touring exhibition, he continued to simplify form and reduce the number of lines. He easily translated his images of John Drew, Julia Marlowe (still bearing her rippling chins), and swimmer Annette Kellerman (fig. 5.22) into the bold relief lines of the linocut. He pared down his image of Marie Dressler, however, to a few thick, curving lines to suggest the comedian's hunched shoulders, heavy jowls, and buxom shape (fig. 5.23).

To Weber and Fields he added more color, pleasanter expressions, and the accusatory pointing finger. Enthusiastic reviews for *Stage Folk*, along with reproductions, appeared in *Vanity Fair, Arts and Decoration, Shadowland, Literary Digest*, and the Cuban journal *Social*. Frank Crowninshield tore out the image of John Drew from *Social* and sent it to Frueh with the comment that it was a masterpiece and he should try to do more "in this method."[42]

In his drawing of George M. Cohan from *The Little Millionaire*, erasure marks document Frueh's decision to remove all features of the face, depending on the pose alone to evoke the famous song-and-dance man (fig.

5.22 *Annette Kellerman* (1887–1975) by Al Frueh. Linocut, 45.7 x 30.5 cm (18 x 12 in.), c. 1915–22. Published in Frueh, *Stage Folk* (New York, 1922). National Portrait Gallery, Smithsonian Institution, Washington, D.C.; gift of the children of Al Frueh: Barbara Frueh Bornemann, Robert Frueh, and Alfred Frueh, Jr.

5.23 *Marie Dressler* (1869–1934) by Al Frueh. Linocut, 37.3 x 26.7 cm (14^{11}/$_{16}$ x 10^{1}/$_{2}$ in.), c. 1915–22. Published in Frueh, *Stage Folk* (New York, 1922). National Portrait Gallery, Smithsonian Institution, Washington, D.C.; gift of the children of Al Frueh: Barbara Frueh Bornemann, Robert Frueh, and Alfred Frueh, Jr.

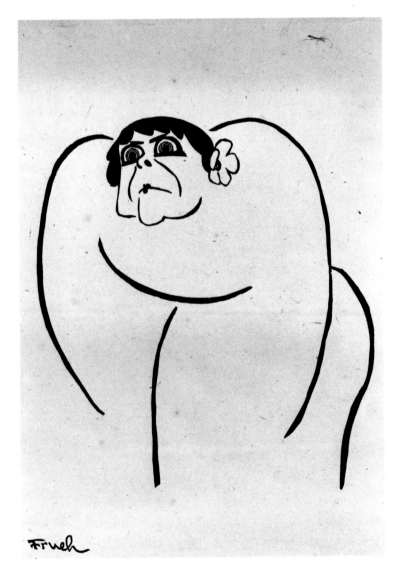

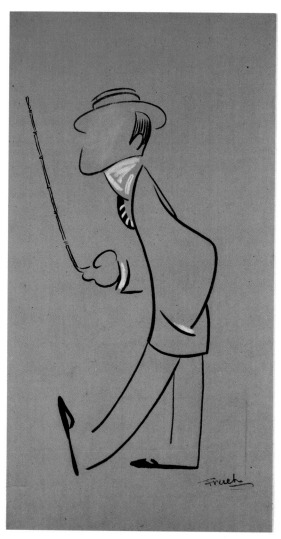

5.24 *George M. Cohan* (1878–1942) by Al Frueh. India ink with white gouache on board, 45.4 x 24.2 cm (17 7/8 x 9 1/2 in.), c. 1911. National Portrait Gallery, Smithsonian Institution, Washington, D.C.; gift of the children of Al Frueh: Barbara Frueh Bornemann, Robert Frueh, and Alfred Frueh, Jr.

5.24). The image, which had received much attention in the 291 show, became even more famous in the linocut version (see fig. 1.18). Noted Carlo de Fornaro in *Arts and Decoration*, "Nothing remains but the angle of the hat, the swing of the cane, the hand in the pocket and the Cohan walk. But the portrait is unmistakable!" Frueh, he wrote, "immortalized these picturesque shadows of the stage more truly than all the photographs, the paintings, the reviews about them." And he ranked him higher as a caricaturist than William Gropper, John

Held, Jr., Massaguer, or De Zayas. "He is a paramount and unsurpassed genius," Fornaro declared. "He can only be compared to the greatest in Europe, to Sem, Cappiello, and Rouveyre." Cuban caricaturist Conrado Massaguer, editor of *Social*, also considered Frueh one of the world's leading artists in the field. The old-fashioned style of carefully modeled but deformed faces was fast disappearing, Massaguer explained. The modern approach to caricature "is to simplify while exaggerating . . . and to endeavor to obtain, at the same time, a decorative effect in harmony with the delicate satire employed in the vivisection of the subject."[43]

That delicacy and the lack of hard-hitting, probing satire separated Frueh's work from much nineteenth-century satiric art. Art critic Willard Huntington Wright, in a July 1922 article in *Vanity Fair* accompanied by a page of Frueh's caricatures, noted the focus on surface, style, and summary instead of analysis.

> *For sheer cleverness, diversity of talent, and ability to set down an interpretative likeness of a given subject, Frueh has no equal in this country. He works with a rigid economy of means, and he can construct a vivid portrait of a person with a few telling strokes. He deals in salients almost exclusively; and so keen is his observation that he is able to sum up a personality in a single feature or lineament. Moreover, Frueh is an adept at sensing the distinctive color of personalities, and he often varies his technique accordingly. . . . But he rarely touches upon the more philosophic and cultural side of caricature and contents himself with the exaggerations of portraiture. His very facilite is at once his attraction and his limitation; but of the narrow field he has chosen to work in he is the undoubted master. In fact, he is the superior of such foreigners as Massaguer, Alvarez, and Sirio; and he marks a decided step in the evolution of American caricature.*[44]

Wright did not see in those bold, sweeping contours and barely suggested features any profound evaluation of the subjects' human qualities. And despite his admiration for Frueh, he deplored the conspicuous cleverness that he felt led to superficiality in much American caricature. But it was precisely the qualities he describes—resulting in a bold, shallow, vibrant, and nonjudgmental summary of personality—that set the work of Frueh and his contemporaries apart from traditional satiric portraits, linking them to the evolving celebrity industry.

The *Stage Folk* prints received more publicity when they were exhibited at the Anderson Galleries from

December 16 to 23, 1922, with caricatures by Massaguer. Henry McBride of the *New York Herald* agreed with Fornaro and Wright that Frueh was superior to Massaguer and at least as clever as Max Beerbohm. He wondered, however, whether Frueh's "summary" of George M. Cohan would seem quite so funny in a country where the actor was less well known. The caricatures of Daumier, Gavarni, and Beerbohm, he pointed out, do not require knowledge of the subject to be appreciated, but to really enjoy the featureless figure with the hat and cane one needed to know Cohan's performance style. Implicit in McBride's statements is the notion that this caricature was indelibly wed to the familiarity of celebrity—this was not a timeless depiction embodying generalized human traits. Unlike nineteenth-century graphic satire, in which a portrait often epitomized stupidity or rapacious greed, Frueh's likeness epitomized Cohan.[45] Focused not just on likeness but on the celebrity image, the caricature exaggerated precisely those traits that were featured in the press. This publicity-based approach to satiric portraiture characterized American caricature of the period.

In his article on Frueh, Fornaro complained that Americans confuse caricatures with cartoons and other humorous drawings. The comment was echoed by Alfred Stieglitz, who, in a rather plaintive letter, wrote to thank Frueh for sending him a copy of *Stage Folk*, which he had shared with Georgia O'Keeffe.

> I can't begin telling you what pleasure your magnificent gift has given me. And also given O'Keeffe. . . . It is truly a very superb piece of work—felt. Very unusual these days over here particularly. I know I am going to look at the portfolio often—show it too—& I know I shall always enjoy it greatly.
>
> What a pity it is that the American people have no conception of or feeling for caricature! But so much is a pity these days.[46]

Despite the discouragement of Fornaro and Stieglitz, Frueh's portfolio marked a turning point for the type of caricature that they had championed. In the early 1920s celebrity caricature exploded in the popular press. In addition to the newspapers, the magazines of the era found these clever stylizations well suited to their new urban home. Frueh's own career reflected the change: despite critical acclaim, he did not begin to earn his income primarily by drawing portraits until the 1920s. But from that point on his caricature career

thrived despite his resistance to political work and his reluctance to be syndicated.[47]

Frueh's first theatrical portraits for *Life*, published in October 1920, marked the beginning of this new phase of his career. The old humor journal boasted considerable talent and a healthy subscription list in the years after World War I. Robert Benchley was writing the drama section for *Life* when Frueh's drawing of George Arliss appeared in the October 7 issue. Benchley opened with a review of the coughers in the audience during one memorable first night, commending in particular one gentleman in excellent voice who never missed a cue, coughing only at the moment of greatest psychological tension in each scene. Robert Sherwood joined the staff as film critic in 1921; Dorothy Parker contributed occasionally. Frueh's drawings were the visual equivalent of these witty new voices, and his sharp, concise delineations stood out among the multitude of busy little pictures scattered throughout each issue.[48]

Frueh's biggest career change came in 1925, when he left the *World* to work for Harold Ross's new magazine. At the *New Yorker* Al Frueh found another congenial outlet for his portraits, as well as a schedule more accommodating to his growing interest in his Connecticut farm. Frueh joined the *New Yorker* soon after it was founded, contributing cartoons to the first issue and the cover drawing for the second. He soon settled into a long and comfortable association with the magazine, supplying many cartoons, several covers, and hundreds of caricatures for the theater pages and the "Profiles" essays. From 1925 until his retirement in 1962 he had a relationship with Ross and successive editors that struck some as unusually serene. Brendan Gill remembered only one instance when Frueh was questioned by the fact-obsessed Ross and the drama critic Wolcott Gibbs. "You've given [Katharine] Cornell a cast in one eye," Ross reputedly told Frueh (fig. 5.25). "Gibbs says she hasn't got a cast." "Tell Gibbs to draw her," Frueh retorted, throwing the drawing at Ross's feet. In due course, Ross had occasion to see Katharine Cornell again on stage. "I saw Cornell last night," he told his art editor when he got to the office. "Tell Al that, goddam it, Gibbs was wrong. She *does* have a cast."[49]

Frueh, along with Ralph Barton and Miguel Covarrubias, forged a tradition of theatrical caricature at the *New Yorker* that would last for decades. His name ultimately became synonymous at the magazine with illustrations of the stage. Frueh's offerings usually included

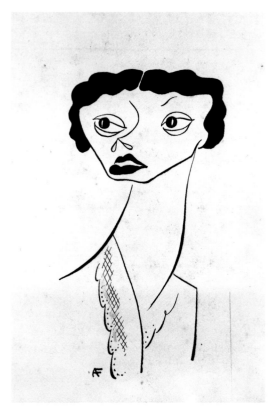

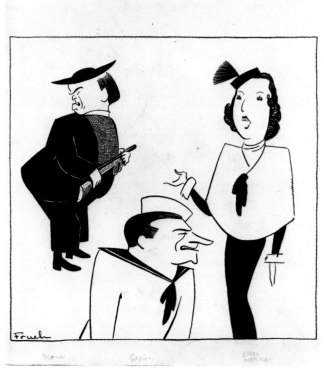

5.25 *Katharine Cornell* (1893–1974) by Al Frueh. Ink and gouache on paper, 32.5 x 29 cm (12³/₄ x 11⁷/₁₆ in.), 1931. National Portrait Gallery, Smithsonian Institution, Washington, D.C.; gift of the children of Al Frueh: Barbara Frueh Bornemann, Robert Frueh, and Alfred Frueh, Jr.

5.26 *Anything Goes* by Al Frueh. Ink and gouache on paper, 37 x 29.9 cm (14⁹/₁₆ x 11³/₄ in.), 1934. Original illustration for *New Yorker*, December 1, 1934. National Portrait Gallery, Smithsonian Institution, Washington, D.C.; gift of the children of Al Frueh: Barbara Frueh Bornemann, Robert Frueh, and Alfred Frueh, Jr.

several leading figures from a recent Broadway show. In his depiction of Ethel Merman, William Gaxton, and Victor Moore in Cole Porter's 1935 hit *Anything Goes* (fig. 5.26), for instance, he relishes the contrasts between the gun-toting gangster-parson, the happy-go-lucky sailor, and the vivacious chanteuse. The composition bristles with sharp corners, angles, and protuberances, from Moore's hindquarters to Gaxton's nose to the square shoulder of Merman's fur cape. In the hats and clothes, the repetition and contrast of black and white shapes establish an intricate visual pattern that binds the characters into a compelling unit.

Frueh's success at this type of illustration can be tracked in his files of correspondence, overflowing with complimentary letters, often from mere acquaintances or total strangers. H. G. Wells and George Gershwin both wrote of their admiration for their own caricatures. Editors and publishers, including Arthur Brisbane of

the *New York Evening Journal*, Ralph Ingersoll of *PM* magazine, and Carey McWilliams of the *Nation* repeatedly begged Frueh to contribute drawings to their own publications. Theatrical designer Robert Edmond Jones had a friend inquire about a caricature of himself published twenty years before; he wanted to own the original.

On the staff of the *New Yorker*, Frueh was appreciated with growing reverence. Extended visits to his Connecticut farm would result in impassioned pleas to return to New York. The note from editor Katherine S. White on September 30, 1933, was typical. "We need you badly this very minute as plays are beginning and important ones opening constantly. . . . Please, please come back to New York and get to work for us. We always need you on profile caricatures and on full page drawings and on everything and anything you can do for us." Wolcott Gibbs felt particularly dependent on Frueh's light touch. A Frueh caricature, he

pointed out in one pleading letter, "is supposed to be a mark of distinction for any show." "To me," he admitted, "the page looks as bleak as the Sahara without your work on it."[50]

Even the critical Ross grew increasingly admiring in his letters. "Innumerable people have spoken to me about the caricature you did on the 'Three's a Crowd' show. . . . I was talking to [art editor Rea] Irvin about it yesterday and I told him I thought you were the greatest caricaturist in the world today." Ross would repeat that opinion frequently, especially when everyone was talking about a successful caricature. "The recent one on the Cornell show" (fig. 5.27), he wrote in a letter not proofed for typing errors, "caused general exclamations of admaration. It was a wonder."[51] For Frueh's many admirers, an important new play — such as Thornton Wilder's *Our Town* — was all the better for his pictorial documentation (fig. 5.28).

By the 1950s the number of caricatures published in the *New Yorker* was beginning to diminish. But by this time Frueh was an institution. As Ross pointed out in 1951, if Frueh stopped submitting drawings, the editors wouldn't try to "run caricatures." "It's you or nobody, as things stand," he insisted. "What we're doing is running *you*, not just caricatures of shows. We long ago decided that." Editor William Shawn was equally reverential. In 1960 he called one of Frueh's caricatures "plainly brilliant." "Please don't think we ever take your caricatures for granted," he pleaded. "We are aware of their unique quality, and very proud of their appearance in the New Yorker."[52]

Frueh's long, successful career at the *New Yorker* should not overshadow his critical pioneering role in modern celebrity caricature. After World War I, as Fornaro concentrated on journalism and De Zayas became an advocate for African and avant-garde art, Frueh's inventive talent captured the attention of the art world and the public. His reductive approach to portraiture was more than linear. He pared away not only lines and details but references and allusions, focusing with precision on that essentially new phenomenon, the publicity-generated celebrity image. To editors of the smart magazines, Frueh's wit, spare line, and insightful summarization conveyed the sophisticated, urbane spirit they strove to evoke. Along with Ralph Barton, Frueh established the stylized portrait as a defining element of the urban magazine, fueling the 1920s caricature vogue.

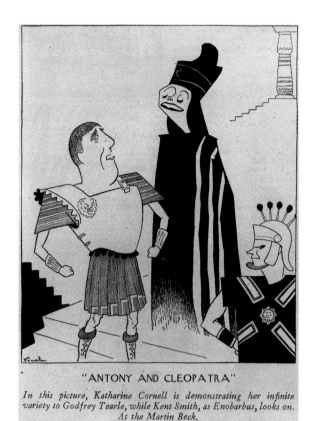

"ANTONY AND CLEOPATRA"

In this picture, Katharine Cornell is demonstrating her infinite variety to Godfrey Tearle, while Kent Smith, as Enobarbus, looks on. At the Martin Beck.

5.27 *Antony and Cleopatra* by Al Frueh. Printed illustration. Published in *New Yorker*, January 10, 1948. Collection of John Kascht.

5.28 *Our Town* by Al Frueh. Ink, 1938. Original illustration for *New Yorker*, March 5, 1938. Barbara F. Bornemann.

Part 3 The Vogue for Celebrity Caricature

6.1 *Ralph Barton and Carlotta Monterey* (1891–1931; 1888–1964) by Underwood & Underwood. Photograph, c. 1922. Diana Barton Franz.

Ralph Barton: *The Observer and the Observed*

It is not the caricaturist's business to be penetrating; it is his job to put down the figure a man cuts before his fellows in his attempt to conceal the writhings of his soul.
—Ralph Barton

It's all a question of masks, really, brittle, painted masks. We all wear them as a form of protection; modern life forces us to. We must have some means of shielding our timid, shrinking souls from the glare of civilization.
—Noel Coward

"Don't settle down comfortably in the ooze," urged a 1916 advertisement for *Vanity Fair* magazine. "The World is moving, moving on all eight cylinders. . . . Don't stall yourself on life's highroad and be satisfied to take everyone else's dust. Hop up and take a little joy ride on the red and yellow band wagon—Vanity Fair's bandwagon."[1] Beneath the bantering tone, this imagery of modern technology, movement, and speed conveyed an optimistic notion of progress integral to the conception of Condé Nast's new urban magazine. "*Vanity Fair* has but two major articles in its editorial creed," editor Frank Crowninshield had announced in the March 1914 issue, "first to believe in the progress and promise of American life, and second to chronicle that progress cheerfully, truthfully, and entertainingly." *Vanity Fair* promoted experimentation in the arts at a time when modern elements of culture seemed to form a dynamic force closely linked to progressive thinking and social change.[2] With its commitment to innovation in art, music, literature, and graphic design, *Vanity Fair* reflected this concept of cultural progression. But its mission was neither political nor solemnly didactic. It would champion the best in humor and the popular arts. This was a joy ride after all, and *Vanity Fair* was not going to leave anyone behind in the dust.

The new form of celebrity caricature seemed perfectly suited for this giddy excursion toward modern sophistication. More than any other contemporary publication, *Vanity Fair* embraced humorous portraits of the famous, promoting new artists and approaches. Although smaller in circulation than Nast's other publications, *Vogue* and *House and Garden*, it was a prestigious arbiter of cultural trends. If it was ignored by the great mass of magazine subscribers, it was noticed by influen-

tial people in publishing and the arts. As a result, other New York editors heeded Crowninshield's increasing use of celebrity portraits. Some had already experimented with these drawings, combining them with other comic offerings. But *Vanity Fair* was the first to make modern caricature integral to its urbane mission. By the time it merged into *Vogue* in 1936 the magazine was featuring stylized portraits on full-page frontispieces and covers; caricature had become part of its identity and its advertising campaign. Many of the magazines of the 1920s and 1930s would follow its lead.

Vanity Fair's promotion of caricature explains how newly emerging artists, such as the talented Kansas City–born Ralph Barton (1891–1931; fig. 6.1), began to specialize in portraiture of the famous. As Bruce Kellner has chronicled in his biography of Barton, the young illustrator moved to New York City in about 1912 after studying briefly at the Art Institute of Chicago and working for the Kansas City newspapers.[3] With his friend Thomas Hart Benton he settled into a studio in the Lincoln Arcade, a stimulating environment that housed other Kansas City expatriates, including actor William Powell and art critic Willard Huntington Wright. Success came relatively quickly as editors discovered Barton's stylish, elongated figures in high-fashion clothing. Throughout the 1910s his reputation and income grew steadily as *Puck, Judge, Collier's*, and other magazines published his black and white illustrations and color covers. *Puck* sent Barton to Europe in 1915 as a special correspondent, publishing his drawings of wartime Paris.

Barton claimed influences as various as Greek vase painting and the Egyptian wing at the Metropolitan Museum of Art, but the editors undoubtedly recognized his affinity for French fashion illustration. The

6.2 *Among Those Noticed on Main Street Were*— by Marius de Zayas. Printed illustration. Published in *Puck*, April 3, 1915. Prints and Photographs Division, Library of Congress, Washington, D.C.

Parisian "mode," closely allied to trends in art, publishing, dance, and theater, had an unusually broad cultural influence. Just before World War I, French designers led by Paul Poiret had introduced revolutionary concepts into haute couture, insisting on less restrictive female clothing. Poiret, inspired by Diaghilev's Ballets Russes and his own fondness for Oriental fantasy, emphasized loose, flowing designs in colorful, exotic patterns. Illustrators such as Erté (Romain de Tirtoff), George Lepape, Charles Martin, and Eduardo Benito disseminated this vision in albums of colored plates, French fashion journals, and covers for *Harper's Bazar*, *Vogue*, and other American magazines. An impossibly long, slim female form of exquisite grace invariably modeled the new look.[4] Barton heightened this exotic Parisian elegance with startling bursts of color and a thin, fluid, calligraphic line that would remain characteristic of his drawing even as his style changed.

Barton's initial success in the New York press exactly coincided with the advent of *Vanity Fair*. Just as his elegant, attenuated figures began appearing in the popular magazines, Nast and Crowninshield were busy reinventing what a smart, urban journal should be. Condé Nast had planned his new magazine, first issued as *Dress and Vanity Fair* in September 1913, for a metropolitan audience of taste and means that would attract advertising for luxury products. The publisher went against conventional wisdom when he ignored mass-marketing techniques and turned his high-toned periodicals into "class publications," targeting a small and specialized

group of consumers. His aim was to "lift out of all the millions of Americans just the 100,000 cultivated people who can buy these quality goods."[5] Since *Vogue* focused on fashion, and *House and Garden* covered home decoration, Nast intended *Dress and Vanity Fair* to examine leisure activities, entertainment, and the arts.

Nast begged his readers in early issues to inform him of their tastes and preferences. From the beginning, however, he knew that he wanted to emphasize those glamorous people who epitomized the metropolitan spirit. "Through these pages," he promised in the December 1913 issue, "will come and go a long procession of interesting persons. Men and women of the fashionable world—stars of the American and European stage; painters, sculptors and musicians; players of games; everyone, in a word, who through some striking merit of one kind or another, makes what Bunyan called "a great stir at the Fair." A Hall of Fame feature was planned, he announced in the same issue, to present the "half dozen or so Cosmopolites who happen at that moment to stand forth most boldly in the roving spotlight of Popular Fancy."[6] Significantly, these were not elections to a Hall of Fame—which would smack of tedious, professorial, historical permanency—but nominations. *Vanity Fair* was positioning itself as a scout for new talent, anticipating those who were going to make their mark.

Early in 1914, Frank Crowninshield was at the helm, bringing to the magazine his understanding of café society arts and culture, his passion for innovative talent, and his keen, polished wit. While Nast worried about advertising revenues and the quality of the printing, Crowninshield concentrated on recruiting talent. In the pages of *Life*, *Puck*, *Judge*, and the *New York World* he found writers like Robert Benchley, Dorothy Parker, and Robert Sherwood, and artists like Frueh and Barton. He promoted new young authors, modern French and American painting, and popular entertainers. *Vanity Fair* would publish the art of Matisse, Gauguin, Picasso; the poetry of Gertrude Stein, T. S. Eliot, E. E. Cummings; the humor of Parker, Benchley, Ring Lardner, and Corey Ford; the photographs of Baron Adolf de Meyer, Cecil Beaton, and Edward Steichen. Crowninshield also intended to cover the cinema, the cabarets, magic, and theatrical masks.

In large measure, the editor's sense of his audience ensured the success of the new venture. Equally at home with the pedigreed establishment and talented

newcomers, he sought to revitalize the conservative sensibilities of the well-born and elevate the taste of those striving to join glamorous society. His conception of his audience was instinctive, drawn from his own range of acquaintances, for Crowninshield dined not only with famous follies stars and society matrons but also with impoverished writers just out of Harvard and secretaries who took him home to meet their parents. He targeted a genteel, progressively minded, middle- to upper-class urban reader with enough breeding and affluence to appreciate quality and enough spirit and imagination to respond to modern ideas. The astute editor understood that this was a group eager to be introduced to the emerging urban culture and its celebrities.

Nast's emphasis on fine printing and famous personalities combined with Crowninshield's focus on updated style and humor to create a perfect context for caricature. Why, then, did the editor wait several years—until the early 1920s—to begin publishing caricature? Crowninshield must have been well aware of stylish, modern forms of distorted portraiture in the 1910s. He appreciated the work of Max Beerbohm, whose essays he had solicited when he was an editor at *Century* magazine, and he could not have ignored the growing reputations of various artists working in New York. He would surely have noticed Al Frueh's linocuts appearing in the *New York World* and in gallery exhibitions, and the caricatures of Carlo de Fornaro and Marius de Zayas in *Puck* before its demise in 1918. Indeed, such images as De Zayas's friezelike illustration of New Yorkers scurrying along Fifth Avenue in *Puck* (April 3, 1915) evoked *Vanity Fair's* own themes of urban modernity and celebrity (fig. 6.2).

The example of the English *Vanity Fair* hovered before him, however. The London version, which had folded just as the New York magazine was being launched, had been famous for its caricatures since its beginning in 1868. With a few exceptions, however, such as Beerbohm's occasional contributions, the drawings had declined after the turn of the century into generally tepid, informal portraits largely lacking in humor or insight. Distancing his magazine from the defunct London publication was one of Crowninshield's chief tasks, and, at first, caricature of the famous probably seemed too imitative. But after the first few years, modern forms of stylized portraiture seemed too germane to *Vanity Fair's* conception to be ignored.

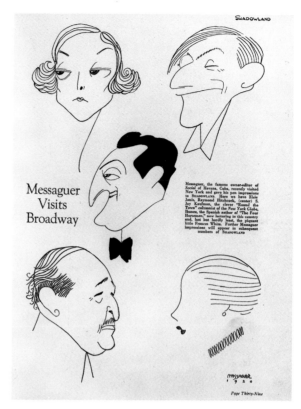

6.3 *Massaguer Visits Broadway* by Conrado Massaguer. Printed illustration. Published in *Shadowland*, June 1920. Library of the National Portrait Gallery and the National Museum of American Art, Smithsonian Institution, Washington, D.C.

Crowninshield may have taken his cue from the film magazine *Shadowland*, which began a caricature series in 1920, replacing bland, barely distorted portraits by Wynn Holcomb with cleverly abbreviated heads by Conrado Massaguer. The Cuban caricaturist, on one of his many visits to New York, had chosen Broadway as his theme for these pages, depicting the faces of well-known actors, drama critics, and playwrights (fig. 6.3).[7] *Life* provided another inspiration, featuring Al Frueh's theatrical drawings between October 1920 and the following June. And the film magazine *Photoplay*, during the same period, published two audience pictures by Ralph Barton. "A Cross Section of Parisian Cinema" combined ages, classes, and ethnic types into a generic movie audience, depicted in profile. In a New York variation on the theme that appeared a few months later, Barton captured a felicitous mix of comic types—the haberdashery salesman, the aspiring actress, the

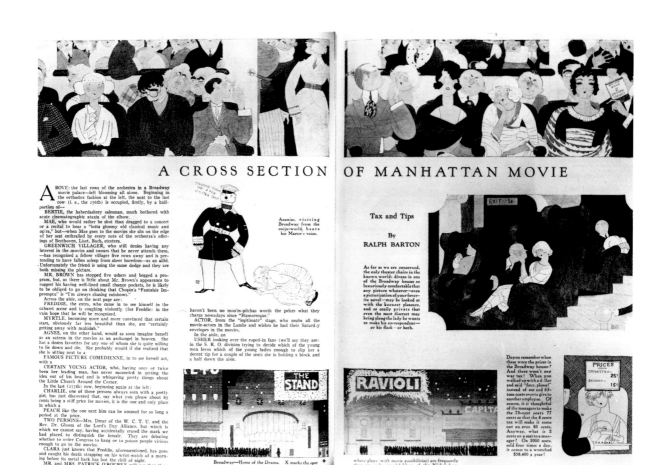

6.4 *A Cross Section of Manhattan Movie* by Ralph Barton. Printed illustration. Published in *Photoplay*, March 1921. Academy of Motion Picture Arts and Sciences, Los Angeles.

Greenwich Villager—all entertainingly described by Barton in the text. This time he showed his audience from the front, directly engaging the viewer (fig. 6.4).[8]

Crowninshield must have recognized more than just clever draftsmanship in Ralph Barton, who had a charm, sophistication, and cosmopolitan taste not unlike the editor's own. The young artist had recently visited Hollywood, where he tried out his skills as an art director for a Rudolph Valentino movie. Although he disliked the movie world's frantic pace and lack of independence, the trip resulted in a lifelong friendship with Charlie Chaplin, a fascination with film, commissions for illustrations, and a familiarity with new Hollywood personalities that few New York illustrators could match. By 1920, Barton had divorced his first wife, remarried, and visited Paris again, establish-

ing a pattern of troubled relationships and ceaseless wandering that related to his struggle with manic depressive illness. But his repertoire had expanded along with his passion for all things French, and *Vanity Fair*'s editor undoubtedly saw his potential.

Perhaps as an experiment, Crowninshield published Barton's first group caricature in the magazine in May 1921 (fig. 6.5). Entitled "Hail! Hail! The Gangplank's Here!" the crowded scene depicted literary lecturers from the British Isles. Assuming a degree of familiarity with Sir Arthur Conan Doyle, G. K. Chesterton, William Butler Yeats, and others on the lecture circuit, *Vanity Fair*'s editors promised the contents of one wastepaper basket to the first reader who could match all the famous names with Barton's caricature figures. The celebrity recognition game proved highly appeal-

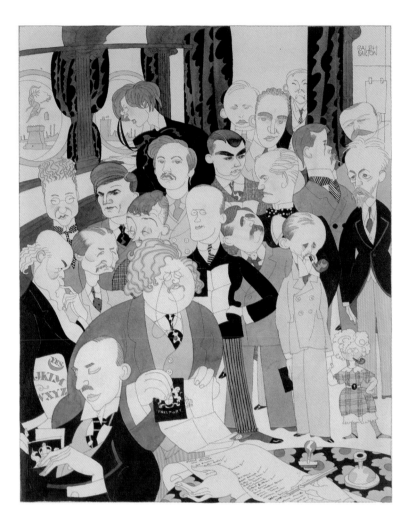

6.5 *Hail! Hail! The Gangplank's Here* by Ralph Barton. Ink and wash on paper, 48.4 x 41.3 cm (19⅛ x 16¼ in.), 1921. Mr. and Mrs. Karl H. Klein.

ing. Critic Bohun Lynch noted a few years later that the success of this one drawing encouraged Barton to abandon more general comic draftsmanship for the portrait caricature that he had until then "regarded merely as a recreation and amusement."[9] The picture worked because *Vanity Fair's* audience made it its business to be well informed. Recognizing the famous signaled one's awareness and taste. Those who aspired to the new café society had to read the right magazines, books, and newspapers and attend the popular restaurants, plays, movies, and events. They had to know, as Crowninshield pointed out to Condé Nast, "the things people talked about."[10] And the current stars of this evolving culture were a major topic of conversation.

Crowninshield and Barton, to their surprise, had identified an enthusiastic audience for modern carica-

ture. These drawings had first appealed to the avant-garde circle of 291 and then to the broader art world of the galleries and the independent artists' exhibitions. They had just begun to make their way into the crowded pictorial realm of the Sunday newspaper. But their most appreciative audience were those urban sophisticates epitomized by the readers of *Vanity Fair* and other smart magazines. Both Barton and Crowninshield were ready to capitalize on its celebrity preoccupation and to showcase caricature as stylish innovation. Crowninshield introduced to his readers new personalities and their accomplishments; Barton made recognizing their faces an entertaining pastime.

In September 1921, *Vanity Fair* published his next caricature scene, "When the Five O'Clock Whistle Blows in Hollywood." In this illustration Mary

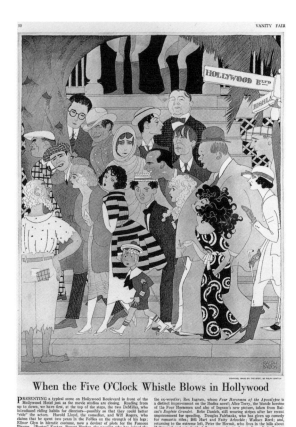

When the Five O'Clock Whistle Blows in Hollywood

PRESENTING a typical scene on Hollywood Boulevard in front of the Hollywood Hotel just as the movie studios are closing. Reading from up to down, we have first, at the top of the steps, the two DeMilles, who introduced riding habits for directors—possibly so that they could better "ride" the actors. Harold Lloyd, the comedian, and Will Rogers, who claims that he spent two years in the Follies on the strength of his legs; Elinor Glyn in hieratic costume, now a deviser of plots for the Famous Players. "Buster" Keaton, Rupert Hughes, the novelist who has joined the Goldwyn staff of eminent authors—in Hollywood all authors are eminent. In broad checks, and with unmistakably pugilistic profile, Bull Montana,

the ex-wrestler; Rex Ingram, whose *Four Horsemen of the Apocalypse* is a distinct improvement on the Ibañez novel; Alice Terry, the blonde heroine of the *Four Horsemen* and she of Ingram's new picture, taken from Balzac's *Eugénie Grandet*. Bebe Daniels, still wearing stripes after her recent imprisonment for speeding. Douglas Fairbanks, who has given up comedy for romantic rôles; Bill Hart and Fatty Arbuckle; Wallace Reed; and, returning to the extreme left, Peter the Hermit, who lives in the hills about Hollywood and sets forth daily on crusades to the studios. Jack Coogan and Charlie Chaplin, the society man who discovered him. Mary Pickford; Nazimova, in her street costume—pyjamas; and, finally, Gloria Swanson.

6.6 *When the Five O'Clock Whistle Blows in Hollywood* by Ralph Barton. Printed illustration. Published in *Vanity Fair*, September 1921. Library of the National Portrait Gallery and the National Museum of American Art, Smithsonian Institution, Washington, D.C.

Pickford, Douglas Fairbanks, Alla Nazimova, Fatty Arbuckle, and other cinema luminaries hustle down Hollywood Boulevard with the comic premise that they are normal mortals going home after a day's work (fig. 6.6).[11] Of course, these celestial beings, with their exotic costumes, dramatic poses, and iconic faces, were far from ordinary. But even though they existed outside the real workaday world, they were not beyond Barton's sphere. *Vanity Fair*'s artist was "on the spot," according to the caption, observing these legendary figures as they went about their daily lives. The reader, smiling with recognition, could participate in that intimate contact. By November 1921, Barton had contributed his third illustration for that year, "self-portraits" of four French Impressionist artists drawn in

imitation of their own distinctive styles.[12] Each of these group caricature pictures drew an outside world into the purview of *Vanity Fair*'s sophisticated audience. British lecturers, French painters, and Hollywood movie stars became a familiar part of that moving panorama of urban culture on which the magazine had set its sights.

Like De Zayas and Frueh, Barton frequented the theater, and his next group portrait for *Vanity Fair*, with its evocation of Broadway glamour, led to even greater success than his first. Barton himself had been a regular "first nighter" ever since 1914, when he began illustrating a column for *Puck* written by critic George Jean Nathan. Although that collaboration yielded mostly generic illustrations, his work for Nathan's successor, Alan Dale, produced his first regular series of caricature portraits, starting in December 1916. Abandoning his generalized ingenues, Pierrots, and villains, he delineated actors and actresses, inking in the name beneath each one. Despite his lively line, these early efforts resembled costumed mannequins more than distorted portraits.

But shortly after his first modest attempts at caricature, he evidently encountered the work of the ubiquitous Max Beerbohm, which served to mature his style. Barton's 1917 drawing of Anton Chekhov surrounded by a group of playwrights documents the English artist's influence.[13] Although the figures are varied and well drawn, they are strikingly derivative of Beerbohm's portrayals of the same individuals. Undoubtedly Barton's enjoyment of Beerbohm's work challenged him to abandon his elongated mannequins and experiment with the distortions of face and figure. His dependence was short-lived, however. The stiff contours of that early drawing soon gave way to a remarkable freedom of line, and the mannered faces became far more spontaneous and vital.

Barton's career up to this point had stationed him squarely in the center of the postwar worlds of fashion, theater, film, and magazine publishing. Dapper, cosmopolitan, and engaging, he had a knack for charming everyone he met—from young, aspiring artists to renowned, publicity-weary public figures. He was the ideal person to capture New York café society from the inside. And his comic interpretation of this world would captivate all Manhattan.

Barton had experimented with both audience pictures and group caricatures of the famous, and for *Vanity Fair*'s April 1922 issue he combined the themes. "A Typical First Night Audience in New York:—The

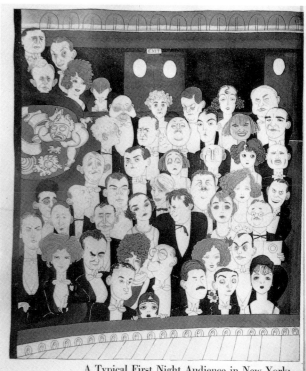

A Typical First Night Audience in New York:—
Ingredients in the Mixed Grill of Metropolitan Life

Left Upper Box—A. H. Woods, Avery Hopwood, Florenz Ziegfeld, Jr., Billie Burke.

Left Lower Box—John Barrymore, Michael Strange.

First Row—John Emerson, Anita Loos, Fritz Kreisler, Irving Berlin, Irene Bordoni.

Second Row—J. Montgomery Flagg, Mrs. Leslie Carter, John Drew, Leonora Hughes, Maurice.

Third Row—Robert C. Benchley, Franklin P. Adams, Mrs. Lydig Hoyt, Heywood Broun, Neysa McMein, Alexander Woollcott.

Fourth Row—George S. Kaufman, Marc Connelly, Herman Tappé, Max Eastman, Victor Herbert, Marilynn Miller, John V. A. Weaver.

Fifth Row—George M. Cohan, J. Hartley Manners, Laurette Taylor, Alan Dale, Bird Millman.

Sixth Row—Oliver Harford, Herbert Swope, Nicholas Murray Butler, Ring Lardner, Molla Bjurstedt Mallory, Deveraux Milburn.

Seventh Row—George P. Baker, Anne Morgan, Joseph Urban, Elsie Janis, Percy Hammond.

Back Foyer—Ralph Barton—sketching.

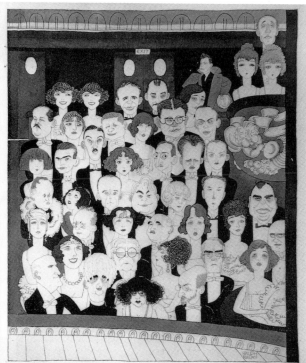

The Scene Which Invariably Confronts the Actor
A Social Panorama, Sketched on the Spot, by Ralph Barton

Right Upper Box—Dorothy Gish, D. W. Griffith, Lillian Gish.

Right Lower Box—Clare Sheridan, Samuel Goldwyn.

First Row—Charles Dana Gibson, David Belasco, Lenore Ulric, Daniel Frohman.

Second Row—Geraldine Farrar, Dr. Frank Crane, Kitty Gordon, Dr. John Roach Straton.

Third Row—Dolores, Charles Hanson Towne, Irene Castle, Otto H. Kahn, Zoë Akins, Elsie Ferguson.

Fourth Row—George S. Chappell, Margaret Severn, Condé Nast, Don Marquis, Elsie De Wolfe, Baron De Meyer, Irvin S. Cobb.

Fifth Row—Gilda Gray, Kenneth MacGowan, Robert E. Sherwood, Constance Talmadge, Louis Untermeyer, Arnold Genthe, Willard Huntington Wright.

Sixth Row—Reginald Vanderbilt, Alma Gluck, Efrem Zimbalist, Mrs. Harry Payne Whitney, Robert W. Chanler, Frank Craven.

Seventh Row—The Fairbanks Twins, Theodore Roosevelt, Jay Gould, Fannie Hurst.

Back Foyer—George Jean Nathan—leaving the theatre in the middle of the second act.

Scene Which Invariably Confronts the Actor" depicted an audience of eighty-nine recognizable figures, all identified below the picture (fig. 6.7)[14] The subtitle, "Ingredients in the Mixed Grill of Metropolitan Life," identifies its principal theme: that rich mix of talent, wealth, and celebrity that constituted New York's café society. Entertainment stars and impresarios consort with the Whitneys and Vanderbilts, members of the press, and anyone else with a famous name in a celebration of glamorous Manhattan nightlife. This merging of once separate social sectors delighted some commentators and astounded others. Mrs. Charles Dana Gibson, one of the famous Virginia Langhorne sisters, remembered that all celebrities in her turn-of-the-century youth came from her own social class. "Of

course, we had others too," she commented, "but one didn't have them for dinner. They came after dinner— to entertain."[15] The change began after the war, F. Scott Fitzgerald recalled, this "blending of the bright, gay, vigorous elements . . . , and for the first time there appeared a society a little livelier than the solid mahogany dinner parties of Emily Price Post." Society editor Maury Paul marveled at the commingling of the "Old Guard" and "Café Society." "It's like a seafood cocktail," he mused, "with everything from eels to striped bass!"[16] Like the mixed grill and seafood cocktail, the new combinations of café society provided a flavorful appeal.

Portraying the entire first-night world in microcosm, Barton captured both the excitement and the humor of

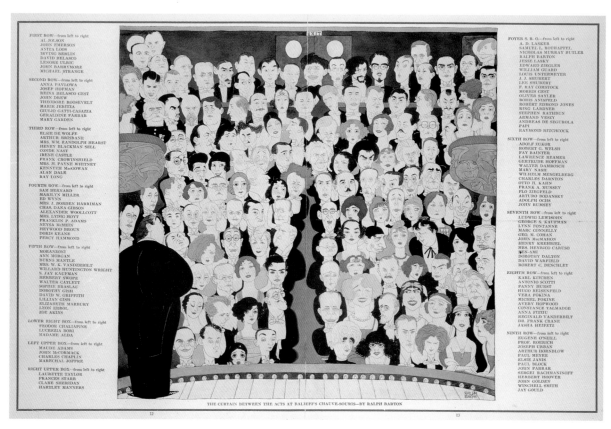

6.8 *Chauve-Souris Curtain* by Ralph Barton. Printed illustration. Published in Chauve-Souris program, 1922. National Portrait Gallery, Smithsonian Institution, Washington, D.C.; gift of Bruce Kellner.

the new urban mix. Once again, the image was "sketched on the spot," implying that the artist himself viewed the scene from the stage, cleverly reversing and expanding the roles of actor and audience. Like other celebrated members of the press, the caricaturist functions here as both the observer and the observed, a prominent performer as well as a detached onlooker. The conception was too good to languish in a single issue of *Vanity Fair*, and it didn't. Before long Barton was blowing up his picture to enormous size: creating his famed intermission curtain for the Chauve-Souris, a popular Russian musical revue.

The Chauve-Souris, or "Bat Theater," that impresario Morris Gest had imported from Paris had opened in February 1922 to rave reviews. The songs, skits, and dances were staged by Russian actor Nikita Balieff, who, "like a Puck in evening dress," introduced each performance with a thick accent and an irresistible comic charm.[17] By April, *Vanity Fair* would point out

that if you had not seen the Chauve-Souris you would be forced to pretend you had at every lunch and dinner, for "all smart New York" had already attended. When Gest negotiated a summer version of the show, Balieff concocted a new bill of musical and comic routines, and company artist Nicholas Remisoff redesigned the stage set. For the opening on June 5, 1922, the *New York Times* reported, an "outpouring of society and theatre folk" came to see Balieff's magic. Remisoff had decorated the newly renovated Century Roof theater as never before in an exotic, colorful fantasy of sun, moon, stars, magic carpets, and flying horses.[18]

But the intermission feature that June evening provoked as much surprise and delight as the famed troupe and romantic stage set. As the huge curtain descended, the assembled crowd found itself confronting an audience of 139 recognizable first-nighters, all staring back. The audience in the theater spent the intermission identifying familiar faces on the curtain,

each individual hoping to glimpse his own caricature among the chosen. The color reproduction in the program provided a permanent souvenir (fig. 6.8). "The effect was electrifying," recalled caricaturist Aline Fruhauf in her memoirs, "and the applause was great." The caricature curtain introduced a theatrical innovation, as Willard Huntington Wright pointed out in *Vanity Fair*, and seemed as novel as the Chauve-Souris itself. "Surely no caricaturist ever enjoyed before so generous an exhibition!" noted critic Bohun Lynch. It was, *Theatre Magazine* raved in September 1922, "probably the most unusual and striking gallery ever executed of humorous likenesses."[19]

The rotund figure of Balieff stood on the stage in Barton's audience scene, and his bat-winged head decorated one of the box seats. But those were the only references to the Chauve-Souris itself. The curtain focused on New York's fashionable celebrity world. According to his daughter's reminiscences, Barton spent considerable time calibrating his mix of people. In the end, he produced what Richard Merkin has called a kind of Broadway Social Register of the intersecting worlds of theater, the press, and society.[20] Inclusion was highly complimentary. The entertainment industry formed a large portion of this cast of characters. In addition to such stage and film luminaries as John Drew, Maude Adams, John Barrymore, and the Gish sisters, Barton included movie director D. W. Griffith, opera singers Feodor Chaliapin and Geraldine Ferrar, set designers Robert Edmond Jones and Joseph Urban, and composers Irving Berlin and Sergei Rachmaninoff. With wry wit Barton relegated several theatrical producers, including Lee and J. J. Shubert and Morris Gest himself, along with his partner, F. Ray Comstock, to the standing room section at the back. These luminaries could hardly be offended. Barton had placed his own self-portrait among them. Scattered among these entertainment stars were a selection of other types sure to be found in a fashionable audience. Theodore Roosevelt, Jr., Jay Gould, and Mrs. William K. Vanderbilt represented political, business, and high-society circles.

In addition, Barton's audience scene teemed with friends and colleagues from the press. Along with Nast and Crowninshield, Barton drew in Adolph Ochs, publisher of the *New York Times*; Herbert Swope, editor of the *World*; and Henry Blackman Sell, editor of *Harper's Bazar*. Drama critics and columnists were also well rep-

resented: Alexander Woollcott, Franklin P. Adams, Heywood Broun, Alan Dale, and others. The press, Barton implies, had become a prominent component of this celebrity elite. Indeed, the postwar media created and maintained that world, refining its parameters on a daily basis. Its most successful practitioners became famous in the process. They were no longer on the periphery of this glamorous circle but central to it.

The entr'acte curtain was not entirely a surprise. Although expanded, it was similar to the *Vanity Fair* audience picture. Almost identical images of Irving Berlin and of the petite Anita Loos and her husband, John Emerson, for instance, appear in the first row on the left. New Yorkers had also gotten a preview of the curtain on May 7, 1922, in a large reproduction in the drama section of the *New York Times*.[21] The caption, with the title "What Balieff sees of America," listed the famous names. The design was nearly complete at that point, although Barton would fit in a few more heads before the curtain was installed. Several other newspapers ran the image after its appearance in the *Times*, including, on May 21, Barton's hometown paper and former employer, the *Kansas City Star*. Barton's mother sent him the clipping from Kansas City.

But the translation of printed illustration to theater curtain startled everyone. It had required a herculean effort. "I have just finished up the enormous task of painting the curtain," Barton had written to his mother. He did it by himself, he explained, with only the assistance of a German painter to help with the "dirty work," and it was "enough to keep me at it during all my waking hours all last month." He worked on a three-foot-wide bridge with no railing installed four stories above the stage of the Manhattan Opera House. The curtain hung loosely on a movable frame. "I do hope it won't be a disappointment after all the talk it has stirred up here," he wrote.[22] Few other personalities would have driven themselves to this degree. Working under extremely taxing conditions, Barton laboriously painted almost twelve dozen separate portraits. Nobody took comic work more seriously or produced more brilliant effects.

Like most other theatrical enterprises, this novelty was in many respects collaborative. Balieff and his resident artist Remisoff might have provided the initial inspiration, for the walls of the original Chauve-Souris in Moscow had been decorated with caricatures of leading theatrical figures from the Moscow Art

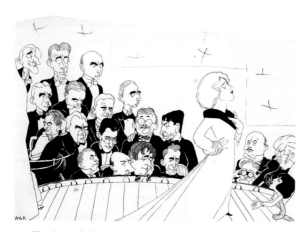

6.9 *The New York Critics* by Walt Kinstler. India ink with colored pencil over pencil, 30.5 x 40.8 cm (12 x 16¹⁄₆ in.), 1923. Original illustration for *Sunday Eagle*, Brooklyn, March 18, 1923. National Portrait Gallery, Smithsonian Institution, Washington, D.C.

Theatre. And Remisoff, himself an accomplished caricaturist, was a former editor of the Petrograd comic weekly *Satirikon*.[23] Morris Gest, endowed with an imagination often described as grandiose, claimed that he had conceived the notion of inflating caricature illustration to the size of a curtain. Remisoff was too busy producing the new set for the Century Roof to do the job, but Gest's friend Henry Blackman Sell knew just whom to recommend. Sell had recently started publishing Barton's illustrations in *Harper's Bazar*.[24]

Whatever the role of others in the initial conception, Ralph Barton transformed it into a compelling theatrical occasion. Although many of his subjects had never appeared on a stage, all were public performers, and Barton understood the desperate theatricality of the age better than anyone. Each one was not only part of the audience but part of the show, participating in the larger drama of a developing urban culture. As everyone knew, a prominent opening night took place on both sides of the curtain; those in attendance could inspire as much comment in the press as the quality of the performance. In this case the curtain that usually separated performer and viewer acknowledged with deft irony the audience's role in the glamour and pageantry of the evening. While onlookers laughed at the distorted likenesses, those who recognized themselves were delighted to be included. Each amusing,

recognizable face was a tribute, a complimentary suggestion that that individual was one of those making what Condé Nast once called a "great stir at the Fair."

By 1932, when F. Scott Fitzgerald wrote his autobiographical essay *My Lost City*, Barton's curtain had already become legendary, a symbol of Jazz Age celebrity. "We 'knew everybody,'" he recalled, speaking of the late 1920s, "which is to say most of those whom Ralph Barton would draw as in the orchestra on an opening night." The audience curtain showcased not only his own talents but caricature itself. Like De Zayas's staged assemblage of cutout boulevardiers, it took caricature off the printed page. But as a public theatrical event it reached a much larger audience than an exhibition at 291. New Yorkers returned to the Chauve-Souris repeatedly—Gest published their enthusiastic letters in the program—and had plenty of opportunity to admire Barton's handiwork. The Chauve-Souris troupe, periodically changing programs and theaters, performed successfully throughout the year and into the next season. In 1923 and 1924 the show toured the country. The audience curtain went along, proving as successful "in the provinces," Bohun Lynch reported, as it had been in New York. Barton was concerned about its welfare; it was dirty even before it left New York, he wrote to his sister. Increasing wear no doubt damaged it further, and the massive curtain does not seem to have survived its tour. But it had already inspired a vogue for curtains designed to entertain the audience before the show or during intermission. And other caricaturists, like the young newspaper artist Walt Kinstler, imitated the audience theme in print (fig. 6.9).[25]

Barton's reputation soared after the triumph of the curtain, resulting immediately in more commissions for his group caricatures. In September 1922 alone, *Theatre Magazine* reproduced the Chauve-Souris curtain, *Harper's Bazar* published a scene of its staff artists crowded into an elevator, and *Vanity Fair* featured "Custodians of the Key Stone in Silent Comedy." In 1923, Barton produced several different group caricature scenes for *Life*. Given the number of faces he composed in these groups, each is surprisingly individual and distinct.

To avoid repetition, Barton tried to find a different, witty context for his crowds of caricature faces. The double page spread in *Vanity Fair* in June 1923, for

instance, entitled "The Pursuit of the Bridegroom: A Tapestry Discovered at Hollywood with Textile Portraits of Some of the Bridegroom's Despairing Fiancées," depicted Barton's friend Charlie Chaplin sitting on a unicorn pursued by eight Hollywood maidens (fig. 6.10).[26] It was an elaborate spoof of John D. Rockefeller, Jr.'s well-publicized purchase of the fifteenth-century millefleur tapestry *The Pursuit of the Unicorn.* The *Vanity Fair* caption described its version as a gothic art treasure from about the same period, recently discovered in an ancient California monastery. Attended by his squire (Douglas Fairbanks in a suit of armor) and his page (young Jackie Coogan in striped tights), the hero, "Carolus Magnus," looks quaintly alarmed. Will Hays, regulatory czar of the film industry, appears as a supreme pontiff washing his hands of the entire affair. Like the theater curtain,

the tapestry theme implied a large-scale, decorative image, this time laden with the prestige of rare, antique, and costly fine art. Lower art aping higher forms would be a recurrent comic motif in caricature.

Barton's celebrity renderings, as much as John Held, Jr.'s flappers and college boys, epitomized for many the energetic spirit of metropolitan life. Stehlisilks Corporation thought so when it selected a Barton group portrait for its Americana series of printed silks. Ever since the war interrupted Parisian haute couture's dominating influence, textile manufacturers like Stehlisilks had been promoting American designs. Modern American art, one corporation pamphlet declared, "is the expression of a virile civilization; it is exciting, energetic, colorful."[27] The company chose Barton's *Vanity Fair* illustration of film notables dining at Hollywood's Cocoanut Grove (fig. 6.11). At the first

6.10 *The Pursuit of the Bridegroom* by Ralph Barton. Printed illustration. Published in *Vanity Fair*, June 1923. Library of the National Portrait Gallery and the National Museum of American Art, Smithsonian Institution, Washington, D.C.

6.11 *A Tuesday Night at the Cocoanut Grove* by Ralph Barton. Printed illustration. Published in *Vanity Fair*, June 1927. Library of the National Portrait Gallery and National Museum of American Art, Smithsonian Institution, Washington, D.C.

table, such "magnates" as Louis B. Mayer, Samuel Goldwyn, D. W. Griffith, Jesse Lasky, and Cecil B. de Mille communed with mock "Last Supper" solemnity. Another table accommodates writers—Dreiser, Mencken, Loos, Van Vechten, and others—while a third gathers together child actors. Famous profiles of Clark Gable, Douglas Fairbanks, Mary Pickford, and Eddie Cantor pop out of the picture. Chaplin arrives late; Will Hays serves as the maître d'hôtel.

The Cocoanut Grove design inspired at least one stylish young woman to make a simple flapper's frock from the silk (fig. 6.12). In an era intensely preoccupied with style, clothing made a definitive statement. Barton himself was a fashion plate, given to expensively tailored suits and silk underwear that matched his shirts. The caricature dress that his design inspired advertised its owner's affiliation with celebrity culture and modern

taste. "As truly as 'the style is the man,'" the Stehlisilks pamphlet insisted, "the style is the age. A certain mode of living, thinking and feeling underlies all the products of any one era—architecture, books, painting, music, clothes, express the same spirit."[28] But for the present generation, the pamphlet implied, style described more than common design trends of an era. It involved a conscious choice of current fashion over outdated aesthetics as a proclamation of one's modernity. Buy Stehlisilks designs, was the message, because they reflect the originality and dynamism of a new American era. Barton's celebrity caricature had become fashionable at a moment when fashion was an urgent matter.

The laborious work of these popular group images kept Barton busy. Although he still produced advertisements and general illustrations, caricature dominated his career in the 1920s. Often frustrated by the uneven

6.12 *Cocoanut Grove Dress* by Ralph Barton. Silk, size 10, c. 1927. National Portrait Gallery, Smithsonian Institution, Washington, D.C.; partial gift of Richard Merkin.

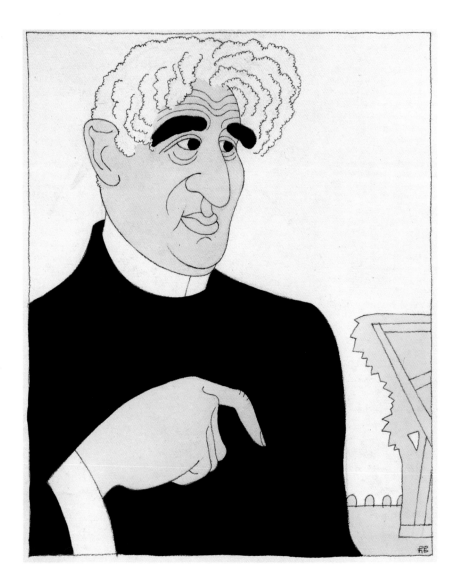

quality of color printing, Barton compensated by developing a largely monochromatic technique that made his drawings dramatic even when poorly reproduced. Although he used the same black ink on white paper employed by most other caricaturists, he was seldom satisfied by bold, reductive formulas. His pen-and-ink portrait of theatrical producer David Belasco (fig. 6.13), for instance, depicted with his curious affectation of an unearned clerical collar, appears at first glance a simple exploitation of monochromatic contrasts: dark brows against a snowy mane of hair and white collar against black coat. But Barton's drawings were seldom simple. The lines of wavy hair and the

jagged profile of a tree-like stage prop animate the image with their nervous, wiggling movement. A midrange tint—a pale blue wash in the original drawing that would reproduce as gray—on the hand, face, footlights, and prop adds a subtle depth to the picture. Barton's restless lines and layered tones invariably add a sense of vitality to the subject. Belasco, known as the "wizard" of Broadway, appears not as an office-bound impresario but as a creative power, directing activities on stage with a motion of one finger.

In his portrait of the comedy team Alfred Lunt and Lynn Fontanne (fig. 6.14) Barton used his monochromatic tones to highlight their differences. There is no

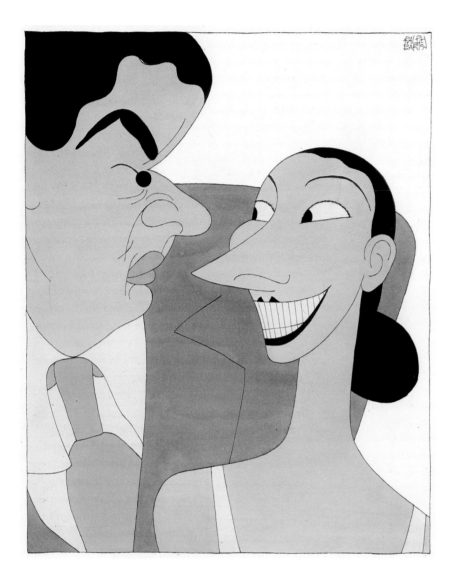

6.14 *Alfred Lunt and Lynn Fontanne* (1893–1977; 1887–1983) by Ralph Barton. India ink and wash with pencil on paper, 56.5 x 39.5 cm (22¼ x 15½ in.), c. 1930. Original illustration for *Life*, January 10, 1930. National Portrait Gallery, Smithsonian Institution, Washington, D.C.

white at all on Lunt's gray-toned face, with its beady-eyed expression of disapproval. The black and white contrasts of Fontanne's impish features, therefore, with their grinning acreage of teeth and expression of pop-eyed innocence, seem to sparkle in comparison. The insouciant expansion of her features against the worried compression of his describe their finely honed comic teamwork. Small details, like the ridiculous triangles of lipstick delineating her mouth, add to the humor, while the elegant interplay of various gray shapes lend a compositional unity to the picture.

By January 1923 the venerable humor magazine *Judge*, which had been publishing Barton's illustrations since 1914, had begun a regular caricature series. In another collaboration with drama critic George Jean Nathan, Barton produced weekly drawings, mostly identified portraits. *Judge* varied such full-page pictures with his occasional double-page theatrical roundup featuring five or six newsworthy performances. In the magazine's mocking "Rotogravure Section" by Barton in 1924, caricature replaced the expected photographic summary of the lives of the famous. Barton eschewed the bold clarity of most caricaturists in the images, interweaving highly complex linear patterns into his pictures. In his portrait of Walter Hampden as Cyrano de Bergerac for the December 8, 1923, issue, for instance,

"CYRANO DE BERGERAC"—by RALPH BARTON

Mr. Walter Hampden in his revival of Rostand's heroic comedy, at the National Theater. Miss Carroll McComas as Roxane

6.15 *Walter Hampden* (1879–1955) by Ralph Barton. Printed illustration. Published in *Judge*, December 8, 1923. Library of the National Portrait Gallery and the National Museum of American Art, Smithsonian Institution, Washington, D.C.

the loose-limbed swagger, the magnificent nose, and the plumed hat are drawn with a fluid freedom of line rather than a strong, tight contour (fig. 6.15). Although the illustration is crudely printed with two garish tints of green and orange, Barton had already achieved a tour de force of monochromatic coloring through his inventive line. Stripes, zigzags, curlicues, and spirals of hair, hat, and costumes create a riot of contrasting patterns that is lively, elegant, and comic.

But Barton could be an effective colorist, as his many magazine covers attest. In his portrait of the Hungarian-born photographer Nickolas Muray, for example, he combined black, white, and brilliant pink with subtle modulations of neutral hues (fig. 6.16). The several pale shades of tan, the tints of red on the face, and the touch of lavender on the framed picture are barely noticeable, but they add an intriguing complex-

ity to the simple geometry of the composition. Like Barton, Muray was a charming, outgoing man engrossed in a career making portraits of celebrities for the New York magazines. "A wild Hungarian," Barton once described his friend, "and the best photographer of his kind in New York."[29] In the drawing, both photographer and camera stare out menacingly at the viewer: Muray, a tensely crouching figure with spiky hair and dilated eyes, attends a rigidly geometric machine covered with a startling pink cloth. As one's gaze moves away from the compelling face and lens, it is drawn to the oversized hand squeezing a shutter bulb grotesquely resembling a human organ. The viewer is left with a sudden, disquieting feeling that the shot has already been taken and that he has been captured in an unintentional pose. Muray, in actuality, worked hard to put his famous sitters at ease. The underlying sense of menace in the picture described the relentless demands of celebrity more than the subject's personality. It suggested Barton's own state of mind and his self-mocking attitude toward his frenzied urban lifestyle.

The mid-1920s were years of frenetic activity. When Balieff's troupe returned to New York in 1925, Gest hired him to design another intermission curtain. The enormous job of painting faces on the fabric was done, according to the publicity, by an artist named Andrei Hudiakoff, but everyone recognized Barton's role in both the contorted faces and the clever conception. This time, inspired by the fad for crossword puzzles, Barton designed a "Chauve-Souris Cross-Face Puzzle," filling 176 blocks with celebrity heads. For the few who could not identify the famous faces, the souvenir program reproduced the image and included such vague clues as "three doughty wielders of the pen" and "two deities of the movies." *Women's Wear* declared that the intermission feature was so diverting that few in the audience left their seats.[30]

Besieged with commissions, Barton worked with manic intensity to produce a prodigious quantity of advertisements, book illustrations, and comic portraits. In 1926, Bohun Lynch described him as the most prolific caricaturist in America, an artist who had done much to revive the art. Barton himself once commented, Lynch noted, that "he had drawn so many caricatures that he must now wait for new subjects to be born. He had 'gone through' the American theatre and figures in 'La Vie New Yorkaise.'"[31] With his resulting affluence, Barton adopted a flamboyant life style of custom-made

6.16 *Nickolas Muray* (1892–1965) by Ralph Barton. Ink, gouache, watercolor, and charcoal over pencil on paper, 37.1 x 36.5 cm (14⅝ x 12¾ in.), c. 1930. National Portrait Gallery, Smithsonian Institution, Washington, D.C.; gift of Mimi and Nicholas C. Muray.

clothes and cars, grand houses, and frequent traveling.

Just before his Chauve-Souris triumph, and shortly after he had divorced his second wife, Barton fell in love with the beautiful actress Carlotta Monterey. In July 1922, not long after the two met, Barton made a portrait of her in watercolor, pencil, and enamel (fig. 6.17). "To Carlotta, this blasphemy," he inscribed it. The sharp distortions of the chin and nose do not fully disguise either Barton's passionate obsession or Monterey's exotic, dark-eyed elegance. The black hair, dress, and lashes are painted in a lacquered enamel, as is the deep, jewel-like red of her lips. Both colors are repeated in the enameled frame. A soft, sophisticated gray in the background sets off the rich tones with dramatic effect.

Carlotta Monterey became Barton's third wife in 1924. Her portrait hung along with other pictures against a background of gold tea paper in the living room of their beautiful apartment on West 47th Street at the time of their marriage (see fig. 6.1). To the young caricaturist Aline Fruhauf, who visited them at the time, the Bartons were the quintessence of sophistication and refined taste. Nickolas Muray remembered the lavish parties they gave, where "there was an apparently inexhaustible supply of food and liquor, always elegantly served." At one such occasion they staged a professional wrestling match in their living room to entertain their guests. At another, Charlie Chaplin performed, doing "double-talk in half a dozen languages" and playing several different instruments.[32]

On the same gold living room wall, however, next to Carlotta's likeness, hung a watercolor self-portrait conveying a different mood (fig. 6.18). This moving image, inscribed "With apologies to [El] Greco and God," reveals the haunted downside of Barton's manic depression, with its sleepless nights and increasingly severe periods of despair. The elongated face, with its sunken cheeks and sad, staring eyes, contrasts with the dapper sophisticate of Fruhauf's description, at the peak of his productivity and success. His illness would worsen, contributing to his restlessness and philandering, his 1926 divorce from Monterey, and the estrangement from his fourth wife, the French composer Germaine Tailleferre. It was the ultimate cause of his suicide in May 1931, just before his fortieth birthday.

In the mid-1920s, however, Barton's career was expanding. In one sleepless week in 1924, according to Dorothy Giles in an article written just after his death,

he completed eighty-five drawings. He had published a small book of light verse, *Science in Rhyme without Reason*, and illustrated several others. One of the most successful was Anita Loos's popular *Gentlemen Prefer Blondes*, the royalties from which netted Barton $30,000 in a few months.[33] From the publishers Boni and Liveright he had accepted a commission to provide pictures for a two-volume edition of Honoré de Balzac's *Droll Stories*. He was publishing regularly in *Liberty* magazine as well as *Life*, *Judge*, *Photoplay*, and *Vanity Fair*. It seemed that he could not possibly fit more into his overwrought schedule.

Nonetheless, in 1925 he agreed to serve as an advisory editor of Harold Ross's new magazine, the *New Yorker*. Ross admitted that his list of advisory editors was largely a gimmick to attract investment in the magazine.[34] But even though Barton's editorship was only titular—and he soon resigned—his extensive contributions, particularly in the first year, had a critical impact on the pictorial policies of the magazine. For the first few issues he concentrated on the theater. His opening salvo, appearing opposite the theater page in the first issue, February 21, 1925, was a synopsis of several recent shows, subtitled "a résumé of the present and rapidly aging theatrical season" (fig. 6.19). Four actors from different plays—Louis Wolheim, Pauline Lord, Lenore Ulric, and Alfred Lunt—are grouped in a circle, as if in conversation. Each, however, is brilliantly differentiated. Besides the obvious variety of costumes, Barton presented an adroit assortment of widely dissimilar noses, mouths, and eyes. The features range from cartoonlike summarization to meticulous rendering of human deformity reminiscent of Leonardo da Vinci's studies of grotesque heads. In Barton's work, however, there is a comic intent largely lacking in Leonardo's scientific explorations of malformation. Barton's invigorating humor adds a sparkling sophistication to the figures, suggesting admiration for each one's theatrical talent.

Despite a vacation to Paris with Carlotta in spring 1925, Barton's extensive contributions to the *New Yorker* helped to establish caricature and visual humor as a major feature of the magazine. His nearly full-page theatrical images had extended captions that served as miniature reviews. Even in monochromatic tones the kinetic energy of these images was hard to ignore. In his picture of Doris Keane and Leon Errol for the March 21 issue, the bright pinks and warm browns of the original drawing are missing in the reproduction,

6.17 *Carlotta Monterey* (1888–1964) by Ralph Barton. Watercolor, pencil, and enamel on paper, 42.2 x 32.1 cm (16⅝ x 12⅝ in.) (sight), 1922. Sarah Jane Morthland.

6.18 *Ralph Barton* (1891–1931) by Ralph Barton. Watercolor and pencil on board; 42.2 x 34.5 cm (16⅝ x 13⅝ in.), c. 1922. National Portrait Gallery, Smithsonian Institution, Washington, D.C.

6.19 *Louis Wolheim, Pauline Lord, Alfred Lunt, and Lenore Ulric* by Ralph Barton. Ink and wash on paper, 42.7 x 35.6 cm (16 13/16 x 14 in.), 1925. Original illustration for *New Yorker*, February 21, 1925. Prints and Photographs Division, Library of Congress, Washington, D.C.

6.20 *Leon Errol and Doris Keane* (1881–1951; 1881–1945) by Ralph Barton. Ink and watercolor on paper, 43.3 x 36.8 cm (17 1/16 x 14 in.), 1925. Original illustration for *New Yorker*, March 21, 1925. Prints and Photographs Division, Library of Congress, Washington, D.C.

but the figures are as restless and active as Barton himself (fig. 6.20). Defying gravity and the human skeleton, they leap and bend in wild, impossible movements, defined by agitated lines of tight spirals, loping curves, and radiating stripes. Never had caricature expressed such vitality, and no other illustrator had that animated quality of line. Barton's pen lines, John Updike has written, "are like wires that are all connected; his drawings give off a peculiar hum, a menace absent from the tidy lines of similar draftsmen."[35]

In that first tenuous year, when the future of the magazine looked grim indeed, Barton invented three new series of comic drawings. In August he started a feature called "The Graphic Section," a crowded page

of five cartoon or caricature vignettes spotlighting generic local officials and prominent newsmakers. Barton indulged himself in such whimsies as depicting tall John Emerson and petite Anita Loos standing side by side—his face from the nose down, hers from the nose up.[36] In September he initiated the "Enquiring Reporter," which lasted for several weeks, in which a question was answered by five different celebrity figures depicted, of course, in caricature. By October he had developed a new idea: calling his portraits "Heroes of the Week." He drew Leopold Stokowski with wildly distorted nose and eyes and mouth, merely suggesting the infamous white thatch of hair with a soft feather-edged ink wash (fig. 6.21).

6.21 *Leopold Stokowski* (1882–1977) by Ralph Barton. Ink wash and crayon over pencil on paper, 55.2 x 36.8 cm (21³/₄ x 14¹/₂ in.), 1931. Original illustration for *New Yorker*, April 11, 1931. Mr. and Mrs. Karl H. Klein.

Just as Harold Ross tinkered with the format of the magazine in a desperate effort to find the right mix, Barton restlessly experimented with new comic features. His theatrical caricature (fig. 6.22) and his "Heroes of the Week" proved the most successful, and he contributed regularly through the spring of 1926. Ross had promised not only to critique arts and amusements but to cover "the personality, the anecdote, the color and chat" of the entertainment world.[37] Barton's drawings—always stylish and up-to-date, never vulgar or slapdash—set the perfect tone.

Barton inevitably wearied of the constant demand for comic drawing. The weekly magazine *Liberty* gave Barton a lucrative contract to provide a noncaricature comic feature entitled "News of the World." Despite sporadic gaps in his submissions—due to overwork and constant transatlantic escapes from New York to Paris and back again—the feature ran from December 1925 until April 1931. In 1931 he would turn forty, he

reminded publisher Alfred Knopf, "the absolute limit for a man to go on drawing pictures merely." He longed to pursue more serious graphic art, rather than "sandwiching it in between obligatory jobs."[38] He had other ambitions as well. Barton had cultivated an interest in amateur filmmaking, for instance. After shooting miles of home movies he eventually put together a feature-length spoof of Alexandre Dumas's *Camille*, developed with Anita Loos and starring a remarkable cast of celebrity friends: Loos in the title role, Paul Robeson as Dumas, Charlie Chaplin, Carl Van Vechten, Theodore Dreiser, H. L. Mencken, Sinclair Lewis, Clarence Darrow, Morris Gest, Nikita Balieff, Ethel Barrymore, Alfred Knopf.

Barton's literary ambitions were equally serious. In 1929 he published his second book, a comic history of the United States called *God's Country*. Some reviewers admired the pictures and appearance of the book, but others judged the effort "repellent," "not much fun," or simply "rather dull." Barton himself concluded that it was a failure, and the realization was bitter. At the end of his tragically short life he was convinced he had not gotten "anything like full value out of my talent."[39]

Few agreed with that assessment. In 1927 he was made a chevalier of the Legion of Honor by the French government. The following year his illustrations appeared in Boni and Liveright's edition of Balzac's *Droll Stories* as well as Anita Loos's *But Gentlemen Marry Brunettes*. American publishers continued to demand his drawings despite increasing lapses and delays. Gest even tried to recruit him for a final caricature curtain for the Chauve-Souris's 1929–30 season. The theme was "Talking Pictures," and Gest had signed up Will Rogers, Ring Lardner, Marc Connelly, and Irving Caesar to write humorously characteristic quotes spoken by each individual portrayed. According to the program, Barton contributed some of the portraits, but the project was designed and painted by Carl Link. Depicting the participants as an angelic host fluttering oddly around a godlike bust of Nikita Balieff, Link's design lacked Barton's wit and deft compositional sensibility. It was a disappointing spinoff of the original.[40]

Barton had spent so much of his life traveling back and forth to Paris that some of his friends called him "the Commuter."[41] But in September 1929, after filing for divorce from his fourth wife, he returned to New York, proclaiming the end of his peripatetic, expatriate life. Americans are crazy, he asserted in an interview to

6.22 *George S. Kaufman, Ruth Donnelly, and Unidentified* by Ralph Barton. Ink wash and crayon over pencil on paper, 55.6 x 39.1 cm (21⁷/₈ x 15³/₈ in.), 1931. Original illustration for *New Yorker*, January 24, 1931. Mr. and Mrs. Karl H. Klein.

the press, as if to explain his frequent desertions. "They like something for fifteen minutes, then turn about and like something else. They are faddists." Nonetheless, he did not want to lose contact with the American public. "As an artist I must comment on modern times, and by that I mean things in America. I can only do that if I live here. . . . You simply can't pass up New York any more. It's the center of the universe."⁴² He settled into an elegant suite at the Wyndham Hotel. The impossible demands of his schedule haunted him, and yet work seemed to provide a temporary escape from his depression.

A brilliant series from the end of Barton's career pushed the caricature figures to the edge of mannered distortion. In October 1929, *Life* magazine engaged him as drama critic for the season. His *New Yorker* submissions lapsed as he focused on this new project, submitting full-page drawings weekly through June 1930. Once again his writing, though passable, was overshadowed by his art. The caricatures combined a whimsical, comic sensibility with a nervous line and an increasingly grotesque distortion of face and figure. The passive face of William Gillette, starring in a

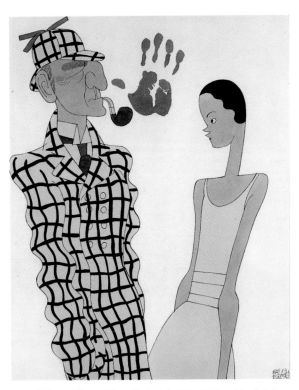

6.23 *William Gillette and Betty Starbuck* (1853–1937; ?–?) by Ralph Barton. Ink over pencil on paper, 55.7 x 39.2 cm (21⁷/₁₆ x 15⁷/₁₆ in.), 1929. Original illustration for *Life*, December 13, 1929. Mr. and Mrs. Karl H. Klein.

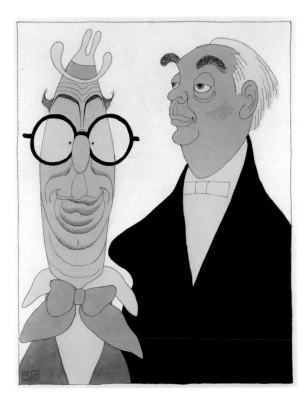

6.24 *Ed Wynn and Richard B. Harrison* (1886–1966; 1864–1935) by Ralph Barton. Ink and wash over pencil on paper, 55.9 x 38.6 cm (22 x 15³/₁₆ in.), 1930. Original illustration for *Life*, March 21, 1930. Mr. and Mrs. Karl H. Klein.

revival of *Sherlock Holmes*, contrasts with the wildest plaid suit in the history of illustration (fig. 6.23). Lines wiggle and waver with such agitation that they seem to move before your eyes. The image of Ed Wynn in a March 21, 1930, illustration was distinguished not only by the pinpoint eyes, enormous glasses, and multiple chins but also small details, like the absurd flapping protrusions of hat, hair, collar, and tie (fig. 6.24). Billie Burke's graceful figure and mounds of hair had never been taken to such impossible extremes (fig. 6.25). The august Mrs. Minnie Maddern Fiske is reduced to a tawdry, vicious, middle-aged scold (fig. 6.26). But even at their most monstrous these images fell short of venomous malice. If their grotesqueness hinted at depravity, it was a judgment on the times rather than the individuals or their theatrical talents. Barton reveals in these images the unhealthy, shallow underside of New York's celebrity glamour. By this time, it was all that he could see.

Barton's close friends, particularly Carl Van Vechten, Charlie Chaplin, and illustrator Neysa McMein were concerned about Barton's increasingly erratic behavior. He still seemed obsessed with Carlotta Monterey, who had recently married Eugene O'Neill. In the summer of 1930, visiting Chaplin in California, he impulsively decided to change apartments again. He telephoned McMein, asking her to rent a studio for him at the Hotel des Artistes. McMein, summering on Long Island, came into the city to meet him at the arranged time, only to find a message that Barton had decided that afternoon to sail for France. By fall he had returned to New York and attempted suicide.

The *New Yorker* was still publishing Barton's theatrical caricature in the winter and spring of 1930–31, as well as a briefly revived "Graphic Section," occasional "Heroes," and a series of black humor cartoons on "The Thirties." The "News of the World" continued in

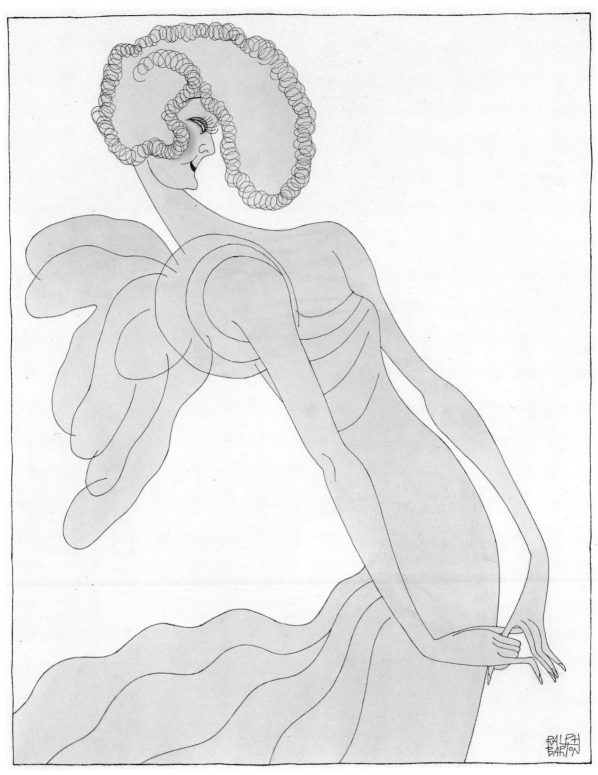

6.25 *Billie Burke* (1886–1970) by Ralph Barton. Ink over graphite on paper, 56.5 x 38.4 cm (22¹/₈ x 15 ¹/₈ in.), 1930. Original illustration for *Life*, January 3, 1930. Mr. and Mrs. Karl H. Klein.

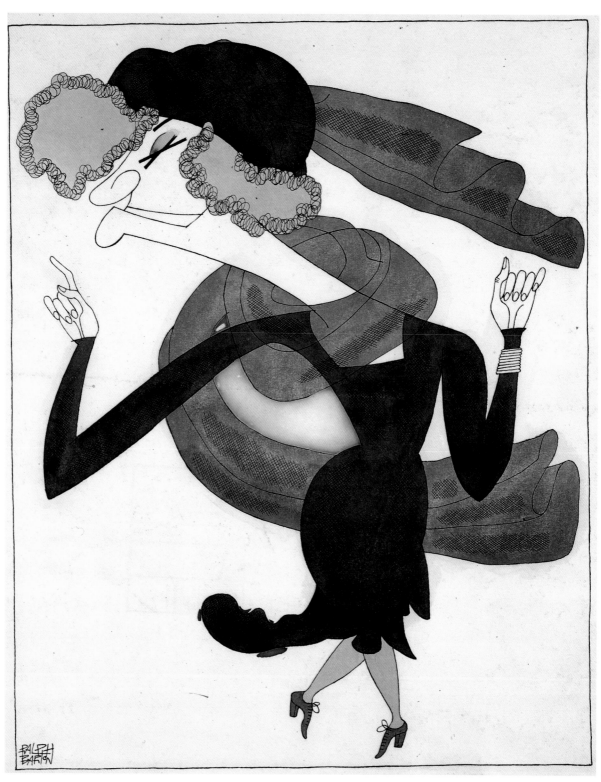

6.26 *Minnie Maddern Fiske* (1865–1932) by Ralph Barton. Ink and wash on paper, 55.9 x 39.2 cm (22 x 15 $^7/_{16}$ in.), 1929. Original illustration for *Life*, November 8, 1929. Mr. and Mrs. Karl H. Klein.

Liberty, and other submissions appeared in *Harper's Bazar,* the *Delineator,* and *Woman's Home Companion.* Chaplin tried to rescue Barton by taking him to London in February 1931 for the premiere of his film *City Lights.* Barton revived briefly while the two led a familiar celebrity life, dining and partying with George Bernard Shaw, Lady Astor, H. G. Wells, Winston Churchill, or Lloyd George. But his depression returned. By March, Barton had returned to New York and moved into another apartment. Early in the morning of May 20, 1931, Barton shot himself in the head, leaving behind a long letter, with "Obit" scrawled across the top. In it he explained that the melancholia which he had long suffered had recently shown definite symptoms of "manic depressive insanity." It made his life unbearable.

In the ultimate act of comic detachment, however, Barton leavened his bitter remorse with a witty assessment of his own luck and renown. He admitted that he had had few real difficulties. "I have had, on the contrary, an exceptionally glamorous life—as lives go. And I have had more than my share of affection and appreciation. The most charming, intelligent, and important people I have known have liked me—and the list of my enemies is very flattering to me."[43] Like other humorists at the *New Yorker*—James Thurber, for instance—he had trained himself to treat the dark side of life with a light touch, to see a fascinating irony even in his own despair. In no other humorist does the effort to maintain this fashionable comic stance seem more tragic. His sophisticated wit required the discipline to turn psychological turmoil, anger, and remorse into urbane effervescence. An outpouring of spleen would have been far less taxing.

"It would seem," Dorothy Giles mused in *College Humor* in February 1932, "as though in every period there were one figure who is so attuned to the spirit of his age that he stands as its symbol." Ralph Barton, she thought, "more than any person, man or woman, represents young, intellectual America of the last decade."[44] Others could compete with Barton for that title. John Held, Jr., famous for his long-legged flappers and coonskin-coated college boys, succeeded equally in the magazines, capturing the antic, spirited frenzy of the young. And F. Scott Fitzgerald, as he himself admitted, was "pushed into the position not only of spokesman for the time but of the typical product of that same moment."[45] But, like Fitzgerald, Barton seemed to both capture the zeitgeist and embody it. His dandified urbanity, exquisite sense of style, celebrity connections, intelligent wit, prodigious talent, even his mania and restlessness, with their dark, underlying current of anxiety, were all traits that seemed to exemplify his fast-paced era.

Celebrity caricature, budding in the pages of *Puck, Life,* and the *New York World* in the years before World War I, had burst into full flower. With his well-publicized curtains, his unparalleled output, and the extraordinary complexity and vitality of his style, Barton stimulated a new vogue for the caricature portrait. He spanned the gap between the nineteenth-century humor journals and the modern smart magazines, introducing caricature into *Vanity Fair* and the *New Yorker* with such flair and artistry that it became a key element in the character of each.

To a certain extent Barton exemplified the dilemma of the twentieth-century flâneur. In a new mass media age it was increasingly difficult to observe the passing show without becoming an integral part of it. To be influential in defining this world, the writer or artist also had to be a performer, generating enough publicity and recognition to be noticed. Barton had to surrender some of the detachment that had inspired modern caricature in the first place. His charm, talent, success, and wealth gave him unparalleled access to the sophisticated urban scene, but they also sucked him into a punishing maelstrom of success and fame.

Some artists and commentators—the Algonquin Round Table writers, for instance—understood the requirements of celebrity; blatant self-promotion and logrolling, only slightly disguised by humor, were all part of the game. For Barton, driven by inner demons, fame was less consciously sought, and the dilemma of his own celebrity could be handled only with a refined sense of irony. Dorothy Giles had called him a "commenter on the commenters," but his vision included a keen awareness of his own complicity in the excesses of his era. Toward the end of his career he at times conjured up a personal phantasmagoria one step away from horrific. But his self-awareness, wit, and abstractly elegant style moderated his images, transforming them into insightful comments on his own environment. Thus with the innate intuition and refined taste of an insider, he limned a celebrity world that seemed to symbolize the spirit of his age. In the process, the modern form of caricature exploded into a new phase of popularity.

Miguel Covarrubias: *Caricature and Modernism in* Vanity Fair

Covarrubias's drawings . . . are bald and crude and devoid of nonsense, like a mountain or a baby.
—Ralph Barton

Our laughter derives . . . wholly and absolutely from [Covarrubias's] draftsmanship itself; from the artist's grasp of character, his clairvoyant vision, his sensitive misdirection of line, or his deft and almost imperceptible misplacement of muscle, shadow or plane.
—Frank Crowninshield

Frank Crowninshield readily admitted to a "perhaps preposterous" preference for the new as opposed to the old in art, music, theater, nightclubs, food, and women.[1] In the pages of *Vanity Fair* he introduced his latest discoveries with infectious fervor. One of his passions was modern French painting, and he filled the magazine with reproductions of his favorite images. An avid collector, a tireless proponent of the 1913 Armory Show, and eventually a founder of the Museum of Modern Art, Crowninshield blithely ignored Condé Nast's concern about advertisers' distaste for "decadent" art.[2] He confidently overlooked the complaints of conservative critics in his enthusiasm for new forms of entertainment. Crowninshield believed that innovation in the popular arts could revitalize high culture, a theme he pursued in *Vanity Fair*'s exploration of the movies, the follies, nightclubs, magic, puppetry, and caricature.

Not long after he began publishing Barton's entertaining group portraits, novel uses of stylized faces in the theater confirmed Crowninshield's budding interest in caricature. In the February 1922 issue he published photographs of the chorus girls from Florenz Ziegfeld's *New Midnight Frolic*, all wearing movie-star caricature masks made by John Held, Jr. (fig. 7.1).[3] Crowninshield was intrigued by theatrical masks—he had previously promoted W. T. Benda's exotic maskmaking in the magazine—and he found the comic faces on the chorus girls' bodies irresistible. "Why," he wondered in the caption, given the "amazingly humorous effects achieved by the false faces shown here," doesn't the legitimate stage experiment with masks put to more serious purposes?

After the success of Barton's Chauve-Souris curtain a few months later, Crowninshield began to explore celebrity caricature in more depth, looking for new artists, innovative approaches, context, and critiques. In July he published a page of theatrical subjects by Al Frueh (fig. 7.2) along with art critic Willard Huntington Wright's article "America and Caricature." Wright commented on the increasing American interest in caricature since the war, citing Barton's curtain, the Beerbohm collecting fad, and the growth of satirical portraiture in magazines and newspapers. In examining the strengths and weaknesses of American work in comparison with European precedents, he singled out Ralph Barton and Al Frueh as superior among the portrait artists.[4]

Following Wright's lead, *Vanity Fair* began to seek a context for caricature in America. Rather than examining the historical tradition, however, Crowninshield associated humorous celebrity portraiture with modernism. The Hall of Fame feature for November 1922, for example, relates caricature to experimental theater, modern humor, and avant-garde art. The portraits of the five nominees all depart from the conventional photograph, and four are caricatures (fig. 7.3).[5] The only photographic image portrays Nijinsky's sister made up for a modernist ballet. Her face, a horrific distortion of the human countenance, is painted with dark stripes and exaggerated features evoking African masks and primal ritual rather than classical balletic elegance. Above her, carved wooden caricature busts, made by

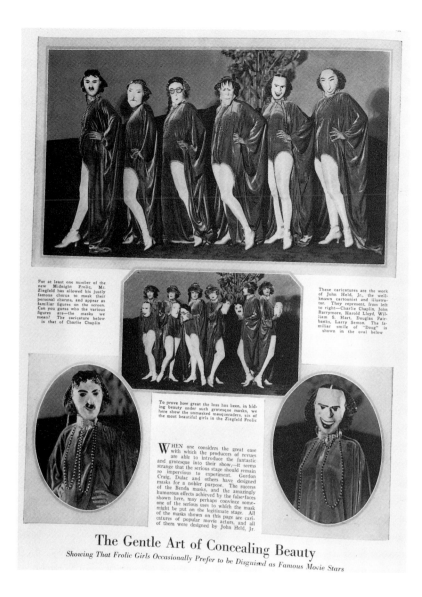

7.1 *The Gentle Art of Concealing Beauty* by John Held, Jr. Printed illustration. Published in *Vanity Fair*, February 1922. Special Collections and Archives, George Mason University Libraries, Fairfax, Virginia.

For at least one number of the new Midnight Frolic, Mr. Ziegfeld has allowed his justly famous chorus to mask their personal charms, and appear as familiar figures on the screen. Can you guess who the various figures are—the masks we mean? The caricature below is that of Charlie Chaplin

These caricatures are the work of John Held, Jr., the well-known cartoonist and illustrator. They represent, from left to right—Charlie Chaplin, John Barrymore, Harold Lloyd, William S. Hart, Douglas Fairbanks, Larry Semon. The familiar smile of "Doug" is shown in the oval below

To prove how great the loss has been, in hiding beauty under such grotesque masks, we here show the unmasked masqueraders, six of the most beautiful girls in the Ziegfeld Frolic

WHEN one considers the great ease with which the producers of revues are able to introduce the fantastic and grotesque into their show,—it seems strange that the serious stage should remain so impervious to experiment. Gordon Craig, Dulac and others have designed masks for a nobler purpose. The success of the Benda masks, and the amazingly humorous effects achieved by the false-faces shown here, may perhaps convince someone of the serious uses to which the mask might be put on the legitimate stage. All of the masks shown on this page are caricatures of popular movie actors, and all of them were designed by John Held, Jr.

The Gentle Art of Concealing Beauty
Showing That Frolic Girls Occasionally Prefer to be Disguised as Famous Movie Stars

Held, depict grim-faced manufacturer Henry Ford and cigar-smoking poet Amy Lowell.

At the top of the Hall of Fame page, caricature dolls of Henri Matisse and Pablo Picasso by the Russian-born Marie Vassilieff give another strange, comic twist to the depiction of celebrity. The creator of these puppetlike portraits, variously described as an actress, sculptor, poet, composer, and producer of "mystical marionette plays," lived in Paris, where she had run a popular canteen for soldiers. Critics invariably saw her doll portraits as modernist distortions. The likenesses of this "Cubist Doll-maker of Montparnasse" are not mere toys, insisted one in *Arts and Decoration*, "but the product of artistic conception and fine craftsmanship." And yet the humorous charm of the little stuffed figures made their stylizations of personality palatable and comprehensible. A reviewer for the *New York Tribune* saw the caricature dolls as a balm for those disgruntled souls who had lost the fight against modernism.[6]

Vassilieff's doll portraits, like theatrical masks, puppetry, and caricature drawing, employed stylized exaggerations to convey a heightened sense of human expression that other faces lacked. The expressive use of distortion related all of these forms to avant-garde art. *Vanity Fair*'s caption for the Matisse doll underscores the implication of modernity. The painter was

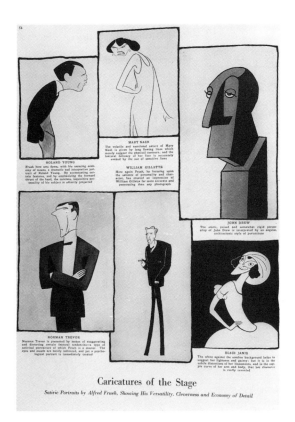

Caricatures of the Stage

Satiric Portraits by Alfred Frueh, Showing His Versatility, Cleverness and Economy of Detail

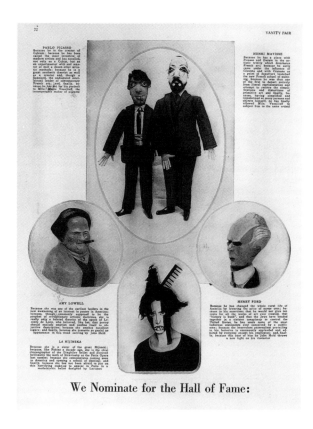

We Nominate for the Hall of Fame:

honored, it asserted, "because he was . . . one of the first to depart entirely from literal representation and attempt to restore the simplifications and distortions of primitive art and . . . because, having simplified and transformed so many persons and objects himself, he has finally allowed Mlle. Vassilieff to subject him to the same ordeal." The silly charm of Picasso and Matisse, the ponderous geniality of Lowell, and the dour stiffness of Henry Ford mix comfortably with the horrifying face of "La Nijinska" in this context, all appearing new and experimental. Modern approaches to the human face, the page implies, find power and vitality in the simplifying distortions of humorous, childish, and primitive sources.

The Hall of Fame page mocks the anxieties about the gulf between highbrow and lowbrow culture. Here the mixing of the comic and the serious, of the avant-garde and the popular, of high and low art forms, proves a

point, rendering the differences between Matisse's or Picasso's visual transformations and those of a caricaturist irrelevant. This was a celebration of new forms and fresh approaches. Caricature did not need to be considered a major art form; it was enough that it provided the vitality, imagination, and humor to inspire innovation.

Crowninshield and his editors committed *Vanity Fair* to following the new caricature trend. The magazine had reported on various developments in the field: masks, dolls, sculpture, Frueh's portfolio, Barton's curtain. And, in March 1923, they ran an illustration of a "new type of cabaret, . . . where the leading caricaturists have contributed wall portraits of famous New Yorkers." In the photograph an actress admired Conrado Massaguer's portrayals of Alla Nazimova, Will Rogers, John Barrymore, John Drew, and Nikita Balieff.[7] But if *Vanity Fair* reported on newsworthy developments, it also commissioned caricature for its

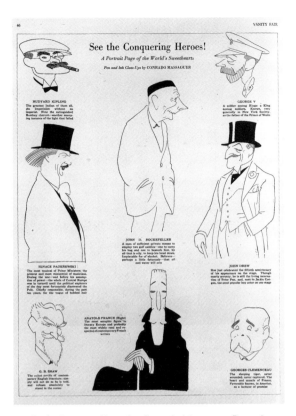

7.4 *See the Conquering Heroes!* by Conrado Massaguer. Printed illustration. Published in *Vanity Fair*, May 1923. Prints and Photographs Division, Library of Congress, Washington, D.C.

7.5 *Modern Napoleons Who Dominate the Present Fracas in Europe* by Nicholas Remisoff. Printed illustration. Published in *Vanity Fair*, December 1923. Prints and Photographs Division, Library of Congress, Washington, D.C.

pages. Soon Massaguer joined the magazine's roster of artists. His "Conquering Heroes" illustration of international celebrities appeared in May 1923 (fig. 7.4), followed in August by his drawing of the evening at the Coffee House club (see fig. 2.21). For the June issue Frueh had supplied another page of caricatures and Barton had contributed his "Pursuit of the Bridegroom" tapestry. The year ended with an article on Max Beerbohm by Aldous Huxley and a page of "parody portraits" by Chauve-Souris artist Nicholas Remisoff (fig. 7.5).[8] Throughout the 1920s, *Vanity Fair* would feature portrait caricature by these artists and introduce new names, such as Henry Major and William Auerbach-Levy.

Eclipsing all the other contributors to the magazine, however, was a talented young artist from Mexico City whose crisp stylizations confirmed for Crowninshield the modernist potential of caricature (fig. 7.6). Miguel

Covarrubias (1904–1957) arrived in New York City in the summer of 1923. In just a few short years this shy but engaging young man with great reserves of humor, talent, and energy had established himself, along with Al Frueh and Ralph Barton, as one of the major caricature artists of the era. Covarrubias helped to define this evolving art form, adding a new precision and graphic sophistication.

The artist Aline Fruhauf also started a career in caricature in the 1920s. She recalled in her memoirs the atmosphere that Covarrubias must have encountered in New York when so many artists were experimenting with expressive distortion in portraiture. Crowninshield's magazine, she remembered, played a prominent role; being published in *Vanity Fair* was the "sine qua non of success." As she learned her craft she paid close attention to others experimenting with stylized portraiture. In time she collected, for her Vanity

7.7 *Aline Fruhauf* (1907–78) by Alexander Calder. Pencil on paper, 19.9 x 13.8 cm (7⅞ x 5⁷⁄₁₆ in.), 1928. National Portrait Gallery, Smithsonian Institution, Washington, D.C.; gift of Erwin P. Vollmer. © 1998 Artists Rights Society (ARS), New York/ADAGP, Paris.

7.6 *Miguel Covarrubias and Frank Crowninshield* (1902–57; 1872–1947) by Nickolas Muray. Photograph, c. 1930. International Museum of Photography at George Eastman House, Rochester, New York.

Corner, as she called it, a number of caricatures of herself made by artists she admired. Once, while struggling to capture a likeness during a press conference, she felt a tap on her shoulder and turned to find Alexander Calder shaking his head over her drawing. Motioning for the pad and pencil, he began to make a drawing of her (fig. 7.7). The result, Fruhauf reported, was a caricature that revealed "not only my own shortcomings, but those of the poorly endowed relatives on both sides of my family."[9]

Fruhauf, a protégé of Ralph Barton and his wife Carlotta, loved visiting the couple's beautiful apartment and marveled over their caricature drawings and exotic ornaments (see fig. 6.1). There she discovered sawdust-stuffed heads of them both, the latest portrait technique devised by Marie Vassilieff. Intrigued, Fruhauf visited Vassilieff on her next trip to Paris and ultimately sat for her own caricature sculpture (fig. 7.8). When her sawdust portrait was completed, Fruhauf recalled in her memoirs, "I went to the studio to claim it. I was glorious in gold lacquer, my hair was black raffia, and I had lustrous glass eyes, straight from a taxidermist's supply store. My eyebrows were black kid, and I had long, luxuriant eyelashes made of strips of monkey fur. My Rossetti neck was a long cylinder that made my head look poised, as someone had described it, like a crystal

DOLL PORTRAITS
OF PEOPLE WHO
DESERVE BETTER

the caricature creations
in the "manière sauvage"
of the russo-french art-
ist, marie vassilieff

7.9 *Doll Portraits of People Who Deserve Better* by Marie
Vassilieff. Printed illustration. Published in *Vanity
Fair*, January 1930. Prints and Photographs Division,
Library of Congress, Washington, D.C.

7.8 *Aline Fruhauf* (1907–78) by Marie Vassilieff. Mixed media: cot-
ton fabric, lacquer, sawdust, wood, 25.5 x 12.5 x 14.6 cm (10$^{1}/_{16}$ x
4$^{15}/_{16}$ x 5$^{3}/_{4}$ in.), c. 1926. National Portrait Gallery, Smithsonian
Institution, Washington, D.C.; gift of Erwin P. Vollmer.

ball on a needle. It was a mask, a puppet head, a carica-
ture, and to me a highly flattering portrait, all in one."
On her return she sent photographs of Vassilieff's heads
of several celebrities to *Vanity Fair*, where they were
published in January 1930 (fig. 7.9). Lacking the child-
like charm of the doll figures, the sawdust heads had an
unsettling, taxidermic quality. The captions compared
Vassilieff's work to medieval black magic and barbaric
totem poles. The distortion, the use of exotic materials,
and the references to primitive art, theatrical masks, and
puppets all were consistent with *Vanity Fair's* notion of
caricature as a modern substitute for more conventional
depictions of the famous.[10]

Miguel Covarrubias arrived in New York just in time
to catch the rising tide of this caricature vogue. As
Adriana Williams has detailed in her biography, the
eighteen-year-old was already an established artist,
having taught art classes, organized an exhibition of
Mexican arts and crafts, and earned his living as a cari-
caturist.[11] The arts were flourishing in Mexico in the
early 1920s, after years of repression and revolution. A
new constitution in 1917 paved the way for peace, and
order was restored in 1920 under the reformist presi-
dency of Alvaro Obregón. The government encour-
aged educational programs, exhibitions, mural paint-
ing, popular art, and folk art, emphasizing particularly

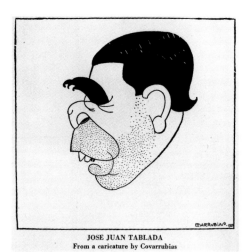

JOSE JUAN TABLADA
From a caricature by Covarrubias

7.10 *José Juan Tablada* (1871–1945) by Miguel Covarrubias. Printed illustration. Published in *Shadowland*, April 1923. Library of the National Portrait Gallery and the National Museum of American Art, Smithsonian Institution, Washington, D.C.

7.11 *Eva Le Gallienne* (1899–1991) by Miguel Covarrubias. Ink, watercolor, and gouache on paper, 38.1 x 25.4 cm (15 x 10 in.), c. 1923. National Portrait Gallery, Smithsonian Institution, Washington, D.C.

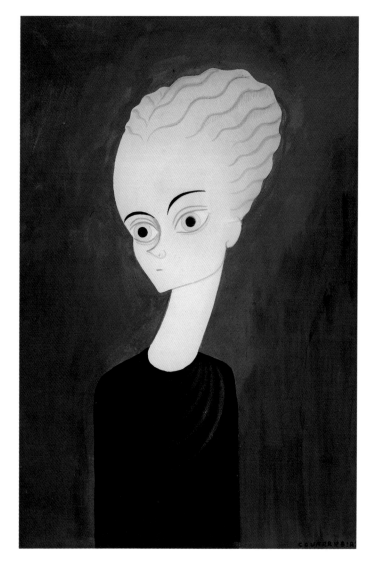

the neglected heritage of native decorative traditions and crafts.[12] At Mexico City's bohemian cafés writers and artists who would soon dominate the nation's cultural renaissance gathered to share their new opportunities. Covarrubias gravitated to Los Monotes, where caricatures by the owner's brother, the painter José Clemente Orozco, decorated the walls. The young boy with the sketchpad and engaging manner began to meet—and draw—the prominent personalities who congregated there, including Orozco, poet and critic José Juan Tablada, painters Diego Rivera, Rufino Tamayo, and Adolfo Best Maugard, and caricaturist Luis Hidalgo. Covarrubias's subjects, who became

his friends, nicknamed him El Chamaco (the kid).

Caricature, considered a vital national tradition in Mexico, was thriving under liberal government policies. Covarrubias was particularly influenced by Orozco, the theatrical caricaturist Ernesto García Cabral, and the populist political printmaker José Guadelupe Posada. Like his contemporaries, he also absorbed the forceful draftsmanship and expressive power of the German caricaturists, whose work appeared in such imported journals as *Simplicissimus*. As Covarrubias developed his own style his work began appearing in Mexican magazines, and by 1923 his drawings were syndicated, according to one writer, in newspapers "from Cuba to Buenos Aires."[13]

That same year he met Tablada, who was visiting from New York City, where he had recently moved. Impressed by the young man's progress, Tablada persuaded the minister of foreign affairs to offer Covarrubias a scholarship to visit America.

Just before Covarrubias arrived in New York, Tablada published an article on Mexican caricature in the film magazine *Shadowland*, illustrated with the young artist's grotesque portrait of the poet himself (fig. 7.10).[14] "Old Mexico is a land of flowers," Tablada maintained, "and for that reason she has a right to her wasps." He could not have been flattered by his portrait, which is stinging indeed. Covarrubias had a delicate line—a "continuous, calligraphic arabesque," Tablada called it—but despite this linear elegance, the image depicts brutal, coarse features. A ridiculously menacing eyebrow and an effeminate curl of the hair complete the repulsive face. The effect was vicious but also ingenious, amusing, and powerful—precisely the qualities the author admired.

Tablada's article established a context for Covarrubias's work in the strong caricature tradition of Mexico, which was not well known in the United States. He traced the roots of this tradition to the fierce, bestial statues of Indian gods and satiric pre-Conquest pictorial manuscripts. After Mexico's emancipation from Spain, Tablada noted, caricature flourished as a form of populist political expression that evolved into a weapon of revolution and social change. Woodcut prints, newspaper illustrations, and posters by Posada and others employed powerful symbols—such as the death's head *calavera* imagery—to speak out against oppression.[15] Modern Mexican caricature reflected the raw, emotional strength of this heritage. Covarrubias, Tablada felt, was one of the most gifted of the younger talents.

As Bernard Reilly has pointed out, the young Covarrubias had already acquired a sophisticated level of cultural awareness, having absorbed a variety of artistic influences.[16] The strength of his draftsmanship and imagery, for instance, reflected both the revolutionary, populist Mexican tradition and the powerful line of contemporary German caricature. His inventive sense of graphic patterning and use of geometric forms suggested both his cultural inheritance of native ornament as well as the abstractions of the French cubists. His caricatures synthesized these sources—ancient and contemporary, traditional and avant-garde, indigenous and cosmopolitan—into a uniquely forceful style.

But in order to launch a caricature career in New York, he had to meet the right people. Tablada, who had opened a Spanish-language bookstore on Fifth Avenue, provided Covarrubias and many other visiting Mexicans with an instant community of creative talent. Through Tablada, Covarrubias met newspaperman and photographer Sherrill Schell, who in September 1923 introduced him to writer Carl Van Vechten. This encounter opened many doors for the young artist. The colorful Van Vechten, a popular novelist and influential critic of the arts, was an indefatigable party giver and member of New York's smart set. "I was immediately convinced," Van Vechten wrote about the meeting, "that I stood in the presence of an amazing talent, if not, indeed, genius." Before the day was out, he had made appointments for Covarrubias to draw H. L. Mencken, playwright Avery Hopwood, actress Eva Le Gallienne, and many others. The British-born Le Gallienne was starring at the time in Ferenc Molnár's hit play *The Swan*. In his drawing of her, Covarrubias featured the heart-shaped face, the swanlike neck, and the prominent forehead that many critics associated with her intellectual approach to her roles (fig. 7.11). The jutting brow, one writer had noted, "is curiously high, remarkably broad, extraordinarily full. It is crammed with brains, which she uses." Van Vechten allowed himself to be subjected to the same treatment. The result was an entertainingly grotesque parody of the writer's flamboyant style, distinctive features, affection for cats, and affinity for the jazz-infused urban scene (fig. 7.12).[17]

Van Vechten took the Mexican artist to lunch at the Algonquin Hotel, noting that he was "acclaimed at once, held, indeed, almost a reception. From that moment he was launched—as I knew he would be." Covarrubias met the young artist Al Hirschfeld, with whom he shared a studio and who drew a pencil sketch of him (fig. 7.13). He was also introduced to the veteran caricaturist Ralph Barton, who helped promote his career. By October, Covarrubias's caricatures were appearing in the *New York Herald*, the *Tribune*, the *Evening Post*, the *World*, and other newspapers. In December the magazine *Screenland* introduced a series of his celebrity drawings. Editors began to recognize what Hirschfeld has called Covarrubias's "wild talent for seeing graphically."[18]

Through Van Vechten, Covarrubias made his most important contact: Frank Crowninshield. In the January 1924 issue of *Vanity Fair*, Crowninshield intro-

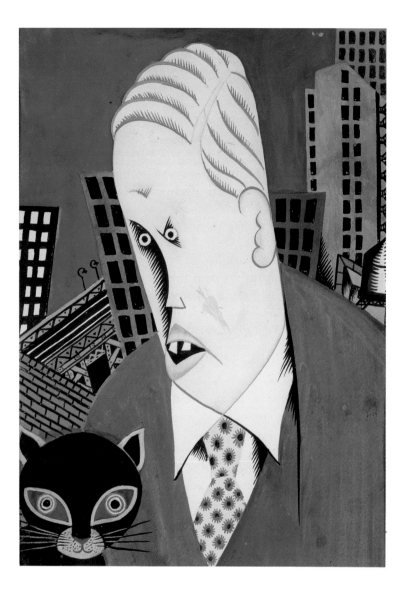

7.12 *Carl Van Vechten* (1880–1964) by Miguel Covarrubias. Gouache on paper, 39.4 x 28.6 cm (15½ x 11¼ in.), 1923. Original illustration for Covarrubias, *The Prince of Wales and Other Famous Americans* (New York, 1925). The Yale Collection of American Literature, Beinecke Rare Book and Manuscript Library, Yale University, New Haven, Connecticut.

duced the young man "who has lately, with his deadly pencil assaulted many of the better liked lads of the village."[19] In his page of drawings, entitled "The Pleasant Art of Caricature: A Pungent Page of Character Studies, from the Pen of a Newcomer" (fig. 7.14), Covarrubias transformed the faces of Avery Hopwood, Minnie Maddern Fiske, Woollcott, Le Gallienne, Chaplin, and Barton into bold geometric form. None of the images could be characterized as brutal, repulsive, or stinging. But if Covarrubias moderated the emotional power often associated with Mexican caricature, he sacrificed none of his artistry, ingenuity, or insight. Stark black and white contrasts in the ink ver-

sion of Le Gallienne magnify the elegant fragility of her features. The dark, tapered lines that suggest the coiffed waves of her hair reverse to white against black around the neck of her dress in a sophisticated interplay of patterning. He depicted Ralph Barton at the bottom of the page as a natty figure with checked pants and meticulously combed hair, seated, according to the caption, "in that posture of embarrassed amusement which all who know him well will recognize." Forming Barton's face into the shape of a mask, he conveys the effect of a guarded personality, of a man hiding behind the self-devised persona of a dandy. The characterization is inventive and insightful.

Paired with this image, as if to exact revenge, is Ralph Barton's caricature of Covarrubias, which appears, at first glance, to be the most stinging likeness of the group. It depicts a leering, jeering foreigner with a slightly menacing sense of ethnic otherness. The satire, however, was aimed not so much at Covarrubias as at his audience. Barton, who immediately recognized the quality of the young man's work, never saw him as a potential rival but generously promoted and encouraged him. Praising Covarrubias's caricatures in a newspaper review the following year, he recognized the irony of his youth and his non-European origins and mocked prevailing notions of cultural superiority. "To be seen through so easily by a boy of twenty, and by a Mexican," he wrote, "a national of a country that we have been patronizing for a century or two, an outlander and a heathen, was a bitter but corrective pill."[20]

Critic William Murrell reproduced Covarrubias's caricature of Barton in his 1938 book on American graphic humor. In describing the artist's distinctive approach Murrell observed an "archaic note in the geometric and sculptural quality of his line." But the heaviness that might be suggested by such a technique, he pointed out, was dissipated by the vitality with which he rendered the personality of his subjects.[21] Murrell and Barton had recognized an innovative approach to comic distortion. Only in Covarrubias's controlled, elegant line and dark contours was there any suggestion of the Parisian style that had influenced the work of many American artists.

Like Barton, Covarrubias moved away from the flat, linear simplicity of unmodeled features toward a resolute plasticity. Unlike his predecessor, however, he achieved this three-dimensional quality not with tonal modeling but with a characteristic shading of sharp,

7.13 *Miguel Covarrubias* (1902–57) by Al Hirschfeld. Pencil on paper, 22.8 x 30.4 cm (9 x 11¹⁵/₁₆ in.), c. 1924. National Portrait Gallery, Smithsonian Institution, Washington, D.C.; gift of Al Hirschfeld. © Al Hirschfeld.

7.14 *The Pleasant Art of Caricature, A Pungent Page of Character Studies from the Pen of a Newcomer* by Miguel Covarrubias. Printed illustration. Published in *Vanity Fair*, January 1924. Prints and Photographs Division, Library of Congress, Washington, D.C.

tapered lines evoking the repetitive gouges of woodcut prints. In his 1925 drawing of Irving Berlin, for instance, his spiky lines define instantly recognizable, heavy-lidded, deep-set eyes (fig. 7.15). Irving Berlin appeared, in reverse, with five other drawings on a *Vanity Fair* page in March 1925 (fig. 7.16).[22] Covarrubias shaded all of the caricatures with sharp little spines, achieving quite different effects in each one. The tapering lines give compact, muscular form to the athletic body of Jack Dempsey, while just beneath him they spread out into the gracefully splayed fingers and swaying grass skirt of dancer Florence Mills. Those same spiky lines suggest the wild, unkempt hairdo of theatrical designer Robert Edmond Jones on one side of the page and the tidy, manicured coiffure of playwright Eugene O'Neill on the other.

The technique gave a clean, geometric look to the picture, modeling and shading his shapes without sacrificing the strength of black and white contrast. His faces thus retain a sharp focus while gaining depth and three-dimensionality. Critics noticed the precision of Covarrubias's images and the sense of unerring judgment. "There was no fumbling around either for the idea or for the method," Henry McBride wrote in the *New York Sun* in 1927, "but an adult assurance that was as startling as it was pleasing." His seemingly inevitable line, combined with the sculptural strength of the images, lent a monumental quality to the figures. "They are bald and crude and devoid of nonsense," Ralph Barton wrote about Covarrubias's drawings, "like a mountain or a baby."[23]

Crowninshield, recognizing how deftly these

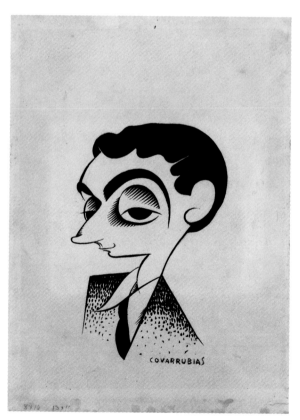

7.15 *Irving Berlin* (1888–1989) by Miguel Covarrubias. India ink on paper, 30.8 x 22.9 cm (12¹⁄₈ x 8¹⁵⁄₁₆ in.), 1925. Original illustration for *Vanity Fair*, March 1925. National Portrait Gallery, Smithsonian Institution, Washington, D.C.; gift of Sarah and Draper Hill.

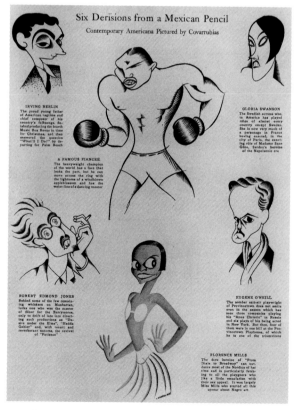

7.16 *Six Derisions from a Mexican Pencil* by Miguel Covarrubias. Printed illustration. Published in *Vanity Fair*, March 1925. Library of the National Portrait Gallery and the National Museum of American Art, Smithsonian Institution, Washington, D.C.

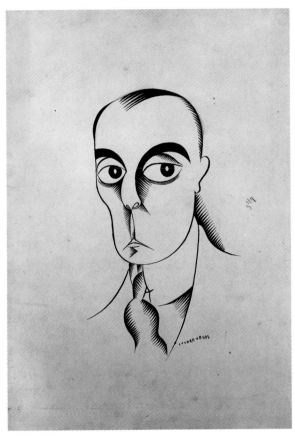

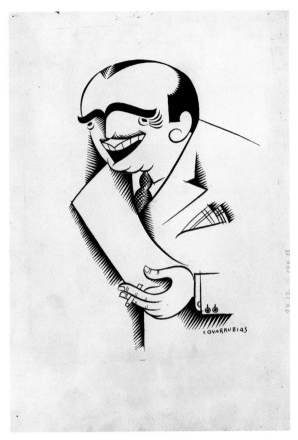

7.17 *Ring Lardner* (1885–1933) by Miguel Covarrubias. India ink on paper, 41.8 x 27 cm (16 7/16 x 10 5/8 in.), 1925. Original illustration for *Vanity Fair*, July 1925. Prints and Photographs Division, Library of Congress, Washington, D.C.

7.18 *Douglas Fairbanks* (1883–1939) by Miguel Covarrubias. India ink on paper, 39.3 x 26.4 cm (15 7/16 x 10 3/8 in.), 1924. Original illustration for *Vanity Fair*, August 1924. Prints and Photographs Division, Library of Congress, Washington, D.C.

celebrity portraits complemented *Vanity Fair*'s tone and mission, made sure that they appeared regularly. Covarrubias's drawing of Ring Lardner accompanied an article by critic Gilbert Seldes (fig. 7.17). The caricature, the caption noted, recalled the qualities that distinguished Lardner's own work: "a humor of preposterousness, resulting, somehow, in a keen fidelity to life." The image of actor Douglas Fairbanks (fig. 7.18) appeared with the title "Now Collecting Royalties" on a page of theatrical figures. Fairbanks and his wife, Mary Pickford, the adored first couple of film, were then touring Europe to such acclaim that commentators likened the trip to a royal procession. Instead of portraying the actor in one of his athletic, swashbuckling roles, Covarrubias depicted him as a celebrity—chatting,

according to the caption, with a fan in front of Ciro's.[24]

On the strength of this inventive new style, Covarrubias quickly established his reputation in New York. In March 1924, the Whitney Studio Club, run by Juliana Force with the patronage of Mrs. Harry Payne Whitney, held an exhibition of his caricatures. The artist Alexander Brook, who organized the exhibition, remembered the impact of the drawings. Looking for variety he had decided to show Covarrubias's portraits along with drawings and watercolors by José Clemente Orozco and country scenes by an academic painter, H. O. Henry. Brook, most impressed with Orozco's work, was surprised when Covarrubias turned out to be the star of show. "The opening was ass-deep in chic and celebrities," he remembered, "so at least there was

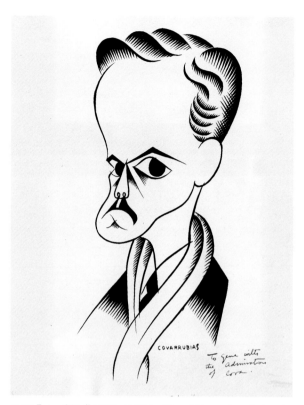

7.19 *Eugene O'Neill* (1888–1953) by Miguel Covarrubias. India ink on paper, 36.8 x 25.4 cm (14¹/₂ x 10 in.), 1925. Original illustration for *Vanity Fair*, March 1925. The Yale Collection of American Literature, Beinecke Rare Book and Manuscript Library, Yale University, New Haven, Connecticut.

7.20 *Xavier Algara* (?–?) by Miguel Covarrubias. Printed illustration. Published in Covarrubias, *The Prince of Wales and Other Famous Americans* (New York, 1925). Library of the National Portrait Gallery and the National Museum of American Art, Smithsonian Institution, Washington, D.C.

something besides pictures to look at if only ever so briefly."[25]

Before long, Covarrubias had seemingly captured everyone of note in the city and befriended many of his subjects. "After being only a few years in New York," his friend Al Hirschfeld remembered, "he knew everybody in the literary world, in the arts, in the theater, in the ballet and all other allied arts. He also knew the Vanderbilts, the Whitneys, and the Rockefellers; the wealthy of the city."[26] In 1925 he collected sixty-six of his portraits into a stylish volume entitled *The Prince of Wales and Other Famous Americans*, published by Alfred Knopf with a preface by Van Vechten. Included were many of the images that had made the young artist's reputation in the pages of *Vanity Fair*: Irving Berlin, Eugene O'Neill, Joe Louis, Florence Mills, Alexander Woollcott, Ralph Barton, Theodore Dreiser, Calvin Coolidge. A handful of foreign celebrities were

thrown in along with the appropriated prince. The volume was an unqualified success. The Dudensing Gallery held a one-man exhibition of some of the originals in November 1925. Barton, in his review of the book, saw a certain inevitability in Covarrubias's arrival in New York at the "moment when we need him most." Bohun Lynch quickly included the newcomer in his book *A History of Caricature*, published in 1926, noting his "agreeable devilry" and facility for capturing likenesses.[27]

No longer competing with four or five other caricatures on the page, each likeness in *The Prince of Wales* appeared even more dramatic and inventive. In the depiction of O'Neill, who often joined Covarrubias and Hirschfeld for jaunts to the nightclubs, the playwright upholds his reputation for impenetrable gloom (fig. 7.19). Sharp, radiating lines of eyelids, nose, brows, and shadows all converge at a central point between the eyes, contracting the features into a fierce

frown. A certain spareness pervades this clean, geometric graphic style, but the effect is neither simple nor flat. O'Neill's protruding forehead, jutting chin, waving hair, and dark circles under the eyes add to the keenness of the characterization.

Covarrubias had adapted to the *Vanity Fair* aura; this was Mexican caricature in evening clothes, not peasant dress. His powerful, hideous portrayals of his countrymen Xavier Algara (fig. 7.20) and the long-suffering Tablada in *The Prince of Wales* stand out in contrast with the others. The image of Algara is a nightmare vision, radiating, as Bernard Reilly has pointed out, a demonic frenzy reminiscent of Posada's revolutionary folk prints. The image of Tablada, with his thick, gross features and checkerboard five-o'clock shadow, also has a monstrous quality. These caricatures represent Covarrubias before he began drawing Manhattanites for Crowninshield. In contrast with the raw power of his Mexican drawings, there was a discernible emotional distance between Covarrubias and his New York subjects. Some of this had to do with youth, with language and culture barriers, and with an unfamiliarity with his American subjects. On the other hand, the elegant tone, the lack of coarseness, and the general avoidance of anything horrific suggests the editor's own personal, polite aesthetic. Covarrubias's drawings, Crowninshield pointed out in 1927 in a statement that conveyed his own predilections, "bear no trace of the decadent, erotic, or saturnine qualities which characterized . . . *fin-de-siecle* masters of black and white. . . . Nor is there in them any of the grossness, the somewhat fat overstatement of Hogarth and Rowlandson. Something within him, a respect for truth, perhaps, or a reverence for restraint in line, has kept him from the errors that follow in the train of *grossièreté*." For a lesser artist this emotional distancing and refinement could have resulted in amiable banality. For Covarrubias, it freed him to concentrate with cool detachment on likeness, line, and pattern.[28]

His portrait of Paul Whiteman, for instance, does not reveal any subtle personality traits (fig. 7.21). The famous band conductor was already renowned for his recordings, his orchestras, and his interest in merging symphonic and jazz traditions. But his Aeolian Hall jazz concert on Lincoln's birthday in 1924, featuring the first performance of George Gershwin's "Rhapsody in Blue" and other commissioned pieces, put Whiteman's name on everyone's lips. Covarrubias reduced the band leader's features to a few abstract

lines that would be completely indecipherable outside the familiar round face. Placed within a large sphere, however, and anchored by the swoop of a chubby chin, they emerge as the familiar eyes, nose, mouth, and tiny mustache. In an undated drawing of Whiteman, Covarrubias refined this conception further (fig. 7.22). The features are slightly shifted to emphasize the bisection of the face. The added viola shape refers to the musical imagery of Picasso's cubist works. To Covarrubias's audience, the witty, high-low juxtaposition of cubist abstraction and cartoon inflation was a recognizable reference to Whiteman's own efforts to merge popular and classical traditions.

Ralph Barton recognized in Covarrubias's work an approach quite similar to his own. In his astute review of *The Prince of Wales* he singled out the full-length watercolor figure of Calvin Coolidge (fig. 7.23). Narrow slits of eyes and the mouth obscured behind an inventively shaped nose reveal little, intimating the secrecy and silence for which the president was famous. But, as Barton pointed out, these images did not need to

7.21 *Paul Whiteman* (1891–1967) by Miguel Covarrubias. Printed illustration. Published in Covarrubias, *The Prince of Wales and Other Famous Americans* (New York, 1925). Library of the National Portrait Gallery and the National Museum of American Art, Smithsonian Institution, Washington, D.C.

7.22 *Paul Whiteman* (1891–1967) by Miguel Covarrubias. Watercolor over charcoal on cut paper, 29.2 x 24.4 cm (11¹/₂ x 9⁵/₈ in.), c. 1924. Prints and Photographs Division, Library of Congress, Washington, D.C..

7.23 *Calvin Coolidge* (1872–1933) by Miguel Covarrubias. Watercolor and india ink on paper, 35 x 24.8 cm (13³/₄ x 9³/₄ in.), c. 1925. Original illustration for Covarrubias, *The Prince of Wales and Other Famous Americans* (New York, 1925). National Portrait Gallery, Smithsonian Institution, Washington, D.C.

expose the innermost nature of their subjects: "Coolidge may, for all we know, dream in the secret depths of his soul that he is a tailed satyr turned loose among a bevy of beautiful nymphs on the shores of Cytherea, but the Calvin Coolidge that is any of our business is the Calvin Coolidge that Covarrubias has drawn."[29]

Barton was articulating a significant change in emphasis for the caricaturist. Before World War I the critics had praised Marius de Zayas for revealing the "soul" of his subject. Barton, in contrast, felt that the soul was none of the caricaturist's business. When he characterized Covarrubias's drawings as neither cruel nor penetrating, he was being complimentary. He did not mean

that the images lacked satiric impact. "Alexander Woollcott has not visited friends all over the orchestra of a theater since Covarrubias has shown him what he looks like standing up," Barton pointed out. "Heywood Broun . . . has foresworn poker; Franklin P. Adams has grown a mustache, and Babe Ruth has gone completely to pot" (fig. 7.24). But it was not the hidden, internal characteristics that Covarrubias had captured so well; it was the external synopsis or, in Barton's words, the "figure a man cuts before his fellows in his attempt to conceal the writhings of his soul."[30]

Willard Huntington Wright had made a similar comment about Al Frueh, noting that the artist avoided the

7.24 *Babe Ruth* (1895–1948) by Miguel Covarrubias.Printed illustration. Published in Covarrubias, *The Prince of Wales and Other Americans* (New York, 1925). National Portrait Gallery, Smithsonian Institution, Washington, D.C.

and reputation into an imaginative portrait form that had its own internal artistic integrity. These images derived their power not from an emotional probing but from an iconic summary of publicized traits and features.

Like Frueh and Barton, Covarrubias played an important role in defining this style of caricature. His portrait of Will Rogers for Corey Ford's book *The John Riddell Murder Case* (1930) repeated the figure published in a January 1925 issue of *Vanity Fair* and again in *The Prince of Wales*. The same radiating lines of the face simultaneously suggest the amiable grin, the twinkling eye, and the wrinkled, weather-beaten complexion (fig. 7.25). The slouching posture and bandanna convey the casual western manner and modest demeanor that were integral to his cowboy stage persona. But in this image of Rogers, Covarrubias did not depict the self-effacing performer but the best-selling author of a recently published book, a shrewd manager of his own celebrity. Ford's satiric tale described a reader who died of acute boredom in his own library, murdered by the best sellers of the past year, including *Ether and Me*, by Rogers. The "alleged cowboy," a character in Ford's book explains, "has achieved some local reputation by dressing up in leather chaps, . . . and touring the vaudeville circuits offering wise cracks about current celebrities. . . . His particular claim to fame seems to rest upon the fact that he knows all the celebrities by their first names." Rogers was thus depicted as a drugstore cowboy, wearing a showy ten-gallon hat and hanging around the street corner commenting about the passersby. Covarrubias increasingly directed his satire at the celebrity system and its manipulation, and the Rogers drawing showed a satiric subtlety missing in his first portraits of New York notables. Ford and Covarrubias would explore this theme further in other collaborations of the 1930s.[32]

Covarrubias recognized the role that his *Vanity Fair* exposure had played in establishing his reputation. In his second book, *Negro Drawings*, published in 1927, he acknowledged his gratitude to the editors "for the unfailing sympathy and understanding which greeted his work." But if Covarrubias had initially felt indebted to *Vanity Fair*, the roles were soon reversed, as the magazine sought to capitalize on Covarrubias's growing reputation. In March 1926 the editors nominated him for their own Hall of Fame, noting that *The Prince of Wales* had been one of the popular books of the holiday season. For the July 1926 issue a few months later,

analytical or "philosophic" side of caricature and dealt with external "salients" almost exclusively. Indeed, he found that American caricaturists, in general, relied on cleverness and "external dexterity," avoiding the tedious search for the deeper and less obvious qualities of caricature.[31] Wright, who did not distinguish between political cartooning and celebrity portraiture in his discussion of the caricature tradition, valued a more penetrating approach, an emphasis on revealing the soul. And yet he recognized the key characteristics of this evolving art form in America as well as its leading practitioners. For Frueh, Barton, and Covarrubias, modern caricature was not a probing analysis nor a revelation of elemental human instincts and emotions. It exploited rather than penetrated the shallow exaggerations of the celebrity process, magnifying those familiar characteristics into something fresh and modern. Using the raw materials that the media had provided, these artists reassembled recognizable features of face

famous contributors were advertised on the cover;
Covarrubias warranted mention, along with comic
artist Milt Gross and such well-known authors as
Sherwood Anderson, Robert Benchley, Heywood
Broun, and Theodore Dreiser. As Crowninshield pointed
out in 1927, "hymns in praise of him seem every day to
be increasing in fervour, and . . . the tenor of many of
them has been to pronounce him the most promising
and significant figure in the field of American black and
white art."[33] Covarrubias's drawings, Crowninshield
realized, appearing almost monthly since the beginning

of 1924, were a foundation of the magazine's reputation.

Covarrubias's sharp, geometric style and unerring
line lent a confident aura to his subjects, no matter how
ridiculously distorted. The tone of the caricatures is
not unlike the comic heroines invented by Anita Loos
and Mae West, who confronted the complexities of
modern life with brash self-confidence, despite their
obvious flaws. Loos had shared the Hall of Fame page
with Covarrubias for the publication of *Gentlemen Prefer
Blondes*. Lorelei Lee, the heroine of her popular book,
epitomized the gold-digging flapper of the jazz age,

7.26 *Carl Van Vechten, Fania Marinoff, and Taylor Gordon* (1880–1964; 1887–1971; 1893–1971) by Miguel Covarrubias. India ink and wash on paper, 40.5 x 35.4 cm (15 15/16 x 13 15/16 in.), 1929. Original illustration for Taylor Gordon, *Born to Be* (New York, 1929). Prints and Photographs Division, Library of Congress, Washington, D.C.

but her honesty, unabashed self-indulgence, and humorously manipulative charm were, in the end, likable character traits. West's film personification of sex appeal was equally crass and materialistic, but her blunt manner and self-reliance endeared her to the audience.[34] Covarrubias's celebrity subjects seem similarly ridiculous but captivating. The flaws that he exploited—Calvin Coolidge's boring demeanor, Eugene O'Neill's gloominess, Will Rogers's corniness—were an integral part of each one's celebrity. Such minor defects added animating, distinctive elements to a personality. In exaggerating those traits, therefore, he was reinforcing public image rather than diminishing character. He could be witty and irreverent without causing offense; celebrity reputations remained intact.

This type of humor contrasted with the other stock character of the 1920s: the weak "little man" anti-hero epitomized by Chaplin, Robert Benchley, and James Thurber. The comic common man was often baffled and confused by the modern world, prevailing by accident or serendipity, if at all. Celebrity caricature, however, dealt with the lionized successes of modern society, not with the common man. Everyone wanted to laugh at their quirks and excesses, but no one really wanted them to fail.

Covarrubias missed none of New York's cultural opportunities and showed as much enthusiasm for theater, dance, and music as he did for art. When the *New Yorker* began in 1925 he contributed portraits regularly, often covering the performing arts. His love affair with the beautiful dancer Rose Rolanda (who later changed

7.27 *Enter, the New Negro, A Distinctive Type Recently Created by the Coloured Cabaret Belt in New York* by Miguel Covarrubias. Printed illustration. Published in *Vanity Fair*, December 1924. Library of the National Portrait Gallery and the National Museum of American Art, Smithsonian Institution, Washington, D.C.

her name to Rosa) strengthened his connection to the theatrical world. He no longer limited himself just to portraiture. Rolanda starred in a "Rancho Mexicano" sketch in *The Garrick Gaieties* of 1925, and theatrical designer Lee Simonson commissioned Covarrubias to create the set. Both dancer and set designer received enthusiastic reviews. Covarrubias subsequently designed a production of Shaw's *Androcles and the Lion* as well as several ballets, one of them for marionettes. Perhaps his most important theatrical contribution was the design of the set for *La Revue Nègre*, the American musical review that opened in France in 1925. Starring dancer Josephine Baker, the show hit Paris like a bombshell, epitomizing for enthusiastic audiences "le jazz hot."

The commission for *La Revue Nègre* had grown out of Covarrubias's increasing fascination with African American music, dance, and culture. Everyone who knew Carl Van Vechten had been introduced to Harlem and the exotic allure of its nightclubs. For some white New Yorkers, this nighttime "slumming" was just a fashionable, alcoholic escapade. For Covarrubias, the experience was revelatory. He started frequenting the Harlem nightspots, sketching black performers, and befriending leading writers and intellectuals. His drawing of Van Vechten, Fania Marinoff, and Taylor Gordon, published in Gordon's *Born to Be* (fig. 7.26), gives some suggestion of the intense encounters and developing friendships of this period. "Once Miguel became involved with the Harlem Renaissance," Hirschfeld recalled, "he had a good reason for never being at the studio."[35] In December 1924 his series of drawings of the "new negro" began appear-

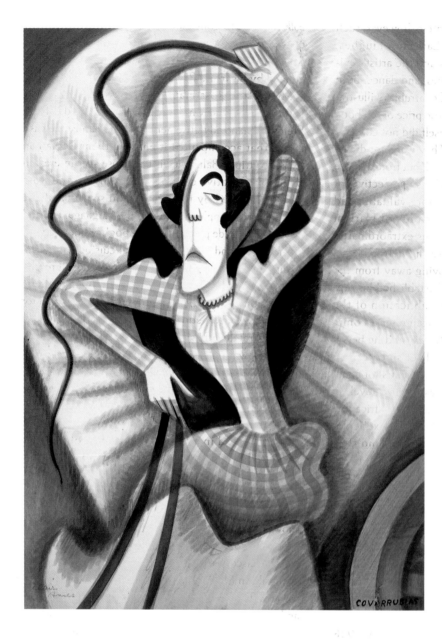

7.28 *Edna Ferber* (1887–1968) by Miguel Covarrubias. India ink and wash on paper, 36.8 x 26.7 cm (14½ x 10½ in.), 1932. Original illustration for John Riddell, *In the Worst Possible Taste* (New York, 1932). Art Collection, Harry Ransom Humanities Research Center, The University of Texas at Austin.

ing in *Vanity Fair*. In addition to *Born to Be* (1929), he illustrated William C. Handy's *Blues: An Anthology* (1926) and Zora Neale Hurston's *Mules and Men* (1935). His *Vanity Fair* images were published by Alfred Knopf in an internationally acclaimed volume entitled *Negro Drawings* in 1927, with a preface by Barton and an introduction by Crowninshield.

With a consuming interest in folk and ethnic traditions that would ultimately lead to a career as an anthropologist, Covarrubias sought to convey the vibrant, distinctive Harlem culture that so fascinated him. His drawings were therefore emphatically racial. Rather than individual portraits, his figures were more often types—the dancing waiter, the gambling man, the "Queen of the blacks and blues." The emphasis on racial features and characteristics in his comic drawings offended some black leaders for their stereotypical exaggerations (fig. 7.27). As Adriana Williams has observed, Covarrubias unintentionally initiated new stereotypes as he challenged old ones. In a review of Gordon's *Born to Be*, W. E. B. Du Bois noted that he "could exist quite happily if Covarrubias had never been

born." Other African American writers, however, such as James Weldon Johnson and Langston Hughes, admired the vitality of the images and the artist's evident admiration for black jazz, blues, and dance. Both Johnson and Hughes wrote that Covarrubias's illustrations for Handy's *Blues* were worth the price of the book all by themselves. Covarrubias himself did not consider his Harlem drawings caricatures. They were not drawn with a satirical purpose, he contended, but from a "more serious point of view."[36] From today's perspective, of course, it would have been far more valuable had Covarrubias concentrated on portraits of Harlem friends and collaborators, such as his extraordinarily powerful James Weldon Johnson (see fig. 1.16).

Covarrubias, however, was moving away from the portraiture of the famous that had established his reputation in New York. After the publication of the *Prince of Wales* he contributed more general comic drawing than portraiture to *Vanity Fair*, and he began to concentrate on other pursuits. Ever since he had taken Rolanda to Mexico in 1926, on the first of many trips, the two had indulged in a passion for travel. In time they explored Europe, South America, Africa, the Far East, and the South Pacific. Both had exuberant personalities and wide-ranging interests, and they made friends wherever they went, always gravitating toward artists and intellectuals. From the fall of 1926 through 1927 they lived in Paris, where they were made welcome by Edward Steichen, Man Ray, Gertrude Stein, Henri Matisse, and other creative personalities. From there they traveled to northern Africa, where Covarrubias made illustrations. Miguel pursued his passion for collecting ethnic and folk art; Rosa became an accomplished photographer and a renowned gourmet cook.

Back in New York at the end of February 1928, Covarrubias opened an exhibition of his caricatures and "negro" drawings. "Each drawing sold for $300," José Clemente Orozco wrote enviously to a friend, "more than Picasso's which only sell for $250."[37] His work was in great demand. He illustrated John Huston's book on the Frankie and Johnny legend, Corey Ford's *Meaning No Offense* and *In the Worst Possible Taste* (fig. 7.28), Theodore Canot's *Adventures of an African Slaver*, and others. He and Rosa spent the summers in Mexico, where Miguel was becoming increasingly interested in pre-Hispanic art and culture. He wrote on Mexican masks for the magazine *Mexican*

Folkways, and he contributed examples from his folk art collection as well as some of his own paintings to the Metropolitan Museum's exhibition on Mexican arts, curated by his friend René d'Harnoncourt.

Miguel and Rosa married in April 1930. He had received the National Art Directors' Medal for a Steinway piano advertisement, and the handsome cash award that accompanied it enabled them to plan an extended trip to Bali. The visit refocused his interest in overlooked, native cultures. Both Miguel and Rosa were captivated by the beauty and serenity of the island and its people: he studied the language, art, and culture, and made plans to write a book, while she took photographs and investigated local cuisine and dance traditions. They spent almost a year there and left resolving to return. Miguel's grant from the Guggenheim Foundation enabled them to go back to Bali in 1933 for another extended period to research his book. *Island of Bali*, illustrated with Miguel's paintings and Rosa's photographs, was published by Alfred Knopf in 1937 to great international acclaim. Despite his readable, anecdotal approach, the volume established his reputation as a serious scholar and writer on native cultures.

Covarrubias's remarkable enthusiasm, energy, and talents resulted in a breathtaking range of achievements in various fields before his death in 1957. He continued to earn much of his income providing illustrations for New York publishers and advertisers, and he found time to exhibit his own paintings, organize shows of arts and crafts for various museums in Mexico and New York, and paint six map murals for the 1939 San Francisco World's Fair. But he and Rosa were living primarily in Mexico by the mid-1930s, settling in the town of Tizapán, outside of Mexico City. Their home and art collections as well as Rosa's garden and international cuisine became famous. Much like Virginia Woolf in London or Gertrude Stein in Paris, they attracted the creative elite of Mexico City.[38] Friends from around the world made a point of visiting Tizapán; their American houseguests included George Balanchine, Nelson Rockefeller, Sonny and Jock Whitney, Georgia O'Keeffe, Amelia Earhart, and Martha Graham.

Often ignoring the entreaties of American publishers, advertisers, museum curators, and friends, Covarrubias turned his considerable energies to serious studies in anthropology, archaeology, and ethnology, focusing on the ancient cultures of Mexico and

Indian art of the Americas. He became a leading figure in the extensive archaeological excavations of the period and the scientific rediscovery of pre-Hispanic art and culture. In addition to writing for scholarly papers and publications, he taught courses at the National School of Anthropology and History, organized exhibitions, and redesigned the galleries of the National Museum of Anthropology in Mexico City. As Smithsonian Institution archaeologist Matthew Stirling pointed out, "Covarrubias would be known as one of the best informed men of Mexican archaeology and ethnology were it not for his fame as a painter, caricaturist, and writer."[39] He continued to draw illustrations and paint murals and canvases. For two years in the 1950s he worked to revolutionize modern dance in Mexico as artistic director of the Academy of Dance at Mexico City's Bellas Artes. Not only did he design sets, he also set up courses in folklore and art history and encouraged young choreographers to incorporate Indian dance traditions. As a cultural leader, historian, scientist, teacher, curator, and artist, Covarrubias made lasting and significant contributions to Mexican life.

Caricature was only a small part of this remarkable career. But his dazzling appearance in the mid-1920s had crystallized the form of modern caricature in America, defining and refining the art of the pen line. And, in the 1930s, before his other interests took precedence, he added another chapter to the evolution of this portrait form as *Vanity Fair* brought him back to celebrity caricature, this time printed in brilliant color. As we assess this two-part role, the overall influence of the Mexican caricature tradition begins to coalesce. The emotional, propagandistic fervor of Mexican satire did not flourish in the urbane world of Frank Crowninshield's New York. But because of their Mexican experiences, Fornaro, De Casseres, and Tablada as critics and De Zayas and Covarrubias as artists each added to the American art form an enhanced cultural weight. In their view caricature was not a peripheral frivolity but a powerful forum for comment and expression. They brought to New York the concept of a legitimate art form, reflecting the social, political, and cultural concerns of the era. Caricature in America would achieve a stronger, more dominant voice through their efforts.

Around the Town: *The Caricature Profession*

And then, what a mixture of delights, what an answering chord to every human mood, caricature provides.
—Bohun Lynch, *A History of Caricature*

The New Yorker will be a reflection in word and picture of metropolitan life. . . . It will be what is commonly called sophisticated, in that it will assume a reasonable degree of enlightenment on the part of its readers. It will hate bunk.
—Harold Ross

By 1922 the growing fascination with celebrity caricature had taken on the dimensions of a fad, propelled by a series of well-publicized events that took caricature off the printed page and into the worlds of fashion, theater, and art. Writing for the July 1922 issue of *Vanity Fair*, the insightful critic Willard Huntington Wright noted the escalating trend. "Of late years, and especially since the war, America has shown a tremendous increase of interest in the art of caricature," he commented.

> *Many of the American magazines—and not alone the art journals—are devoting pages to pictorial satire. Numerous publications are running series of caricatures; and it is not uncommon for these periodicals, instead of illustrating personal articles with photographs, to make use of caricatures instead. Even our daily newspapers reflect the general interest in satirical portraiture; and when we open a paper today we are as likely as not to be confronted by a caricature of some celebrity of the moment. Furthermore, a New York theatre has recently introduced an innovation by ordering a drop curtain decorated entirely with caricatures.[1]*

Ralph Barton's June 1922 Chauve-Souris audience curtain had undoubtedly catapulted celebrity caricature to a new level of fashion. By September, John Murray Anderson had copied the idea, commissioning Reginald Marsh to paint an overture curtain for *The Greenwich Village Follies*. Although the curtain is lost, the show's publicist described it as teeming with famous Village personalities. While Edmund Wilson, Stephen Vincent Benét, John Dos Passos, F. Scott Fitzgerald, and other young intellectuals rocketed down Seventh Avenue in a truck, another group of Village notables sat in the theater watching a drama by Eugene O'Neill. Various artists and writers peered out of windows or wandered the streets. Al Frueh climbed the arch in

Washington Square; Zelda Fitzgerald dove into the fountain. As comedy curtains became the rage, the temptation to distort the celebrity face became that much more irresistible.[2]

In the fall of 1922, not long after the appearance of the caricature curtains, popular Cuban caricaturist Conrado Massaguer (1889–1965) arrived in New York on one of his periodic sketching trips. Founder and director of the Havana humor magazine *Social*, Massaguer was already known in New York from his work in *Shadowland* and in the *New York World*.[3] He arrived with copies of his own newly published book of international faces, *Guignol Massaguer*, which included such American celebrities as William Howard Taft, Theodore Roosevelt, John D. Rockefeller, Sr., and cowboy actor William S. Hart (fig. 8.1). Soon after his arrival, S. J. Kaufman, author of the *New York Telegram*'s "Around the Town" column, threw a large party for Massaguer, who was both the guest of honor and the chief entertainment. Armed with his sketchpad, Massaguer began to draw the guests, all notables from the artistic, theatrical, and journalistic worlds. In less than an hour he had drawn more than a hundred sketches, to the amazed delight of his admiring victims, who lined up to be recorded by his rapid pencil. Naturally this private affair did not go unnoticed in the press.[4]

The fall publication of Al Frueh's portfolio *Stage Folk* was another milestone of 1922, and its critical success undoubtedly encouraged the ensuing surge of caricature collections published in book form. From the hand of Gene Markey, later a Hollywood film writer, came *Literary Lights* (1923) (fig. 8.2) and *Men about Town* (1924). British-born comedian, film star, and caricaturist Roland Young compiled his likenesses in *Actors and Others* in 1925, the same year Covarrubias's *The Prince of Wales* was published. Hungarian-born sketch artist

8.2 *Booth Tarkington* (1869–1946) by Gene Markey. Printed illustration. Published in Markey, *Literary Lights: A Book of Caricatures* (New York, 1923). Library of the National Portrait Gallery and the National Museum of American Art, Smithsonian Institution, Washington, D.C.

8.1 *William Hart* (1870–1946) by Conrado Massaguer. Printed illustration. Published in Conrado Massaguer, *Guignol Massaguer* (Havana, 1922). Brooklyn Museum of Art Library Collection, Emil Fuchs Collection, Brooklyn, New York.

Henry Major issued *Portraits and Caricatures* (1927); Eva Herrmann focused on literary figures in *On Parade* (1929).[5] As Herrmann's title suggests, these modest volumes do little more than present a procession of amusing, famous faces.

Waldo Frank, who wrote *Time Exposures* under the pen name "Search-Light," noted in the preface to his volume that the editors of the *New Yorker* had prevailed on him to compile the book. They had urged him to expose his friends in public, he explained: "to shine upon all their virtues (for which of course he could not forgive them), and upon all their failings (for which he generously loves them)." *Time Exposures*, a collection of twenty short essays about the famous, was issued "together with" (rather than merely "illustrated by")

caricatures by *New Yorker* contributing artists.[6] Inexpensive to compile and sure to sell, humorous portrait collections quickly became a fashionable notion in publishing circles.

Frueh's *Stage Folk* did more than just inspire books, however. The portfolio of linocuts had new implications for caricature, presenting celebrity likenesses as art: eye-catching prints meant to be collected and displayed. In December 1922 the Anderson Art Gallery exhibited Frueh's linocuts along with drawings by Massaguer. In the invitation, drawn by Carlo de Fornaro, a lanky Al Frueh plucks his squat Cuban colleague off his palm tree island (fig. 8.3). Frueh was just as deftly moving caricature from the milieu of illustration to the world of mainstream art.

With this new visibility, the pace of critical commentary noticeably increased. Most writers recognized a genre distinct from other types of comic drawing and more closely aligned to recent aesthetic trends. Dismissing old preconceptions, enthusiastic critics attempted to define the concept of caricature, separating the word from "cartoon" and grappling with the implications of the new streamlined style and light tone. Writing for *Arts and Decoration*, Fornaro reflected on Frueh's "economy of line which amazes the connoisseur and the artist." The critic for the *New York Post* noted that the "greater restraint of this modern method of caricature calls for correspondingly greater technique." The *Brooklyn Eagle*, after struggling with dictionary definitions, concluded that "now the true caricaturist is an artist."[7]

The proliferating commentary gave American audiences a broader perspective on caricature; no longer could it be viewed as just the hackneyed tool of the newspaper cartoonist. In the September 1922 issue of *Shadowland*, Willard Wright explored the broader historical tradition and contemporary characteristics of various European, and North, South, and Latin American schools.[8] An array of international portraits illustrated the article. José Juan Tablada's commentary on Mexican caricature followed in the same magazine in April 1923, introducing the work of José Clemente Orozco, Ernesto García Cabral, and Covarrubias. Fornaro began his series of lively and informed caricature articles in 1922 in *Arts and Decoration*, focusing on Frueh, Massaguer, Oliver Herford, and William Gropper, as well as such French masters as Sem, Jean-Louis Forain, and Caran D'Ache (Emmanuel Poiré). The press coverage established satiric portraiture as an international phenomenon, indicating that a new generation approached caricature with a powerful, refined line reflective of modern design.[9]

Critics Henry McBride and Willard Wright, despite their admiration for American caricaturists (especially Frueh) questioned whether American society had enough maturity to sustain a caricature tradition. McBride, writing for the *New York Herald* on December 24, 1922, referred to the widespread notion that the comic spirit developed only in older countries. "The capacity to stand satire is a proof of civilization," he wrote, noting that youthful wit was apt to be "acrobatic and raw." Wright had raised the same question a few months before in *Vanity Fair*: "A young nation . . . can no more produce finished caricaturists than an adoles-

8.3 *Anderson Gallery Exhibit Invitation* by Carlo de Fornaro. Printed card, 23.5 x 14 cm (9¼ x 5½ in.), 1922. National Portrait Gallery, Smithsonian Institution, Washington, D.C. Transfer from the Archives of American Art.

cent youth can raise a beard."[10] Although they recognized the proliferating vogue and identified some of the distinguishing qualities of American work, both critics were still struggling to interpret the new form of portraiture, particularly in relation to European precedents and the historical tradition.

The Anderson Gallery's December exhibition was not the last event of that caricature-packed season of 1922. Even the last day of the year added to the momentum. On December 31, the *New York World* reported on the festive opening of Barney Gallant's Intellectual Toy Cabaret, a Greenwich Village dining spot where amusing portraits of Manhattan personalities covered the walls. "When the notables arrived in person," the article recounted, "they found themselves

already there in pictures. For instead of the usual tapestry or fresco, they discovered caricatures of themselves as seen through the eyes of the black and white boys." The Latvian-born Gallant, a former roommate of Eugene O'Neill's and the poker-playing pal of many local intellectuals, was already renowned for his endearing, illegal habit of selling liquor to anyone who could pay. His Club Gallant on Washington Square was not aimed at impoverished bohemians, however, but at affluent, uptown sightseers. Frank Crowninshield, the glamorous Alla Nazimova, and "all the smart people of New York" attended the opening. In February 1923, *Vanity Fair*'s society and fashion writer Johnnie McMullin reported that the place had acquired quite a reputation and was "crowded with interesting people from the four corners of the town." A photograph of actress Martha Lorber, admiring the club's "wall portraits of famous New Yorkers" by Massaguer, appeared in the following issue (fig. 8.4). When Gallant commented to the *World* on the night of the opening that

THE CLUB GALLANT

A new type of cabaret, Viennese in decoration, where the leading caricaturists have contributed wall portraits of famous New Yorkers. Martha Lorber is admiring Conrado Massaguer's caricature portraits of Nazimova, Will Rogers, John Barrymore, John Drew and Nikita Balieff

8.4 *The Club Gallant* (Martha Lorber; 1901–?) by Conrado Massaguer. Printed illustration. Published in *Vanity Fair*, March 1923. Prints and Photographs Division, Library of Congress, Washington, D.C.

"the whole place is a caricature. It's all wrong artistically and practically," he was counting on the newly fashionable word to attract customers.[11]

The events of 1922, all connected by the escalating trend, each generated imitations and refinements. Gallant had not originated the idea of a caricature-decorated eatery, of course. An outgrowth of bohemian café culture, coffeehouses with wall portraits could be found in cities from Paris to Rome to Mexico City. Before the turn of the century, these neighborhood cafés served as gathering places for avant-garde artists and intellectuals sharing their talents and ideas. In America in the 1920s, however, clubhouses and restaurants ornamented with caricature were, instead, part of the fashionable entertainment world, places for café society patrons to share their celebrity status. The portraits on the wall lent an aura of stylish sophistication, an irresistible sense of intimate association with the famous. After such tenuous beginnings as the Club Gallant, caricature-decorated dining spots proliferated in New York City, epitomized by the renowned Broadway restaurant Sardi's, still in existence.

In 1927, when the Italian-born Vincent Sardi and his wife moved their establishment into a new building on 44th Street, business slowed despite favorable notices by columnists Walter Winchell and Ward Morehouse. Wondering how to attract more attention, Sardi remembered Joe Zelli's in Paris, where the walls were covered with caricatures of the famous. The idea appealed to him. He first asked Irving Hoffman to draw the portraits but found him too busy working as a press agent, writer, and caricaturist. Sardi settled instead for Alex Gard (1900–1948), a Russian refugee whom Hoffman had often encountered on his weekly rounds to the newspaper offices. With mock solemnity, Gard and Sardi signed a formal contract on September 19, 1927, pledging to exchange portrait caricatures for daily meals. Agreeing that the restaurateur would not criticize the drawings nor the artist complain about the food, they launched a friendly relationship that would profit them both. Gard drew caricatures for Sardi's for the next twenty years, providing, according to Vincent Sardi, Jr., the first 720 portraits for the restaurant's ever-changing display.[12]

The Sardi's subjects—"All Gard's Chillun," the artist called them—were invariably connected to the theater or the arts. Gard drew each bust portrait with ink contours, filled in with watercolor. Harsh distortions often

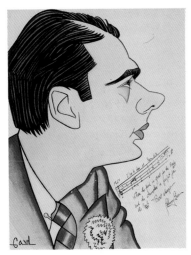 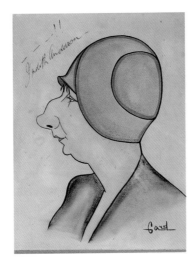 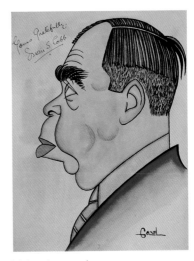

8.5 *John W. Green, Judith Anderson,* and *Irvin S. Cobb* (1908–89; 1898–1992; 1876–1944) by Alex Gard. Ink and watercolor on paper, approx. 38.1 x 27.3 cm (15 x 10³/₄ in.), c. 1927–40. Billy Rose Theatre Collection, New York Public Library, New York, Astor, Lenox and Tilden Foundations.

rendered the faces of such famous players as Judith Anderson quite ugly (fig. 8.5). But his well-trained celebrity clients did not seem to mind. Each one signed the drawing, generally adding a witty comment. Judith Anderson contained her displeasure with dashes and exclamation points: "---------!!" "Yours gratefully," scrawled humorist Irvin S. Cobb. Composer Johnny Green wrote down a few bars of music with the lyrics, "I love to dine at Sardi's." The signatures and remarks proved that each portrait was made from life, a document of an authentic celebrity encounter between artist and subject.

The collective significance of these images, of course, outweighed their individual importance. No matter how distended the protruding lips or outrageous the nose, each likeness signified a complimentary inclusion in a modern-day pantheon of the famous. Eventually hung in three rows on the walls, the drawings surrounded the diners (fig. 8.6). Combined with the welcoming friendship of the debt-forgiving Sardis, the pictures created for regular Broadway patrons the atmosphere of a theatrical club. Celebrity-seeking tourists, on the other hand, had the sense of being in the heart of a theatrical world pulsating with color, personality, talent, and fame.

The caricatures and consequent celebrity patronage quickly became the defining aspect of the restaurant. Sardi's evolved into part of the Broadway ethos, a sym-

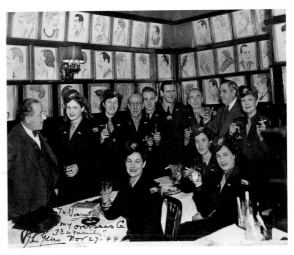

8.6 *Vincent Sardi, Sr., and Guests* by unidentified photographer. Photograph, 1944. Historical files, Sardi's Restaurant, New York City.

bol of New York's theatrical world. The 1932 movie *Love Is a Racket* was the first of several films in which Sardi's banquettes and caricature-covered walls were replicated on Hollywood sound stages to evoke a Broadway setting. The restaurant appeared as the set for several scenes in the Broadway revue *Bright Lights of 1944.* Even in the background of the advertising for the 1953 film *Forever Female,* the famous caricature walls

8.7 *Herbert Bayard Swope*
(1882–1958) by Peggy Bacon.
Chalk on paper, 42.6 x 35 cm
(16³/₄ x 13³/₄ in.), c. 1934–35.
National Portrait Gallery,
Smithsonian Institution,
Washington, D.C.

instantly suggest the theatrical milieu of the story line. In time, so many movie scenes were filmed on the premises that Vincent Sardi, Jr., who always played himself as the proprietor, joined the Screen Actors Guild. If much of Sardi's mythic success resulted from the astute management and personality of the owner and his family, the installation of celebrity caricature at Sardi's during the peak of its vogue in the late 1920s certainly helped.[13]

In those few years between Barton's curtain and Sardi's restaurant, portrait caricature entertained the cognoscenti in books, art galleries, private living rooms, clubhouses, theaters, and cabarets. Critics, pub-

lishers, and arbiters of fashion praised and debated its merits. Distorted likenesses on the printed page, still the primary outlet for a mass audience, grew correspondingly. As demand increased, editors searched for new contributors. Young sketch artists were attracted to the field, and foreign caricaturists arrived to try their hand at depicting American celebrity.

The *New York World*, which had been publishing the work of Fornaro and De Zayas for more than a decade, led the newspapers toward the vogue for caricature at the beginning of the 1920s. The tall, red-haired executive editor Herbert Bayard Swope set the tone (fig. 8.7); he was a figure so colorful, dynamic, and forceful,

according to one associate, that he towered over other newspapermen like a Paul Bunyan. Columnist Westbrook Pegler once described him as "all gall, divided into three parts—Herbert, Bayard, and Swope."[14] The editor assembled New York's liveliest columnists, commentators, and critics for his entertainment and op-ed pages. Heywood Broun, Alexander Woollcott, Franklin P. Adams, and Deems Taylor labored at the *World* as regular columnists, sharing office space, arguments, gossip, and witticisms. H. L. Mencken and Will Rogers also wrote for the paper at the time, and those famous personalities who did not contribute appeared so frequently in one or another column that they seemed to be part of the paper's brilliant, intimate circle. Swope paid his writers well, entertained them at his Long Island estate, protected them from the objections of publisher and business manager, and tolerated both their acerbic, contradictory opinions and their blatant logrolling. The *World* did not have the resources for the best news reporting, but with its spirited opinion, wit, and celebrity connections, it was well suited to chronicle the fast pace of metropolitan life.

Caricature would flourish in this atmosphere. Herb Roth and other regular *World* caricaturists re-created dinners, balls, political conventions, and the annual theatricals of the Dutch Treat, Lambs, or Friars clubs for the readers of the Metropolitan Section. By the early 1920s, Al Frueh, whose comic strips had been running for years, finally began to publish portraiture in the *World* as well. By 1922, no one would think of drawing a solemn charcoal likeness of the Chauve-Souris's puckish Nikita Balieff; several of the *World*'s artists, including Frueh, attempted to express his irresistible charm through caricature (fig. 8.8). As the 1920s progressed, all of New York's most prominent caricaturists appeared in the entertainment section of Swope's Sunday paper.

Rival papers were not going to be outdone for long in the competitive journalistic world of the day. In March 1923, just as the vogue had taken firm hold, the Budapest-born caricaturist Henry Major (1889–1948) arrived in New York. By mid-April he had been hired by William Randolph Hearst's *New York American*. Armed with an advertising brochure trumpeting his accomplishments, Major launched a fast-growing career. He had trained formally at the Academy of Fine Art and less formally at his hometown's bohemian cof-

8.8 *Nikita Balieff* (1877–1936) by Al Frueh. Ink and gouache on paper, 42 x 33.3 cm (17 x 13¼ in.), 1922. Original illustration for *New York World*, October 15, 1922. National Portrait Gallery, Smithsonian Institution, Washington, D.C.; gift of the children of Al Frueh: Barbara Frueh Bornemann, Robert Frueh, and Alfred Frueh, Jr.

feehouses.[15] After working as a sketch artist in Paris, Vienna, and Amsterdam, he moved to London and a position with the renowned *Graphic* and *Bystander*. Through these publications his fame preceded him to America, and journalists welcomed him with fanfare. "Major has come to be a name to be reckoned with in European capitals," one newspaper announced on his arrival. "He never draws his caricatures unless he has actually seen the person in question. No photograph will serve. He must have the original and he prefers the original to be famous."[16]

Major claimed that he could sketch a portrait in half a minute, and his perceptive and instantaneous analysis of an individual face was one key to his success. In his quick sketch of William Howard Taft (fig. 8.9), for instance, he conveyed the ex-president's ruddy com-

8.9 *William Howard Taft* (1857–1930) by Henry Major. Pencil on paper, 22.7 x 17.5 cm (9 x 6⅞ in.), 1930. National Portrait Gallery, Smithsonian Institution, Washington, D.C.

8.10 *Caricatures by Henry Major* by Henry Major. Printed illustration. Published in *Detroit News*, November 15, 1925. National Portrait Gallery, Smithsonian Institution, Washington, D.C.

plexion, balding head, bulges under the eyes, and extravagantly curling mustache in a portrait at once undignified and affectionately jovial. As he started his career at the *New York American*, Major provided a range of portraits, all rendered with rapid pencil lines and gentle distortions. He covered the 1924 presidential nominating conventions and went to Washington, D.C., to draw national political figures, copyrighting some of his drawings through Premier Syndicate. Often he was teamed with humor writer "Bugs" Baer to draw athletic heroes for the sports page. In addition, the newspaper featured his sketches of a varied array of metropolitan functions: a coal conference, a dance competition, an insurance convention, a shippers' lun-

cheon, a Rotary club gathering, or a courtroom scene. Any man or woman or group who seemed newsworthy was deemed a candidate for caricature.

A gregarious and entertaining man who loved to travel, Major made a successful, extended tour of American cities in 1925 to draw for their newspapers. Over the course of two years he visited Buffalo, Indianapolis, Kansas City, Louisville, St. Louis, Los Angeles, Hollywood, San Francisco, Seattle, Detroit, Harrisburg, Pa., and the Canadian city of Toronto. A local newspaper sponsored each visit, promoting him with banner headlines, a photograph or self-portrait caricature, and an article describing his successes on two continents (fig. 8.10). His drawings—clever

sketches of officials, city fathers, and business leaders—invariably impressed the readers. The Harrisburg *Evening News* reported that copies of the paper with Major's caricatures sold "like hot cakes" and that people cut out the "art galleries" and hung them on the walls.[17]

When Major arrived in Los Angeles in June 1925 he found Hollywood moguls, directors, and stars quite willing to endure his gentle exaggerations for the sake of publicity. The *Los Angeles Times* reported that he had drawn more than five hundred sketches in forty-eight hours and that those not yet caricatured were "more than anxious to have fun at the expense not only of others but of themselves."[18] His portrait of Ernst Lubitsch (fig. 8.11) suggests the remarkable speed with which he captured his subject: he distilled all the producer's legendary energy into a reflective, cigar-chomping frown. Major, greatly attracted to the celebrity glamour of the movie capital, drew many film industry luminaries over the years, a predilection that resulted in the 1938 volume *Hollywood with "Bugs" Baer and Henry Major*.

Even a serious, controversial event could signal opportunity for the caricaturist. In July 1925, Major interrupted his tour to go to Dayton, Tennessee, where the Scopes "monkey" trial had captured national attention, pitting evolutionary science against fundamentalist religious teaching. Major's sketches of the defendant, the young schoolteacher John Scopes, prosecuting lawyer William Jennings Bryan, defense counsel Clarence Darrow (fig. 8.12), and other principals, was syndicated by the Alma Art Agency, which promised that a complete set of "Majorgraphs" with a guaranteed minimum of thirty sketches was available in "mat form."[19] They appeared in newspapers around the country. Major took no stance on the issues raised or the personalities that the sensational trial had thrust into the national spotlight. His even-handed portrayals left the national debate to the journalists and editorial cartoonists.

Major was more concerned with entertaining his audience. Like Massaguer, the genial artist could parlay his skills into a "chalk talk" performance. The Toronto *Daily Star*, responding to public interest, arranged for him to appear at the Uptown Theatre so that everyone could see him sketch. With all the requisite ingredients for an amusing presentation—startling speed, humor, and the fun of celebrity recognition—he turned caricature drawing into an entertainment worthy of the vaudeville stage. In fact, when a second visit to Detroit

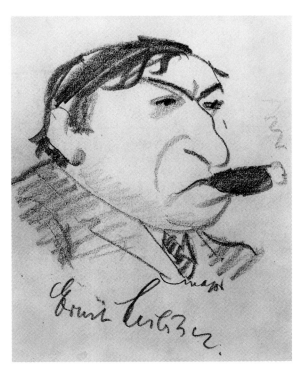

8.11 *Ernst Lubitsch* (1892–1947) by Henry Major. Pencil on paper, 22.3 x 15.2 cm (8¹³/₁₆ x 6 in.), 1925. Original illustration for *Los Angeles Times*, June 9, 1925. National Portrait Gallery, Smithsonian Institution, Washington, D.C.

in 1927 followed his triumphant first appearance, the newspaper booked him into the Oriental Theater for his caricature routine, part of an extraordinary triple feature that included Prince Lei Lani and the Hawaiians and a dance revue called the *Whiteway Gaieties*. He had become so famous that the familiar self-portrait caricature even appeared in a Detroit newspaper advertisement as a celebrity endorsement for Webster cigars.[20]

Major's travels had not kept him out of the New York press. In 1925 he contributed several portraits to the fledgling *New Yorker*, and a page of "Moving Caricatures of Moving Pictures Personalities" appeared in *Vanity Fair* in January 1926. Most of his career, however, was based on work for the newspapers. He began sketching portraits of businessmen for the *Wall Street Journal* in mid-1926, a venture that culminated in the book *Portraits and Caricatures* in 1927. In 1928 the Hearst papers sent Major to Amsterdam to cover the Olympics, and for the next several years he traveled

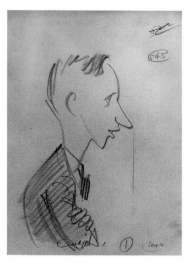 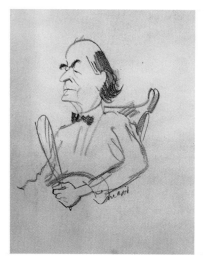

8.12 *John Scopes* (1900–70), *William Jennings Bryan* (1860–1925), and *Clarence Darrow* (1857–1938) by Henry Major. Pencil on paper, 30.3 x 22.5 cm (11¹⁵/₁₆ x 8⁷/₈ in.), 1925. National Portrait Gallery, Smithsonian Institution, Washington, D.C.

8.13 *Aline Fruhauf* (1907–78) by Aline Fruhauf. Lithograph with pencil, 48.2 x 31.8 cm (19 x 12½ in.), 1933. National Portrait Gallery, Smithsonian Institution, Washington, D.C.; gift of Erwin P. Vollmer.

abroad much of the time. His extensive trips as well as his old-fashioned, pencil-sketch style in an age of bold pen lines kept him out of the front rank of Manhattan caricaturists, however, so that during the Depression he experienced a distinct downturn in his career and reputation. But with his remarkable facility and speed, he rode the crest of the caricature wave throughout the 1920s.

Many younger artists started into the field in these years, eager to supply a growing demand. Many of them concentrated on the performing arts, for while a newspaper's regular art staff would cover political figures and local events, the theatrical world was a specialty more suited to free-lance caricaturists. Although many of the charcoal portrait artists with whom they competed had routinely worked from publicity photos, the caricaturists generally tried to work from life. As William Auerbach-Levy explained it, the average photograph—formally posed, badly lit, and "atrociously retouched with all the vital forms so weakened as to make the material emaciated and lifeless"—was useless for the caricaturist's purpose.[21] These artists searched not just for likeness but for the actor's characteristic vitality and his interpretation of a specific role.

Would-be caricaturists pored over the Broadway press and fraternized with a network of press agents and theater managers to secure tickets for the best

shows. The young Al Hirschfeld was launched in the newspapers in 1926, when his friend, press agent Dick Maney, arranged to have one of his drawings published in the *Herald Tribune* (see chap. 10). Those not so well connected had to scramble for attention. Aline Fruhauf (1907–78), whose own self-portraits display her whimsical approach to distortion (fig. 8.13), wrote in her memoirs a vivid description of how the system usually worked. In March 1926, Fruhauf was volunteering at the Neighborhood Playhouse, where she sketched a drawing of actress Paula Trueman. The theater's business manager admired it and passed it on to the press agent, who took it to Alexander Woollcott, then drama critic for the *World*. Her first published drawing appeared in the paper the following Sunday. Fruhauf soon discovered that press agents often arranged for backstage sittings with the actors at rehearsals or out-of-town tryouts. Frequently the press agent or producer would pay the artist for the publicity when the image appeared in print.[22]

Generally, however, the free-lance artists had to market their drawings directly to the newspaper. The process, often difficult for a newcomer to the field, depended on the whim of the features editor or drama critic—whoever controlled the layout of the entertainment pages. Many artists, Fruhauf explained, started at the prestigious *World*, waiting for Alexander Woollcott on an ugly oak settle in the room outside his office. She met many of her fellow caricaturists at that spot on Tuesday afternoons, each hoping to have his or her drawings published in the following Sunday's edition. Here she encountered Irving Hoffman, who also collected bits of theater news for gossip columnist Walter Winchell; Alex Gard, the Sardi's artist; Malcolm Eaton, who caricatured film stars; Abe Birnbaum, who worked for the *New Yorker*; Al Hirschfeld, already well published in the *Times* and the *Herald Tribune*; William Auerbach-Levy, one of Woollcott's favorites; Al Frueh; and Irma Selz, a young artist from Chicago.[23]

When Woollcott rejected Fruhauf's drawings, she asked Irving Hoffman where to go next. "To the *Post*," was his instant reply, initiating the young artist into a ritual of weekly rounds, visiting drama critics and editors at one New York daily after another. In addition to New York, she often got on the subway to try her luck at the Brooklyn papers, starting with the *Brooklyn Daily Eagle*. Fruhauf peddled her wares to the art editors of the magazines as well, striving, like most other carica-

8.14 *Brooks Atkinson* (1894–1984) by Aline Fruhauf. India ink and watercolor over pencil on paper, 27.4 x 23.4 cm (10 3/4 x 9 3/16 in.), 1929. Original illustration for *Theatre Magazine*, February 1929. National Portrait Gallery, Smithsonian Institution, Washington, D.C.; gift of Erwin P. Vollmer.

turists, to land a weekly assignment. Eventually she found a niche at *Theatre Magazine*—where her portrait of Brooks Atkinson appeared in February 1929 (fig. 8.14)—as well as at *Musical America*, *Musical Courier*, and *Musical Digest*.[24]

Irma Selz (1905–77) made similar rounds of the newspapers and drew a weekly caricature for the *Herald Tribune*. On Monday afternoons, Selz recalled, she and Hirschfeld, Gard, and Don Freeman would congregate at the *Tribune*, waiting to get assignments from drama editor Arthur Folwell for the next Sunday's theater pages. Sometimes Selz made her sketches at out-of-town tryouts so that the drawings would coincide with the New York opening. Taking an afternoon train to New Haven, Boston, Philadelphia, or Washington, she would attend the theater, quickly visit her subject's dressing room afterward, and try to catch the "last milk run" back to New York. It was an established practice among *Tribune* artists, she remembered, to bill the

8.15 *William Auerbach-Levy*
(1889–1964) by William
Auerbach-Levy. Ink and tempera
on paper, 57.3 x 47.6 cm (22½ x
18¾ in.), c. 1945. National
Portrait Gallery, Smithsonian
Institution, Washington, D.C.

show's producer small additional fees for any published drawings of his stars.[25]

Long a popular hobby for both amateur and professional artists, caricature sketching now acquired a new status as a commercially viable art form. William Auerbach-Levy (1889–1964) (fig. 8.15), already launched on a career as an etcher, a painter, and a teacher in New York, was drawn into the field after the Pennsylvania Academy of the Fine Arts held its first caricature exhibition in 1924.[26] Born in Brest-Litovsk, Russia, Auerbach-Levy had immigrated as a child to New York, where one of his public school teachers arranged for him to take classes at the art school of the

National Academy of Design. In 1911, after attending the College of the City of New York, he went to Paris on a scholarship and studied briefly at the Académie Julien under Jean-Paul Laurens. He had always sketched portraits of those around him, and even though fellow students appreciated his talent, he did not consider caricature as a career possibility. On his return he became an etching instructor at the National Academy of Design art school and began to win prizes for both his paintings and his prints.

The Pennsylvania Academy of the Fine Arts' 1924 exhibition included competitive cash prizes, offered by its president, John Frederick Lewis, in order to "stimu-

late a genuine interest in the art of caricature." When Auerbach-Levy heard about the show, he was already prepared, having drawn amusing portraits, as was his wont, of fellow artists in Provincetown, Massachusetts, the previous summer. Assembling a few drawings and sending them off under an assumed name, he was very surprised to receive the $100 second prize. "That was all I needed to send me into action," he later recalled. "With glee, I made caricatures of everyone who came near me."[27]

On the advice of an agent, Auerbach-Levy started making caricatures of celebrities and took his drawings to Louis Weitzenkorn, the features editor of the *New York World*'s Sunday edition. Impressed, Weitzenkorn began publishing his work in the newspaper in February 1925 and promised him a regular weekly assignment.[28] Alexander Woollcott, who arrived as drama critic the following summer and took over the job of reviewing caricatures, also loved his portraits. From that point on, Auerbach-Levy had a regular association with the newspaper until its demise in 1931. Woollcott, he recalled, gave him complete freedom in his drawings and often helped to persuade difficult sitters to cooperate. "No posing, no picture in the Sunday *World*," Woollcott would threaten.[29] Auerbach-Levy, although he continued to paint, teach, and etch, garnered more fame through his caricatures in the metropolitan newspapers. In 1927 he won first prize in the Pennsylvania Academy of the Fine Arts caricature exhibit.

Newspaper editors, however, did not need an art world imprimatur to prove Auerbach-Levy's prominence in the field. The *World* staff found his work so impressive, they reproduced such caricatures as his head of George Gershwin, in an unusually large four-column format (see fig. 1.2).[30] In addition to its size, the contrast of the dark hair with the featureless, white profile created a bold image that popped off the page. Strong contour lines and featureless faces recalled the work of Al Frueh, but Auerbach-Levy had his own muscular style. A skilled draftsman, he used india ink, sometimes with the addition of a lighter wash, and a sable watercolor brush rather than a pen. The rich, dark masses of ink and the thick, fluid line reproduced especially well on poor-quality newsprint paper. Although he could produce very amusing images, his drawings only rarely relied on the wit or whimsy used by Frueh or Fruhauf. Many caricatures are not comic at all, and some, like his image of Ring Lardner, are poignant (fig. 8.16).

8.16 *Ring Lardner* (1885–1933) by William Auerbach-Levy. India ink and watercolor wash on paper, 48.2 x 35.7 cm (19 x 14 in.), c. 1925–33. National Portrait Gallery, Smithsonian Institution, Washington, D.C.

Auerbach-Levy's astute abbreviation of a head, however, could produce an ingenious likeness that invariably entertained the subject's admirers. Often, he noted, the victim himself came to appreciate his portrait only after the enthusiastic response to its publication in the paper. Gershwin thought his portrait undignified until it appeared in the *World* and his friends loved it; only then did he pronounce it "a peach" (see chap. 1). Renowned theatrical producer Jed Harris was hurt when he first saw his caricature, although director George Abbott, in the office at the time, fell out of his chair with laughter. Auerbach-Levy's editor also loved the image. "I had intended to use the drawing for a two-column at the bottom of the page," he told the artist, "but now I think I'll give it four columns at the top." It was published on October 24, 1926. Harris, pleased by the many compliments he received, acquired the original. When Auerbach-Levy had Harry De Maine make a color woodcut of it, the

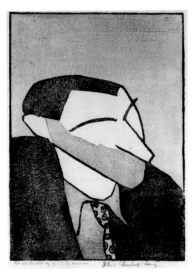

8.17 *Jed Harris* (1900–79) by William Auerbach-Levy and Harry De Maine. Color linocut, 36.9 x 26.6 cm (14½ x 10½ in.), 1928. National Portrait Gallery, Smithsonian Institution, Washington, D.C.

8.18 *Heywood Broun* (1880–1939) by William Auerbach-Levy. India ink on paper, 48.3 x 34.9 cm (19 x 13¾ in.), c. 1925–30. National Portrait Gallery, Smithsonian Institution, Washington, D.C.

print was purchased by many of the producer's friends (fig. 8.17).[31]

As he eliminated details and distilled shapes into an iconic emblem of the individual, Auerbach-Levy often relied on clever summation rather than comic distortion. In his ink drawings of Heywood Broun, Franklin P. Adams, and George S. Kaufman (figs. 8.18 and 8.19, fig. 1.19), he employed unusual, not-quite-profile angles of the heads. These poses deemphasized the eyes, relying on the distinctive facial contours and such details as pudgy jowl, cigar, or glasses to anchor the likeness. Although instantly recognizable, these heads, turned just slightly away from the viewer, have a timeless, impersonal quality that evokes the relationship the subjects had to the average New Yorker. Such images suggest the glimpse of a celebrity from across a crowded theater lobby rather than a direct association between friends or colleagues. The audience cannot

search the eyeless faces for clues about intelligence, emotion, mood, or character. Once again, access to the soul is barred; it is none of the caricaturist's business. It is replaced by a summary of the subject's celebrity, complete with those details that repeated publicity provided—Broun's legendary uncoiffed mop of hair, for instance—thus becoming an emblem, a trademark of their media-generated fame.

The emblematic summary was often so acute, however, so evocative of that carefully contrived public persona, that it had particular resonance and humor for the subject's closest associates. Thus one of F. P. A.'s friends had his Auerbach-Levy caricature printed on several decks of cards for playing poker. Like any logo or trademark, the image succeeded because its message—the evocation of the individual—had an undeniable specificity. The artist was delighted when Adams's three-year-old son greeted the caricature

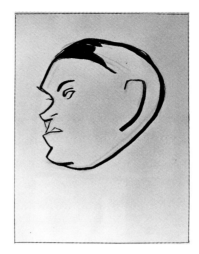

8.20 *H. L. Mencken* (1880–1956) by
William Auerbach-Levy. India ink on
paper, 30.5 x 21.6 cm (12 x 8¹/₂ in.), 1925.
Original illustration for *New York World*,
October 18, 1925. Museum of the City of
New York. Bequest of William Auerbach-
Levy.

8.19 *Franklin P. Adams* (1881–1960) by William Auerbach-
Levy. India ink and tempera on paper, 27.1 x 20.4 cm
(10³/₄ x 8 in.), c. 1930. Original illustration for *Woman's
Home Companion*, June 1930. National Portrait Gallery,
Smithsonian Institution, Washington, D.C.

drawing with a kiss for "Daddy." The toddler was par-
ticularly pleased with the many "Daddies" on the poker
cards and refused to go to sleep until he was allowed to
take one of them to bed.[32]

For a time, the *World* also published Auerbach-Levy's
caricatures of its famous columnists at the top of their
columns, the visual equivalent of a by-line. The styl-
ized portrait-emblems represented the public figure,
suggesting the recognition he had garnered through
his column in the *New York World*. Those celebrity sub-
jects, who well understood the publicity game, recog-
nized the value of Auerbach-Levy's bold, recognizable
condensations. "I like the caricature very much," H. L.
Mencken wrote when the artist promised to send him
his portrait (fig. 8.20). "It is grotesque and yet it does
justice to my underlying beauty. Needless to say, I'll be
delighted to have the original. I only hope that Swope
has not stolen it for his collection of Great Christian

leaders. . . . I shall have it framed and hang it on the
wall of my music, beer and Rinderbrust room. An
excellent caricature!"[33]

No one understood modern caricature better than
Alexander Woollcott, the *World's* drama critic. Taking
over the composition of the entertainment pages, he
pored over endless submissions from troops of aspiring
artists. Woollcott recognized caricature as an exten-
sion of his own mordant sense of humor, much like the
vivid, memorable insult of which he was so fond. His
friends understood that much of his well-publicized
contentiousness was an act. "His quarrelsome and
unwholesome tongue was a foil to his good deeds,
which were many," his biographer quoted an associate
as saying, "and which he jealously kept secret while
painstakingly publicizing his vices."[34] Well-advertised
flaws, Woollcott's circle knew, added a distinctive zest
to the personality. Caricature did the same.

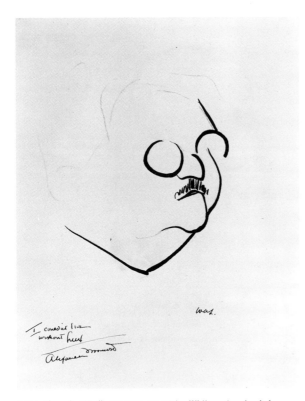

8.21 *Alexander Woollcott* (1887–1943) by William Auerbach-Levy. Ink, graphite, and gouache on paper, 48.4 x 54.8 cm (19 1/16 x 21 1/2 in.), c. 1929–39. Billy Rose Theatre Collection, New York Public Library for the Performing Arts, New York, Astor, Lenox and Tilden Foundations.

A favorite target of the caricaturists himself, Woollcott generally bore the many distortions of his own owlish face and plump figure with grace. "Mr. Woollcott loves caricatures of himself," *New York Times* drama editor John Byram told artist Irma Selz. "He collects them." Indeed, Woollcott used one of Auerbach-Levy's caricatures as a personal logo (fig. 8.21). He had the abbreviated outline of his pudgy face engraved on stationery —one such card was sent to Gertrude Stein—printed on advertisements and dust jackets, and stamped onto the board covers of his books. One day, as Auerbach-Levy discussed the Sunday page with the editor, Woollcott delightedly pulled out some handkerchiefs embroidered with the cryptic head, a gift from his friend Harpo Marx.[35]

Such was the vogue for caricature at the beginning of his career that Auerbach-Levy also had occasion to turn his talents into what he called a party stunt. George Gershwin, planning a gala affair in 1926, had invited such talented guests as Lynn Fontanne, Irving Berlin, George Kaufman, and Katharine Cornell to perform. With Gershwin's help, Auerbach-Levy devised a performance using humorous ink portraits of the invitees drawn in advance on glass slides. At the appointed moment, the company was seated in a darkened room. As the slide portraits of the assembled celebrities were projected on a screen, playwright Marc Connelly gave a comic monologue about the strange natives he and the artist had encountered on their travels to a mythical land. It was the surprise event of the evening, Auerbach-Levy later recalled, and much enjoyed. *Vanity Fair*'s editors, who attended the party, arranged for a page of the caricatures to appear in the magazine a few months later (fig. 8.22).[36]

While maintaining an active painting, etching, and teaching career, Auerbach-Levy was in great demand as a caricaturist. His work appeared regularly in the newspapers—on the *New York Post* drama page starting in 1929, for instance, and the *Brooklyn Eagle* starting in 1935—as well as a wide range of magazines. His popular portraits appeared in print venues as various as *Collier's, Esquire, Ladies' Home Journal, Finance, Polo,* and the *Christian Herald.* Although other caricaturists found their careers waning as the war followed the Depression, Auerbach-Levy, one of the leaders in the field, found steady work and was still resolutely optimistic about the future when he published *Is That Me? A Book about Caricature* in 1947. Both a collection of autobiographical anecdotes and a manual for students of the art, the volume received enthusiastic reviews. As Russell Maloney wrote in the *New York Times,* "William Auerbach-Levy on caricature has the same indisputable authority as Freud on sex, Tilden on tennis, or Fanny Farmer on cookery."[37]

For all those artists developing a career in caricature in the 1920s, an important new outlet for their work arrived in the middle of the decade with the advent of the *New Yorker* magazine. Editor Harold Ross had honed his editorial craft in Paris during World War I, as a reporter-editor, along with Woollcott and F. P. A., of the *Stars and Stripes.* Moving to New York after the war, Ross edited various journals, including *Judge,* and he participated in the regular gatherings of the Algonquin Round Table. Meanwhile, he planned his own sophisticated entry into the magazine field, intending to focus on Manhattan.[38]

Ross's poker-playing Paris buddies—Woollcott,

F. P. A., and Heywood Broun—all worked at the *New York World* in the 1920s, and many other members of the Algonquin circle contributed to *Vanity Fair*. Ross's initial conception of the weekly *New Yorker* had overtones of the urbane humor established in both Swope's daily paper and Crowninshield's monthly magazine. As different as the three publications were, each provided its metropolitan audience with a guide to the sophisticated celebrity world and emerging entertainment culture of postwar Manhattan, and each became an important purveyor of modern American caricature. Sharing and

exchanging the same core group of artists and writers, the three editorial offices had numerous interconnections enhanced by friendships and common interests.

Ross's prospectus for the *New Yorker*, written in 1924, thus has a familiar tone that reveals the editor's links to the columnists, critics, and playwrights gaining fame as members of the Algonquin circle. "The New Yorker will be a reflection in word and picture of metropolitan life," Ross wrote. "It will be human. Its general tenor will be one of gaiety, wit and satire, but it will be more than a jester. It will not be what is commonly called

8.22 *The American Seen and Heard, Too* by William Auerbach-Levy. Printed illustration. Published in *Vanity Fair*, June 1926. Library of Congress, Washington, D.C.

radical or highbrow. It will be what is commonly called sophisticated, in that it will assume a reasonable degree of enlightenment on the part of its readers. It will hate bunk." In covering entertainment and the arts, each department would present, Ross promised, not only criticism but "the personality, the anecdote, the color and chat of the various subdivisions of this sphere." The new magazine would give New Yorkers a ready answer to the query "What shall we do this evening?" In order to reassure Raoul Fleischmann, his new partner and financial backer, Ross created an "advisory board," of such famous friends as Woollcott, Broun, George Kaufman, Dorothy Parker, Edna Ferber, Alice Duer Miller, Lawrence Stallings, Ralph Barton, and Rea Irvin. "Some of them didn't really work on the magazine," he joked later, "and others I had no expectation of getting actual help from. It was one of the shoddiest things I have ever done. I have been ashamed of it ever since."[39]

8.23 Harold Ross (1892–1951) by Rea Irvin. Unpublished printed illustration, 1926. From the collection of his daughter, Patricia Ross Honcoop.

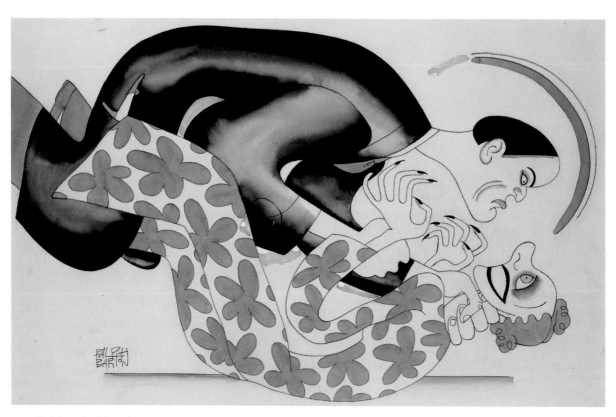

8.24 *Noel Coward and Gertrude Lawrence* (1899–1973; 1898–1952) by Ralph Barton. Ink wash and crayon over pencil on paper, 36.8 x 52.7 cm (14¹/₂ x 20³/₄ in.), 1931. Original illustration for *New Yorker*, February 28, 1931. Mr. and Mrs. Karl H. Klein.

The finances of the magazine that first year were precarious. Ross struggled to extract contributions from his unreliable and overcommitted Algonquin friends, to lure fresh young writers to underpaid positions at the magazine, and to find the right balance and format. The art, as it was called—covers, illustrations, cartoons, and caricatures—was the strongest element of the magazine at the beginning, the one part of the mix that worked almost from the start.[40] Rea Irvin, a veteran editor of *Life* who became the unofficial, part-time art director, designed the layout and typography of the magazine as well as its inaugural "Eustace Tilley" cover, which he later spoofed in a portrait of Ross that he signed "Penaninksky" (fig. 8.23). He also presided, along with Ross, at the weekly art meetings, deciding on the many drawings to be included in each issue.

The genial Irvin persuaded the best comic draftsmen in New York to contribute to Ross's fledgling enterprise, and the caricaturists numbered prominently among them. He recruited Ralph Barton, already in demand by every publisher; Miguel Covarrubias and Al Frueh, whose reputations were soaring; Conrado Massaguer and Henry Major, whose names appeared frequently in the press. Barton's vivid full-page theater caricatures set high standards for the *New Yorker* in the first few issues (fig. 8.24). In addition, Barton experimented with one humor series after another, contributing an insider's view of New York's comic quandaries. In the "Enquiring Reporter," for instance, which he wrote and drew, Woollcott, Broun, F. P. A., George Jean Nathan, and George, the head waiter at the Algonquin Hotel, addressed the question of whether the Algonquin group could justly be accused of logrolling (fig. 8.25). The accusation was "stuff and nonsense," Barton had Woollcott reply, the group never said anything nice about each other. "Isn't Heywood Broun always saying nasty things about Franklin P. Adams's superb writing in 'It Seems to Me,' Broun's magnificent daily column in the New York *World*? And isn't Adams's brilliant 'Conning Tower' almost completely devoted to roasting Broun's epoch-making novels?"[41]

Miguel Covarrubias, busy producing *The Prince of Wales*, was nonetheless drawn into the fold with the first issue, contributing a portrait of Giulio Gatti-Casazza for a "Profiles" essay. From then on his work enlivened art, music, and theater commentary. His

8.25 *Enquiring Reporter* by Ralph Barton. Printed illustration. Published in *New Yorker*, August 29, 1925. Collection of Alex Miller.

memorable image of Mae West as Diamond Lil, for instance, complete with hourglass figure, opulent gown and jewels, and unabashed sexual innuendo, re-creates the popular icon that censors couldn't destroy (fig. 8.26). As West wrote, "It wasn't what I did, but how I did it. It wasn't what I said, but how I said it; and how I looked when I did it and said it."[42] Covarrubias captured the "how"—the inimitable swagger, the come-hither stance. Al Frueh, who drew a cartoon for the first issue and a cover for the second, was soon supplying small "Profiles" portraits and large theatrical caricature scenes along with Barton and Covarrubias.

The *New Yorker* had quickly built up a stable of regular contributors and could scatter caricature portraits throughout every department of the magazine. Alex Gard's image of Nikita Balieff, incorporating the bat symbol of the Chauve-Souris into the lines of the face, was squeezed into a "Goings On" calendar of events;

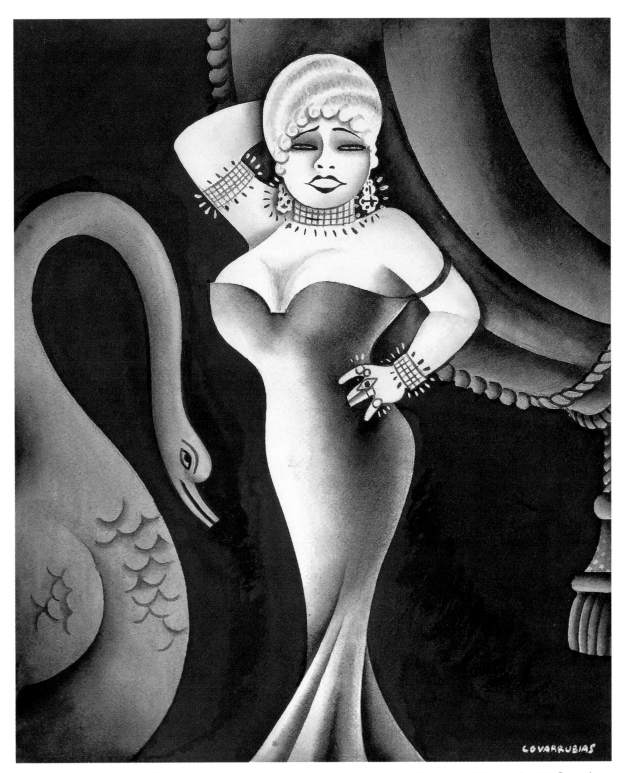

8.26 *Mae West* (1893–1980) by Miguel Covarrubias. Ink and ink wash with gouache on paper, 33 x 27.9 cm (13 x 11 in.), 1928. Original illustration for *New Yorker*, May 5, 1928. National Portrait Gallery, Smithsonian Institution, Washington, D.C.

8.27 *Alla Nazimova* (1879–1945) by Einad Nerman. Printed illustration. Published in *New Yorker*, June 27, 1925. Collection of Alex Miller.

8.28 *Henry Ford* (1863–1947) by Al Frueh. India ink on paper, 35.2 x 23.6 cm (13⅞ x 9⁵⁄₁₆ in.), 1928. Original illustration for *New Yorker*, March 3, 1928. National Portrait Gallery, Smithsonian Institution, Washington, D.C.; gift of the children of Al Frueh: Barbara Frueh Bornemann, Robert Frueh, and Alfred Frueh, Jr.

Fornaro's monocled Stravinsky appeared in the music department; John Decker sent some portraits for the "From Paris" commentary; the *Tatler*'s Einad Nerman supplied a graceful Nazimova for the "Moving Pictures" column (fig. 8.27); Henry Major's Georgia O'Keeffe enlivened an Art section.[43] Caricature of the famous was everywhere. The drawings were not all equally good, but on average they were of consistently higher quality than those in the newspapers, even the *New York World*. More important, they were a contrast to the stale, outdated fare of *Life* and *Judge*, which Ross had come to abhor during his brief stint at the latter. Of course, both of the old humor journals published many of the writers and caricaturists whom Ross would recruit for the *New Yorker*, but the fresh material competed with

banal jokes, dumb gags, and conversational "he-she" comic scenes popular in the 1890s. A small, recognizable portrait of a celebrity was instead a sharp, smart jest requiring no gag line at all, only an intelligent awareness.

The lively "Profiles" essay, introducing the *New Yorker*'s own celebrity of the week, regularly sported caricature portraits. Generally a small, rather modest likeness, it served as an introduction to the writing, an ornamental grace note setting the tone and mood. Al Frueh's Henry Ford (fig. 8.28) illustrated the first of a four-part essay in the March 3, 1928, issue. Atop a scrawny body and thin neck, the large head, button eye, and oversized brow lend a manic intensity to the figure, suggesting the excesses of Ford's temperament. In part three of the article, two weeks later, the editors

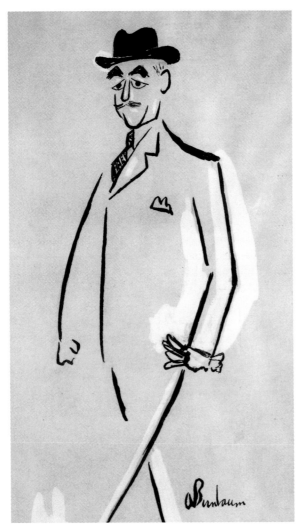

8.29 *Dean Acheson* (1893–1971) by Abe Birnbaum. India ink on paper, framed, 44.5 x 29.8 cm (17¹/₂ x 11³/₄ in.), 1949. Original illustration for *New Yorker*, November 12, 1949. Philip Hamburger.

mentioned, Hans Stengel, John House, Jr., Johan Bull, Peter Arno, Abe Birnbaum, Aline Fruhauf, Constantin Alajalov, and William Auerbach-Levy all made amusing likenesses for the biographical essays in the first few years.[44] Birnbaum (1899–1966) published more than most; by the time of his 1932 one-man show at the 144 West Thirteenth Street Gallery, the *New Yorker* audience knew him well. Before his death he had made more than 150 covers and more drawings for the "Profiles" and "Reporter at Large" sections than any other artist. Although he had a sketchier line, Birnbaum's caricature style was modeled on Al Frueh's, and his figures and faces, reduced to minimum contours, had a similar impact on his admirers. Reviewing his 1932 exhibition, a *New York Times* critic particularly admired his drawings of Herbert Hoover and Florenz Ziegfeld, considering them among the most "scintillant of Birnbaum's elliptical satires." Years later, in 1949, the artist's "Profiles" sketch of Dean Acheson (fig. 8.29) still seemed current and clever, aptly conveying the secretary of state's aristocratic bearing, dapper perfectionism, and quick, impatient intelligence.[45] Birnbaum gave the drawing to Philip Hamburger, the author of this and many subsequent insightful essays, who has kept it hanging on the wall of his study ever since.

"Profiles" caricature did not illustrate the words of the author; artist and writer worked independently. Frueh's ink drawing of Marc Connelly (fig. 8.30), for instance, a playwright famous for his collaborations with George S. Kaufman, accompanied the overblown prose of an Alexander Woollcott essay. In his concluding paragraph, the drama critic identified his subject as "irresponsible but honorable, gaudy but unworldly, preposterous but sensitive, generous, sympathetic, witty, lazy, that is Marc Connelly—somehow a timeless person."[46] Frueh did not have to summarize such a catalogue of diverse traits. His task was merely to set the mood, launching the reader into the long essay with an appreciative smile. He undoubtedly knew the title, however, and couldn't resist illustrating the "Two-eyed Connelly" article with a one-eyed drawing.

Surviving the pressure of the *New Yorker*'s weekly deadlines required a keen sense of humor, and the quips, mischief, and practical jokes of the editor's inner circle—particularly E. B. White, James Thurber, Wolcott Gibbs, and Ross himself—are legendary. But like the antics of the Algonquin group, to which it was

ran the image again, printed in reverse, a time-saving device they used frequently for multipart profiles. Such a casual approach to art would never have been accepted under the more leisurely, monthly deadlines of Frank Crowninshield's *Vanity Fair*. But since the writing, not the image, was showcased in this section, the editors could chop down, flip over, or slightly alter the drawings with impunity and run them again.

All of the *New Yorker*'s caricaturists contributed portraits for the weekly "Profiles." In addition to those

inextricably connected, *New Yorker* gaiety had a disturbing undercurrent that reflected the psychological stresses of the modern age. Peter Arno's quick pencil sketch of famed illustrator John Held, Jr., implies the complexity of this comic outlook (fig. 8.31). Though better known for his covers and gag cartoons, Arno contributed many caricatures in the early years of the magazine. He drew his image of Held on the back of an Algonquin Hotel menu, hastily ripped to size, and the amusing cowlick, eyebrows, nose, and shape of the head in his sketch reveal the bold energy of his style. But if the drawing of Held suggests the ready wit of a collegial lunch, it also reveals the ambiguity of Algonquin and *New Yorker* humor. Held was at the peak of his fame and prosperity that day he lunched with Arno, but his expression seems sad, uncertain, driven. With ironic prescience, Arno had drawn his poignant

image on a menu dated September 24, 1929, just weeks before the stock market crash obliterated Held's fortune.

James Thurber's whimsical self-portrait is equally revealing (fig. 8.32). Entitled "Thurber and his Circle," it depicts the writer gesturing emphatically in mid-speech while his apathetic audience, including the dog, the sculpted bust, and the portrait on the wall, slumbers with eyes shut. Like so much of Thurber's visual and written humor, the drawing has an unexpected, original comic twist. On the back of the sheet, Thurber drew small ink markings in the area of each face. When light shines through the upheld paper, the additions on the verso become visible, and the eyes of the sleeping characters, including dog, bust, and portrait, pop open in ferocious scowls (fig. 8.33). The image reflects Thurber's own comic persona, conveying the frustrations of the ordinary, common man beset by indiffer-

8.30 *Marc Connelly* (1890–1981) by Al Frueh. India ink with white gouache on paper, 28.9 x 24.9 cm (6 1/8 x 7 1/2 in.), 1930. Original illustration for *New Yorker*, April 12, 1930. National Portrait Gallery, Smithsonian Institution, Washington, D.C.; gift of the children of Al Frueh: Barbara Frueh Bornemann, Robert Frueh, and Alfred Frueh, Jr.

8.31 *John Held, Jr.* (1889–1958) by Peter Arno. Pencil on paper, 20.4 x 17.4 cm (8 x 6 13/16 in.), 1929. National Portrait Gallery, Smithsonian Institution, Washington, D.C.; gift of the estate of Mrs. John Held, Jr., and museum purchase.

8.32 *Thurber and His Circle* by James Thurber. Pen and ink on paper, 21.5 x 28 cm (8¹/₂ x 11¹/₁₆ in.), 1930–39. National Portrait Gallery, Smithsonian Institution, Washington, D.C.; gift of Elizabeth Darling Benchley and Robert Benchley III.

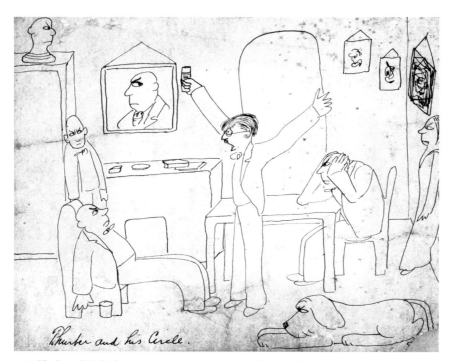

8.33 *Thurber and His Circle* (with verso markings) by James Thurber. Ink on paper, 21.5 x 28 cm (8¹/₂ x 11¹/₁₆ in.), 1930–39. National Portrait Gallery, Smithsonian Institution, Washington, D.C.; gift of Elizabeth Darling Benchley and Robert Benchley III.

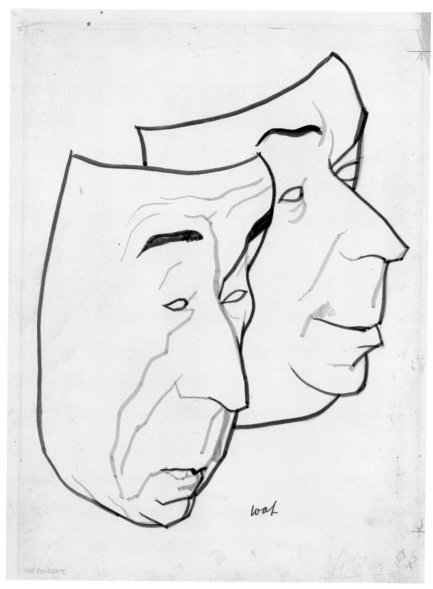

8.34 *Levi Lee Shubert and Jacob J. Shubert* (1875–1953; 1880?–1963) by William Auerbach-Levy. Black and gray ink on paper, 48.2 x 35.5 cm (19 x 13¹⁵/₁₆ in.), 1939. Original illustration for *New Yorker*, November 25, 1939. National Portrait Gallery, Smithsonian Institution, Washington, D.C.

ence on the one hand and outright hostility on the other.

In time, the celebrity caricature that had helped establish the *New Yorker*'s reputation played a diminished role, giving way to the featured, short-captioned cartoons by Arno, Thurber, and others that reflected the psychological probing of a new generation of urban humorists. Although the number of contributing caricaturists dwindled, the editors continued to publish their favorites. In the 1930s, '40s and '50s, Abe Birnbaum was a steady contributor, as was Al Frueh, whenever the editors could persuade him to come into town for the season's theatrical offerings. Such felicitous conceptions as Auerbach-Levy's 1939 image of Lee and J. J. Shubert as comic and tragic masks (fig. 8.34) or his 1954 depiction of famed jeweler Harry

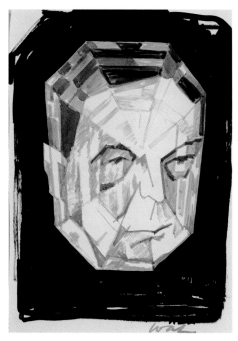

8.35 *Harry Winston* (1896–1979) by William Auerbach-Levy. Black and gray ink on paper, 41.5 x 34.5 cm (16¹/₂ x 13⁵/₈ in.). Original illustration for *New Yorker*, May 8, 1954. National Portrait Gallery, Smithsonian Institution, Washington, D.C.

8.36 *Charles Atlas* (1892–1972) by Paolo Garretto. Airbrushed gouache, india ink, and pencil on paper, 38.1 x 25.4 cm (15 x 10 in.), 1941. Original illustration for *New Yorker*, January 3, 1942. National Portrait Gallery, Smithsonian Institution, Washington, D.C.

Winston as a faceted diamond (fig. 8.35) proved timelessly entertaining. The *New Yorker* also solicited drawings from the renowned *Vanity Fair* stars of the 1930s, Will Cotton and Paolo Garretto (fig. 8.36).

Ralph Barton died in 1931, and Miguel Covarrubias had given up pen-and-ink portraits. Color dominated the forefront of caricature, and the *New Yorker* remained resolutely monochromatic. By the early 1930s, the magazine's black and white caricature could not compete with the brilliant pastels and watercolors of Cotton, Garretto, and Covarrubias appearing in *Vanity Fair*. By midcentury, as Harold Ross articulated to

Frueh, the *New Yorker* was no longer systematically running caricature any more, only sporadically publishing portraits by their favorite artists. In the 1920s, however, the *New Yorker* had played a major role in promoting the caricature vogue. Not only did it feature established artists and encourage many new, younger talents, it also provided another stylish, urban context within which caricature would flourish.

Ross's *New Yorker*, along with Swope's *New York World* and Crowninshield's *Vanity Fair*, helped to promote New York City's caricature vogue in the 1920s, lending it an aura of celebrity glamour. In many other cities dis-

torted portraits began appearing on clubhouse and restaurant walls, and newspapers hired caricaturists for their entertainment pages. Barton's Chauve-Souris curtain toured the country, and so did Henry Major. In Charles Bartholomew's 1922 handbook *Chalk Talk and Crayon Presentation*, he recommended portrait caricature as one of the stunts that could turn drawing skills into stand-up performance.[47] Anyone, professional and amateur artist alike, could become a caricaturist.

Nowhere else, however, would caricature thrive the way it did in Manhattan. The bright, smart wit of New York columnists and caricaturists glossed over the anxiety and terrifying complexity of rapid urbanization. To the writers, editors, and comic artists of the day, it was a triumph of the intellect over the psyche, a heroic struggle to maintain that distance and perspective necessary to comment on the modern world. For such deeply troubled figures as Dorothy Parker, Ralph Barton, and James Thurber, the effort to meet the unceasing demand for sparkling comic verse, essays, and caricature under the pressure of unrelenting deadlines was costly. "This type of writing is not a joyous form of self-expression," Thurber once commented, "but the manifestation of a twitchiness at once cosmic and mundane." To call the authors of such pieces humorists, he noted, "is to miss the nature of their dilemma and the dilemma of their nature. The little wheels of their invention are set in motion by the damp hand of melancholy. . . . [Their] gestures are the ludicrous reflexes of the maladjusted."[48]

Darker, more acerbic forms of humor might have been better suited to the personalities of these talented figures. The fact that each became renowned for brilliant contributions to this prevailing mode of light, sophisticated wit emphasizes the high value it received in the urban culture of their generation.

Part 4 The Climax of the Caricature Era

9.1. *Clare Boothe Brokaw* (1903–87) by Miguel Covarrubias. Watercolor on paper, 38.4 x 26.5 cm (15 1/8 x 10 5/8 in.), c. 1932–33. Margery Nelson and William Link.

Art Deco Color in Vanity Fair

The magazine regards a conspicuous caricature . . . as an acknowledgment of world importance, rather than as an insult, even if the portrait may seem, on the surface, to be uncomplimentary. Figures . . . are given attention because of their great interest as personalities; not because Vanity Fair *wishes to analyze or criticize their characters.*
—Vanity Fair, *1933*

In the heady atmosphere of 1927, the stock of Condé Nast Publications, Inc., went public and began to soar. Editor Frank Crowninshield, with stunning prescience, sold his shares at their virtual peak in 1929. The publisher himself was not so lucky. The stock market crash in October ruined Condé Nast's vast personal fortune, forcing him to relinquish control of his company. Until his death in 1942 he struggled on despite crushing debts, giving glamorous parties at 1040 Park Avenue and attempting to keep his magazines solvent and contemporary. He argued passionately with his bankers and financiers to justify expenses for quality paper, color printing, sufficient advertising. *Vanity Fair*, the least profitable of the Condé Nast ventures, was particularly vulnerable.[1]

Initially, Crowninshield, like many others, treated the economic depression as a temporary aberration. But as the months wore on and revenue declined, change seemed inevitable. "Nast insisted on making it a more serious magazine," he told Geoffrey Hellman.[2] Nonetheless, after so many years of perfecting his beloved monthly, Crowninshield could not face a complete overhaul. Instead of rejecting the old, light-hearted mix of arts and entertainment, he attempted to graft on a new political focus. Others on the editorial team, like the young associate editor Clare Boothe Brokaw, entertainingly depicted by Covarrubias shortly after her arrival early in 1930 (fig. 9.1), grappled with more serious business. It was an uneasy mix of approaches. "Twixt cardtricks and African sculpture," Brokaw later remembered, "Mr. Crowninshield laid glibly before the editors, for their distracted consideration, the serious articles on labor, politics, and science which Mr. Nast was then [1932] ordering from Jay Franklin, Walter Lippmann, and Matthew Woll."[3] Although Brokaw contributed clever, satirical essays of contemporary society in *Vanity Fair*'s traditional mode, she also had

keen instincts for the tougher, more pragmatic mood of the Depression years, and is often credited with changing the focus. Crowninshield remained uncomfortable with solemn topics, no matter how timely or reflective. "Heavy-sounding subjects like Reparations, War Debts, Tariffs, and Disarmament become brilliant and entertaining in the hands of *Vanity Fair*'s engaging writers," read a breezy advertisement of 1932 that did not bode well for the future.[4]

The overall look of *Vanity Fair* also changed during this period. Even before the crash, Condé Nast had been planning a stylistic modernization of his magazines. In the late 1920s he assigned one of his renowned *Vogue* cover artists, Eduardo Benito, to develop concepts for a new layout. Benito's design abandoned the traditional look, based on eighteenth-century typographic styles, and invoked a modern, Bauhaus-inspired aesthetic that stressed geometry, legibility, and clarity. A sans serif typeface set the tone for Benito's design, along with bold use of white space, asymmetrical placement of photographs, and a generally simpler, less ornamented assembly of text and illustration. "The setting up of a magazine page is a form of architecture," Benito explained to Nast. "It must be simple, pure, clear, legible like a modern architect's plan, and as we do a modern magazine we must do it like modern architecture."[5]

Benito refused Nast's offer to become art director of *Vogue*, so to implement the updated look Nast hired Mehemed Fehmy Agha, a cosmopolitan artist born in Ukraine of Turkish parents. Dr. Agha, as he was known (because of a doctorate in political science), came to New York in 1929, taking over the art directorship of *Vanity Fair* and *House and Garden* as well, and transforming the look of the Condé Nast magazines. Not all the new ideas worked. For the sake of legibility, the editors abandoned in March 1930 a five-month attempt to

eliminate uppercase letters, but in many other ways the magazine had changed.[6] Steichen's photograph of Katharine Cornell from that issue, for instance, is placed asymmetrically on the page and trimmed of the usual lined border. The brevity of the caption and title, lettered in strong, clean, sans serif typography, results in wide, white margins, giving a modern, uncluttered feel to the page and a heightened drama to the image. In Dr. Agha's capable hands the magazine seemed poised to enter a new era.

Condé Nast's entree into color printing accompanied these design initiatives. Always striving for the look of luxury and high quality, Nast had built a lavish printing plant in Greenwich, Connecticut, complete with the most modern machinery on the inside and ornamental gardens, fountains, and Italian sculpture on the outside. In the late 1920s he bought a photoengraving company that pioneered the production of four-color engravings. Nast's printing technology by the early 1930s was so advanced that the company printed many of the most sophisticated magazines of the period. Previously the only color in *Vanity Fair* had appeared on the cover or in the loud, trumpeting hues of the advertising pages. Now the art reproductions and illustrations so dear to Crowninshield's heart would have new significance.

Vanity Fair's cover of April 1931 exemplified these various design changes (fig. 9.2). French artist Jean Carlu superimposed against a nighttime landscape the heads of a top-hatted man and a bobbed-haired girl, outlined in shimmering neon lights of orange, pink, and white. An unbroken line defines each contour, curving upward to form a chin, angling sharply to suggest a nose, doubling back to outline a mouth. The *Vanity Fair* audience would have recognized in this emblematic shorthand the sleek modern icons of Manhattan nightlife and the glow of the Great White Way. This traditional *Vanity Fair* theme, however, had been updated to match the new look and layout of the magazine. Although the heads lack the humor of recognizable portraits, they establish the contextual meaning for the caricature within the pages, suggesting how closely figural stylization related to fashion, innovative European design, and modern urban culture.

As the editors plotted their strategies for the future of the magazine, they decided to refocus on celebrity caricature, which had been so successful in the early and mid-1920s. In the struggle to merge the serious and the light-hearted, satiric portraiture appealed to both sides. Caricaturists, the editors felt, by simply applying their witty stylizations to more statesmen, economists, and international leaders, could suggest the magazine's new political and global point of view. With the addition of color and fresh stylistic approaches, these portraits would also enhance the magazine's updated design. The editors, therefore, with boldness and confidence, introduced in the early 1930s a revitalized form of caricature unmatched by any other journal. Recruiting the best artists, enlarging and featuring their work on frontispieces and covers, spending lavishly on color printing, *Vanity Fair* established the standards for the decade in brilliant, stylized portraits that represented the climax of the celebrity caricature era. In the hands of such artists as Will Cotton, Paolo Garretto, and Miguel Covarrubias, caricature maintained its lively,

9.2 *Vanity Fair cover* by Jean Carlu. Printed illustration. Published in *Vanity Fair*, April 1931. Library of the National Portrait Gallery and the National Museum of American Art, Smithsonian Institution, Washington, D.C.

9.3 *Eddie Cantor* (1892–1964) by Frederick J. Garner. Watercolor, ink, and pencil on paper, 37.8 x 30.5 cm (14^{15}/$_{16}$ x 12 in.), 1933. Original illustration for Brown and Bigelow advertising cards. National Portrait Gallery, Smithsonian Institution, Washington, D.C.

urbane spirit while changing with the times.

The color caricature that *Vanity Fair* promoted had a different contextual resonance from that of the black and white drawings. Most important, it correlated with other graphic forms, particularly advertising art. Pen and ink caricature of the 1920s, enlivened by celebrity associations, had made the crowded, wordy advertisements seem dowdy and outdated. By the 1930s, commercial art had caught up, as the precepts of Art Deco styles permeated the design community. Many advertisers, from the late 1920s through the 1930s, began emphasizing the art rather than the text, employing bold, emblematic images. A growing emphasis on

color, fashion appeal, and urbane sophistication pervaded the industry, often communicated through geometric, streamlined, or asymmetrical designs derived from modern art.[7] Such ads more closely resembled magazine covers and caricature.

In some instances, advertisers incorporated caricature directly, building on the growing vogue for celebrity endorsements. In 1933, Brown and Bigelow published Frederick J. Garner's twelve caricature images of Eddie Cantor for use as direct mail advertising cards (fig. 9.3). Business owners could buy the set in bulk and mail them out monthly to special customers. According to the *Business Builder*, a direct mail

9.4 *Will Cotton* (1880–1958) by unidentified photographer. Printed illustration. Published in *Vanity Fair*, May 1932. Library of the National Portrait Gallery and the National Museum of American Art, Smithsonian Institution, Washington, D.C.

9.5 *Joseph Stalin* (1879–1953) by Will Cotton. Printed illustration. Published in *Vanity Fair*, May 1931. Library of the National Portrait Gallery and the National Museum of American Art, Smithsonian Institution, Washington, D.C.

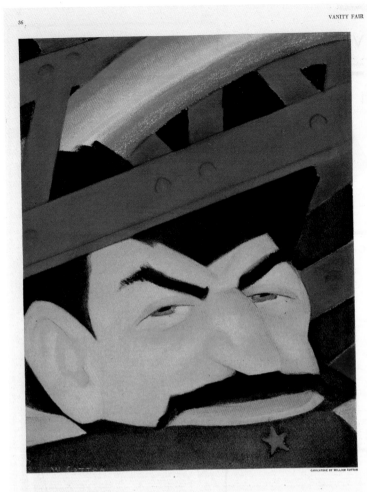

Joseph Stalin

trade publication, the brisk sale of the Cantor cards to auto body shops, funeral directors, dental laboratories, vegetable wholesale dealers, and water pump manufacturers proved not only the actor's enormous appeal, but also the complete obsolescence of billboard, radio, and newspaper advertising. "It's a regular poster, that's what it is," the promoters shrilled. "We did it by eliminating the border, by letting the picture bleed off all around. That's modern treatment, and it was particularly effective with these Cantor cards where Eddie Cantor himself must be the dominating feature."[8]

Caricaturists themselves were becoming graphic designers rather than just humor illustrators, producing advertisements, brochures, and other visual materials for the commercial market. Even when not using faces of the famous, the caricaturists' closer relationship to commercial design would change the impact of their stylized portraiture. Roland Marchand, in his study of American advertising, points out that bold slogans and pictures insistently repeated through the popular media created a common vocabulary, an integrative language of imagery and ideas shared by a mass audience.[9] Celebrity caricature, as it was more widely disseminated, achieved a similar familiarity and meaning. Like a silk stocking, a new Nash, or the logo for a pancake mix, a face could instantly convey sex appeal, sophisticated wealth, or comfortable domesticity. This accessibility and broad appeal brought obvious

benefits, but it also subjected caricature to the whims of fashion and the stigma of commercialism. Although a stylized portrait, appearing as a magazine frontispiece, had nothing to sell, it often seemed to be marketing Hollywood, the publishing firm, or the individual.

In addition, as caricature expanded from its focus on New York's celebrity circles to a worldwide perspective, it began to lose some of its emphasis on personality. While a thriving Manhattan café society and the glamorous Hollywood milieu continued to produce colorful candidates for caricature, dictators, economic theorists, and New Deal politicians rarely proved as entertaining. Inevitably, light, stylish pictures of such subjects would send confusing messages to some; the serious figures of the Depression and prewar years begged a darker, more sharply satiric treatment. But these trends were not evident in the early 1930s. Like the luxury advertising and high-society film comedies of the period, caricature would still exploit glamour and sophistication to escape economic and political tensions. *Vanity Fair* planned to lead the way.

With the new printing technology in place, the magazine's regular black and white artists had to be supplemented by colorists. By 1931, a troika of caricaturists had emerged who would, the editors hoped, bring new vigor to the magazine. Covarrubias, who had been working in watercolor and oils for years, easily made the transition to color. Despite his divergent interests, *Vanity Fair* editors began to redirect his contributions to the caricatures of the famous that had done so much for both his reputation and their own. In addition, two new recruits joined the magazine's stable of artists: William H. Cotton, a painter from Newport, Rhode Island, and Paolo Garretto, an Italian illustrator who had worked for the Condé Nast organization in Paris. *Vanity Fair* made the three artists an integral part of its style and tone during the 1930s, and in the process brought caricature to a peak of artistic achievement.

In 1930, as the editors began to plan future issues in color, Covarrubias was unavailable, creating an opportunity for Will Cotton (1880–1958) to establish himself at the magazine. Cotton (fig. 9.4), who had studied at the Académie Julien in Paris, was a portrait painter and a muralist. But the response to his series of pastel caricatures of famous authors, supposedly done for his own amusement, encouraged him to continue. In 1926 he won first prize in the Pennsylvania Academy of the Fine Arts' caricature competition, and the Ehrich

Gallery in New York exhibited a group of his drawings. The following year, Cotton's caricatures appeared in a show at the Art Association of Newport, which, the *New York Times* reported, attracted hundreds of tourists and "arrested the attention of fashionable Newport at the height of the social season." When Cotton showed his pastel portraits at the Art Institute of Chicago's annual watercolor exhibition of 1927, one journalist noted that "even caricature and humor are not below the artist with ideals." In the opinion of another, Cotton's "clever take-offs" were among the best offerings of the show.[10]

Vanity Fair's editors recognized in Cotton a colorist who could showcase their printing technology. His vivid hues appeared with startling boldness in 1931, starting with a portrait of Sinclair Lewis in the January issue and a likeness of Einstein the following month. Captions by H. L. Mencken added a touch of piquant sarcasm—"The award of the Nobel Prize to Lewis for his novel, *Babbitt*," he wrote, "must have come as gruesome news to the pedagogues who have been laboring so shrilly of late to restore sweetness and light to the national letters"—and the color itself signaled a new direction for caricature.[11] Although the front and back sections had flamed with garish advertisements for Pierce Arrow automobiles, Camel cigarettes, or Standard plumbing fixtures, the body of the magazine had always been black and white. Cotton's bright pastels, covering two-thirds of the page, along with occasional art reproductions, shattered the monochromatic tradition. Perhaps encouraged by a positive response, the editors moved quickly to give the caricatures more prominence. By May, Cotton's likeness of Stalin, positioned after the table of contents as the frontispiece, filled an entire page with brilliant color (fig. 9.5). Only the sans serif title shared the space; the caption was moved to the adjoining page. Before the end of the year, Cotton had published full-page frontispieces of the Prince of Wales, Charles Lindbergh, Charles Francis Adams, Sigmund Freud, Theodore Dreiser, and Giulio Gatti-Casazza.

Cotton's pictures were so different from other comic offerings that the table of contents initially listed them under "Miscellaneous" rather than "Satiric sketches." In addition to the astonishing effect of the color itself, the soft texture of the pastel technique contrasted dramatically with the familiar bold ink contours of much published caricature. Acknowledging their unusual quality,

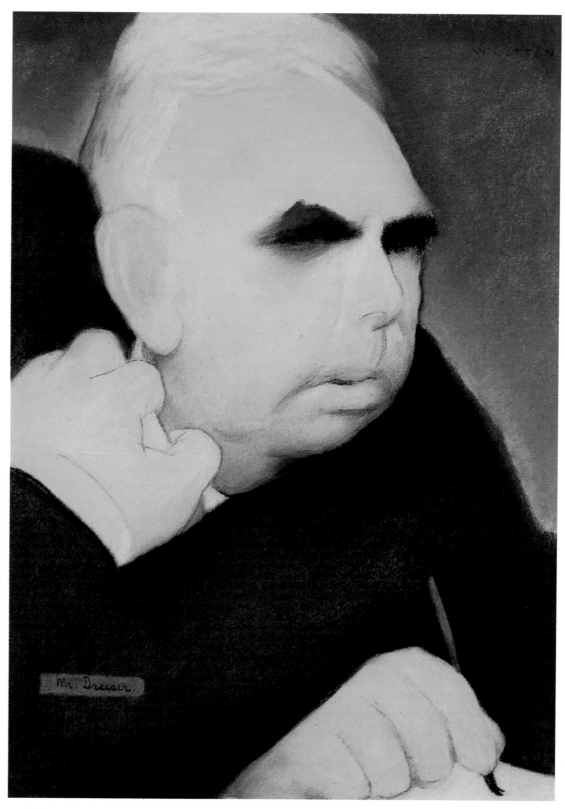

9.6 *Theodore Dreiser* (1871–1945) by Will Cotton. Pastel on board, 48.2 x 35.6 cm (19 x 14 in.). Original illustration for *Vanity Fair*, October 1931. National Portrait Gallery, Smithsonian Institution, Washington, D.C.

critic William Murrell called them "excellent but rather woolly-looking compositions."[12] Cotton clearly did not need linear sharpness; he wielded a new weapon. Color rather than line provided the skeptical, satiric tone. Despite the soft texture, the strong, beautifully printed hues delivered a powerful, sometimes brutal impression. Modern artists, ever since the Fauves, had been exploring the interaction of intense, unmodulated colors, searching for expressiveness and emotional impact. Cotton took this heightened sensibility into the realm of popular art and humor. Red might have been an obvious embellishment to the portrait of Stalin, but in Cotton's caricature of May 1931, the color assaults the eye. Playing on the meaning of the name "Stalin" (of steel), the image shows the dictator peering out from beneath massive girders of a pulsating scarlet hue. The harshly gleaming rainbow at the top does not alleviate the oppressive weight of that color.

Nast's remarkable new printing technology produced an astonishing range of color effects, from the strong hues to the delicate. In Cotton's pastel of Theodore Dreiser, for instance, published in October 1931, the brilliant green of the background sets off flesh tones of exquisite subtlety (fig. 9.6). The image has plenty of humorous components. The eyes vanish under dark smudges of thick eyebrows, and the figure knots itself into a ridiculous contortion, with one arm twisted over the other and awkwardly hooked onto the collar. Nonetheless, despite the title of the picture— An American Tragedian—Cotton does not mock Dreiser's perpetual glumness. The picture is not even comic. From the pale, balding dome of a forehead with its wisps of white hair, the face sags into a permanent frown. An unshaven stubble of an oddly delicate lavender-blue weighs down the heavy jowls. The paleness and delicacy of the colors heighten the sadness of the face. Perhaps in reaction to Cotton's depiction, caption writer Ernest Boyd wrote of Dreiser on the accompanying page: "American life is to him a vast American tragedy, a blind and often meaninglessly cruel welter of forces. . . . In his lumbering strength there is a vitality which endures. The sprawling record of his literary life resembles one of his own novels: straggling, repetitious, chaotic, full of rugged power and at times deeply moving."[13]

Cotton's choice of colors was usually imaginative and often witty. In his drawing of Frances Perkins (fig. 9.7), Franklin Roosevelt's newly appointed secretary of labor, he depicts the first female cabinet member with fragile, feminine delicacy: pale flesh tones and lipstick, elegant pearls, proper hat. The massive figure of a laborer at a cogwheel looms behind, rendered in earthy brown and steely gray against the dramatic blue background. Although the placement of Perkins's head in the lower half of the picture implies her petite stature, her firm gaze and resolute air suggest a highly capable intelligence. But it is primarily the contrast of hues that imparts the humorous incongruity of strong feminine leadership in a domain of men and machines.

Cotton's portrayal of Nicholas Murray Butler (fig. 9.8), published in Vanity Fair in February 1933, depicts the renowned president of Columbia University with the slit-like eyes and paunchy wisdom of an owl, but again color rather than distortion provides the sizzling humor of the picture. Butler, who had recently won the Nobel Peace Prize, is bedecked with a laurel wreath and decorations that he had "gathered by the trayful" in his role as an unofficial ambassador in international affairs. It took a two-column caption to summarize Butler's remarkable accomplishments, but Cotton neatly undermined this respectful recitation by casting the flesh tones in painfully florid, bubble-gum pink.[14] This undignified color energizes the mild distortions of the face, adding satiric thrust.

The editors hoped that Cotton's vivid frontispieces would entice new readers. In May 1932, just a year and a half after Cotton's first appearance, Vanity Fair advertised the artist's work as an inducement to subscribe. "Meet three typical contributors to Vanity Fair," ran the promotion, "the magazine for connoisseurs of the eighth art—the art of enjoying this very modern world." The subscription notice pictured Cotton along with Paul Gallico, "Peck's bad boy of sports writers," and George Jean Nathan, "trenchant critic of the stage." That October the magazine nominated Cotton for its own Hall of Fame page. The caption noted not only his caricature contributions—"models of polite causticity"—but also his satiric play, The Bride the Sun Shines On, which had had a respectable Broadway run, and his murals for several New York theaters.[15]

The magazine's staff, rather than the artist, undoubtedly chose the subjects for Cotton's caricatures. At first the portraits reflected the old, lively Crowninshield mix, alternating actresses and opera impresarios with statesmen and dictators. But in time serious men of affairs appeared more frequently while the number of entertainment figures and urban sophisticates declined.

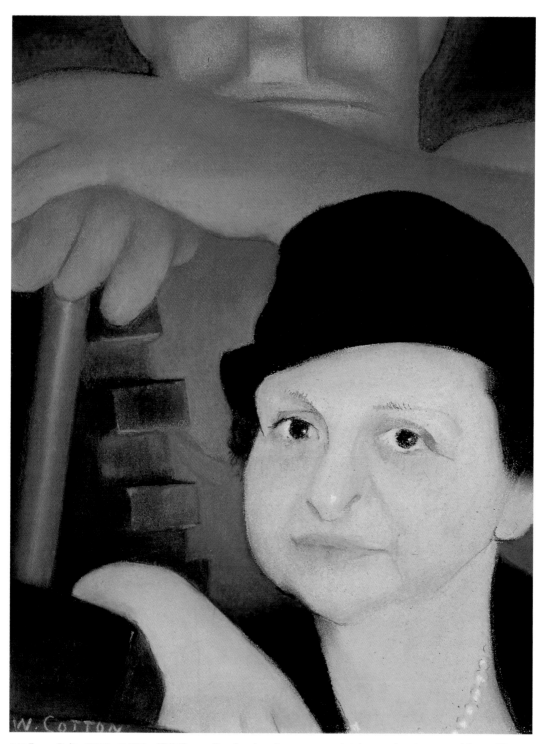

9.7 *Frances Perkins* (1882–1965) by Will Cotton. Pastel on board, 48 x 37.6 cm (18⁷/₈ x 14¹³/₁₆ in.), c. 1935. National Portrait Gallery, Smithsonian Institution, Washington, D.C.

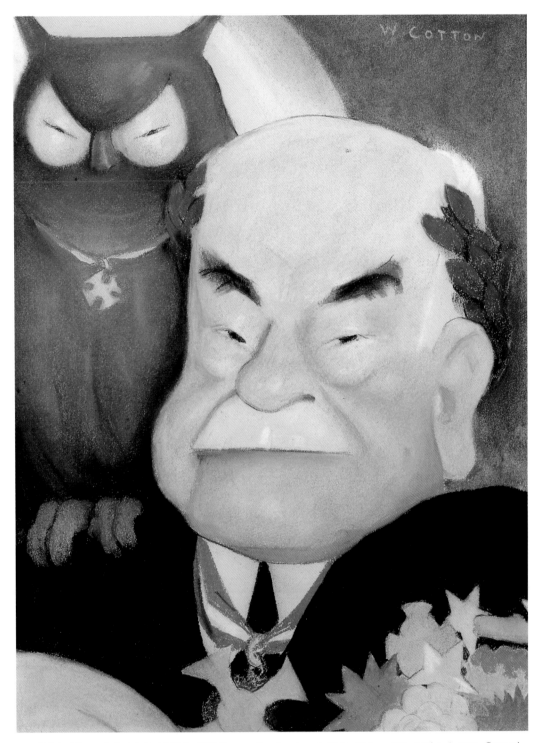

9.8 *Nicholas Murray Butler* (1862–1947) by Will Cotton. Pastel on board, 48.3 x 37.1 cm (19 x 14 5/8 in.), 1933. Original illustration for *Vanity Fair*, February 1933. National Portrait Gallery, Smithsonian Institution, Washington, D.C.

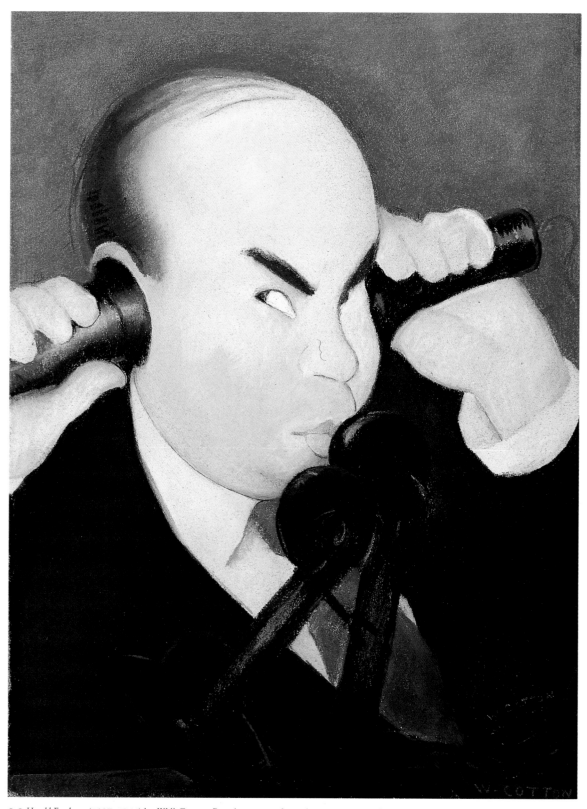

9.9 *Harold Freedman* (1897–1966) by Will Cotton. Pastel on paper, framed, 50.8 x 38.1 cm (20 x 15 in.), c. 1930–35. Robert A. Freedman.

When the sparkle of a vivid personality was no longer an inherent component of the celebrity image, however, the caricature could send mixed messages. The distorted likeness of a serious public figure began to read like a political cartoon. Readers expected it to contain a partisan or corrective comment related to issues, events, or character flaws. One letter to the editor, published in February 1933, criticized Cotton's frontispieces of Secretary of State Henry Stimson and Senator William Borah in recent issues. Acknowledging the artist as a colorist "of the first order," the writer nonetheless complained that the Stimson caricature made "Wrong Horse Harry look like a very dear and amiable soul" and that the picture of Borah was a "beatific vision" that overlooked the senator's self-righteousness "bellowing and barking over practically nothing at all."[16]

Cotton's caricatures of nonpolitical figures never elicited such complaints. His portraits from the theatrical world—such as his image of theatrical play agent Harold Freedman juggling two telephones (fig. 9.9)—invariably proved entertaining. The Algonquin Round Table writers particularly intrigued him, inspiring a number of his cleverest pastels. In "Professional Jealousy," columnist Franklin P. Adams turns up his nose at Columbus on top of *his* column, the newly erected monument at Columbus Circle (see fig. 2.3). F. P. A. holds a diary in his hand, a reference to one of his columns, as well as the 1935 publication of his *Diary of Our Own Samuel Pepys*. Adams, the picture implies, considered himself the discoverer and chronicler of urban America and all others mere impostors. This gently mocking appraisal reflected the themes of the Algonquin Round Table humorists, who simultaneously deflated and promoted each other as the arbiters of urban sophistication.

In a drawing entitled "The Swimming Pool of the Thanatopsis Club" (fig. 9.10), Cotton drew regular members of the Round Table's whimsically named poker group out for a swim, accentuating, through color, the different qualities of the five nude bodies. Heywood Broun, F. P. A., George Kaufman, Harold Ross, and Alexander Woollcott are each rendered in a different, sickly, thoroughly urban shade of pallor. Depicting chubby Broun in pale green, Woollcott in china doll ivory, and so forth, he conjures up five gargoyle-like grotesques. To the subjects, Cotton's ability

to individualize the figures entertainingly deflected the unflattering depictions, suggesting each subject's own vivid impact on contemporary culture. In the drawing "Lunch at the Astor," producer Jed Harris and an unidentified friend sit back to back, looking like a scene from a broadway musical (fig. 9.11). The pink of the round face on the right contrasts with the blue five-o'clock shadow of Harris's sharp chin, the yellow countenance of George Kaufman, and the pallid nose of Henry Botkin (a Gershwin cousin). Again, Cotton cheerfully mocks these figures much the way they satirized themselves, focusing on the artificial posing and vanity that his flamboyant subjects flaunted.

Cotton's success with his Algonquin group portraits, in comparison with the relative blandness of his political likenesses, suggests the integral relationship of celebrity caricature to the urban humorists of the 1920s. For the Algonquin Round Table group, an undignified caricature or an insulting quip focused complimentary attention on the subject. Their victims should be grateful, they felt, to be worthy of their barbs—amusing, negative publicity was more memorable and effective than any other. "The fact is," a *New Yorker* profile of Woollcott pointed out, "that insult is a casual demonstration of regard with him, as it is with most of his friends. 'Hello, repulsive' is a tender greeting under his roof and goodbye is said as sweetly. 'I find you are beginning to disgust me, puss' the great man will say as his bedtime approaches. 'How about getting the hell out of here?'"[17]

Cotton's frontispiece of Woollcott appeared in September 1935, and up until the last three, increasingly slim issues, Cotton maintained a prominent presence in *Vanity Fair*. But after its final issue in February 1936, Cotton never found as congenial an outlet for his particular brand of caricature. He contributed regularly to the *New Yorker* in the early 1930s, frequently supplying heads for the "Profiles" section. But with the exception of his occasional covers, his drawings were reproduced in black and white, thus losing their most distinctive and effective element. Without color, Cotton's portraits lost some of their imaginative wit. Ultimately his soft pastel technique probably competed poorly with the hard-edged, streamlined shapes that dominated graphic design in the 1930s.

On the other hand, Cotton's humorous likenesses consistently elicited praise from art audiences and

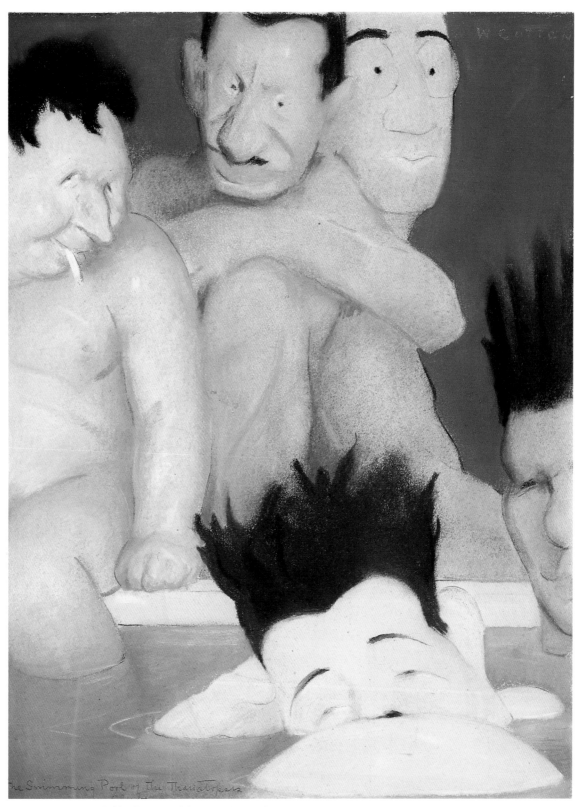

9.10 *The Swimming Pool of the Thanatopsis Club* by Will Cotton. Pastel on board, 46 x 35.6 cm (18 1/8 x 14 in.), c. 1930–35. National Portrait Gallery, Smithsonian Institution, Washington, D.C.

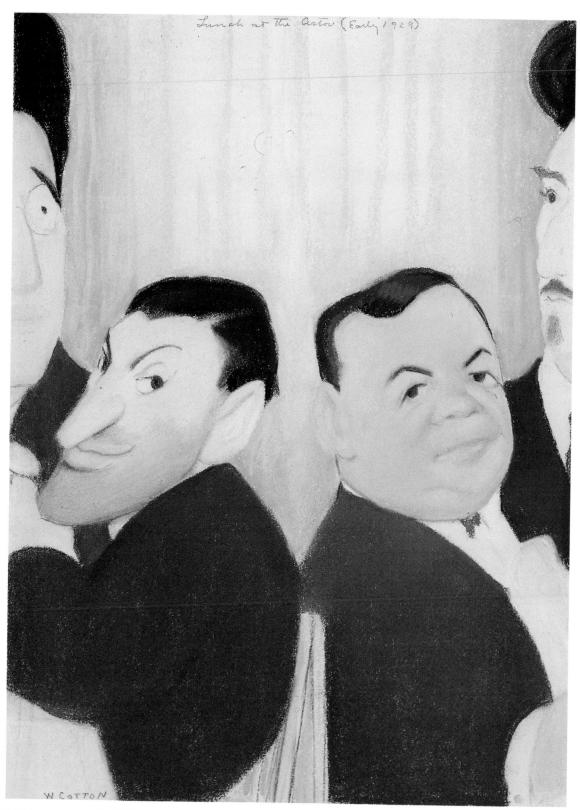

9.11 *Lunch at the Astor* by Will Cotton. Pastel on board, 48.2 x 35.6 cm (19 x 14 in.), 1929. National Portrait Gallery, Smithsonian Institution, Washington, D.C.

9.12 *Paolo Garretto* (1903–89) by unidentified photographer. Printed illustration. Published in *Vanity Fair*, August 1934. Library of the National Portrait Gallery and the National Museum of American Art, Smithsonian Institution, Washington, D.C.

critics, who became increasingly interested in celebrity caricature as it changed to color. Cotton exhibited his pastels frequently at the Art Institute of Chicago's prominent annual watercolor exhibition. In 1932, *Christian Science Monitor* critic Charles Kelley considered a group of his pastel caricatures "one of the high spots, as usual," and thought that he raised "his friendly libels to the height of real art."[18] Twenty-eight of his *Vanity Fair* drawings drew praise in the 1937 watercolor exhibition, including Alfred Lunt and Lynn Fontanne in *Elizabeth the Queen* (see fig. 1.6) and "Swimming Pool of the Thanatopsis Club." In fact, Cotton was among three artists "featured" at this enormous international show, according to the Art Institute's *Bulletin*, the other two being Walt Louderbach and Pablo Picasso.[19]

Cotton admirer Paul Hyde Bonner, a regular member of the Round Table's poker group, felt that the artist deserved more appreciation. Weary of hearing about Max Beerbohm, Bonner wrote in the *Saturday Review* in 1939 about "our own great caricaturist,"

pointing out that Cotton was a "far better artist than Max, with a wit that is equally stylish and literate." He had first seen his work when he visited theatrical producer Crosby Gaige, whose study was lined with original Cotton drawings of literary figures. Overwhelmed by their quality, Bonner arranged to be introduced to the artist and ordered his own copy of "The Thanatopsis Pleasure and Inside Straight Club" (see fig. 1.3).[20] Despite such enthusiasm, Cotton's career as a caricaturist waned along with the fortunes of *Vanity Fair* and the Algonquin Round Table. But he had played a major role in establishing the effectiveness of color in the stylized celebrity portrait.

He was not alone in that endeavor. In 1930, as the *Vanity Fair* editors planned their transition to color, Clare Boothe Brokaw wrote to the young caricaturist and advertising artist Paolo Garretto (1903–89) (fig. 9.12), who lived in Paris and published in British, French, German, and Italian magazines and newspapers. His work had only begun to appear in the colored Sunday issues of the *Philadelphia Public Ledger*, in the Sunday *New York World*, and in *Fortune* magazine. The latter was a glossy, expensive new business journal that appeared just after the crash of the stock market and, illogically, thrived. The publisher, Henry Luce, soon to be Clare Brokaw's husband, emphasized good writing and fine design, spending lavishly on stylish covers and illustrations by prominent American and European designers. He had *Fortune* printed by the best printing plant around—Condé Nast's. But *Vanity Fair* did not intend to be upstaged by *Fortune* when it came to color caricature. "The Editors were very much impressed with your cartoon of Gandhi in the August issue of *Fortune*," Brokaw wrote Garretto in October 1930, noting that they also had in their files some excellent caricatures from the December 1927 issue of *The [London] Graphic*. She asked whether he had any other cartoons or caricatures of famous people that he could send to them.[21]

The multinational and peripatetic Garretto, born in Naples of an Italian father and a Swiss-English-German mother, had lived briefly in America in his teens while his father was researching a book on the history of the United States. He had studied art and architecture in Milan and then at the Superior Institute of Art in Rome, where the family moved in 1920. Attracted to cubism, futurism, and stylistic innovation, he began to gather with such artists as Filippo Tommaso Marinetti

and Fortunato Depero at Rome's famous Cafe Aragno. Like so many other artists, he found in that café culture the ferment of new ideas, an eclectic mix of young artists, actors, and intellectuals, and the inspiration to draw caricature. At the Cafe Aragno he got into the habit of sketching the faces of the Roman intelligentsia on the white marble table tops, only to have his portraits wiped away at closing time. Finally a journalist friend, Orio Vergani, persuaded him to draw his caricatures on paper for publication, launching the career of another café sketch artist.[22]

A fervent hatred of communists—which began when a gang of Bolsheviks assaulted his father—led Garretto to a youthful enthusiasm for fascism that would cause him many problems in later years. In 1922 he even served briefly on Mussolini's personal honor guard, designing an all-black uniform that was immediately adopted. He soon returned to his art studies, however. Struggling to find his own approach, he was influenced by his friend Depero, whose creations he remembered as "always so unexpected." Depero inspired him to experiment with collage and work with other materials besides pencils and brushes.[23] Ever afterward, his caricature drawings would retain a sense of material construction and collage, even when drawn directly on paper. Other friends, such as Marinetti, encouraged his experiments in color, urging him to move to Paris for better publishing opportunities. He finally did settle in the French capital in 1927, and then he visited London, hoping to place his caricatures in one of the "Great Eight" English periodicals, such as *The Bystander* and *The Graphic*. Shortly afterward, on a visit to Rome, he was astounded when a friend informed him that four of his drawings had just appeared in *The Graphic* and that the publishers wanted to sign a contract for more. Although he continued to live in Paris, his contract with the London journals established his international career in advertising, poster design, and illustration.

The former architecture student worked with a tight, mechanical precision. In his monochromatic drawing of film star Mae Murray from the late 1920s (fig. 9.13), the symmetrical coiffure, perfect rosebud mouth, and streamlined chin evoke the likeness. Garretto achieved his smooth, precise effects through innovative use of the airbrush, a pen-sized instrument that sprays a mist of pigment onto the paper. Capable of producing fine lines and subtle gradations of tones, airbrush was first

9.13 *Mae Murray* (1889–1965) by Paolo Garretto. Ink and wash on paper, 45.7 x 35.7 cm (18 x 14 in.) (sight), 1929. Anne and Ronald Abramson.

used commercially for tinting, dyeing, and gilding and was best known as a tool for retouching photographs. But artists such as Man Ray started experimenting with airbrush as a creative medium in the late teens, and German Bauhaus designers of the 1920s began to exploit its sleek, machinelike edges and smooth tonal modulations. Soon Jean Carlu in Paris and other French artists adopted airbrush in their advertising and poster art. Without any sign of brush strokes or pen lines, the technique imparted a clean, impersonal effect. Carlu's posters, Alan Fern has pointed out, "seem to bear no mark of the designer's hand; colors and shapes either end precisely or flow off in utterly smooth gradations."[24]

Garretto, arriving in Paris in 1927, met leading poster artists, including Carlu, Adolphe Mouron Cassandre, Charles Loupot, and Paul Colin, and he quickly absorbed the prevailing aesthetic. He even was briefly associated with their advertising agency, the Alliance Graphique. Just two years before his arrival

9.14 *Calvin Coolidge* (1872–1933) by Paolo Garretto. Collage with pastel, charcoal, gouache, and airbrushed watercolor on board, 30.9 x 23.3 cm (12³/₁₆ x 9³/₁₆ in.), 1927. Original illustration for *New York World*, May 6, 1928. National Portrait Gallery, Smithsonian Institution, Washington, D.C.

the elaborate Exposition des Arts Décoratifs et Industriels Modernes had established the stylistic tenets of Art Deco, as it was later termed. Geometric formality, uncluttered simplicity, machinelike precision, brilliant color contrasts, and stylized distortions characterized the new amalgam of styles that Art Deco represented. The structural formality of Bauhaus artists and Russian constructivists underlay these design principles. In the hands of French poster artists, however, an emphasis on wit and bold, emblematic forms moderated any sense of rigidity.[25] Garretto's own evolving style synchronized with popular aesthetic standards, and his career escalated rapidly.

Although others used the airbrush for advertising, Garretto, who claimed to have discovered the tool in London, was one of the first to apply it to caricature.[26] Like Carlu's posters, the portraits lacked any obvious sign of the artist's hand and judgment. Rather than the product of a biased individual, these precise likenesses, drifting on the page, suggest the ineluctable truth, stamped out by an omniscient machine. As one critic commented about Garretto in 1947, "under his hands persons become moving puppets, in an atmosphere that no longer smells of typography or of paper, pen and inkstand."[27] Seemingly less rooted in the personal response,

9.15 *Babe Ruth* (1895–1948) by Paolo Garretto. Collage with pastel, airbrushed gouache, and lithographic crayon on paper, 31.2 x 24.3 cm (12 5/16 x 9 3/8 in.), 1929. Original illustration for *New York World*, September 22, 1929. National Portrait Gallery, Smithsonian Institution, Washington, D.C.

caricature acquired a more persuasive, sometimes propagandistic, power.

"Garretto's images seem to float on the page," Elyce Wakerman has written in her history of airbrush art, "like balloons blown up for the reader's enjoyment."[28] It was not only the smooth, textureless surface of Garretto's heads that rendered this quality, however, but also their neckless detachment from the figure. Without the neck as a pedestal to suggest the gravity-bound status of the human body, the heads appear weightless and buoyant. Garretto heightened the effect by cutting out his portraits and mounting them onto another sheet, often with a bright, airbrushed background. The scissored edges of his 1929 Calvin Coolidge (fig. 9.14), for instance, intensified by a pink tint at the chin and dark charcoal at the hairline, stand out sharply against a rich, blue ground, seeming to hover on the page.

Especially gravity-defying is Garretto's 1929 image of home run hero Babe Ruth as a baseball (fig. 9.15). The plastering of the heavy, porcine features onto a hard, spherical surface and the unexpected combination of pink and orange spice the humor, but the concept of the ball in mid-air gives the picture its emblematic impact. Caricaturists delighted in depicting the man one sportswriter called "our national exaggera-

tion," for few figures of the era could furnish such a well-defined celebrity reputation. Endowed with speed, strength, and almost unparalleled coordination, Ruth struck many experts as one of the most complete athletes baseball had ever known. But his fame was based on more than his extraordinary feats on the field. With an instinct for pleasing the crowd, he created the image of an ordinary man inflated to heroic proportions. He performed great feats of gluttony, spent money lavishly, visited sick children, flouted every rule, wept in public, and promised to reform. His fans collected statistics on his hot dog consumption. An Irish sportswriter managed his off-the-field activities: barnstorming in exhibition games and vaudeville tours, broadcasting on the radio, endorsing commercial products. "Above all, get the fans a star whom they may worship," one baseball owner exhorted, "no matter what he costs." By such a standard, Babe Ruth was a dream come true. Garretto encapsulated this gargantuan reputation into a single, compelling emblem. From Ruth's bat, the baseball soared, and so does the image on the paper.[29]

Vanity Fair's watchful editors undoubtedly noticed Garretto's depiction of Ruth, which appeared in the Sunday *World* Magazine on September 22, 1929. The spare, geometric formality of Garretto's style and his success in working in color synchronized with both the Bauhaus-inspired layout that Dr. Agha had introduced and the new strategy for using color caricature. When Clare Boothe Brokaw did not receive an immediate response to her October 1930 letter, she persisted. The editors were "indeed anxious" to see his work, she wrote him in December, and hoped to use it in a forthcoming issue. Finally, Garretto set sail for New York to meet with *Vanity Fair*'s editors. He always remembered the association fondly: "I never had the slightest problem with them," he wrote of the staff in later life. He considered Agha a close friend, Crowninshield very kind, and Brokaw and fellow editor Helen Lawrenson "beautiful, bright and intelligent."[30] From that point on Garretto came regularly to New York, often staying for two or three months at a time. In addition to his contributions to Condé Nast, he continued to work for *Fortune*, supplied pictures to the *New Yorker* and *Harper's Bazar*, and sold designs to such advertising agencies as J. Walter Thompson and N. W. Ayer. Above all, his frequent caricatures for *Vanity Fair* secured his reputation.

Garretto's image of Herbert Hoover in the April

1931 issue was the first caricature to be placed as a frontispiece after the table of contents. (Cotton's pastels would thereafter make a regular appearance in this position.) The bloated face of dull gray skin, tinted with a sickening hue of greenish yellow, floated like a helium-inflated monster on an ominous dark ground. Ballooning bulges of flesh engulfed the facial features. The nightmarish distortion, sharp-edged precision, dissonant color, and polished smoothness of the airbrushed surface were all fresh additions to the caricaturist's arsenal. Visually compelling, they also created an unsettling sense of psychological tension and irresolution. This added a political edge that was just as new as the airbrushed tint.

The updated *Vanity Fair* wanted to exploit Garretto's cosmopolitan experience as well as his sophisticated European style. Expanding the magazine's outlook with international celebrities, he drew "strong men of the old world" for the July 1931 issue; "royal playboys" for August; "world financiers" for December. The first of these was a page of six dissimilar leaders: Stalin of Russia, Mussolini of Italy, Pilsudski of Poland, Briand of France, Hitler of Germany, and Gandhi of India (fig. 9.16). "Their methods are different," the accompanying article notes, "but their goals are the same. Charlatan, poseur, saint, tyrant, sabre-rattler—each is fighting for what his people needs most, whether it is independence, power, wealth or glory." Like a page of Covarrubias pen portraits, the six geometric constructions merge into an entertaining display of clever design. Although the article attempts to distinguish between the subjects, there is little political differentiation in the portraits themselves. The theme of the page is not the political power of these individuals but the international fame resulting from it. Although the choice of subjects fitted the magazine's new preoccupation with global issues and figures, the new assortment lacked the cohesion of the 1920s café society mix. Readers had been used to a spicy amalgam of playwrights, actors, and quipsters, with the Prince of Wales and Babe Ruth thrown in for good measure. Pilsudsky and Briand could never evoke the personality, wit, and glamour that had animated previous caricature pages. Nor could subscribers ever have the same sense of intimate connection with world "strong men" that they felt for Manhattan "first nighters."

Nonetheless, Garretto's caricatures, constructed with such compelling ingenuity, had an immediate impact

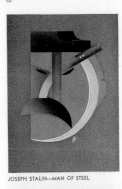

JOSEPH STALIN—MAN OF STEEL

"HANDSOME ADOLPH" HITLER

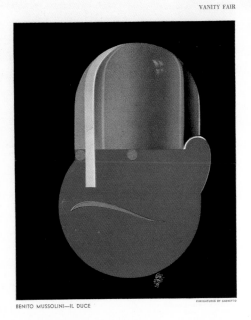

BENITO MUSSOLINI—IL DUCE

CARICATURES BY GARRETTO

Strong men of the old world

MARSHAL JOSEF PILSUDSKI

HOLY MAN GANDHI

ARISTIDE BRIAND—PRINCE OF PEACE

9.17 *John Pershing* (1860–1948) by Paolo Garretto. Collage with airbrushed gouache, colored pencil, and lithographic crayon on paper, 31 x 22.8 cm (12³/₁₆ x 9 in.), 1931. Original illustration for *Vanity Fair*, February 1932. National Portrait Gallery, Smithsonian Institution, Washington, D.C.

9.16 *Strong Men of the Old World* by Paolo Garretto. Printed illustration. Published in *Vanity Fair*, July 1931. Library of the National Portrait Gallery and the National Museum of American Art, Smithsonian Institution, Washington, D.C.

in the magazine. The keen-edged geometric shapes and inventive colors of his images attracted the eye with posterlike insistence. Read as simplified iconic forms, the images belie a subtlety immediately apparent in the original drawings. Garretto's John Pershing (fig. 9.17), for instance, published with three other "peace-time warriors" in February 1932, can be divided at a glance into the distinctive components that crystallize the image: crisp military cap, bright yellow nose, stern frown, strong chin. The drawing, however, reveals the numerous small details that help to achieve the effect of simplicity. The reflection of light on the

brim of the cap, achieved with airbrushed tone beautifully modulating from black to white, projects it forward. Thin lines of white define the edges of the brim while smudges of dark charcoal shade it just beneath, imparting the merest suggestion of an eye. The nose also protrudes outward by means of a brilliant and incongruous splotch of yellow which fades magically into the tan skin tones. Delicate touches of white gouache, charcoal, and airbrushed tint suggest a mustache, a sideburn, a jutting jaw. The subtle highlighting and shading give the flat, geometric shapes depth and structure. Instead of implying the three-dimensionality

Art Deco Color in Vanity Fair 229

9.18 *Don Budge* (born 1915) by Paolo Garretto. Collage, air-brushed watercolor, gouache, pastel, and pencil on paper, 35.6 x 25.6 cm (14 x 10 in.), c. 1935–40. National Portrait Gallery, Smithsonian Institution, Washington, D.C.

of the human head, however, they convey the sense of a shallow-relief construction or collage that refuses to lie flat on the page or be ignored.

All of Garretto's distinctive strengths—his witty ingenuity, Art Deco styling, inventive color sense, and repertoire of international faces—qualified him as a perfect cover artist for *Vanity Fair*. In November 1931 one of his many caricatures of Gandhi appeared on the cover. From that point on he contributed three, four, or five covers a year, most of them caricatures. Since Condé Nast himself took an obsessive interest in cover art, the prominence of caricature is significant. Detailed memos flowed from his office with his analyses of *Vogue*'s covers—their color, content, and "poster value" —in relationship to newsstand sales. "I have always

advocated that a cover should serve as an eloquent barker in behalf of the show that goes on within the pages of the magazine," he once wrote to Crownin-shield.[31] At the same time that caricature proliferated on the cover of *Vanity Fair*, color photographs began to dominate the front of *Vogue*. Both were calculated moves, reflecting the careful redefinition of each magazine.

Other New York publishers had also discovered Garretto's potential as a cover artist. In his caricature of tennis star Don Budge, created as a mock-up for the cover of an unidentified book or journal, splatters of paint emerge as freckles and flamelike tongues of red convey the unruly hair (fig. 9.18). The gaunt, worried face with the poke-out ears is humorously at odds with the young athlete's dazzling mastery of the courts, suggested by the severe lines behind him. Garretto depicts his youth and indecision, his reputation supplies his record-breaking competence, and the incongruence made for eye-catching cover art.

Adapting to the editorial emphasis on personality, Garretto depicted New York's own colorful politicians in two of *Vanity Fair*'s most animated caricatures. In the October 1934 issue his drawing of Al Smith (fig. 9.19)—four-term governor, progressive reformer, and one-time presidential contender—evoked the "Happy Warrior" of the campaign trail. Rather than critique his accomplishments, Garretto captures his flamboyant character with a Jimmy Durante–sized nose, sharklike mouth, yellow sweat stain of the armpit, and outrageous green polka-dot tie. Smith's patriotic red, white, and blue heart, clashing gaily with the brilliant turquoise background, and his gleeful, theatrical gesture suggest a magnanimous figure. The skyscrapers of the city rock in joyous response. Garretto's depiction has no relation to Smith's political fortunes within the Democratic Party, which were declining at the time into a rancorous feud with Franklin Roosevelt. Instead, it celebrates New York's own son and his distinctive contributions to national political life.

Garretto also depicted the high-profile New York mayor Fiorello La Guardia for *Vanity Fair* in August 1934. The stocky, combative former congressman was a political dynamo who had begun his legendary mayoral career the previous January. Battling to balance the budget, overturn Tammany patronage, and clean up municipal corruption, he lashed out at his opponents, using dramatic radio addresses to build support. The

9.19 *Al Smith* (1873–1944) by Paolo Garretto. Collage with airbrushed gouache and pencil on paper, 28.3 x 24 cm (11 1/8 x 9 7/16 in.), 1934. Original illustration for *Vanity Fair*, October 1934. National Portrait Gallery, Smithsonian Institution, Washington, D.C.

9.20 *Fiorello La Guardia* (1882–1947) by Paolo Garretto. Collage with airbrushed watercolor and gouache with pencil on board, 29.2 x 22.5 cm (11 1/2 x 8 7/8 in.), 1934. Original illustration for *Vanity Fair*, August 1934. National Portrait Gallery, Smithsonian Institution, Washington, D.C..

July speech reviewing his first six months in office was broadcast nationwide. Garretto's August caricature for *Vanity Fair* interpreted this forceful character as a Napoleon in command of the microphone (fig. 9.20). The historical allusion, low viewpoint, and squat shape simultaneously suggest both his stature and his oversized, pugnacious character.

Garretto constructed his *La Guardia* as a collage of folded paper, placing it against an intense, modulating red background. He glued a wisp of cotton at the top for clouds and drew the image of City Hall at the bottom. La Guardia's folded hat stands off the page, while the two feet and the cuff of the sleeve cast minute shadows as they curve slightly away from the background. *Vanity Fair* reproduced all these subtleties with remarkable fidelity. The glorious color appears on the printed page with nearly the same intensity as the original. As in many Cotton pastels, the strong background hue enlivens rather than overwhelms the figure, suggesting La Guardia's own forceful energy and will. The fiery red sky, isolated City Hall building, and earthy mound on which La Guardia stands conjure up a surrealistic urban landscape. Gone are the towering buildings that existed before and will remain after the next mayoral election. In this dreamlike world, a second-generation Napoleon has, for the moment, complete dominance over City Hall and his patch of earth.

Garretto's floating heads can have similar surrealistic overtones. His witty conflation of violin and violinist in the depiction of Fritz Kreisler (see fig. 1.28), published on a page of musicians in March 1934, has an internal logic missing in much surrealist art. But the one-eyed, anthropomorphic violin, drawn on a piece of wood veneer and bobbing weightlessly on a brilliant blue ground, evokes the powerful effects that music could have on the subconscious. Garretto hints at the strong visual imagery and sense of fusion between musician and instrument that performance can summon in the imagination. Although Garretto exploited incongruous juxtapositions, intensity of color, and tricks of the subconscious, he only hints at the psychological confusion and unease that often permeate surrealist art. In the Kreisler image the comic conflation works remarkably well—it looks uncannily like the man—and the color is so beautifully rendered that its unnatural strangeness seems smart and clever. Humor and celebrity resolve the tension of incongruity. Garretto had adapted to the *Vanity Fair* buoyancy of spirit, still intact in the hands of its caricaturists.

After *Vanity Fair* merged into *Vogue* in 1936, Garretto continued to work for other American magazines. But his early flirtation with fascism haunted him as war approached. *Vanity Fair's* 1934 biographical note about him, entitled "Fascist Artist," came to the attention of the editors and art director of *Harper's Bazar* five years later, and they immediately canceled his contract to do twelve monthly covers for 1940. Visa problems, arrest as an Italian journalist, and deportation back to Europe were only part of his dramatic wartime story. His fascist affiliation made him suspect, but when he returned to Italy he was out favor for his caricatures of Hitler and Mussolini and his antiwar writing. Refusing to produce war propaganda, he contrived instead to produce language-training films and was sent to Budapest. He balked at signing allegiance papers to the "new Fascist" regime and was imprisoned for nine months. Evacuated by the Germans, deported back to Italy, and finally freed through the help of friends, he and his wife remained suspect citizens at home and enemies when out of the country.[32]

After the war Garretto moved back to Paris and began to reestablish his career. In 1946 he returned to the United States to renew his contacts. Although he did some advertising work, he found the magazines less receptive to his drawings. He recalled his 1951 *Vogue* illustrations of *South Pacific* as his last serious appearance in the American press. Returning again to France (and eventually moving to Monaco), he spent the rest of his career working for French and Italian "low-circulation, low-paying magazines." Although he continued doing caricatures, his images of more contemporary subjects were no longer in the vanguard of design and humor—"quite out of sync with the times," in the opinion of one critic. But Garretto had introduced an invigorating Art Deco style to caricature that lent a cosmopolitan relevance and a revived sense of modernity. Working simultaneously in advertising and commercial design, he aligned the caricature portrait more closely to other graphic forms, broadening its frame of reference.[33]

Miguel Covarrubias, the third member of *Vanity Fair's* 1930s artistic team, added his own distinctive contributions to the evolution of color caricature. Although, along with Frueh and Barton, he had always exploited the most publicized aspects of each individual's fame, he now explored more explicitly the manipulation of the celebrity image and the ludicrous

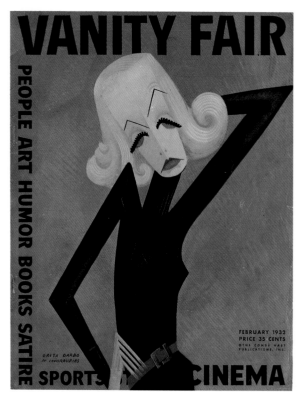

9.21 *Greta Garbo* (1905–90) by Miguel Covarrubias. Printed cover illustration for *Vanity Fair*, February 1932. Library of the National Portrait Gallery and the National Museum of American Art, Smithsonian Institution, Washington, D.C.

of heavily lidded eyes, and the disapproval of a pouting mouth, imparting the requisite aura of remoteness.

Within the magazine, Clare Boothe Brokaw's article on Garbo uses similar imagery and sly humor. The actress was a great beauty, Brokaw wrote with catty irony, because, with her too large, often sullen mouth, thin shoulders, and limp, "dun-colored" hair, she escaped chilling perfection. Only her eyes, Brokaw felt, "slumberous beneath the gloom of her lashes . . . approach perfection, and even they are marred by shaved eyebrows, which have been replaced by inane, pencilled hieroglyphics, springing upward like the antennae of a butterfly." Like Covarrubias, the author used a satirical tone to manipulate the celebrity image. Even Garbo's famed beauty could be twisted into a mockery of Hollywood fame. Brokaw based her judgment of "The great Garbo"—she intentionally used the lowercase letter in her title—largely on the actress's handling of publicity and image. Garbo, she felt, had the potential to be a historic beauty, a Helen of the age, but would ultimately fade from memory because she had not had a public love affair with a powerful man and because she had avoided the "tawdry publicity, the spot-light madness, the vulgar exhibitionism of Hollywood." The star system was shabby, in other words, but Garbo deserved the ultimate doom—obscurity—for defying it.[34]

Covarrubias, no longer the shy eighteen-year-old meeting prominent New Yorkers, exposed the celebrity system with equal deftness. He and writer Corey Ford used the mockery of modern fame as the theme for *Vanity Fair*'s most famous and popular caricature series, the "Impossible Interview." The comic chat between two opposite personalities probed obvious differences to reveal an underlying commonality. In their first example, published in December 1931, they paired the colorful, much-married American evangelist Aimée Semple McPherson with the Indian passive resistance advocate Mahatma Gandhi. Her arm aloft in exhortation, McPherson has the upper hand in more ways than one. She does all the talking, dispensing advice and suggestions on how to promote both their careers. "Appeal," she points out to Gandhi, is what you need to "put over your act in America." She suggests that they combine forces: he could preach like her, she could dress like him (in a loincloth), and they could "stack 'em in the aisles."[35] McPherson's theme is fame, American style—how to compete for it and how to

extremes of publicity and promotion. He had been traveling for several months in 1931, but by autumn he had reappeared as the cover artist for the October issue with a portrait of Herbert Hoover. He was soon back in the fold, providing frequent covers and regular caricature portraits for the magazine.

In his February 1932 *Vanity Fair* cover of Greta Garbo, brilliant color attracts the eye and heightens the characterization (fig. 9.21). He silhouettes the laconic, black-clad figure against a vibrant red ground that radiates energy. Bristling corners of knuckles, elbows, and breast stand out in sharp relief. Touches of the same red in the lipstick, nail polish, and belt allude to her effortless glamour. Covarrubias's keen sense of geometric patterning, however, remains. The downward facing arcs and angles of her features create the skepticism of a penciled, raised eyebrow, the boredom

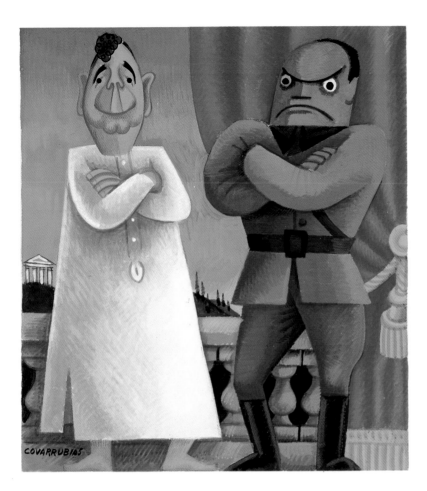

9.22 *Huey Long and Benito Mussolini* (1893–1935; 1883–1945) by Miguel Covarrubias. Gouache on paper, 27.9 x 35.7 cm (11 x 14 in.), 1932. Original illustration for *Vanity Fair*, March 1932. Art Collection, Harry Ransom Humanities Research Center, The University of Texas at Austin.

maintain it. Under the glare of that spotlight madness all the famous shine alike, and any differences in profession, nationality, class, moral sensibility, or intellect fade.

The brash newcomer, in these cleverly written episodes, always dominates the more established or powerful figure: Americans appropriate and reinvent the ideas of foreigners, popular culture outclasses high art, charlatans score points on revered intellectuals. In January 1932, Albert Einstein consulted popular astrologer Evangeline Adams. In February, Howard Chandler Christy advised Pablo Picasso to paint round legs on his girls instead of square ones to improve his sales in America. In March, populist governor Huey Long tried to persuade Mussolini to change his black shirt to a Ku Klux Klan nightshirt (made of southern cotton) and establish pot-likker as the national drink of Italy (fig. 9.22). And in April, John D. Rockefeller, Sr.,

delights in his discovery that Stalin's communist Five-Year Plan has the same effect on the people—character-building deprivation—as his own capitalist approach.

Covarrubias's accompanying drawings in watercolor and gouache complement the interviews with a hilariously contrasting pair of figures. Even before one reads the caption, the comic juxtaposition of two familiar characters is instantly recognized, and Covarrubias's geometric stylizations, extensive repertoire of graphic patterns and shapes, and use of color combine to create his humorous contrasts. "Impossible Interviews—No. 6," published in May 1932, shows two famous nonconversationalists, Greta Garbo and Calvin Coolidge, ensconced on a couch, with a picture of the sphinx hanging on the wall behind (fig. 9.23). Covarrubias repeats his well-honed faces of each of them and adds ridiculously contrasting bodies. She, clothed in elegant

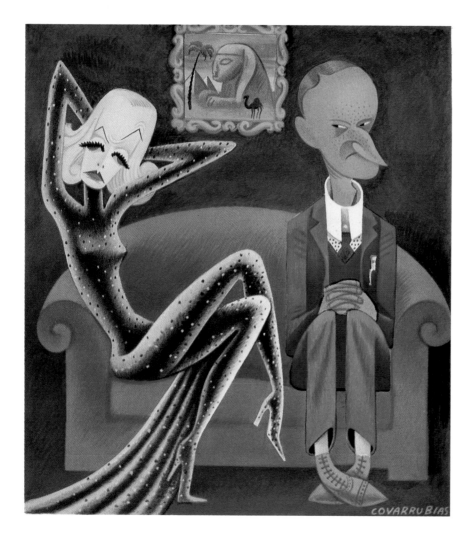

9.23 *Greta Garbo and Calvin Coolidge* (1905–90; 1872–1933) by Miguel Covarrubias. Printed illustration. Published in *Vanity Fair*, May 1932. Library of the National Portrait Gallery and the National Museum of American Art, Smithsonian Institution, Washington, D.C.

monochromatic tones, lounges sensuously, while he, dressed in overly bright blue and green, sits woodenly in the opposite corner. Her flowing dress is skintight; his stiff-collared shirt hangs loosely around the neck. The details reveal similarities as well: the angle of her breast and his adam's apple, the polka-dots on their clothes, the contorted feet. But the real pictorial commonality that unites them, of course, is the familiarity of their famous faces.

Like Garretto, Covarrubias incorporated aspects of modernism into his caricatures in such a way that they seemed exciting and contemporary while remaining completely unthreatening. Advertisers of this period, Roland Marchand has pointed out, adopted the delib-

erate discontinuities of modern art in search of a dynamic impact.[36] Similarly, the contrasts employed by Covarrubias and Corey Ford create a tension—in this case humorous—that is then resolved by the comfortable association with celebrity. The intentional disequilibrium that such techniques as fragmentation, geometric stylization, and harsh color juxtapositions created in modern works of art were here moderated by wit and resolution. No matter how jarring the colors or abstract the features, the audience could recognize the faces and celebrity character traits. Because the images were so accessible, what might have seemed ugly, baffling, or illogical in a cubist, futurist, or surrealist painting became stylish, obvious, and funny.

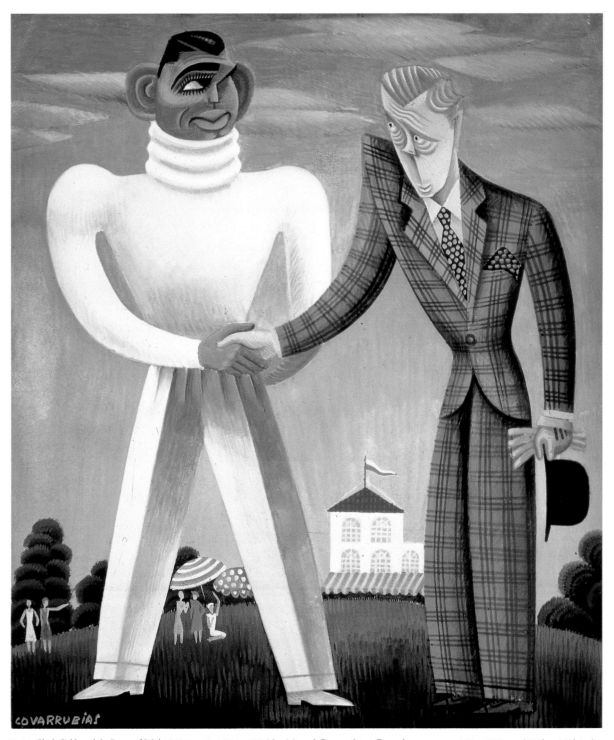

9.24 *Clark Gable and the Prince of Wales* (1901–60; 1894–1972) by Miguel Covarrubias. Gouache on paper, 35.2 x 28.9 cm (13⁷/₈ x 11³/₈ in.), 1932. Original illustration for *Vanity Fair*, November 1932. Art Collection, Harry Ransom Humanities Research Center, The University of Texas at Austin.

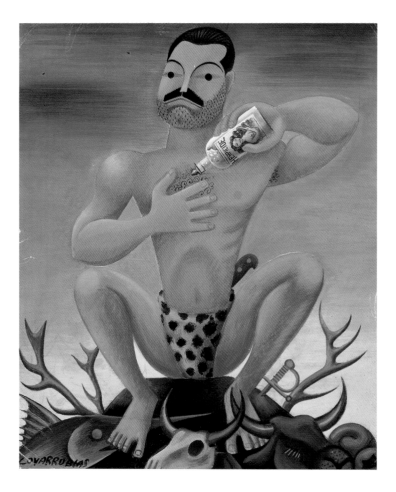

9.25 *Ernest Hemingway* (1899–1961) by Miguel Covarrubias. Gouache on paper, 30.5 x 25.4 cm (12 x 10 in.), 1933. Prints and Photographs Division, Library of Congress, Washington, D.C.

Instead of being on the outside, excluded from an elite that could understand impenetrable abstraction, the viewer was on the inside, included in a mass audience that possessed the requisite celebrity information.

In May 1932, just six months after it began, Covarrubias's series received the ultimate measure of popular recognition: appropriation into advertising. The announcement of the "new Nash" automobile in the pages of *Vanity Fair* that month bore the title "Possible Interviews No. 1001." On the top half of the page, two caricatured heads, identified below as first and second motorist, discussed the new model. Their lengthy, turgid conversation noted all the impressive features of the car, down to the "Bohnalite aluminum alloy pistons." Lacking Covarrubias's aesthetic finesse, the instant impact of celebrity recognition, and the clever repartee, the ad has very little appeal. But the

name alone, the advertiser assumed, would attract sufficient attention to be successful.

Twenty interviews followed in quick succession in the pages of *Vanity Fair*. Mobster Al Capone chatted with Chief Justice Charles Evans Hughes in October 1932 (see fig. 1.25). The picture presents a feast of contrasts: judicial black robes versus loud plaids, lace jabot versus diamond stick pin, two bushy white eyebrows versus a continuous dark one. Completely undifferentiated, however, are their respective positions of power as they peer through prison bars at each other. Indeed the unrepentant Mafia chief with an amused smile seems to have the dominant place in the picture. "Ain't my gang," he points out, "the real Government of the U. S. A.?"

The following month Covarrubias and Corey Ford peer at the theme of love through their own distorted glass, as the Prince of Wales, the English "heartbreaker

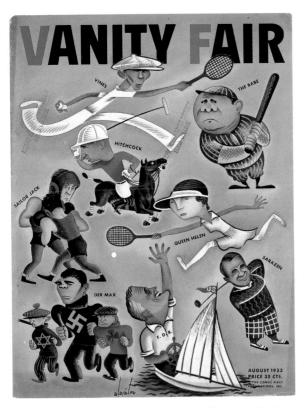

9.26 *Franklin Delano Roosevelt* (1882–1945) by Constantin Alajalov. Printed cover illustration, *Vanity Fair*, August 1933. Library of the National Portrait Gallery and the National Museum of American Art, Smithsonian Institution, Washington, D.C.

9.27 *Franklin Delano Roosevelt and Others* (1882–1945) by unidentified artist. Printed cover illustration, *Vanity Fair*, March 1934. Library of the National Portrait Gallery and the National Museum of American Art, Smithsonian Institution, Washington, D.C.

of the world," relinquishes his post to Clark Gable, his American successor (fig. 9.24). The suntanned Hollywood star confronts the anglo-pink prince in an entertaining study of American strength versus British weakness: muscular masculinity versus a concave physique; heavy, sensual lips versus a tiny, pursed mouth; two famous, large ears versus a thin sliver of one. Gable suggests machine-made newness and durability from the tubular forms of his turtleneck to the knife-sharp pleats of his trousers, while the prince cringes with human vulnerability. The ugly, assertive face of the American star exudes a powerful magnetism, while Edward's handsome features shrivel into infantile wrinkles. But the caption focuses on their shared fate as the relieved prince points out that popularity such as theirs is short-lived and unenviable. In the end, the anonymous reader prevails over both glamorous celebrity figures,

recognizing the shallow insubstantiality of their fame.

After twenty "Impossible Interviews" (see also figs. 1.26, 1.27), Covarrubias dropped the series to pursue an idea entitled "The Private Lives of the Great," which began in October 1933. His lampoon of Emily Post with her feet up on the table (see fig 1.1) proved the potential of the premise that the private lives of the famous were no more than a comic subversion of their public celebrity. In his parody of Ernest Hemingway's machismo style, however, Covarrubias pushed Crowninshield too far (fig. 9.25). The drawing was inspired by the author's well-publicized argument with Max Eastman, who had speculated in a review about Hemingway's confidence in his masculinity, noting "that small inward doubt" that led to "a literary style . . . of wearing false hair on the chest." Crowninshield felt that the bare-chested figure in a leopard skin loincloth

was in bad taste and declined to publish it. Covarrubias responded furiously, but Crowninshield refused to accept his resignation. Although he did not publish the drawing, he sent a placating letter. Clare Brokaw also wrote, calling him "*Vanity Fair's* brightest jewel."[37]

It was no mere flattery. Readers had objected to the loss of their beloved "Impossible Interviews." Letters beseeched the editors to start them again until finally, in December 1934, the humorous pairings reappeared. One reason for reviving the series, the editors explained the following February, was their shock at discovering that the interview format had been pirated in the Chinese *Shanghai Miscellany*. They were annoyed, they admitted, when the picture of Chiang Kai-shek and Mussolini was first brought to their attention, but, "on second thoughts we could not help feeling somewhat gratified that China should have thought enough of our thunders to steal them."[38] The series itself ironically was receiving the fame and publicity that it sought to lampoon, and the editors, struggling to keep the magazine afloat, hastened to build on its success.

With the contributions of these three artists and others, caricature had become a major element of *Vanity Fair*. The issue of January 1932, for example, is crammed with distorted portraits. Garretto's absurd vision of British Prime Minister Ramsay MacDonald, dressed half in tweeds and half in overalls, graced the cover. On page 20, the ferocious face of the U.S. ambassador to Great Britain, Charles Dawes, drawn by William Cotton, frightens the British lion peering over his shoulder. Two pages later, quick sketches by Covarrubias capture the easy grace of Spanish dancer Vicente Escudero. "Brass Ringers on the Washington Merry-Go-Round," by Aurelius Battaglia, satirizing the political world, is followed by an "Impossible Interview." Salvadoran-born artist Tono Salazar depicted four literary titans on one page, and Constantin Alajalov's little sketch of Senator Smith W. Brookhart accompanies a satiric "audit" on another. Finally, Douglas Fairbanks, Jr., an enthusiastic amateur, supplied a tiny caricature of Constance Bennett to accompany his reminiscence of her.

At least a dozen caricatures of President Franklin Delano Roosevelt alone appeared in *Vanity Fair* between September 1932 and May 1935, many of them cover portraits. Constantin Alajalov depicted the president as a sailor on his August 1933 cover, amid a group of renowned sports figures (fig. 9.26). On the March 1934 cover an outline of FDR's strong features stamped his

dominating personality on top of a composite cover of *Vanity Fair's* recent caricature victims (fig. 9.27). On the March, April, and May 1935 covers, Roosevelt was depicted as puppeteer manipulating the fight between big business and labor, as a ringmaster controlling performing animals from Wall Street, Tammany, and the two political parties, and as the moving force pushing the utilities over the helpless figure of private ownership.

The stylized outline of Roosevelt on top of a cover filled with other figures could be read as an image of personality, but many other images of the president addressed specific political issues. A confused response to this mixing of political cartoon with celebrity caricature continued to dog the editors. Theodore Sedgwick, rector of St. Paul's American Church in Rome, had been deeply offended by Covarrubias's October 1932 cover of Mussolini (fig. 9.28) and sent a shrill letter of complaint to New York. "It is not only bad taste, cheap, but excessively harmful to the spirit of accord which is slowly rising into new reality," he fumed. "Why, because you have a clever artist, allow yourself to wound the feelings of this nation?" The clergyman also deplored the October 1931 cover of President Hoover, which, he maintained, "fails of all common decency and ordinary respect, in so ridiculing the incumbent of our highest office. Am I alone," he wondered, "to feel the sense of shame?"[39]

Not alone, perhaps, but the editors were convinced that few subscribers would see opinion-swaying editorial comment in Covarrubias's humorous portrayals. The figure of Hoover (fig. 9.29) is squared off and lightweight, floating on the page, resembling more than anything else a cigarette butt: used, stale, and discarded. But it hardly seems a satiric political comment on the president's inability to handle the worst depression in American history; nor did the stern features and stiff salute of Mussolini seriously address the rising threat of fascism. Reprinting the letter on its January 1933 editorial page, *Vanity Fair's* editors attempted to explain their caricature policy.

> *The magazine regards a conspicuous caricature . . . as an acknowledgment of world importance, rather than as an insult, even if the portrait may seem, on the surface, to be uncomplimentary. Figures like Gandhi, Hindenburg, MacDonald, Hoover, and Roosevelt are given attention because of their great interest as personalities; not because Vanity Fair wishes to analyze or criticize their characters.*

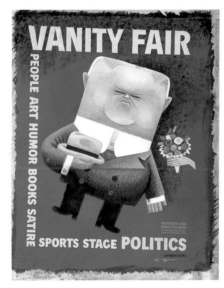

9.29 *Herbert Hoover* (1874–1964) by Miguel Covarrubias. Printed cover illustration, *Vanity Fair*, October 1931. Library of the National Portrait Gallery and the National Museum of American Art, Smithsonian Institution, Washington, D.C.

9.28 *Benito Mussolini* (1883–1945) by Miguel Covarrubias. Printed cover illustration, *Vanity Fair*, October 1932. Library of the National Portrait Gallery and the National Museum of American Art, Smithsonian Institution, Washington, D.C.

The magazine believes that the use of caricature is a legitimate and effective method of keeping readers closely in touch with the march of world events. We prefer caricatures of international figures to photographs of them simply because we seek some vivid interpretation; the artist's treatment may be unorthodox, but is not intended to be malicious.[40]

With the contents of the magazine offering increasingly serious political fare, the implication that these pictures of statesmen were merely personality studies seems disingenuous. As the occasional complaints suggest, *Vanity Fair*'s audience began looking for analytical, political content in its caricatures and would sometimes find the tone either too critical or not strong enough. In the 1920s, a caricature, even of a politician, carried the subtext of the subject's celebrity publicity. Calvin Coolidge's most famous character trait, for instance, was having no personality at all, and caricatures invariably played on Silent Cal's reputation. In the 1930s, the demeanor of a magnetic public figure like Fiorello La Guardia or Franklin Roosevelt still animated pictures of the mayor as Napoleon or the president as ringmaster. But Mussolini and Senator Borah were not perceived as entertainingly vivid characters, and the old formula did not work the same way.

One caricature in the magazine even caused a minor international incident. In August 1935 cartoonist William Gropper drew five caricatures for a page called "Not on your Tintype," which included an image of Emperor Hirohito carrying the Nobel Peace Prize on a

9.30 *Not on Your Tintype* by William Gropper. Printed illustration. Published in *Vanity Fair*, August 1935. Library of the National Portrait Gallery and the National Museum of American Art, Smithsonian Institution, Washington, D.C.

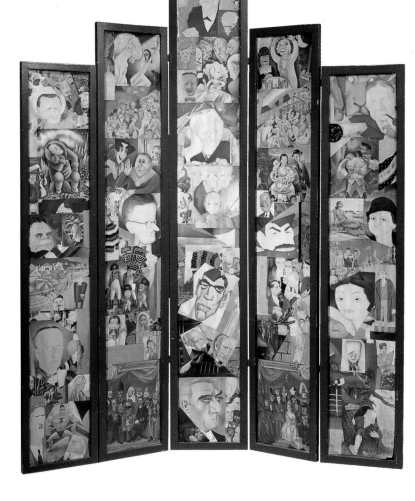

9.31 *Vanity Fair Caricature Screen* by various artists (assembled by Sally and Dave Forrest). Wood and paper, 189.9 x 152.4 cm (72 x 60 in.), c. 1935. Sally Sloan.

gun carriage (fig. 9.30). That issue of the magazine was immediately banned in Japan, and Ambassador Hiroshi Saito complained to Secretary of State Cordell Hull. When reporters caught up with Frank Crowninshield on the golf course, the editor protested that it was "innocent sort of stuff" and that J. P. Morgan and Admiral Byrd and others depicted on the page had not complained. Meeting with the ambassador's representative shortly afterward, Crowninshield learned that the affront was not so much the militaristic allusion as the depiction of the emperor doing a menial task. In a letter of apology to the ambassador, Crowninshield pointed out that the magazine had published the drawing "only as a piece of good-natured humor."[41] Gropper, a

powerful cartoonist capable of using grotesque distortions to connote human depravity, had, ironically, treated Hirohito relatively mildly. But the incident indicated that the meaning of celebrity caricature was beginning to mutate. What Crowninshield still saw as "innocent sort of stuff" was taking on new overtones.

In spite of the occasional complaints, caricature in the 1930s continued to be a high point of the magazine. The editors knew it—in January 1935 they promoted their next issue by announcing Cotton's frontispiece and Covarrubias's "Impossible Interview"—and so did subscribers. One enthusiast cut out her *Vanity Fair* caricatures to decorate a screen (fig. 9.31). Another reader wrote to the editors from Woodstock, New

York, to commend their caricature choices. He had been looking through issues from the mid-1920s, he told the editors, and was surprised to find the "shadows of statesmen, social figures, actors, authors, and a host of celebrities . . . spring back into reality" through the pictures and their humorous captions. Turning to the recent issue, of June 1933, he tried to read the serious, heavy articles that the "newer editorial policy is providing us" but found his eye sneaking over to the opposite page where, in full color, appeared a "glittering caricature of Secretary Woodin, pop-eyed and fantastic." He gave up the article to focus on the portrait by Will Cotton and then proceeded to caricatures by Covarrubias and Garretto, getting enough information from the captions to feel "in the know" and gaining more insight about the "Impossible Interview" depiction of four dictators than anything he had read about them. *Vanity Fair* should realize its importance as a magazine of comment, illustration, and satire, he felt, and "forgo the mission of trying to instruct and be profound." While the letter recognized the weakness of *Vanity Fair*'s editorial confusion, it summarized the usual audience response to its caricature. The pictorial content of the magazine captured for the writer the history of an epoch, the spirit of an age. He felt intimately connected to the "hard and restless sophistication which ruled the Coolidge era" and "in the know" when his immediate contemporaries were presented "in a blaze of color."[42]

Meanwhile, *Vanity Fair*'s advertising revenues had continued to decline, and Nast felt extreme pressure from his creditors. The once prosperously fat magazine had diminished markedly, and the editors searched for a solution. Clare Boothe Brokaw proposed purchasing the old title *Life* from the recently deceased humor publication and using it for a new magazine of photojournalism. Nast's hesitation gave her the opportunity to take the idea to her new husband, Henry R. Luce, who launched the famous and successful new *Life* in 1936. The editors discussed other proposals, but Nast responded only with newly stringent budgets rather than radical new concepts.[43] A small insert in the February 1936 issue tersely informed loyal readers that *Vanity Fair* would be merged into *Vogue* the following month. This was merely a polite fantasy. Scathingly dismissive of fashion, Crowninshield had a strained relationship with *Vogue*'s pragmatic, tough-minded editor, Edna Chase. Each thought the other's mission friv-

olous, and they had always competed intensely for talented editorial staff. Crowninshield, given the title editorial adviser to *Vogue*, was reduced to a relatively minor role, and although some of *Vanity Fair*'s caricaturists contributed to *Vogue*, few found as congenial a home in editor Chase's domain.

The causes for *Vanity Fair*'s demise were numerous and complex. As Caroline Seebohm has noted, other journals had begun to siphon off *Vanity Fair*'s core offerings as magazine publishing became increasingly specialized.[44] The publication of *Esquire* in 1933, for instance, trespassed on its domain of men's fashion and introduced full-page color cartoons. The *New Yorker*, after a shaky beginning, had taken the lead in mirroring the urbane spirit of the metropolis. Although it avoided expensive color printing, it evolved its own special-

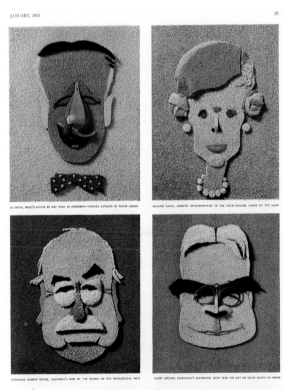

Bold soaks of the dry decade—sculptured in sponge

9.32 *Bold Soaks of the Dry Decade* (Al Smith, Pauline Sabin, Nicholas Murray Butler, and Albert Ritchie) by Frank Lemon. Printed illustration. Published in *Vanity Fair*, January 1933. Library of the National Portrait Gallery and the National Museum of American Art, Smithsonian Institution, Washington, D.C.

9.33 *Celebrated Faces of Our Time* by Frank Dunn. Printed illustration. Published in *Vanity Fair*, October 1935. Library of the National Portrait Gallery and the National Museum of American Art, Smithsonian Institution, Washington, D.C.

ized brand of modern humor. Its editors also proved acutely attuned to new literary styles, starting with the contributions of Harold Ross's Algonquin Round Table friends, who had once dominated *Vanity Fair*.

As Cynthia Ward has pointed out, *Vanity Fair* became outdated in part because many of the battles it had set out to wage were largely won. By the 1930s various types of modern art had gained wider acceptance (Crowninshield was one of the founders of the Museum of Modern Art in 1929). The popular entertainments and stars that *Vanity Fair* had championed had developed a mass audience through film and radio.[45] Since innovation in art, literature, music, and leisure pursuits no longer preoccupied New York's intellectual and social elite, no one really needed Crowninshield to point the way. *Vanity Fair* was in the vanguard no longer.

With so much caricature in the magazine, there had been, toward the end, a somewhat desperate search for novelty on the part of editors and artists alike. Portraits of anti-prohibitionists made from sponges was a new angle. Frank Lemon's illustration of the "Bold soaks of the dry decade" was published in January 1933 (fig. 9.32). The following April, Parisian artist Nikolaus Wahl's "Hollywooden celebrities" appeared, made out of planed and highly polished wood. Constantin Alajalov began a series of caricature paper dolls, starting with a September 1933 image of J. Pierpont Morgan garbed in dollar-sign-embellished undershorts and surrounded by such clothes as an office uniform and a pirate costume for fête days on his yacht. Alajalov's second doll depicted evangelist Aimée McPherson (by now Hutton) in her slip, Bible aloft, surrounded by such costumes and accoutrements

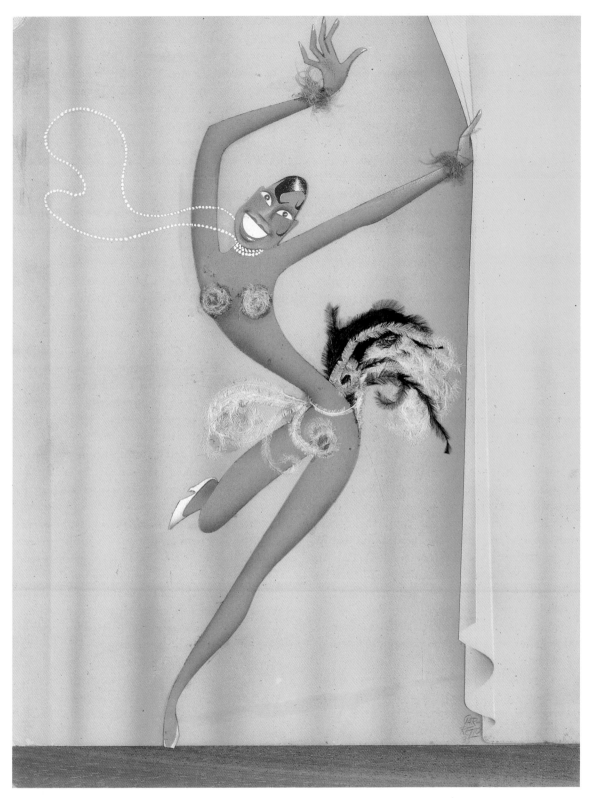

9.34 *Josephine Baker* (1893–1974) by Paolo Garretto. Collage with handpainted and airbrushed watercolor and gouache, crayon, colored pencil, wood veneer and feathers on yellow and brown wove paper, 31.5 x 24 cm (12 ³/₈ x 9 ⁷/₁₆ in.), 1935. Original illustration for *Vanity Fair*, February 1936. National Portrait Gallery, Smithsonian Institution, Washington, D.C.

as a baptismal font suite and a bed for chronic nuptials.[46]

All of these were amusing enough, but celebrities in their underwear clearly strained the limits of sophisticated humor and taste. Even *Vanity Fair* had to admit that the vogue was beginning to get out of hand. In introducing the minimalist sketches of Frank Dunn in October 1935 (fig. 9.33), the editors explained that the drawings contracted elaborate faces into single strokes of the pen which made them "something unique in the overdosed field of caricature."[47] The celebrities of the day had been distorted so relentlessly that everyone would have immediately recognized the pointed nose in the top row of the right-hand page as Calvin Coolidge, the square face beneath it as Herbert Hoover, the squiggled mustache to its right as Hitler. In January 1925, Al Frueh had published two pages of caricatures created out of stenography symbols with somewhat similar minimal results, but Dunn's images came ten caricature-packed years later. And without the wit, elegance, and sure draftsmanship of Frueh or Covarrubias, such presentations began to wear thin. The search for novelty eventually led to such preposterous extremes as an image of Haile Selassie created from a old brown shoe, with a shoehorn for the nose and a polishing brush for the beard.[48] This racist shoeshine boy image of the African emperor was not witty, only offensive. These were signs of decay in the ripening world of caricature.

But the Haile Selassie caricature, appearing in a tiny reproduction on the editorial page, was not featured as one of *Vanity Fair*'s own commissions. Cotton, Covarrubias, and Garretto were doing their best work for the magazine right up until the end. In the last, pitifully thin February 1936 issue of *Vanity Fair*, Garretto provided one of his most inspired creations. Blazing out at page twenty-eight is the beautiful full-length figure of Josephine Baker dancing sensuously against a bright yellow backdrop (fig. 9.34). In the original collage, the cut-out figure, dancing on a stage made of wood veneer, is dressed in thin threads of actual feathers, encircling the wrists as red and green bracelets and spiraling evocatively around breasts and buttocks as a black and white plumed costume. Garretto knew Josephine Baker and claimed to have introduced her to her husband, Pepito Abatino.[49] He had drawn her many times, but no other drawing evoked so well the famed beauty of her slim body, the athletic grace of her dancing, the exotic costumes, and the extraordinary vivacity of her stage presence. By using wood veneer, feathers, and cutout paper, Garretto established a shallow depth to the narrow stage and filled it with a compelling sense of movement that reminds one of his youthful friendships with the futurist artists in Rome. And, once again, the vibrating intensity of the yellow background serves an allusive purpose, conveying the personality that had established her, the caption states, as the "darling of the European intellectuals."[50] The irony of Garretto's illustration in *Vanity Fair*—that this great exemplar of sophisticated American popular entertainment had had to establish her career in France—was undoubtedly lost on both creator and audience. Sparkling with humor, color, and glamour, it was a dramatic farewell gesture for Nast's and Crowninshield's great, dying magazine.

Vanity Fair's color portraits of the 1930s exemplified a climactic moment in the history of celebrity caricature. Cotton, Garretto, and Covarrubias brought the genre into the mainstream of graphic design by exploring new uses of color, adopting Art Deco styles, suggesting the dynamism and psychological tension of modern art movements, and introducing a newly satiric approach to celebrity. Thanks to their fashionable covers and frontispieces, magazines of all types and newspapers around the country published nonpolitical caricature, art galleries organized exhibitions, and Hollywood beckoned. Amid all these measures of success, of course, lay the first signs that the trend had peaked, for lesser artists diminished the quality, and the boundaries between caricature and political satire started to blur. Nonetheless, even the war did not quash the genre. A final flowering of celebrity caricature survived almost to midcentury before satiric portraiture evolved into forms more suitable for the postwar era.

A Spicy and Clairvoyant Comment

The aim of a caricature is to heighten and intensify to the point of absurdity all the subject's most striking attributes . . . , the whole drawing imparting a spicy and clairvoyant comment upon the subject's peculiarities.
—Peggy Bacon

The caricatured after a while come to believe that they . . . constitute the real elite.
—Henry McBride

"They used to say that Americans didn't like satire, weren't up to it," mused the *New York Sun's* Henry McBride in 1928 after seeing an exhibition of caricatures by Peggy Bacon. "They said it took poise and a certain amount of age and experience to accept outside criticism gracefully, and that, in fact, America was too young for it. Well, apparently, we are fast acquiring the requisite years and experience. If Miss Bacon escapes alive from her exploit I should say that the fact is proved that we now possess poise." But if he felt that some sort of national maturation contributed to this aplomb, McBride also acknowledged a changed attitude toward the satiric portrait. No stranger to the victim's sensitivity—Bacon caricatured him three years later (fig. 10.1)—he admitted that the subjects of such treatment eventually realized the distinction conferred on them. "Indeed," he noted, "the caricatured after a while come to believe that they . . . constitute the real elite."[1] Buoyed by this perception, celebrity caricature thrived into the 1930s.

Peggy Bacon (1895–1987), who worked both in color and in black and white, had a sharper wit than most caricaturists. And the critical success of her several art gallery exhibitions, as well as a 1934 book of likenesses that critic William Murrell called an "artistic sensation," added considerable momentum to the caricature fad. Bacon was already an established artist and illustrator when she was lured to the field of caricature.[2] A student of John Sloan's and Kenneth Hayes Miller's at the Art Students League in the 1910s, she specialized in graphic art at the beginning of her career. Her etchings and illustrations, peopled with humorous figures, crackle with a wry, satiric tone and amusing distortions that anticipated her portraiture of specific individuals. In 1927, inspired by Will Cotton's caricatures, she began to draw color pastel portraits of members of her own art world circle. When she exhibited these images—starting with the Intimate Gallery's show of seven large drawings in 1928—critics were intrigued. Because her images ranged from gently mocking to grotesquely distorted, commentators differed in their analysis of her approach. But most ascribed to Bacon's work the universal qualities of art rather than the more ephemeral, time-bound characteristics of comics, cartoons, and magazine humor. McBride noticed the authority with which she imbued her drawings. Charles Demuth, who wrote the catalogue essay for the Intimate Gallery exhibit, felt that the pastels would "have a place in our history of painting" and could hang successfully alongside portraits by such painters as Cranach, Brueghel, and Sharaku.[3]

Bacon generally had a comic but compassionate view of humankind. Occasionally, however, her wicked wit gave a caustic, sometimes venomous edge to her characterizations. A few of Bacon's portraits offended viewers because of their hideous exaggerations. Her searing 1927 pastel of Louise Hellstrom (fig. 10.2) exemplified what Henry McBride called the "emotional school of caricature." The powerful but humorlessly ugly effects of the enlarged brown and pink lips and flaring nostrils were unusual in her work. McBride's own portrait revealed a more typical comic flair. Despite the air of startled perplexity and the unmanly presence of a dainty teacup, the critic remains a courtly, respectable figure. McBride himself thought he looked like a "broken-down actor" in the portrait but acknowledged that he "came out luckily from this affair."[4]

When Bacon exhibited seventeen pastel portraits at the Downtown Gallery in April and May 1931, the critics continued to debate whether her pictures had a

10.1 *Henry McBride*
(1867–1962) by Peggy Bacon.
Pastel on canvas, 60.9 x
52.4 cm (24 x 20¼ in.),
1931. Syracuse University
Art Collection, Syracuse,
New York.

vicious or an affectionately teasing impact. One
reviewer felt that the gentle medium of pastel had
been put to "quite ferocious uses," and another sug-
gested that Bacon was "too much of the humanitarian
to resort to fantastic flights of vitriolic fancy."
However they described her approach, most commen-
tators admired her skills. Holger Cahill considered her
the most talented of the contemporary caricaturists.
Paul Rosenfeld claimed that no one since Marius de
Zayas had displayed greater wit and penetration in
this highly civilized form of portraiture. On the basis
of this growing reputation she received a Guggenheim
fellowship in 1934 and was encouraged to use her

funds to draw humorous likenesses of other
Americans.[5]

Bacon's Guggenheim project resulted in a series of
caricatures of famous subjects, all drawn from life. The
artist habitually made several sketches at each sitting,
using charcoal, black crayon, or black pastel and jot-
ting down words and phrases to pinpoint her observa-
tions. In November 1934 she published a collection of
these images in a volume entitled *Off with Their Heads*,
and the Downtown Gallery opened another exhibi-
tion, featuring thirty-eight of the original drawings. By
this time Bacon had honed her skills into a delicate bal-
ance between satiric distortion and affectionate mock-

ery. The shrewd comments that accompanied each of her portraits in the book reinforced this equilibrium, both sharpening the satire and adding an occasional backhanded compliment. The words reveal the keenness of her observations and explain the meaning of her visual exaggerations. In no other caricature volume is the distorted line so well matched by commentary.

Audiences and critics loved the undeniable edge to her satire—the memorable noses, wrinkles, and unflattering phrases. One reviewer felt that the artist drew with a "jovial brutality" and wrote "strychnine-flavored" epithets. But with endearing self-mockery, Bacon disarmed her victims by saving the most wicked

impulses for her own self-portrait (fig. 10.3). The accompanying notes appraised her own looks and traits ruthlessly: "Pin-head, parsimoniously covered with thin dark hair, on a short, dumpy body. Small features, prominent nose, chipmunk teeth and no chin, conveying the sharp, weak look of a little rodent. Absent-minded eyes with a half-glimmer of observation. Prim, critical mouth and faint coloring. Personality lifeless, retiring, snippy, quietly egotistical. Lacks vigor and sparkle."[6]

Bacon mockingly reverses in this self-analysis all the qualities most admired by the celebrity press—a vigorous, athletic body; a sparkling, theatrical personality; and a grandly egotistical confidence and demeanor. But

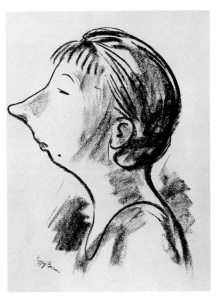

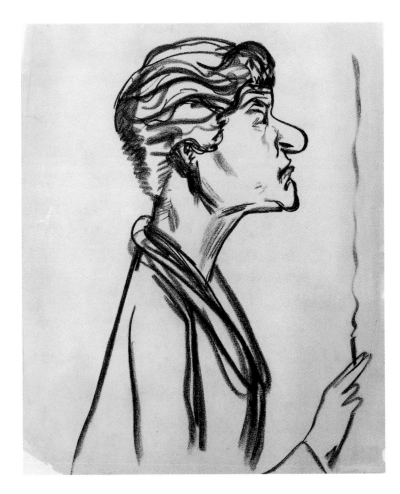

10.3 *Peggy Bacon* (1895–1987) by Peggy Bacon. Printed illustration. Published in Bacon, *Off with Their Heads* (New York, 1934). Prints and Photographs Division, Library of Congress, Washington, D.C.

10.4 *Juliana Force* (1876–1948) by Peggy Bacon. Black pastel on paper, 42.6 x 35.2 cm (16 13/16 x 13 7/8 in.), c. 1934. National Portrait Gallery, Smithsonian Institution, Washington, D.C.

although the cleverness of the commentary belies the weakness and primness she recounts, she does not hesitate to draw a devastating likeness of her own features, carefully matching each descriptive phrase with her merciless pencil.

Because of the extraordinary precision of her written and visual observations, Bacon could achieve her ends with a minimum of distortion. As critic William Murrell pointed out, Bacon exaggerates "by the very subtlest projections, withdrawals, and tightenings."[7] In one preliminary drawing of Juliana Force, the director of the Whitney Museum of Art (fig. 10.4), she captures with a thick, dashing stroke the characteristics she lists in her notes: "small menacing eyes that miss nothing. Nose of Cyrano de Bergerac, mouth like a circumflex accent. Figure erect, trim, magnetic, packed with audacity and challenge." In another preliminary sketch,

the elegant contours of writer Djuna Barnes (fig. 10.5) are no less satiric than Force's homely profile. Tilting the needle-sharp nose up and the fashionable hat down, Bacon created a pose of supercilious indifference.

In contrast, she envisioned her friend, the writer Dawn Powell, as a plump cartoon of the middle-class suburban matron (fig. 10.6), a figure more evocative of the author's fictional characters than of the free-spirited Greenwich Village novelist herself. Bacon's tart and knowing commentary, scrawled on the bottom of an early sketch, suggests the real personality: "Sturdy, robust body like Brueghel roisterer, dwindling abruptly to dainty extremities. Pert, alert features on heavy face foundation. Bright satirical shoe button eyes far apart; tiny but dashing, eyebrows darting off face. Neat witty mouth vivid crimson pursed with wistful corners. Turbulent black hair 'a la guillotine.' Expression of can-

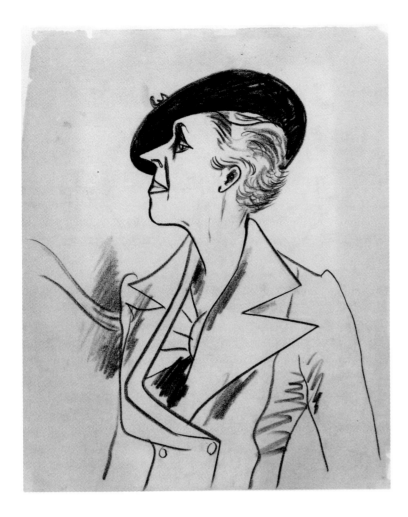

10.6 *Dawn Powell* (1897–1965) by Peggy Bacon. Black pastel on paper, 42.7 x 35.3 cm (16⅞ x 13⅞ in.), c. 1934. National Portrait Gallery, Smithsonian Institution, Washington, D.C.

10.5 *Djuna Barnes* (1892–1983) by Peggy Bacon. Black pastel on paper, 42.5 x 35.2 cm (16¾ x 13⅞ in.), c. 1934. National Portrait Gallery, Smithsonian Institution, Washington, D.C.

nie wood-beastie peeping through thicket. Really ribald sophisticate au natural. Orchids & daisies."[8]

Critic Paul Rosenfeld insisted that Bacon's approach was ironic rather than malicious. Bacon herself claimed that she simply drew as intensive a portrait as she could. The aim of a caricature, she wrote, "is to heighten and intensify to the point of absurdity all the subject's most striking attributes; a caricature should not necessarily stop at ridiculing the features but should include in its extravagant appraisal whatever of the figure may be needed to explain the personality, the whole drawing imparting a spicy and clairvoyant comment upon the subject's peculiarities."[9]

Bacon usually sweetened her spicy portrayal with the hint of a compliment—Force's magnetism and intelligent tenacity, for instance, Barnes's elegant stylishness, and Powell's sophisticated, ribald wit. Her portrait of

the alcoholic and periodically suicidal Dorothy Parker resonates with sympathetic insight (fig. 10.7). Parker, unlike her unusual-looking friends Woollcott, F. P. A., and Broun—all with faces from a caricaturist's dreams—had bland, pretty features that belied her sizzling wit and made her difficult to draw. With relatively little distortion—slightly disheveled hair, raised eyebrows, and bleary, bulging eyes—Bacon achieves a haunted look that hints at Parker's decadent behavior but also her alert intelligence and vulnerability. Rosenfeld acknowledged a keen, mocking insight in Bacon's work but also sensed a generous fund of sympathy. "There is no ugliness in Miss Bacon's conceptions," he concluded, "but much good nature, patience, humor, a little weariness, and something which in unguarded moments verges dangerously close upon tenderness."[10]

A Spicy and Clairvoyant Comment 251

10.7 *Dorothy Parker* (1893–1967) by Peggy Bacon. Black pastel on paper, 40.6 x 30.5 cm (16 x 12 in.), c. 1934. Original illustration for Bacon, *Off with Their Heads* (New York, 1934). National Portrait Gallery, Smithsonian Institution, Washington, D.C.

In the best traditions of satiric art, Bacon merged her sharp, penetrating observations with just the right degree of underlying humanity. The artist's little poem from her book *Cat-Calls* reveals the sympathy with which she peers beneath the facade. As the author, in the role of a cat, observes a smiling woman presenting her "thin, fastidious profile" to the world, she comments,

> I'd like to watch her when she sleeps
> or catch her unawares,
> for I divine the face she keeps
> beneath the face she wears,
> is but a rather furtive face,
> collapsible with cares.[11]

Bacon recognized each face as a disguise. Through her precise observations she forces us to acknowledge the mask her subjects wear in a vain attempt to obscure their frailties. Nonetheless, as the poem suggests, she sympathized with the need to conceal what Ralph Barton had called the "writhings of the soul."

After the success of *Off with Their Heads*, many magazines wanted to commission Bacon to draw caricatures. She published some portraits in the *New Yorker* and a few in *Stage* magazine. The *New Republic* featured a series of sketches in 1935, mostly made on a trip to Washington. Some people could not see the empathy beyond the devastating wit. When her *Off with Their Heads* drawings were exhibited in Washington in 1935,

a reviewer from the *Washington Star* found them "coarse," "vulgar," and "repulsive." Bacon hated to be misunderstood and disliked offending her subjects, and she quickly lost her taste for caricature. "I couldn't stand getting under people's skins," she explained in 1943. "The caricatures made them smart so."[12] She also chafed at not being able to choose her own subjects, finding that many of her assigned targets bored her and others refused to pose. Although she had gone beyond the art world in her book to include writers and editors (Sinclair Lewis, Carl Sandburg, Edmund Wilson), politicians (Franklin Delano Roosevelt, Fiorello La Guardia, Hugh Johnson), and theatrical figures (George Gershwin, Lillian Gish), she still gravitated to the vivacious celebrity circles covered by the New York media. Like other caricaturists, she found it more difficult to present witty characterizations of government appointees and other well-known but colorless subjects. Although she had a long and successful career as a painter and graphic artist, she ceased to draw caricature after 1935.

Bacon's foray into the field had an impact, however. Her success undoubtedly encouraged the trend for more gallery exhibitions of caricature in the 1930s. In 1938, for instance, the Downtown Gallery exhibited twenty-five small plaster caricature sculptures by Bacon's friend Isabella Howland. Working from memory and giving each sculpture an abstract title, Howland envisioned La Guardia as "Dynamo," Thomas Dewey as "Dynamite," and John Marin as "Wit."[13] Cotton, Covarrubias, Fruhauf, Birnbaum, Hirschfeld, and others also showed their work in the commercial galleries in the 1930s.

An increasing presence in the art galleries, accompanied by critical commentary, indicated a change of status for caricature since the turn of the century. Ever since Stieglitz's first shows of drawings by De Zayas and Frueh, caricature had been crossing back and forth over traditional boundaries separating the fine and minor arts. Like posters and illustrations, satiric art boasted new aesthetic standards that appealed to critics, collectors, and gallery owners. In addition, as Michele Bogart has explored, those once strict borders between commercial, industrial, popular, and fine art activities blurred and readjusted during this period.[14] Shifting definitions of art opened the door for serious appraisal of excellence in any field. Popular entertainment went through a similar transformation, gaining a

new legitimacy. Gilbert Seldes celebrated the best qualities of films, comic strips, vaudeville, jazz, and Tin Pan Alley in his book *The Seven Lively Arts.* In *Vanity Fair,* Frank Crowninshield promoted popular entertainment as an invigorating influence on higher cultural forms. Caricature reflected that irreverent urban vitality that artists sought as they turned to the popular arts for inspiration.

But if caricature benefited from this new appreciation for popular culture, it also intersected with the traditional fine art world in several critical ways. The art audience of the time, for instance, appreciated the witty and fantastical for its own sake, recognizing the mischievous fun in the work of many artists, from Picasso to Calder. Furthermore, these portraits related in formal, stylistic ways to the figural distortion of much 1930s easel painting, mural art, and printmaking. Although fine artists often applied distortion with more satiric or expressive intent, they used similar techniques of exaggeration and abbreviation. All these trends would change after World War II, when the

10.8 *Al Hirschfeld* (born 1903) by Don Freeman. Lithograph, 22.8 x 17.8 cm (9 x 7 in.), 1940. Published in *Newsstand* (New York), January 1940. National Portrait Gallery, Smithsonian Institution, Washington, D.C.; gift of Lydia Freeman.

"ideological borders" of fine art grew more rigid, as Bogart has pointed out.[15] Both fun and funny elements became highly suspect as darker humor came into vogue and a new avant-garde ignored figural representation in an embrace of abstraction.

But in the interwar period, caricature's new legitimacy as art offset some of the economic reverses of the publishing world. Even as the Depression deepened and many publications cut back on illustrations or switched to color, another caricature artist launched a remarkable career as a black and white portraitist. Theater fans perusing the January 1940 issue of *Newsstand* magazine may not have recognized the face of the bearded artist sketching comfortably in a barber's chair (fig. 10.8), but his elegant caricatures had become well known to the readers of the newspapers' Sunday drama sections. Don Freeman, publisher of *Newsstand* and artist of the lithograph, identified his subject as Al Hirschfeld, "caricaturist, traveler, collector of masks and sculpture, hot record connoisseur, intense enjoyer of life, humorist, keeper of open house to multifarious friends, lithographer, and drum beater." By the time the image appeared, Hirschfeld's name was established in the theatrical and newspaper worlds.

Born in St. Louis in 1903, Hirschfeld moved with his family to New York when he was twelve.[16] Although he briefly attended the Art Students League and the National Academy of Design, his youthful career in New York's motion picture industry may have had an equal impact on his artistic sensibilities. By the age of eighteen, Hirschfeld was an art director for film producer Louis Selznick, having already worked for Goldwyn and Universal Studios. His friendship with Miguel Covarrubias, whom he met in 1923, would also influence his career. The two young artists shared a studio and many common interests, including a fascination with Harlem, the theater, and foreign travel. Hirschfeld's career began with a concentration on sculpture, painting, and lithography. In 1924 he left to study art in Paris, and for the next several years he traveled extensively. Encouraged by Covarrubias, he spent nearly a year in Bali, where, he claimed, the color-bleaching sun reinforced his interest in pure line.

Returning periodically to his native land "to get a fresh shirt," as he explained it, Hirschfeld began to publish caricature drawings. On one of his return visits he and his friend, press agent Dick Maney, went to the theater to see the French actor Sacha Guitry. Intrigued by the likeness of Guitry that Hirschfeld had doodled on the program, Maney submitted a redrawn version to the *New York Herald Tribune*. Its appearance on December 26, 1926, started Hirschfeld's newspaper career and began a twenty-year association with the paper that included a stint as theater correspondent in Moscow for the 1927–28 season.[17] Gradually Hirschfeld began to publish in the *World*, the *Brooklyn Eagle*, the *Daily Telegraph*. His legendary affiliation with the *New York Times* began slowly after the appearance of his drawing of the Scottish vaudevillian Harry Lauder, on January 22, 1928 (fig. 10.9). In the beginning he received commissions by terse telegram from the *Times* drama editor, Sam Zolotow. But a couple of years later, when he finally met Zolotow, he started contributing his theatrical images on a regular basis. By the early 1930s, propelled by a keen interest in people, the urban milieu, and the theater, Hirschfeld had purchased his comfortable secondhand barber's chair and settled down to devote himself to caricature. "It would never occur to me to do a drawing of the Grand Canyon," he has admitted in explaining his preference for portraiture. "It is just a decayed molar under a very dramatic light."[18]

Absorbing the techniques of fellow artists, Hirschfeld searched for his own distinctive style. From Covarrubias he adapted a strong sense of graphic patterning, a three-dimensional solidity, and geometric abstraction. Like Al Frueh, he often employed a loose, graceful, swinging line, relying on characteristic full-figure poses to achieve a likeness. Like Ralph Barton, he embellished his drawings with careful detailing and an unusual complexity of line. Melding these influences with his own sure draftsmanship and ability to capture a likeness, he began to develop a distinctive approach. From the beginning Hirschfeld specialized in the theater. He taught himself how to draft his figures in the dark, and he claimed that he could even draw in his pocket if circumstances required. To assist his memory he added verbal notations to his working sketches: "fried egg" would remind him of an wide-open eye, "fricassee chicken" would recall a particularly skinny arm. In the studio he redrew his image, refining it for publication.[19]

By the 1930s, Hirschfeld's distinguishing characteristics had emerged. His 1935 caricature of the Marx Brothers, for instance, raised the art of collage to a new height of witty absurdity (fig. 10.10). Around the grinning faces of Chico, Groucho, and Harpo he placed a patchwork of music fragments. The graphic cacopho-

ny of this musical clutter simultaneously refers to their most recent movie, *A Night at the Opera*, conveys the antic confusion of their performance, and suggests all three brothers' substantial musical skills. Steel wool, fur, and cotton provide an uncanny resemblance to the famous wigs and hair of their characters—a playful combination of household materials and luxury goods with a contrast of textures. Such humor mocks the collage conventions of the cubists, of course. But these materials, along with the felt, silk, and string used for mustache, hat, and glasses, also imply the ease with which the Marx Brothers could turn the familiar stuff of daily life into hilarious comedy. With his own insight and comic intuition, Hirschfeld differentiated the three individuals in this caricature and also evoked the spirit of their combined performance.

Few caricatures of the Marx Brothers could do more than replicate the characteristic costumes, leers, and poses of the comedians themselves. In fact, as Hirschfeld himself has pointed out, all of his theatrical heroes, villains, and clowns were originated by others. His own contribution, he explained, "is to take the character—created by the playwright and acted out by the actor—and reinvent it for the reader. The aim is to re-create the performed character and not reinterpret *its* 'character' by ridicule or aggressive insult."[20] By acknowledging his debt to these collaborative inventions, he goes beyond them. Following the tradition of Frueh, Barton, and Covarrubias, Hirschfeld's re-creations thus remain quintessentially true to their originals while recombining their exterior elements into an entirely fresh view of the familiar.

Hirschfeld's exceptional eye could analyze exactly which features to emphasize in order to convey that recognizable summary. In a whimsical display of this talent for *Life* magazine in 1937, he drew three pages of "photo-doodles," touching up photographs of celebrities with ink to turn them into other famous faces. With the deft addition of a mustache, a hairdo, eyebrows, or a hat, Hirschfeld converted Herbert Hoover into John L. Lewis, Gertrude Stein into Albert Einstein, Harold Ross into Joseph Stalin, Mary Pickford into Adolf Hitler, and himself into Rasputin.[21] This entertaining exercise did not produce great caricature, but it does demonstrate his ingenuity and analytical eye.

Hirschfeld relied on the theatricality of performance to provide crucial raw material. Indeed, he discovered that public figures could not live up to their own repu-

10.9 *Harry Lauder* (1870–1950) by Al Hirschfeld. Printed illustration. Published in *New York Times*, January 22, 1928. National Portrait Gallery, Smithsonian Institution, Washington, D.C. © Al Hirschfeld. Art reproduced by special arrangement with Hirschfeld's exclusive representative, the Margo Feiden Galleries, Ltd., New York.

tations when encountered off the stage. Later in life, after meeting Richard Burton, he joked that the famous actor was not a perfect likeness of himself, only a striking resemblance: "His face was too large, his eyebrows too small; and his actions were indistinguishable from those of normal extroverts who infest lobbies during intermissions." Meeting Franklin Delano Roosevelt at the White House in 1944 had a similar effect on Hirschfeld. "The GOD became man-size," he wrote. "As the end of the allotted fifteen minutes drew near, I was thankful that I had never met President Lincoln."[22] He preferred to find his subjects on the theatrical or political stage, in the glare of the spotlight, playing to an audience.

Much like Barton, Hirschfeld learned to achieve textural contrasts and dramatic effects through line alone, drawing on a vast repertoire of dots, curls, flecks, strokes, and thin, wavering threads of ink. In his draw-

10.10 *The Marx Brothers* by Al Hirschfeld. Collage with sheet music, silk, felt, steel wool, fur, cotton, string, ink, and opaque white, 43.8 x 38.8 cm (17 1/4 x 15 1/4 in.), 1935. National Portrait Gallery, Smithsonian Institution, Washington, D.C. © Al Hirschfeld. Art reproduced by special arrangement with Hirschfeld's exclusive representative, the Margo Feiden Galleries, Ltd., New York.

10.11 *The Cradle Will Rock* by Al Hirschfeld. India ink with opaque white on illustration board, 44.3 x 39.5 cm (17 7/16 x 15 9/16 in.), c. 1945–50. National Portrait Gallery, Smithsonian Institution, Washington, D.C. © Al Hirschfeld. Art reproduced by special arrangement with Hirschfeld's exclusive representative, the Margo Feiden Galleries, Ltd., New York.

HOWARD DA SILVA ~ BERT WESTON ~ OLIVE STANTON ~ BLANCHE COLLINS ~ MARC BLITZSTEIN AT THE OPEN UPRIGHT

FROM
"The CRADLE WILL ROCK"

ing of the *The Cradle Will Rock* (fig. 10.11), he playfully limns the difference between slicked-back hair, fuzzy curls, and soft, swinging tresses and then goes on to contrast smooth, draping silk with nubby wool. Some of the details seem extraneous to the caricaturist's message. How many people noticed the wicker caning of the chairs, which reflected a polka-dotted blouse, or the humorous differentiation of eyebrows and eyeballs? But it was this richness of detail that gave his drawings a memorable depth and complexity.

The Cradle Will Rock records a dramatic incident from the annals of American theater. On June 16, 1937,

composer Marc Blitzstein, director Orson Welles, and producer John Houseman produced their militant, pro-labor musical in defiance of the Federal Theatre Project's attempt to close them down.[23] The ticketed audience arrived at the Maxine Elliot Theater that evening to find the doors locked. Loading an upright piano on a truck, the cast and audience moved twenty-one blocks uptown to an empty theater. With Blitzstein on the bare stage at the piano and the actors reciting from their seats to avoid breaking union rules, the performance proceeded, to great acclaim. When Hirschfeld made his drawing a few years later, he

10.12 *Luther (Bill "Bojangles") Robinson* (1878–1949) by Al Hirschfeld. India ink on paper, 32.7 x 55.6 cm (12⅞ x 21⅜ in.), c. 1939. National Portrait Gallery, Smithsonian Institution, Washington, D.C. © Al Hirschfeld.

assembled his actors on stage. But the stark simplicity of the space and the open upright piano recalled the impromptu performance, and the complexity of his lines and patterns adds drama and tension to his depiction of this defiant theatrical moment.

Hirschfeld's 1939 drawing of Bill "Bojangles" Robinson dancing across the stage in *The Hot Mikado* proves how brilliantly he had integrated the techniques of other caricaturists into his own developing style (fig. 10.12). The fluid contours of the figures hint of Al Frueh's graceful characterizations. Strong, solid figural forms and sharp definition suggest the influence of Covarrubias; the comic exaggerations of the dancer recall particularly the Mexican artist's Harlem drawings. Indeed, the use of Covarrubias's characteristic sharp, tapering lines to evoke the dark skin tones of Bojangles's face seems an imitative tribute. And the drawing's complex linear structure recalls Ralph Barton's graphic versatility. Lines swoop, arc, wiggle, waver, curl, and bolt across the page, first thick then thin, now black, now white, here delicate and there bold. Like Barton, Hirschfeld lavished attention on the details, rendering with painstaking exactness a shirt collar, cuff-linked sleeve, wavy hairdo, and minutely shaded hat. Barton's riotous, unfettered profusion of line made his black and white drawing seem alive and colorful. Hirschfeld, though precise and controlled, achieves a similar effect.

But if *Bojangles* embodies an astute synthesis of the techniques of others, it also represents Hirschfeld's own distinctive strengths. The deadpan expressions and contrasting profiles of designer Nat Karson and producer Hassard Short reveal his subtle brand of humor. Handsome patterns of black and white convey the stylish elegance so pervasive in his work. And the image imparts an extraordinary quality of movement that already had become the most characteristic feature of his style. As Lloyd Goodrich has suggested, Hirschfeld's drawings are "dynamic creations in moving line and form. The line is alive; it . . . zooms with whiplash speed. Every line has rhythm and plays its precise part in an over-all linear ballet."[24] The repeating white arcs of the seat backs in the foreground, for instance, add an underlying staccato rhythm, appearing almost like sound waves emanating from Bojangles's tapping feet. The swooping curves and sharp angles of

the body produce the stretches and bends of a dancer in midstep, a stop-action view of high-speed movement. Perhaps Hirschfeld's early exposure to film explains this kinetic energy. The low viewpoint of this drawing and the brilliant white of the stage give the effect of a lighted screen looming above the audience. And the sharply detailed faces and sense of rapid action suggest the pace of the camera cutting from close-ups to wider shots rather than the more leisurely rhythms and distant focus of the theater.

Even in far simpler drawings, Hirschfeld's line is so energetic that it seems poised to burst into new configurations. In his drawing of columnist Walter Winchell (fig. 10.13), the head strains forward, tugging at the collar of the shirt; eyes squint from the recent removal of glasses, the mouth turns down in fierce concentration. Tense, focused, the figure seems ready to pounce. Loosened tie, pushed-back hat, and clenched fingers all signify an activity level unmatched by other newspapermen. No Broadway tidbit will escape this predatory gossip monger. The image creates the marvelous illusion that the artist himself can barely control his explosive, stretching, recoiling line.

This distinctive quality of movement adds a zestful exuberance to the drawings that undoubtedly helps to explain Hirschfeld's enduring popularity. Playwright Arthur Miller, discussing how the artist made all his subjects appear interesting, identified this elusive trait:

10.13 *Walter Winchell* (1897–1972) by Al Hirschfeld. India ink on paper, 29.5 x 37.8 cm (11 5/8 x 14 13/16 in.), c. 1950. National Portrait Gallery, Smithsonian Institution, Washington, D.C. © Al Hirschfeld. Art reproduced by special arrangement with Hirschfeld's exclusive representative, the Margo Feiden Galleries, Ltd., New York.

10.14 *Wilshire Bowl Mural Studies* by John Decker. Gouache, watercolor, silver paint, ink, and pencil on board, each panel, approximately 21.6 x 50.8 cm (8 1/2 x 17—20 in.), c. 1941. National Portrait Gallery, Smithsonian Institution, Washington, D.C.

"People in a Hirschfeld drawing all share the one quality of energetic joy in life that they all wish they had in reality. Looking at a Hirschfeld drawing of yourself is the best thing for tired blood. The sheer tactical vibrance of the lines and their magical relationships to each other make you feel that all is not lost . . . that he has found a wit in your miserable features that may yet lend you a style and a dash you were never aware of in yourself. . . . Something like joy is in every one of his drawings."[25]

Humming with this exhilarating energy as well as visual drama, Hirschfeld's inked images could compete with color caricature. Many other newspaper artists had struggled in the Depression era. By the mid-1930s, caricaturist Aline Fruhauf pointed out, "the newspaper market for art work, with the exception of the New York Times and the Tribune was practically nonexistent; and the demand for caricatures was at an all-time low." Some sketch artists tried to develop their skills in color; some switched to other types of humor drawing. Hirschfeld's work, editors realized, conveyed an excitement that others lacked. As one critic pointed out in his review of Hirschfeld's 1939 exhibition of caricature at the Charles Morgan Gallery, "few black and white artists can stand up in so large a showing as Hirschfeld does here."[26] In order to compete, the monochromatic caricature image had to be stronger and more eye-catching than ever. Along with Auerbach-Levy, Frueh, and Bacon, Hirschfeld kept the art of black and white portraiture alive and vibrant in the 1930s and 1940s.

In spite of the Depression, therefore, celebrity caricature thrived. Although some newspapers trimmed their lavish use of these portraits in the early 1930s, the magazines provided steady work for many caricaturists and attracted new recruits to the field. Along with *Vanity Fair*, the *New Yorker*, and *Fortune*, new publications emerged featuring drawings of the famous. *Esquire* magazine, for instance, which started in 1933, promoted a number of new young artists. Among them was Sam Berman (born 1906), who had created a caricature curtain with Russell Patterson for Joe Cook's 1933 show *Hold Your Horses*. In addition to his watercolor drawings, Berman made doll-like puppets with heads modeled in clay or plasticine and cast in plaster, one of which became a famous logo character for the magazine. "Eskie" was a rakish little gentleman who cavorted around on pages or covers with such personalities as Mae West.[27] In 1938, *Esquire* publisher David Smart

founded another magazine, the anti-fascist *Ken*, that depended heavily on cartoons and caricatures by Henry Major, William Sharp, Hirschfeld, Berman, Gropper, Auerbach-Levy, and others.

Stage magazine, which had originated in 1932 as a publication of the Theatre Guild, provided an additional outlet during the decade. When John Hanrahan took over *Stage* as publisher and editor in the mid-1930s, he elicited the financial support of *New Yorker* co-founder Raoul Fleischmann. Consciously imitating the *New Yorker's* successful formula, Hanrahan solicited contributions from many of Harold Ross's writers and artists. *Stage* was soon publishing caricature by Frueh, Cotton, Birnbaum, Berman, and Bacon. Many general magazines followed the trend.

None of these periodicals could compete with the *New Yorker* or *Vanity Fair* in the quantity or quality of their caricatures. *Esquire* tended to emphasize full-page color cartoons and suggestive "pretty girl" pictures over caricature. *Ken* lasted only from April 1938 through August 1939.[28] *Stage* lingered through most of the decade, but *New Yorker* stockholders and a furious Ross, who felt that he was subsidizing a competitor, forced Fleischmann to withdraw his support.[29] With its lower artistic standards, *Stage* became a second-rate imitation. Nonetheless, all these additional outlets allowed caricature to flourish. Sparkling on the covers of *Vanity Fair*, defining the Sunday drama sections of the *Times*, *Herald Tribune*, and *Brooklyn Eagle*, and enlivening the pages of dozens of magazines, stylized faces of the famous had permeated the press.

Celebrity caricature staked an additional claim on the public imagination when Hollywood took notice. By the mid-1930s the Brown Derby, the legendary restaurant where Clark Gable proposed to Carole Lombard, was hanging Eddie Vitch's caricatures of rising film stars on its walls in imitation of Sardi's.[30] John Decker painted caricature murals for the Wilshire Bowl Restaurant. They were installed in September 1941 to accompany a cabaret production about the golden age of film entitled *The Silver Screen*. Surviving watercolor studies document Decker's depictions of three decades of Hollywood legends (fig. 10.14).[31] Movie magazines spread the caricature vogue, encouraging many young artists to draw portraits of the stars.

The greatest impact, however, was Hollywood's adaptation of celebrity caricature to the new medium of animated cartoons. Since the beginning years of the

film industry, animators had experimented occasionally with the faces of public figures; Theodore Roosevelt had provided an irresistible target for a number of film clips as early as 1909 and 1910. During the silent era, such cartoon characters as Felix the Cat would occasionally encounter identifiable figures.[32] But in the 1930s, Disney, Warner Brothers, and other studios created a series of animated cartoons around the celebrity theme. By this time animation had become a major public entertainment medium. Walt Disney's "Steamboat Willie" in 1928, historians generally agree, featuring the first fully synchronized soundtrack and artist Ub Iwerks's appealing new character, Mickey Mouse, helped launch the explosive growth of film cartoons.[33]

Walt Disney's foray into celebrity animation seems to have started with his admiration for the work of Joe Grant (born 1908), a newspaper caricaturist working at the *Los Angeles Record* in the early 1930s under contract to MGM.[34] Grant's drawings of such stars as Jean Harlow in *Red Dust* (fig. 10.15) and Marie Dressler in *Emma* (fig. 10.16) appeared every Saturday in the *Record* with reviews of recent MGM releases. Using an assortment of styles to vary the look of his pictures, Grant incorporated the flexible contours, tapered-line shading, and textural contrasts of Frueh, Covarrubias, or Barton, always with a sure sense of graphic impact and wit. Sometimes he resorted to collage, using, for example, in the image of Eddie Cantor from *Roman Scandals*, terry cloth, velvet flowers, and steel wool (fig. 10.17).

Intrigued by Grant's depictions, Disney began to think about animating famous faces. In November 1932, when he received his first Oscar and a special citation for the creation of Mickey Mouse, his studio produced a short film of animated caricatures to show during the Academy Awards ceremony at the Ambassador Hotel. The two-and-a-half-minute "Parade of the Award Nominees," photographed in Technicolor, humorously acknowledged his own and Mickey's new status in the movie community. The clip features each of the nominees—Wallace Beery (in his costume from *The Champ*) (fig. 10.18), Lynn Fontanne, Alfred Lunt, Helen Hayes, Fredric March, and Marie Dressler— parading through Storyland. A marching band of cartoon characters leads the procession, with Mickey as drum major. Since Disney had no caricaturists on the staff at the time, he directed his artists to imitate Grant's portraits of the stars from the newspaper. The clip delighted its audience at this single showing. Al-

though it lacked character development and storyline, it featured Mickey Mouse in color for the first time, Fredric March's Dr. Jekyll transforming into Mr. Hyde, and a humorous parade of stars that undoubtedly appealed to the celebrity-studded Academy Awards audience.[35]

The response inspired Disney to create a full cartoon animating the faces of the famous. In 1933 he recruited Joe Grant to design caricatures of movie actors for "Mickey's Gala Premiere" and soon offered him a full-time position at the studio.[36] Grant proved his talents as an artist, designer, writer, storyman, and producer, becoming, as animators Frank Thomas and Ollie Johnson recalled, "the studio authority on the design and appearance of nearly everything that moved on the screen." By the mid-1930s Disney had put him in charge of the character model department, a unit that developed the initial art and story ideas of new films, producing the inspirational drawings, as they were called, that animators could copy. No character model sheet was official, Thomas and Johnson remembered, until it bore the seal, "O. K., J. G." Ultimately Grant would work on such Disney classics as *Snow White*, *Fantasia*, and *Pinocchio*, as well as the series of animated caricature cartoons.[37]

In "Mickey's Gala Premiere," Mickey Mouse attends the glamorous opening night of one of his own films. Cleverly lampooning Hollywood stars arriving at Grauman's famed Chinese Theater, Grant and other Disney artists exploited the well-known characteristics of each, whether accurate or not. Greta Garbo's reputation for having big feet, for instance, was based on her predilection for wearing warm, fuzzy slippers on the set; she had, in fact, slim feet of average length.[38] The truth was irrelevant; she teeters on gigantic shoes in all her cartoon images. Clark Gable's flapping ears, Joe E. Brown's wide grin, Ed Wynn's high-pitched laugh were also publicity clichés, but the fast pace of the medium required instant recognition. Although each figure appeared only briefly on the screen, any attentive moviegoer could have identified Bela Lugosi, Fredric March, and Boris Karloff seated companionably together as Dracula, Mr. Hyde, and Frankenstein, and would have recognized Douglas Fairbanks and Jimmy Durante falling into the aisle in a fit of laughter. After the screening of the cartoon, Will Rogers ropes Mickey with his lasso and pulls him out onto the stage (fig. 10.19). Film stars such as William Powell, Maurice Chevalier, George Arliss, Edward G. Robinson, and

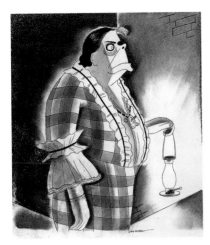

10.16 *Marie Dressler* (1869–1934) by Joe Grant. India ink with pencil on paper, 32.3 x 25.7 cm (12 11/16 x 10 1/8 in.), 1932. Original illustration for *Los Angeles Record*, 1932. National Portrait Gallery, Smithsonian Institution, Washington, D.C.; gift of Carol Eve Grubb and Jennifer Grant Castrup.

10.15 *Jean Harlow* (1911–37) by Joe Grant. India ink with pencil on paper, 36.6 x 28.4 cm (14 3/8 x 11 3/16 in.), 1932. Original illustration for *Los Angeles Record*, 1932. National Portrait Gallery, Smithsonian Institution, Washington, D.C.; gift of Carol Eve Grubb and Jennifer Grant Castrup.

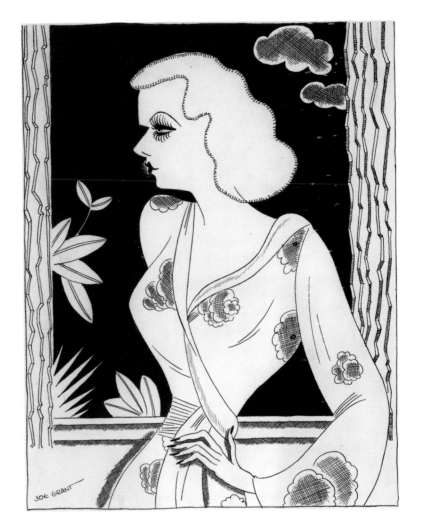

Wallace Beery crowd around to shake his hand (fig. 10.20). Finally, Greta Garbo—murmuring "wonderful, wonderful, marvelous"—slinks onto the stage, kneels down, and covers Mickey with kisses (fig. 10.21). Mickey awakens to Pluto licking his face and is crushed to discover that the whole incident has been a dream.

In earlier films that combined live action with animation, Disney had played with similar themes of truth confronting fiction. Here, combining animated caricatures of actual people with an image of a fictional character, the film twists presumptions about reality and invention. The cartoon character, as film commentators have noted, is the only one not caricatured in the film; he is a straightforward presentation of the "real" thing.[39] By this time, of course, Mickey Mouse did have a real,

off-screen identity as both an American icon and a hugely profitable commercial entity. In the cartoon, he aspires to the glamour and acclaim of other renowned film personalities only to have his pretensions deflated. On the surface, "Gala Premiere" retains Mickey's modest, little-man image while exploring the self-consciousness of Hollywood stardom. But, as the cartoon's ironic subtext suggests, the other celebrities knew that he was, in fact, not only a "real" star, but one of Hollywood's most successful. Mickey's dream represents the truth after all. In the end, the pretensions of Hollywood fame, not Mickey's vanity, provide the satiric target.

"Gala Premiere" proved the rich potential of the celebrity theme. Joe Grant also worked on "Who Killed Cock Robin" of 1935, helping to visualize a voluptuous,

10.17 *Eddie Cantor* (1893–1964) by Joe Grant. Collage with ink, ink wash, fabric, steel wool, and wire on paper 35.5 x 28 cm (14 x 11¹/₁₆ in.), 1933. Original illustration for *Los Angeles Record*, November 11, 1933. National Portrait Gallery, Smithsonian Institution, Washington, D.C.; gift of Carol Eve Grubb and Jennifer Grant Castrup.

10.18 *Wallace Beery and Jackie Cooper* (1885–1949; born 1921) by Disney Studios. Pencil on paper, 24 x 30.2 cm (9¹/₂ x 11⁷/₈ in.), 1932. Original animation drawing for "Parade of the Academy Award Nominees," 1932. National Portrait Gallery, Smithsonian Institution, Washington, D.C.; gift of Miriam and Stuart Reisbord.

10.19 *Will Rogers* (1879–1935) by Disney Studios. Pencil on paper, 24.2 x 30.5 cm (9¹/₂ x 12 in.), 1933. Original animation drawing for "Mickey's Gala Premiere," 1933. National Portrait Gallery, Smithsonian Institution, Washington, D.C.; gift of Miriam and Stuart Reisbord.

Mae Westian Jenny Wren and a title character who sings like Bing Crosby. These celebrity allusions dispensed with subtlety. "Ohhh Hello Robin. . . . Ya' Fascinate Me!" Jenny Wren proclaims with a recognizable drawl in the caption of an early story sketch. Mae West herself, writing to congratulate Walt Disney, called "Cock Robin" one of the most amusing and entertaining cartoons she had ever seen. An enthusiastic press also responded well to the film. A critic from the London *Daily Express* marveled that an old nursery rhyme could be turned into a "commentary on crooning, American police methods, and Miss Mae West." The *New York Post* recommended it with "four dozen stars."[40]

In addition to animals impersonating the stars, however, a number of cartoons treated the celebrity theme directly, featuring animated drawings of the actors themselves. The concept for "Mickey's Polo Team" of 1936 grew out of Hollywood's—and Disney's—pas-

10.21 *Greta Garbo* (1905–90) by Disney Studios. Pencil on paper, 25.4 x 30.5 cm (10 x 12 in.), 1933. Original animation drawing for "Mickey's Gala Premiere," 1933. Walt Disney Feature Animation Research Library, Burbank, California.

10.20 *Stars with Mickey Mouse* by Disney Studios. Pencil and colored pencil on paper, 24.1 x 30.5 cm (9 ½ x 12 in.), 1933. Original animation drawing for "Mickey's Gala Premiere," 1933. National Portrait Gallery, Smithsonian Institution, Washington, D.C.; gift of Miriam and Stuart Reisbord.

10.22 *Stan Laurel* (1890–1965), *Oliver Hardy* (1892–1957), *Charlie Chaplin* (1889–1977), and *Harpo Marx* (1893–1964) by Disney Studios. Pencil on paper, 25.4 x 30.5 cm (10 x 12 in.), 1936. Original model drawings for "Mickey's Polo Team," 1936. National Portrait Gallery, Smithsonian Institution, Washington, D.C.

sion for the sport. Will Rogers often invited Hollywood friends out to his ranch in Rustic Canyon for games on his full-size polo field, and the animators chose this handsome setting for their film. Rogers himself, originally one of the characters, had to be removed from the cartoon after his untimely death in an airplane crash. So the filmmakers pitted Harpo Marx, Stan Laurel, Oliver Hardy, and Charlie Chaplin, each riding matching steeds (fig. 10.22), against cartoon figures Mickey Mouse, Goofy, Donald Duck, and the Big, Bad Wolf. Actor Jack Holt appeared as referee of a game studded with wild antics and thundering chases and

cheered by an audience that included both Hollywood personalities and cartoon subjects. An admiring writer for *Variety* made an exception to the publication's rule against reviewing shorts, highlighting "Mickey's Polo Team" because it "augurs unusual b.o. [box office] potentialities."[41] The audience could laugh at all the Hollywood notables while enjoying a gently satiric poke at their frivolous lifestyles.

The animated caricature films satirize notions of celebrity much the way Covarrubias's "Impossible Interviews" did. Brash newcomers (the cartoon characters) invariably overwhelm established figures (the

movie stars) whose fame and importance is taken for granted. In "Autograph Hound" of 1939, Donald Duck tries to sneak onto the studio lot to get celebrity signatures, only to have the stars abandon their tasks—Garbo, clutching Gable, drops him on the floor (fig. 10.23)—and stampede over to *him* for autographs when Shirley Temple shouts his name.

Walt Disney's ironic perceptions of his own fame, as well as Mickey's and Donald's, underlie his exploration of the celebrity theme. Although he allowed himself to be caricatured as a toreador in the cartoon "Ferdinand the Bull" (fig. 10.24), he sometimes affected an innocent disengagement from Hollywood's pursuit of fame. When asked how he felt about his own renown, Disney noted that beyond getting choice seats for a football game, fame had its limits: "As far as I can remember, being a celebrity has never helped me make a good picture, or a good shot in a polo game, or command the obedience of my daughter, or impress my wife. It doesn't even seem to help keep fleas off our dogs and, if being a celebrity won't give one an advantage over a couple of fleas, then I guess there can't be that much in being a celebrity after all."[42] Of course, his joking comment belies an intense engagement with the subject. All Hollywood professionals participated in a sophisticated celebrity game, and Disney and his animators brought a sharp, discerning eye to the sport. Despite the obvious big feet or protruding ears, the satiric interplay of caricatured stars and cartoon characters probed celebrity overexposure with a new, satiric twist.

"Mother Goose Goes Hollywood" of 1938 constituted Disney's most elaborate venture into animated caricature. Opening with a goose that roars and the statement that any resemblance to real people was purely coincidental, the cartoon lampoons a huge cast of film stars as Mother Goose characters. Katharine Hepburn provides a loosely connecting thread between the various scenes in her role as Bo Peep searching for her sheep (figs. 10.25, 10.26)—"I can't find them, rah-ly I can't." W. C. Fields as Humpty Dumpty (fig. 10.27), Stan Laurel and Oliver Hardy as Simple Simon and the Pieman, and the Marx Brothers as the Fiddlers Three are only a few of the characterizations in this densely populated film. Hollywood stardom easily disintegrates into nursery-rhyme comic fantasy as the animators merge each celebrity's attributes with those of his storybook character.

The complex process of preparing such cartoons involved thousands of sequential pencil drawings made by dozens of different artists. A series of five animation

10.23 *Greta Garbo and Clark Gable* (1905–90; 1901–60) by Disney Studios. Pencil on paper, 25.4 x 30.5 cm (10 x 12 in.), 1939. Original animation drawing for "Autograph Hound," 1939. National Portrait Gallery, Smithsonian Institution, Washington, D.C.; gift of Miriam and Stuart Reisbord.

10.24 *Walt Disney* (1901–66) by Disney Studios. Pencil on paper, 19.8 x 22.9 cm (7 3/4 x 9 in.), 1938. Original animation drawing for "Ferdinand the Bull." National Portrait Gallery, Smithsonian Institution, Washington, D.C.; gift of Miriam and Stuart Reisbord.

10.25 *Katharine Hepburn* (born 1909) by Disney Studios. Pencil on paper, 25.4 x 30.5 cm (10 x 12 in.), 1938. Original animation drawing for "Mother Goose Goes Hollywood," 1938. Jeff and Thérèse Lotman.

10.26 *Katharine Hepburn* (born 1909) by Disney Studios. Gouache and ink on celluloid, 25.2 x 31 cm (10 x 12¹/₈ in.), 1938. Original animation cel for "Mother Goose Goes Hollywood," 1938. National Portrait Gallery, Smithsonian Institution, Washington, D.C.; gift of Miriam and Stuart Reisbord.

drawings from "Mother Goose Goes Hollywood," showing Martha Raye kissing Joe E. Brown, bear numbers between twenty-eight and sixty-one (fig. 10.28). The many drawings in between filled in the incremental movements of the figures. Ultimately each drawing was traced in ink onto celluloid, hand colored, and photographed. All cartoon figures in multiple drawings and cels had to retain an exact, recognizable likeness

through progressive images. Celebrity subjects, however, created extra problems. Instead of the broad features and stylized costumes of the cartoon animals, the animators had to define more complex figures. This could be done only by simplifying the exaggerations as much as possible, emphasizing a number of critical, obvious features in the face and costume, and then following the details with exacting precision. Lead artists prepared photostatic model sheets on individual characters, giving instructions and different poses to help the animation team. A brilliant Disney caricaturist named Thornton Hee—inevitably dubbed T. Hee by his fellow jokesters—conceived many of the characters in "Mother Goose Goes Hollywood." On his model sheet of Katharine Hepburn (fig. 10.29) he stressed her chin, half-closed eyes, and cheekbones but also instructed his team with such subtle details as the correct angle of brow and nose and the exact amount of space between the ruffles in her pantaloons. The broad exaggerations of the animated caricatures actually required meticulous accuracy.

Other studios soon adopted the celebrity caricature theme. Warner Brothers produced an inventive series of cartoons, often substituting for Disney's polished, wholesome fare an upstart attitude, faster pace, more sexual innuendo, raucous humor, and adult references to current trends and events. From their earliest films of the 1930s, the animators adapted well-known voices and characteristics of radio and film stars, populating their comic storyland with a mixture of figures from history, advertising, fiction, and contemporary life.[43] Fractured names provided such characters as Owl Jolson, W. C. Fieldmouse, and Maestro Stickoutsky, while famous celebrity ears, feet, voices, and mannerisms inspired endless animated slapstick. Some of the most notable films involve a combination of fictional and celebrity subjects who step out of magazines, books, posters, or product labels to act out a story. "Three's a Crowd" and "I Like Mountain Music" of 1933 served as prototypes for many others. In Frank Tashlin's two classics "Speaking of the Weather" (1937) and "Have You Got Any Castles" (1938), book and magazine subjects come to life. Figures like Leopold Stokowski from *Etude* magazine, Greta Garbo from *Photoplay* (rocking on her big feet) (fig. 10.30), or a stick-like William Powell from the Thin Man novels hop off covers and out of volumes to chase a thief (sentenced to "Life" by "Judge" but escaping to "Liberty")

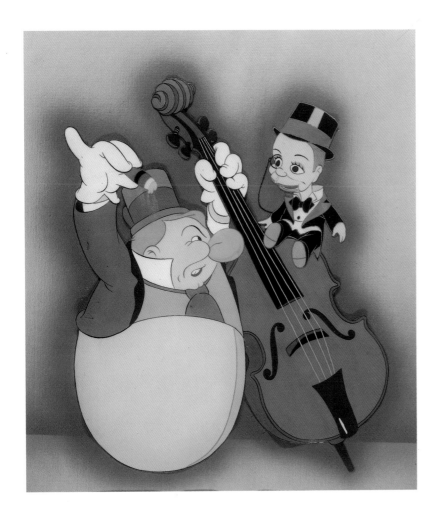

10.27 *W. C. Fields* (1880–1946) by Disney Studios. Gouache and ink on celluloid, 23.1 x 20.3 cm (9 1/4 x 8 in.), 1938. Original cel for "Mother Goose Goes Hollywood," 1938. Jeff and Thérèse Lotman.

10.28 *Martha Raye and Joe E. Brown* (1916–94; 1892–1973) by Disney Studios. Pencil and colored pencil on paper, 25.4 x 30.5 cm (10 x 12 in.), 1939. Set of five original animation drawings for "Mother Goose Goes Hollywood," 1938. National Portrait Gallery, Smithsonian Institution, Washington, D.C.; gift of Miriam and Stuart Reisbord.

10.29 *Katharine Hepburn* (born 1909) by Disney Studios. Photostatic model sheet, 30.5 x 25.4 cm (12 x 10 in.), c. 1938. Model sheet for "Mother Goose Goes Hollywood," 1938. Jeff and Thérèse Lotman.

and join the general melee. The gags come so fast and furiously in these breathless routines that one barely notices recycled jokes from other cartoons.

Other Warner Brothers films, such as "The Coo Coo Nut Grove" (1936), "Hollywood Steps Out" (1941), or "Malibu Beach Party" (1940), exploit the celebrity theme with relatively little plot, depicting stars—such as Edward G. Robinson (fig. 10.31) and Clark Gable—dining at Hollywood's legendary eateries or attending private parties. Impersonations of the famous continued to populate these cartoons throughout the 1940s. Although the Warner Brothers films do not satirize Hollywood stardom as explicitly as the first Disney films, they help establish comic celebrity images as part of the recognizable visual vocabulary of the age. Fared from communicating information about individuals,

10.30 *Greta Garbo* (1905–90) by Warner Brothers Studio. Pencil and colored pencil on paper, 20.3 x 25.4 cm (8 x 10 in.), 1937. Original concept drawing for "Speaking of the Weather," 1937. The Steve Schneider Collection.

these endlessly repeated distorted faces of the famous deny any off-screen existence.[44] Often they were reduced, like Snow White's dwarfs, to single attributes. Familiar features instantly evoked the sexy, droll, strong, stingy, or glamorous association the media had outlined for each star. Like advertising logos, fictional heroes, and the cartoon characters themselves, the famous radio and film performers belonged to the landscape of the familiar. Gable, Garbo, Crosby, and Astaire joined Porky Pig, Bugs Bunny, Cleopatra, Alice in Wonderland, Aunt Jemima, and the umbrella-carrying Morton Salt girl as part of the common discourse of American culture.

Caricature had soared to great heights of popularity, but, in a process endemic to the modern media spotlight, overexposure inevitably took its toll. The cartoon industry's appropriation of caricature had encouraged the vogue, but ultimately animated celebrity pictures undermined their pen and ink cousins. Although cartooning required extraordinary precision, it necessitated a broad, obvious reduction of physical characteristics. Animators substituted a rounder, squatter, more childlike figural style closer to comic strip art than linear, geometric caricature. But those newspaper and magazine artists who began to imitate cartoon styles could not replicate the energetic movement, antic slapstick, and fast pace of animation. Often their drawings suggested merely an unsophisticated miniaturization. Furthermore, as the animated film, initially enjoyed by all ages, began to be perceived as children's fare, cartoons and caricature began to lose their aura of clever sophistication. The concern over violence in comic books that culminated in congressional hearings in the mid-1950s undoubtedly tainted other child-oriented comic fare. Many forms of cartoon and caricature were thrown into the low culture dustbin in a concern over the intellectual corruption of American youth.

More immediately, however, the cartoon films of the 1930s reinforced the move toward color that the covers and frontispieces of *Vanity Fair* had already inspired. Even Al Hirschfeld, while continuing to produce his pen and ink drawings, turned to color in the 1940s for magazine illustration. His 1949 portrait of H. L. Mencken depicted the infamously opinionated author reading a volume entitled *Me, the People* (fig. 10.32). Hirschfeld implies that this aging literary figure, once the influential editor of the *American Mercury*, had developed a myopic, self-reflective view of American cul-

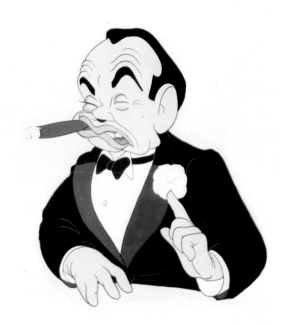

10.31 *Edward G. Robinson* (1893–1973) by Warner Brothers Studio Paint on celluloid, 1941. Original cel for "Hollywood Steps Out," 1941. The Steve Schneider Collection.

ture. Although the image accompanies a highly critical editorial in *Collier's*, the bright colors, whimsical top-knot, and spiral eyes leaven the humor and dissipate any suggestion of bitterness.[45]

Mencken was owned for many years by Lawrence Spivak, who, as publisher of the *American Mercury*, hired Hirschfeld to make a series of color covers. With one eighteen-month gap, the lively series ran from January 1944 through November 1950. Hirschfeld provided most of the drawings.[46] On the May 1944 cover the artist presented Wendell Wilkie as a forceful presidential candidate, waving his arm and bristling his brows at a cowering microphone (fig. 10.33). Wilkie had just been defeated in the Republican primary but was still a potent political voice over the airwaves. Despite the posturing of power in the image, the green bulges under the eyes and the straining intensity of the face prophetically conveyed the toll that an unceasing public life had exacted. Wilkie died the following October at the age of fifty-two. Other periodicals also sported Hirschfeld's colorful cover art. His image of news commentator Edward R. Murrow, drawn for the cover of the November 3–9, 1956, issue of *TV Guide*, probes the

10.32 *H. L. Mencken* (1880–1956) by Al Hirschfeld. Gouache with pencil on paper, 44.3 x 37 cm (17 7/16 x 14 9/16 in.). Original illustration for *Collier's*, November 19, 1949. National Portrait Gallery, Smithsonian Institution, Washington, D.C. © Al Hirschfeld.

10.33 *Wendell Willkie* (1892–1944) by Al Hirschfeld. Ink, watercolor, and gouache on board, 57.2 x 46.2 cm (22 9/16 x 18 3/16 in.), 1944. Original illustration for *American Mercury*, May 1944. National Portrait Gallery, Smithsonian Institution, Washington, D.C. © Al Hirschfeld. Art reproduced by special arrangement with Hirschfeld's exclusive representative, the Margo Feiden Galleries, Ltd., New York.

10.34 *Edward R. Murrow* (1908–65) by Al Hirschfeld. Watercolor and gouache on board, 54.8 x 42.4 cm (21 5/8 x 16 3/4 in.), 1956. Original illustration for *TV Guide*, November 3–9, 1956. National Portrait Gallery, Smithsonian Institution, Washington, D.C. © Al Hirschfeld.

frenetic pace of live-action broadcasting (fig. 10.34). Depicting Murrow entangled in the coiling wires of two telephones, Hirschfeld suggests that resourceful perfectionism that invariably added a dramatic edge to the commentator's radio and television reporting.

While a handful of the top artists maintained their successful careers in the 1940s and beyond, celebrity caricature as a distinct genre was losing its hold on the American imagination. Plentiful evidence of its prevalence disguised this waning, however. At the 1941 Gridiron Club dinner, wags presented President Franklin Delano Roosevelt with an enormous comic sculpture of himself as a sphinx. Magazines such as the *New Yorker*, *Collier's*, *Saturday Evening Post*, and *American Mercury* still sought the talents of Auerbach-Levy, Frueh, Sam Berman, Hirschfeld, and others. Jacques Kapralik (1906–60) produced a series of portraits for such film publications as MGM's magazine, the *Lion's Roar* (fig. 10.35). Band leader Xavier Cugat caricatured Adolphe Menjou in a memorable scene from the 1942 Fred Astaire film *You Were Never Lovelier*. Other movies of the 1940s featured the walls of Sardi's and the Brown Derby; new celebrity animated cartoons entertained children and adults alike. Auerbach-Levy, optimistic about the future of the caricature portrait, published *Is That Me?* in 1947.

Other signs suggest, however, that the sophisticated, gently mocking caricature portrait was evolving into other forms. The political tone of the Depression years and the advent of World War II demanded a more emotional and derisive response. Urbane detachment had to give way to the need for stronger, more derisive satiric voices. By the late 1930s, no images of Hitler, Hirohito, or Mussolini could be interpreted as irreverent celebrations of fame or as clever reconstructions of celebrity attributes. In comparison with Sam Berman's chilling caricatures of war criminals for *Collier's* in the mid-1940s, for instance, light-hearted portrayals of the famous risked looking banal and meaningless.

Furthermore, changes in both the theater and publishing worlds had reduced the demand for caricature portraits. In his memoirs, press agent Dick Maney remembered fourteen different New York newspapers of the 1910s and 1920s devoting considerable space to the theater. But starting in the mid-1930s, he noted, many papers folded or merged, and the survivors greatly reduced their amusement sections. At the same time, many theaters were driven out of business by various

10.35 *William Powell and Myrna Loy in* Love Crazy (1892–1984; 1905–93) by Jacques Kapralik. Collage, 55.9 x 40.7 cm (22 x 16 in.), 1941. The Michael Kaplan Collection.

economic reverses, including competition from radio and film. The press agents, who hawked pictures and releases to drama editors, found their own numbers reduced. Maney, and others who survived, learned to use different outlets, planting bits of gossip about their plays and players in syndicated newspaper columns.[47] The columnists, however, did not use pictorial material.

Magazine caricature diminished as well. Photographic covers and illustrations dominated the design aesthetic. Paolo Garretto, returning to the United States in 1946, discovered that editors no longer wanted his brand of stylized portraiture. "It was not me who stopped working for the American magazines," he later wrote, "but the American magazines [had] changed a lot. They published less and less drawings." Designers, who had once adapted modern art for covers, features, and advertising, turned increasingly to photography for its innovative look or its perceived

sense of realism. In his study of American advertising Roland Marchand found that advertisers of the mid-1920s considered color and modern art more effective than photographs in capturing attention, but that during the Depression, the trend began to reverse. In a 1932 Gallup poll readers ranked photographs above all other illustrations in effectiveness.[48] By the mid-1940s Garretto and many others faced a rapidly declining market. Many soldier draftsmen did not return to caricature after the war.

Literary and artistic changes in the postwar period contributed to new fashions in humor; existentialism, abstract expressionism, and the theater of the absurd did not bode well for Beerbohmian detachment or Algonquin-style wit. Charles Demuth, who had admired Peggy Bacon's ability to review her subjects lightly but completely, had prophetically recognized that this quality would not always be appreciated. "Lightness is seldom understood," he wrote, "and never forgiven." The nature of celebrity transformed as well in the second half of the century. Television familiarity reduced the size and grandeur of famous individuals, and promoters and feature writers no longer colluded to reinforce reputations. Al Hirschfeld observed in 1984 that his famous subjects "used to be bigger than life; now they're smaller. They used to kind of invent themselves. The Carol Channings and Ed Wynns. They were remarkable. And they were much easier to do, to establish a symbol for."[49]

In the 1940s caricature began to lose its clear celebrity definition and stylish sophistication. In the pages of Henry Luce's *Life* magazine, for instance, the use of distorted portraiture indicates shifting criteria. During the decade *Life* reported on the canteen at the Hotel Edison, where Sam Norkin drew free caricatures for servicemen to send home to their families, and on the caricature mural at Donahue's bar and grill in the Bronx, which artist Clifford Saber filled with portraits of regular patrons. The editors reproduced the photograph of a refrigerator filled with famous faces made from fruits and vegetables, and another of Hitler, Mussolini, and Hirohito caricatures painted on the back of chorus girls' panties.[50] In these, the spirit of Frank Crowninshield seems to have been entirely extinguished. Without its urbane sophistication, celebrity focus, or high artistic standards, the distorted portrait could easily return to the realm of the amateur artist's prank or county fair midway attraction.

Life's photographs by Alfred Eisenstaedt, published on September 26, 1949, twisted comic portraiture in another direction.[51] Working on assignment in Hollywood, Eisenstaedt challenged a studio makeup artist to transform him into such famous film stars or roles as Veronica Lake, Groucho Marx, Peter Lorre, Mr. Hyde, Napoleon Bonaparte, and Samson. The resulting images have elements of exaggeration, witty intent, and satiric approach to celebrity that connect them to caricature. They overtly mock the Hollywood glamour photograph, which is touched up, posed, and lighted to conform to ideals of beauty or manliness. The images do not depict actual stars but Eisenstaedt's mock-celebrities, only suggesting the essence of the actors themselves. With reference to the artifice and illusion of the movie industry, as well as personal exploration of identity, playacting, and gender attributes, they introduce layers of meaning far beyond the intent of the caricature draftsmen. The American public, nearly four decades after Stieglitz's pioneer exhibitions at 291, had become accustomed to the more complex significance of figural distortion in art. Stylized exaggerations had formal, expressive values that no longer necessarily seemed comic.

Did celebrity caricature disappear, then, after World War II, in response to changing trends and fashions? The conclusion of the story is neither so grim nor so tidy. Instead of vanishing, distorted portraits of the famous retreated to specialized niches. Hirschfeld continued to uphold the tradition with his pen and ink sketches of entertainment figures in the *New York Times*, well aware that his was an unusual publishing arrangement. "There is no lack of talent in caricature," he commented in the 1966 article "Vanishing Caricaturists" for the *National Observer*, "but there is a lack of sponsorship. There is no place to go with it. I seem to be alone with a 40-mile-an-hour gale around me."[52] The article also discussed David Levine, who was just beginning a successful caricature career against all odds. His specialty, carefully hatched pen and ink caricatures of literary figures, published primarily in the *New York Review of Books*, proved enduringly popular. Despite these beloved, well-established niches, however, celebrity caricature waned in the decades that followed, as artists such as Ronald Searle, Ed Sorel, and Pat Oliphant led new generations of humorists toward a sharper, more satirical analysis of fame. "Let's face it," Hirschfeld admitted in 1971, "caricature is not a growth industry.

10.36 *Radio Talent* by Miguel Covarrubias. Watercolor on paper, 40 x 61.7 cm (15 ¾ x 24 ¼ in.), c. 1938. Original illustration for *Fortune* (New York), May 1938. National Portrait Gallery, Smithsonian Institution, Washington, D.C.

The impact of caricature in present-day publishing is not all that important."[53]

The flowering of celebrity caricature thus remains a story of the first half of the century. Covarrubias's image "Radio Talent" (fig. 10.36) from the May 1938 issue of *Fortune* reminds us that such pictures spoke to a generation wrestling with mass media–generated celebrity as a new phenomenon. Caricature pinpointed the attributes of freshly minted public figures and strengthened a bond with their audience by establishing a teasing, nonthreatening familiarity. On the other hand, it also explored the unsettling effects of mass communication. For all its humor, Covarrubias's ghostly evocation of disembodied personalities wafting out over the evening airwaves has nightmarish overtones. The accompanying article addresses the spiraling costs of famous voices, competition between sponsors, and Hollywood's controlling role as the "greatest maker and taker of Names on earth."[54] Ultimately, this bright,

fresh genre of popular portraiture shed new perspective on the celebrity industry, serving as a witty counterbalance to unrestrained fandom.

Caricature, along with other popular arts of the period, helped Americans adapt to change in their environment. Sharply stylized portraiture alleviated the shock of radical art movements. Spoofing everyone of note with equal relish, caricature eased the class, gender, and ethnic mixing that characterized café society and new leisure activities. Mocking highbrow-lowbrow anxieties, it relieved tensions as it tore down barriers. Unlike some of their satiric predecessors, caricaturists of the era lacked a revolutionary zeal. Only Fornaro landed in jail, and that was because of his scathing words, not his mild portrayals. Few of Crowninshield's artists set out to change the world; but by exploring fame and contributing to a common vocabulary of visual imagery, they helped forge a new consciousness of contemporary life.

Reflecting current trends in American art, publishing, theater, advertising, and humor, caricature also left its mark on all of those fields. "Radio Talent," for instance, conveys the panoramic vision of mural art, a reminder of the use of celebrity faces in wall-sized paintings. The impact of the caricature vogue can also be seen in the launching of the smart magazines, dada portraiture in the 1920s, figural distortion in art and advertising of the 1930s, and comic imitation in radio, stage performance, and film. Absorbed into the creative influences of the time, the light, satiric tone of these pictures resonated in ways we have yet to fully explore.

Celebrity caricature often reflected the bright, glossy surface of the age rather than the underlying essence. But that gay, gaudy exterior was a critical element of the culture, serving as a protective device in confronting and absorbing the new. The caricaturists probed that glittering fiction, portraying "the figure a man cuts before his fellows," as Barton called it, "to conceal the writhings of his soul." Rather than strip away the outer coating, they exaggerated and mocked it. The humor of Frueh, Barton, Covarrubias, and others was a bracing astringent, fortifying their audience as it faced the challenges of the modern urban era.

Notes

CHAPTER ONE

1. "Editor's Uneasy Chair," *Vanity Fair* (February 1934), 9.

2. William Auerbach-Levy, "A Caricaturist Switches on His Victims," *New York World* (October 18, 1925).

3. "Editor's Uneasy Chair," *Vanity Fair* (January 1933), 11.

4. Useful essays that give more detail on the history of cartoon and caricature are Ernest H. Gombrich and E. Kris, *Caricature* (Harmondsworth, England: Penguin, 1940); *Caricature and Its Role in Graphic Satire* (Providence, R.I.: Brown University, 1971), introduction; and Maurice Horn, "Caricature and Cartoon: An Overview," in Maurice Horn, ed., *World Encyclopedia of Cartoons* (New York: Gale Research, 1980), 15–34.

5. *Caricature and Its Role*, 6, 25.

6. *Creating French Culture: Treasures from the Bibliothèque Nationale de France* (New Haven: Yale University Press, 1995), 400–402.

7. See Bernard F. Reilly, Jr., *American Political Prints, 1766–1876* (Boston: G. K. Hall, 1991).

8. Horn, "Caricature and Cartoon," 27.

9. Carlo de Fornaro, "Caricature and Cartoon: A Distinction," *The Criterion* (October 1900), 6–7.

10. Frank Crowninshield, "Introduction," in Miguel Covarrubias, *Negro Drawings* (New York: Knopf, 1927), n.p.

11. Roland Marchand, *Advertising the American Dream: Making Way for Modernity, 1920–1940* (Berkeley: University of California Press, 1985), 117–163.

12. Marchand, *Advertising the American Dream*, xv.

13. Stehlisilks Corporation, *Americana Prints: A Collection of Printed Silks Designed by Six Contemporary American Artists* (New York: Stehlisilks Corporation, 1926), 1.

14. William Auerbach-Levy, *Is That Me? A Book about Caricature* (New York: Watson-Guptill, 1947), 25.

15. Warren I. Susman, "Personality and the Making of Twentieth-Century Culture," in *Culture as History: The Transformation of American Society in the Twentieth Century* (New York: Pantheon, 1973), 271–285.

16. Daniel J. Boorstin, *The Image: A Guide to Pseudo-Events in America* (New York: Atheneum, 1971), 13.

17. Albert Bigelow Paine, *Th. Nast: His Period and His Pictures* (New York: Macmillan, 1904), 109–111.

18. Leo Braudy, *The Frenzy of Renown: Fame and Its History* (New York: Oxford University Press, 1986), 298.

19. Elmo Scott Watson, *History of Newspaper Syndicates in the United States, 1865–1935* (Chicago, 1936), 84.

20. Richard Schickel, *Intimate Strangers: The Culture of Celebrity* (Garden City, N.Y.: Doubleday, 1985), 66–67.

21. Sally F. Griffith, "Mass Media Come to the Small Town: The *Emporia Gazette* in the 1920s," in *Mass Media Between the Wars* (Syracuse, N.Y.: Syracuse University Press, 1984), 148.

22. Richard DeCordova, *Picture Personalities: The Emergence of a Star System in America* (Urbana: University of Illinois Press, 1990), 8–12.

23. Ben Yagoda, *Will Rogers: A Biography* (New York: Knopf, 1993), 267 n.

24. Dwight Macdonald, "A Theory of Mass Culture," in Bernard Rosenberg and David Manning White, eds., *Mass Culture* (Glencoe, Ill.: Free Press, 1957), 66–67. See also Boorstin, *The Image*, 57–58. *International Celebrity Register*, Cleveland Amory, ed. (New York: Harper, 1959), v.

25. See Lawrence W. Levine, *Highbrow/Lowbrow: The Emergence of Cultural Hierarchy in America* (Cambridge: Harvard University Press, 1988).

26. Erich Posselt, ed., *On Parade: Caricatures by Eva Herrmann* (New York: Coward-McCann, 1929), 18. Van Wyck Brooks, *America's Coming of Age* (New York: B. W. Huebsch, 1915), 7.

27. For discussion of the role of the media in the emergence of middlebrow culture, see Amy Henderson, *On the Air: Pioneers of American Broadcasting* (Washington, D.C.: Smithsonian Institution Press, 1988).

28. Ibid., 51–52.

29. *Vanity Fair* (October 1932), 49, (January 1932), 37.

30. *Vanity Fair* (December 1934), 40.

31. Howard Greenfeld, *Caruso* (New York: Putnam's, 1983), 182. Philip Hoare, *Noel Coward: A Biography* (New York: Simon and Schuster, 1995), 250.

32. Schickel, *Intimate Strangers*, 4; Braudy, *Frenzy of Renown*, 494.

33. Braudy, *Frenzy of Renown*, 576.

CHAPTER TWO

1. Louis Baury, "Wanted: An American Salon of Humourists," *Bookman* 40 (January 1915): 525, 539–540.

2. Robert Henri, John Sloan, George Luks, William Glackens, and Everett

Shinn were prominently featured, along with such *Masses* artists as Maurice Becker, Art Young, Stuart Davis, Glenn Coleman, Boardman Robinson, and Oscar Cesare. A number of reviews for the exhibition are collected in a scrapbook in the Stuart Davis papers, Archives of American Art, Smithsonian Institution, Washington, D.C.

3. The only hint of modernism was an abstract canvas painted by George Luks, satirically entitled *Portrait of a New Art Critic*, that spoofed the extremes of contemporary painters. Luks' parody baffled reviewers who described it as an impenetrable picture of "occult mystic significance" or simply a "rather dizzy looking thing." *New York Evening Post* (April 17, 1915); *New York Morning Telegraph* (April 25, 1915).

4. Max Beerbohm, "Laughter of the Public," *Living Age* 233 (April 5, 1902): 52.

5. Max Eastman, *The Sense of Humor* (1921; rpt., New York: Octagon, 1972). Eastman developed his ideas further in *The Enjoyment of Living* (1936; rpt., New York: Harper, 1948).

6. Walter Blair and Hamlin Hill, *America's Humor: From Poor Richard to Doonesbury* (New York: Oxford University Press, 1978), 370–371. Kenneth S. Lynn, *The Comic Tradition in America* (New York: Doubleday, 1958), xii. Jeannette Tandy published *Crackerbox Philosophers in American Humor and Satire* in 1925; Constance Rourke's *American Humor: A Study of the National Character* appeared in 1931; and Walter Blair's *Native American Humor (1800–1900)* followed in 1937. See also William Bedford Clark and W. Craig Turner, *Critical Essays on American Humor* (Boston: G. K. Hall, 1984).

7. As one film historian has pointed out, "The American comic tradition and the American movies were made for each other." Robert Sklar, *Movie-Made America: A Cultural History of American Movies* (New York: Vintage, 1975), 104.

8. *Puck* published a series of caricature supplements, entitled "Puckograms," from 1879–83. For the most part, however, these magazines concentrated on political cartooning. As Rebecca Zurier has pointed out, the papers of a number of New York artists working for *The Masses*, such as Maurice Becker, Kenneth Chamberlain, Al Frueh, John Sloan, and Art Young, include copies of the leading European humor magazines. Zurier, *Art for the Masses* (Philadelphia: Temple University Press, 1988), 34, 190 n. 17.

9. Eastman, *Enjoyment of Living*, 421. See also Zurier, *Art for the Masses*.

10. Allen Churchill, *The Improper Bohemians* (New York: E. P. Dutton, 1959), 107.

11. Eastman, *Enjoyment of Living*, 416. David Ewen, *George Gershwin: His Journey to Greatness* (New York: Ungar, 1986), 236.

12. The *Twillbe* playbill is in the Sloan papers, Library, Delaware Art Museum. Sloan's reminiscences, Library, Delaware Art Museum, quoted in William Innes Homer, *Robert Henri and His Circle* (Ithaca: Cornell University Press, 1969), 79.

13. Theatrical press agent Edward Bernays was undoubtedly typical of many Americans when he wrote that his notions of Paris came entirely from reading Du Maurier's novel; see Edward L. Bernays, *Biography of an Idea: Memoirs of Public Relations Counsel Edward L. Bernays* (New York: Simon and Schuster, 1965), 42. Jan Seidler Ramirez, *Within Bohemia's Borders: Greenwich Village, 1830–1930* (exh. script) (New York: Museum of the City of New York, 1990), 10.

14. Descriptions of PAFA caricature exhibits can be found in Cheryl Leibold's introduction to Peter Hastings Falk, ed., *The Annual Exhibition Record of the Pennsylvania Academy of the Fine Arts, 1876–1913*, 3 vols. (Madison, Conn.: Sound View Press, 1989), 2: 8, 9, 22, 23. Photographs of the caricature images are in the PAFA archives and are also on microfilm in the Archives of American Art. See also "A Caricature Exhibition," *Philadelphia Times* (March 4, 1894).

15. Manuscript poem, Sloan papers, Library, Delaware Art Museum.

16. The story of these Philadelphia sketch artists, Henri's Tuesday nights, and the amateur theatricals is told frequently in the literature about these individuals. Helpful sources include Ira Glackens, *William Glackens and the Eight* (1957; rpt., New York: Horizon, 1984); Bennard B. Perlman, *The Immortal Eight* (New York: Exposition, 1962); and Homer, *Robert Henri*.

17. Charles Rearick, *Pleasures of the Belle Epoque: Entertainment and Festivity in Turn-of-the-Century France* (New Haven: Yale University Press, 1985), 35–42.

18. Ibid., 37–38, 43–46.

19. Bruce Kellner, *The Last Dandy: Ralph Barton, American Artist, 1891–1931* (Columbia: University of Missouri Press, 1991), 52–53. "Art and Artists Pass in Review," *Philadelphia Inquirer* (May 18, 1919).

20. Charles Baudelaire, "Peintre de la Vie Moderne," translated in P. G. Konody, *The Painter of Victorian Life* (New York: William Edwin Rudge, 1930), 52. The language in this early translation of Baudelaire's essay is more consistent with the popular concepts of the period than are later translations.

21. George du Maurier, *Trilby: A Novel* (New York: Harper and Brothers, 1895), 76–77.

22. John Sloan, "Artists of the Press," *Philadelphia Museum Bulletin* 41, no. 207 (November 1945): 7.

23. The beginning verses, now torn off, are inscribed in pencil just beneath the poem. In the same hand, at the bottom of the sheet, is the pencil inscription: "This drawing hung for years on wall of Phila Press Art Dept." Delaware Art Museum.

24. "Everett Shinn on George Luks: An Unpublished Memoir," *Journal of the Archives of American Art* 6, no. 2 (April 1966): 5.

25. James B. Moore, proprietor of Café Francis, frequently had the group over to his own brownstone mansion, where they decorated the basement rooms with humorous paintings. Once, when Moore was away, Sloan, Shinn, and Glackens created a mural featuring their host in a high hat and ladies' lingerie, with caricatures of their friends in the background (Perlman, *Immortal Eight*, 135–136; Bruce St. John, ed., *John Sloan's New York Scene from the Diaries, Notes, and Correspondence, 1906–1913* [New

York: Harper and Row, 1965], 26).

26. John Sloan to Dolly Sloan [c. 1903–4], Sloan correspondence, Delaware Art Museum. Homer, *Robert Henri*, 31, 195.

27. See Churchill, *Improper Bohemians*, 93, 108–113.

28. *New York World* magazine, December 27, 1914.

29. Max Beerbohm, *Caricatures of Twenty-Five Gentlemen* (London: Leonard Smithers, 1896), 12. For information on Beerbohm in America, see Katherine Lyon Mix, *Max and the Americans* (Brattleboro, Vt.: Stephen Green, 1974).

30. Mix, *Max and the Americans*, 13.

31. J. G. Riewald, ed., *Beerbohm's Literary Caricatures* (Hamden, Conn.: Archon, 1977), 20.

32. Mix, *Max and the Americans*, 58, 179–183. Willard Huntington Wright "America and Caricature," *Vanity Fair* (July 1922), 55.

33. Aline Fruhauf, *Making Faces: Memoirs of a Caricaturist*, Erwin Vollmer, ed. (Cabin John, Md.: Seven Locks Press, 1987), 78. As Eric Denker has pointed out, Beerbohm had himself photographed by Filson Young in 1916 in a similar pose. Denker, *In Pursuit of the Butterfly: Portraits of James McNeill Whistler* (Washington, D.C.: National Portrait Gallery in association with University of Washington Press, 1995), 158–160.

34. Max Beerbohm, "The Spirit of Caricature," *Pall Mall Magazine* (January–April 1901), 121–125. The essay was partially quoted in a New York magazine article liberally illustrated with his caricatures (Arthur Lawrence, "Max," *The Critic* [November 1901], 456) and reprinted in Max Beerbohm, *A Variety of Things* (New York: Knopf, 1928), 119.

35. Benjamin de Casseres, "Caricature, and Max Beerbohm," *Metropolitan Magazine* (November 1906), 199.

36. *Current Opinion* (March 1921), 393; Bohun Lynch, "Max Beerbohm," *Dial* (February 1921), 181. Riewald, *Beerbohm's Literary Caricatures*, 16. Baudelaire, "Peintre de la Vie Moderne," 134.

37. Lewis A. Erenberg, *Stepping Out: New York Nightlife and the Transformation of American Culture, 1890–1930* (Westport, Conn.: Greenwood, 1981), 40–50, 114–132.

38. Cleveland Amory, *Who Killed Society?* (New York: Harper and Brothers, 1960), 108.

39. Milton W. Brown, *The Story of the Armory Show* (New York: n.p., 1963), 117.

40. Robert C. Benchley, "Mr. Vanity Fair," *Bookman* 50 (January 1920): 430. Geoffrey T. Hellman, "Last of the Species—I" (Profile of Frank Crowninshield), *New Yorker* (September 19, 1942), 22.

41. Geoffrey T. Hellman, "Last of the Species—II," (Profile of Frank Crowninshield) *New Yorker* (September 26, 1942), 27.

42. Raymond Wemmlinger, Brooks McNamara, Robert Carter, et al., *Edwin Booth's Legacy: Treasures from the Hampden-Booth Theatre Collection at the Players* (New York: Hampden-Booth Theatre Library, 1989), 13.

43. "Some Coffee House Pre-History," Program, the Coffee House Golden Anniversary Dinner, 1965.

44. *Vanity Fair* (August 1923), 40.

45. Tina Margolis, "A History of Theatrical Social Clubs in New York City" (Ph.D. diss., New York University, 1990), 51–122.

46. "The Solemn, Sepulchral Seance Scene at the Dutch Treat Club's Ides of March Show," *New York World* (March 21, 1920).

47. James Montgomery Flagg, *Roses and Buckshot* (New York: G. P. Putnam's Sons, 1946), 112–114.

48. Caruso, whose talent for drawing was recognized before his vocal skills were, drew caricatures for most of his career. *La Follia di New York* occasionally published a volume of his collected portraits. Walt Kuhn remembered Caruso making caricatures when he came to visit the Armory Show in 1913; see Kuhn, *The Story of the Armory Show* (New York: n.p., 1938), 17.

49. Blair and Hill, *America's Humor*, 368.

50. Frank Luther Mott, *A History of American Magazines*, 5 vols. (Cambridge: Harvard University Press, 1968), 5: 246–251. James Wyman Barrett, *Joseph Pulitzer and His World* (New York: Vanguard, 1941), 304.

51. See Sally Ashley, *F. P. A.: The Life and Times of Franklin Pierce Adams* (New York: Beaufort, 1926); F. Scott Fitzgerald, "My Lost City," in Edmund Wilson, ed., *The Crack-Up* (1945; rpt., New York: New Directions, 1993), 26.

52. Hellman, "Last of the Species—II," 24.

53. "In Vanity Fair," *Vanity Fair* (March 1914), 15.

54. Ibid.

55. Cynthia L. Ward, *Vanity Fair Magazine and the Modern Style, 1914–1936* (Ph.D. diss., State University of New York at Stony Brook, 1983), 117–123; Benchley, "Mr. Vanity Fair," 432.

56. Carl Van Doren, "Day In and Day Out, Adams, Morley, Marquis, and Broun: Manhattan Wits," *Century* (December 1923), 311.

57. Franklin P. Adams, "It Was Originally the Thanatopsis Pleasure and Inside Straight Club," *Stage* (February 1935), 24–25. The Algonquin Round Table and its poker club are described in the biographies of all its principal members. Another early chronicler was Margaret Case Harriman, *The Vicious Circle* (New York: Rinehart, 1951). A recent appraisal appears in Thomas Kunkel, *Genius in Disguise: Harold Ross of the New Yorker* (New York: Random House, 1994), 75–82.

58. Ann Douglas, *Terrible Honesty: Mongrel Manhattan in the 1920s* (New York: Farrar, Straus, and Giroux, 1995), 31–40.

CHAPTER THREE

1. *Dramatic Mirror* (New York) (January 21, 1899), 15. For additional biographical details on Carlo de Fornaro, see "Chicago's New Caricaturist," *Chicago Chronicle* (May 16, 1897); "Carlos de Fornaro," *Arte y Letras* (1906); "Carlo de Fornaro," *Bruno's Weekly* (Aug. 19, 1916); and Carlo de Fornaro, *A Modern Purgatory* (New York: Mitchell Kennerley, 1917), vii–xiv. See also the

microfilm of Fornaro's scrapbooks at the New York Public Library.

2. "Chicago's New Caricaturist," *Chicago Sunday Chronicle* (May 16, 1897).

3. For example, see Beatrice Farwell, *The Charged Image: French Lithographic Caricature, 1816–1848* (Santa Barbara, Calif.: Santa Barbara Museum of Art, 1989), 123–124.

4. Gordon M. Marshall, "The Golden Age of Illustrated Biographies: Three Case Studies," in Wendy Wick Reaves, ed., *American Portrait Prints: Proceedings of the Tenth Annual American Print Conference* (Washington, D.C., 1984), 29–30.

5. Charles Baudelaire, "On the Essence of Laughter," in Jonathan Mayne, ed. and trans., *The Painter of Modern Life and Other Essays* (London: Phaidon, 1964), 164.

6. *Illustrated American* (April 9, 1898), 464. Although many of Otto Toaspern's contributions to *Life* were mild exaggerations of photographic images, his full-page caricature series, which ran from October 1897 through June 1898, featured powerful distortions of such figures as James Gordon Bennett, Joseph Pulitzer, Theodore Roosevelt, and William Jennings Bryan. Toaspern had studied at the Fine Arts Academy in Munich, and this series reflected a heavier, more satiric Germanic flavor than the Parisian caricature that Fornaro was introducing.

7. *Dramatic Mirror* (New York) (January 21, 1899), 15.

8. Ibid.

9. *New York Telegraph* (November 9, 1902). A similar drawing of Fitch with the same head but different clothes appeared in the *Dramatic Mirror* (June 3, 1899).

10. *The Critic* (July 1900), 12–14.

11. Carlo de Fornaro, "Caricature and Cartoon: A Distinction," *The Criterion* (October 1900), 6–7.

12. Sem's album of fashionable demi-mondaines was said to be a particular success, causing the price to skyrocket. Carlo de Fornaro, "The Caricaturist Who Draws with a Scalpel," *Arts and Decoration* (September 1923), 19.

13. Christian Brinton, "Sem, Cappiello, and Fornaro," *The Critic* (December 1904), 545, 550–552.

14. Alan Fern, *Words and Image* (New York: Museum of Modern Art, 1968), 15.

15. Brinton, "Sem, Cappiello, and Fornaro," 552–553.

16. Paul Haviland, "Photo-Secession Notes," *Camera Work* 28 (October 1909): 51.

17. Benjamin de Casseres, "Caricature and New York," *Camera Work* 26 (April 1909): 17.

18. *Everybody's* magazine published eight Fornaro caricatures of "Presidential Possibilities" in the June 1904 issue with the comment that "Mr. de Fornaro's reputation in this line of work is second to none" (867).

19. *New York Evening Journal* (January 3, 1903). *Millionaires of America* was issued by the Medusa Publishing Company. According to a pamphlet in the New York Public Library clipping file, it was published in two limited deluxe editions, one of one hundred copies at ten dollars (signed by the artists) and the other of four hundred copies at five dollars. Untitled newspaper clipping (review of *Millionaires of America*), c. 1902, New York Public Library clipping file.

20. "Twelve Famous American Millionaires Caricatured Freely in New Book," *New York World* (January 4, 1902).

21. Changes in staff following the November 1902 death of Nelson Hersh, editor of the *New York World* Sunday edition, probably inspired the new format. See *Editor and Publisher* (November 22, 1902), 1.

22. For Pulitzer's effort to expand circulation and reach diverse groups of readers, see George Juergens, *Joseph Pulitzer and the New York World* (Princeton, N.J.: Princeton University Press, 1966).

23. James Wyman Barrett, *Joseph Pulitzer and His World* (New York: Vanguard, 1941), 81. Pulitzer initially used the Russian artist Valerie Gribayedoff to make these portraits.

24. Juergens, *Joseph Pulitzer*, 105.

25. Ibid., 112.

26. Jib Fowles, *Starstruck: Celebrity Performers and the American Public* (Washington, D.C.: Smithsonian Institution Press, 1992), 25–28.

27. The cartoonist Herb Roth took on many of the subjects that Fornaro had covered. His black ink style seemed to be influenced by Fornaro, but his short, squat figures, more closely related to comic-strip cartooning than to the refined lines of Sem and Cappiello, never seemed as distinctive on the page. Other *World* illustrators, however, were influenced by the Fornaro formula.

28. On Fornaro's political involvement and trial, see Fornaro, *Modern Purgatory*, introduction. See also clippings about the trial in the Fornaro scrapbooks. Fornaro retained his interest in Mexican affairs, writing about Mexico for *The Masses* in March and April 1911 and publishing *Carranza and Mexico* in 1915.

29. In 1922–25, Fornaro wrote an important series of articles on caricature for *Arts and Decoration*. At about the same time, he published a small book of his theater posters, *Let Fornaro Do It*, written by Benjamin de Casseres, and painted a mural on the walls of the Park Theatre. An exhibition of his portraits of the presidents—"both conventional and in caricature"—was held at the Hudson Park Branch of the New York Public Library (*New York Times*, June 2, 1944). Fornaro died at the West Shore Hotel on West 42nd Street on August 25, 1949 (*New York Times*, August 26, 1949).

30. "As Pictured by Fornaro," *New York World* (February 17, 1912); F. E. A. Curley, "Caricatures," *Dramatic Mirror* (August 1912). See also "Cartoons by C. de F.," *New York Times* (March 10, 1912), and Henry Tyrrell, "We Have with Us Today," *New York World* (February 4, 1912).

31. Benjamin de Casseres, "The Psychology of Caricature," in *Mortals and Immortals* (New York: Hornet, 1911), n.p.; "A Gallery of Caricature by Fornaro," *New York American* (April 6, 1912).

32. De Casseres, "Psychology of Caricature."

33. De Zayas's article "The New Art in Paris" was reprinted from *Forum* magazine (February 1911), and his essay on Picasso was also printed in pamphlet form for the 291 exhibition. See *Camera Work* 34–35 (April–July 1911): 29–34, 65–67.

34. William Allen White, *The Autobiography of William Allen White* (New York: Macmillan, 1946), 298.

35. Albert Shaw, *Cartoon History of Roosevelt's Career* (New York: Review of Reviews, 1910), viii.

CHAPTER FOUR

1. *As Others See Us: A Semi-Monthly of Comment and Caricature* 1 (January 1, 1908): 1.

2. Ibid.

3. The most extensive source for biographical data on Marius de Zayas is Douglas Hyland, *Conjuror of Souls* (Lawrence, Kan.: Spencer Museum of Art, 1981). The De Zayas Archive is owned by his son, Rodrigo de Zayas, and is in Seville, Spain. Some of De Zayas's correspondence can be found in the Stieglitz papers at the Beinecke Rare Book and Manuscript Library, Yale University. Other important sources include Craig R. Bailey, "The Art of Marius de Zayas," *Arts Magazine* 53 (September 1978) 1:136–144; Marius de Zayas, "How, When, and Why Modern Art Came to New York," introduction and notes by Francis M. Naumann, *Arts Magazine* 54, no. 8 (April 1980): 96–126; Willard Bohn "The Abstract Vision of Marius de Zayas," *Art Bulletin* 62, no. 3 (September 1980): 434–452; and William Innes Homer, *Alfred Stieglitz and the American Avant-Garde* (Boston: New York Graphic Society, 1977).

4. *América* (December 1909), 462. *La Follia di New York* (September 8, 1912).

5. *Current Literature* 44, no. 3 (March 1908): 281. For more on the Vagabonds, see *The Bang* 2, no. 3 (October 28, 1907): 1–4, *The Bang* 4, no. 17 (January 25, 1909): 1–4. Copies of this rare publication can be found in the New York Public Library.

6. Bailey, "Art of Marius de Zayas," 137.

De Zayas made caricature portraits of Gertrude Käsebier, Clarence White, John Nilsen Laurvik, Alfred Stieglitz, and Edward Steichen, many of which are in the collection of the Metropolitan Museum of Art. In his 1909 caricature exhibition at 291, one wall featured his portraits of the members of the Photo-Secession.

7. *The Bang* 2, no. 3 (October 28, 1907): 1–4.

8. "Marius de Zayas: A Master of Ironical Caricature," *Current Literature* 44, no. 3 (March 1908): 281–283. According to the article, De Casseres's comments about De Zayas were first published in the Mexico City *Daily Record*. A copy of the article, in English, is in the De Zayas Archive.

9. Warren I. Susman, "'Personality' and the Making of Twentieth-Century Culture," *Culture as History: The Transformation of American Society in the Twentieth Century* (New York: Pantheon, 1973), 271–285. Henri Laurent, *Personality and How to Build It* (New York: Funk and Wagnalls, 1916), 25. Mae West, *Goodness Had Nothing To Do with It* (Englewood Cliffs, N.J.: Prentice-Hall, 1959), 7.

10. "The Secret of Personality as Theodore Dreiser Reveals It," *Current Opinion* 66 (March 1919): 175–176.

11. William Young, *Famous Actors and Actresses on the American Stage* (New York: R. R. Bowker, 1975), 2: 853.

12. *As Others See Us* 1, no. 5 (March 1, 1908): 10. De Zayas signed the picture with the initials "B. S.," probably assuming that his refined readers would never admit to understanding the vulgar reference.

13. Arthur Brisbane, *New York World* (August 22, 1894). Quoted in John J. O'Neill, *Prodigal Genius* (New York: Ives Washburn, 1944), 283.

14. Dorothy Norman, *Alfred Stieglitz: An American Seer* (New York: Random House, 1973), 107.

15. The *New York Post* (January 9, 1909) described this picture as "Alfred Stieglitz holding up to the light one of his beloved autochromes as only a photographer would."

16. Douglas W. Druick et al., *Odilon Redon: Prince of Dreams, 1840–1916* (Chicago: Art Institute of Chicago in association with Harry Abrams, 1994), 110–111, 252.

17. Agnes E. Meyer, *Out of These Roots* (Boston: Little, Brown, 1953), 68.

18. Hyland, *Conjuror of Souls*, 90. The gilt sun drawings and numerous other De Zayas works were given to Stieglitz after the first exhibition at 291. "I told him to keep all of it," De Zayas told Norman. "I gave him everything of mine on display at 291." Norman, *Alfred Stieglitz*, 107. They are now in the collection of the Metropolitan Museum of Art.

19. The exhibition of Rodin drawings became the second nonphotographic show at 291, mounted in January 1908. Homer, *Alfred Stieglitz*, 34, 40.

20. Paul Haviland, *Camera Work* 26 (April 1909): 36–37. Information on the show also appears in the comment on the plates, *Camera Work* 29 (January 1910): 61. Reviews include Henry Tyrrell, "De Zayas's Work in Charcoal Shown," *New York Evening World* (January 6, 1909); *New York Post* (January 9, 1909); and *The Bang* 4, no. 17 (January 25, 1909).

21. Benjamin de Casseres, "Caricature and New York," *Camera Work* 26 (April 1909): 17–18.

22. Guy Pène de Bois, "Caricatures Are Difficult to Draw, Because They Must Be Devoid of All Malice," *New York American* (August 8, 1910).

23. "Marius de Zayas: A Kindly Caricaturist of the Emotions," *Craftsman* 13 (January–March 1908): 385–395. *The Bang* 4, no. 17 (January 25, 1909): 2–4. Leon Dabo, *The Bang* 2, no. 3 (October 28, 1907): 4; Sadakichi Hartmann, "De Zayas," *Camera Work* 31 (July 1910): 32.

24. Henri Bergson, *Laughter: An Essay on the Meaning of the Comic* (1911; rpt., New York: Macmillan, 1937), 28–29, 49. Henry Tyrrell, "Exhibition of Caricature by Noted Artist at Photo-Secession Galleries," *New York Evening World* (January 6, 1909).

25. *Camera Work* 29 (January 1910): 61.

The paragraph about the De Zayas plates explains: "The originals are 22 x 28 inches, executed in black French chalk; so subtle in their color value as to defy reproduction by the ordinary methods. This is the first occasion on which an adequate representation of their original humor and technical charm has been attempted. We feel sure that our readers will detect in these few examples the very unusual quality of mind and craftsmanship possessed by De Zayas."

26. Hyland, *Conjuror of Souls*, 13.

27. The mock-up for the book is in the De Zayas Archives, Seville.

28. Caroline Caffin, *Vaudeville* (New York: Mitchell Kennerley, 1914), 25, 29–32.

29. *New York Times* magazine (May 1, 1910). Henry Tyrrell, "De Zayas Applies Parisian Novelty to Fifth Avenue," *New York Evening World* (April 27, 1910).

30. Madeleine Bonnelle and Marie-José Meneret, *Sem* (Périgueux, 1979), 79–80. Sem also published two similar panoramas, *Le Retour des Courses* and *Les Acacias*, made of accordion-folded paper. By unfolding the pages and attaching the first to the last, one could make a circular frieze depicting the parade of passersby.

31. De Zayas would also have been familiar with Pamela Coleman Smith's experiments with a miniature theater. The first nonphotographic show at 291 had featured Smith's drawings preceding the Rodin exhibition that Steichen had advocated. See Bailey, "Art of Marius de Zayas," 137; and Hyland, *Conjuror of Souls*, 28.

32. *Camera Work* 31 (July 1910): 31; *New York Times* magazine (May 1, 1910); *New York Sun* (May 1, 1910); *New York Evening World* (April 27, 1910).

33. Acton Davies, "News of the Theatres," *Evening Sun* (May 5, 1910). Hartmann, "De Zayas," 31–33.

34. See, for example, a series of caricature sketches of Picasso and his friends at the Museo Picasso, Barcelona.

35. Letter from Rodrigo de Zayas,

November 22, 1995, National Portrait Gallery.

36. The Picasso exhibition opened in April 1911 at 291; the first exhibition of African sculpture opened in November 1914.

37. For analysis of De Zayas's abstract caricatures, see Bohn, "Abstract Vision of Marius de Zayas," 3: 434–452. See also Hyland, *Conjuror of Souls*, 30–39; and Bailey, "Art of Marius de Zayas," 138–144. Marius de Zayas, "Pablo Picasso," *Camera Work* 34–35 (April–July 1911): 66.

38. De Zayas, "How, When, and Why Modern Art Came to New York," 114.

39. Hyland, *Conjuror of Souls*, 108.

40. Marius de Zayas, *Camera Work* 42–43 (April–July 1913): 20–22.

41. "Drawings by Marius de Zayas," *American Art News* 11, no. 20 (April 25, 1913): 2; Bohn, "Abstract Vision of Marius de Zayas," 439.

42. The newspaper reviews were reprinted in *Camera Work* 31 (April–July 1913): 51–65.

43. Since the portrait of Dr. A. A. Berg was not listed in the catalogue, it may not have been in the exhibition. See Bohn, "Abstract Vision of Marius de Zayas," 437.

44. See William A. Camfield, "The Machinist Style of Francis Picabia," *Art Bulletin* 48, nos. 3–4 (September–December 1966): 314; William Rozaitis, "The Joke at the Heart of Things: Francis Picabia's Machine Drawings and the Little Magazine 291," *American Art* 8, nos. 3–4 (Summer–Fall 1994): 44–48.

45. William Agee, "New York Dada, 1910–1930," in Thomas B. Hess and John Ashbery, eds., *The Avant-Garde* (New York: Macmillan, 1968), 107.

46. Bailey, "Art of Marius de Zayas," 136, 138; Bohn, "Abstract Vision of Marius de Zayas," 435; Hyland, *Conjuror of Souls*, 33. For the mutual influence and collaboration between De Zayas and Picabia, see Bailey, "Art of Marius de Zayas," 144; Bohn, "Abstract Vision of Marius de Zayas," 434–435; and Agee, "New York Dada," 107–108.

47. Martha S. Anderson, "The Indigenous Roots of New York Dada" (Ph.D. diss., University of Maryland at College Park, 1986), 111–126.

48. Hartmann, "De Zayas," 32.

CHAPTER FIVE

1. Joseph Van Raalte, "Gallery of The World Notables. No. 1—Frueh," *New York World* (January 23, 1921). *Who's Who on the World* [n.d.], 17, Frueh papers, Archives of American Art, Smithsonian Institution (hereafter cited as Frueh papers).

2. Brendan Gill, "Alfred Frueh," *New Yorker* (September 28, 1968), 184.

3. Van Raalte, "Gallery of The World Notables." Years later Frueh re-created those shorthand caricatures for *Vanity Fair*. Despite the constraints of the exercise, the likenesses of celebrities emerge from the shorthand notations, the limber flexibility of Frueh's draftsmanship contrasting humorously with the fixed rigidity of the Pitman symbol. "Alfred Frueh: Once a Stenographer, Always an Artist," *Vanity Fair* (January 1925), 52–53.

4. Al Frueh to Richard Sherman, September 20, 1933, Frueh papers.

5. William Marion Reedy, *St. Louis Mirror* (November 9, 1905).

6. Frueh's reminiscences of his theatrical work appear in Stuart W. Little, "A Half Century of Sketching Stars," *Theatre Arts* 45, no. 7 (July 1961): 60–63; see also Carlo de Fornaro, "Celebrities of the Stage in Caricature," *Arts and Decoration* 18 (December 18, 1922): 21.

7. Little, "Half Century of Sketching Stars," 63.

8. William Marion Reedy, "Alfred Frueh," *St. Louis Mirror* (September 12, 1907). Reedy's comments accompanied a grasshopper-legged caricature of Frueh by local cartoonist Albert Bloch.

9. William C. Young, *Famous Actors and Actresses on the American Stage: Documents of Theater History* (New York: R. R. Bowker, 1975), 1: 307.

10. The clippings relating to the John Drew drawings are found in the Frueh papers.

11. *Who's Who on the World* [n.d.], 17. On March 7, 1909, the *St. Louis Post-Dispatch* published Frueh's illustrated article "Impressions of Paris," describing the art student's life. Henry Tyrrell, "Remarkable Caricatures by a New York Artist—Alfred J. Frueh," *New York World* magazine (January 5, 1913). On the cover of a 1913 exhibition catalogue of Matisse's work, now owned by Barbara Frueh Bornemann, Frueh wrote with humorous deference, "And he's been 'blamed' for *me*." Van Raalte, "Gallery of The World Notables.

12. "Frueh's Caricature Brings Post Card to Ex-Gov. Folk," undated clipping, *St. Louis Post-Dispatch* [1909], Frueh papers. According to biographical notes compiled years later by his wife, a news reporter boarded his boat as it entered New York harbor with a message from O. K. Bovard of the *New York World*; biographical notes by Giuliette Frueh, Frueh papers. See also postcards from Al Frueh to Minnie Frueh, December 3 and 31, 1909; contract between Al Frueh and the Press Publishing Co., July 1, 1910, Frueh papers. Frueh's first signed drawings started appearing in the *New York World* in May 1910.

13. Roy McCardell, "Those Fifty American 'Immortals' Simply Won't Do," *New York World* (December 11, 1910).

14. *Morning Telegraph* (New York) (November 29, 1912).

15. Al Frueh to Giuliette Fanciulli, July 28 and August 25, 1912, Frueh papers. The hot Italian summer involved other hazards. A letter of August 5, 1912, contained a pop-up gallows made of paper and thread. Hanging in the noose was a dead flea, one of the persistent pests described in his letters.

16. Al Frueh to Giuliette Fanciulli, mid-October 1912, June 2[?], 1912, June 3, 1912, November 11, 1912, and December 4, 1912. Frueh enjoyed sightseeing in Paris, sending Giuliette a miniature fold-out gallery of the Louvre with four rooms, doors that opened, and famous pictures painted on the walls. Frueh papers.

17. Al Frueh to Giuliette Fanciulli, December 10, 1912, March [?], 1913, March 24, 1913.

18. Al Frueh to Giuliette Fanciulli, March [?], 1913.

19. Samuel Swift, *New York Sun* (December 12, 1912), reprinted in *Camera Work* 41 (January 1913): 24–25.

20. Giuliette Frueh's biographical notes, Frueh papers.

21. Although Stieglitz undoubtedly had all of Frueh's drawings in his possession, he could not fit them all into the 291 show. The image of McIntyre was not in the exhibit, although it was included in the show that went to St. Louis and Boston.

22. *Camera Work* 41 (January 1913): 24.

23. "An Exhibition of Caricatures of Popular American Actors and Actresses by Alfred J. Frueh" (annotated exhibition brochure), Frueh papers. In addition to the pieces Stieglitz noted, he added the drawing of Alla Nazimova, which does not appear on the printed brochure list. According to one review, it was put in a "box on the side," along with images of Mrs. Fiske and Charlotte Walker (*New York Evening Sun*, December 7, 1912). Alfred Stieglitz to Al Frueh, November 30, 1912, Frueh papers.

24. *New York World* (January 5, 1913).

25. "Actresses' Lines in Caricature," *New York Evening Sun* (December 7, 1912).

26. "The Stars of the Stage Aslant," *New York Morning Telegraph* (December 29, 1912); Samuel Swift, *New York Sun* (December 12, 1912); "Actresses' Lines in Caricature," *New York Evening Sun* (December 7, 1912).

27. *New York Evening Sun* (December 7, 1912); *New York World*, (January 5, 1913).

28. Ann Douglas, *Terrible Honesty: Mongrel Manhattan in the 1920s* (New York: Farrar, Straus, and Giroux, 1995), 60, 55.

29. Alfred Stieglitz to Al Frueh, November 30, 1912; Al Frueh to Giuliette Fanciulli, February 4 and 19, 1913. Frueh papers.

30. At both sites there was a printed list of sixty-five drawings, all caricatures except for the image of the bicycle race that Stieglitz had included at the last minute in the New York show. The newspaper reviews were similar to the critics' assessments in New York. The *Boston Transcript* appreciated his keen sense of humor and remarkable draftsmanship, noting that Frueh's method "is simple and direct, and he makes a minimum of lines tell the whole story, often with astonishing effect" (April 7, 1913).

31. Al Frueh to Giuliette Fanciulli, February 8 1913, April 19, 1913, Frueh papers.

32. Barbara Frueh Bornemann's notes on her mother's recollections of her trip home in September 1914, Frueh papers.

33. *Vanity Fair* (February 1915), 30. The Montrose Gallery chose some of his paper animals as well as a few sketches for a show that ran from March 23 to April 24, 1915 (catalogue of the Montrose Gallery exhibition, Frueh papers). The paper sculpture was featured again in December at the exhibition of "Art Associated with the Child," organized by the Art Alliance of America (*Christian Science Monitor*, December 9, 1915).

34. Melville Johnson, "Alfred Frueh— Who Carries His Fun with Him," unidentified newspaper clipping, 1922, Frueh papers. See Janet A. Flint, *Provincetown Printers: A Woodcut Tradition* (Washington, D.C.: Smithsonian Institution Press, 1983).

35. According to the catalogue of the Salon of American Humorists 1915 exhibit, Frueh's caricatures of George M. Cohan, Lew Fields, George Monroe, and John Drew were all prints. *New York American* (April 26, 1915); *New York Times Magazine* (April 18, 1915); *Boston Evening Transcript* (April 17, 1915). Frueh papers.

36. *New York World* (January 27, 1918). The commentary accompanied a picture of William Courtenay and Thomas A. Wise. The rest of the series is composed of Raymond Hitchcock and Leon Errol, February 3, 1918; Barney Bernard and Alexander Carr, February 24, 1918; and Nat Goodwin and Shelly Hull, March 3, 1918.

37. *New York World*, April 6, 1919; *New York World*, March 20, 1920.

38. Undated clipping [March–April 1919], *New York Times*, Al Frueh Papers, Archives of American Art.

39. For PAFA exhibit, see Walter Pach, "At the Pennsylvania Academy," *Freeman* (May 18, 1921). For National Arts Club exhibit, see various clippings, Frueh papers. Bernardo G. Barros, "Los Grandes Dibujantes Norteamericanos," *Social*, undated clipping [1921]. For *New York World* ad, see undated clipping, Frueh papers.

40. Frueh was, of course, friendly with cartoonists and caricaturists, including Robert Minor, Art Young, Oscar Cesare, George Herriman, Milt Gross; see Frueh correspondence, Frueh papers. Few drafts of Frueh's outgoing correspondence remain. Frank Crowninshield to Al Frueh, January 3, 1929, Frueh papers.

41. In the Frueh collection at the National Portrait Gallery are numerous prints that the artist did not include in the portfolio. Frueh selected the final group carefully, scrawling the word "out" on some of the rejected linocuts.

42. *Vanity Fair* (June 1923), 40; *Arts and Decoration* (December 18, 1922), 20–21, 100; *Shadowland* (October 1922), 46; *Literary Digest* (December 30, 1922), 24–26; *Social* (January 19, 1922), 24, 54. See also clipping from *Social*, inscribed by Frank Crowninshield, Frueh papers.

43. Fornaro, "Celebrities of the Stage," 20–21. *Tavern Topics* (February 1923), 9.

44. Willard Huntington Wright, "America and Caricature," *Vanity Fair* (July 1922), 54–55, 102.

45. Henry McBride, "Amusing Burlesques of the Player Folk at Anderson's," *New York Herald* (December 24, 1922). See also the reviews: *New York Evening World* (December 16, 1922); Henry Tyrrell, *New York Evening World* (December 20, 1922); Milton Raison, *New York World* (December 24, 1922); and *Brooklyn Eagle* (December 24, 1922).

46. Stieglitz to Al Frueh, February 17, 1923, Frueh papers.

47. Frueh was persuaded, however, to go to Washington to cover the Teapot Dome scandal for the *Washington Post*. Albert W. Fox to Al Frueh, October 8,

1927, Frueh papers. His friend Bugs Baer, the humor writer, once tried to persuade him to sign with King Features Syndicate. Frueh showed the same reluctance to being tied down, Baer reported after his friend's death in 1968, "as a leopard having his spots counted." Bugs Baer to Robert Frueh [Al's son], September 18, 1968, Frueh papers.

48. George Arliss in *Poldekin* appears in *Life* (October 7, 1920), 631.

49. Brendan Gill, *Here at the New Yorker* (New York: Random House, 1975), 199.

50. Katherine White to Al Frueh, September 30, 1933. Wolcott Gibbs to Al Frueh, November 30, 1950; December 30, 1950. Frueh papers.

51. Harold Ross to Al Frueh, November 19, 1930, and January 12, 1947, Frueh papers.

52. Harold Ross to Al Frueh, January 23, 1951; William Shawn to Al Frueh, January 8, 1960, Frueh papers.

CHAPTER SIX

1. *Vanity Fair* advertisement, *Puck* (April 22, 1916), 27.

2. "In Vanity Fair," *Vanity Fair* (March 1914), 15. Cynthia L. Ward, *Vanity Fair Magazine and the Modern Style, 1914–1936* (Ph.D. diss., State University of New York at Stony Brook, 1983), 5–7.

3. Bruce Kellner, *The Last Dandy: Ralph Barton, American Artist, 1891–1931* (Columbia: University of Missouri Press, 1991). For other biographical sources, see Dorothy Giles's two-part series for *College Humor*: "Ralph Barton— Genius Destroyed Him" (February 1932), 34–36, 129–131, and "Ralph Barton—Death" (April 1932), 76–77, 92–99. See also Richard Merkin, *The Jazz Age, as Seen Through the Eyes of Ralph Barton, Miguel Covarrubias, and John Held, Jr.* (Providence: Rhode Island School of Design, 1968); John Updike, "A Critic at Large: A Case of Melancholia," *New Yorker* (February 20, 1989), 112–120; and the Ralph Barton papers owned by Mr. and Mrs. Karl Klein, Kansas City.

4. Caroline Seebohm, *The Man Who Was Vogue: The Life and Times of Condé Nast*

(New York: Viking, 1982), 168–178.

5. Seebohm, *Man Who Was Vogue*, 80, 73.

6. *Dress and Vanity Fair* (December 1913), 19, 109.

7. "Massaguer Visits Broadway," *Shadowland* (June 1920), 39; "Impressions of Broadway," *Shadowland* (July 1920), 50; "Massaguer's Broadway Impressions," *Shadowland* (September 1920), 54.

8. Ralph Barton, "Comedy Types Still at Large, Or—A Cross-Section of Parisian Cinema," *Photoplay* (December 1920), 34–35; Ralph Barton, "A Cross-Section of Manhattan Movie," *Photoplay* (March 1921), 56–57.

9. "Hail! Hail! The Gangplank's Here!" *Vanity Fair* (May 1921), 62. Bohun Lynch, *A History of Caricature* (London: Faber and Gwyer, 1926), 118.

10. Geoffrey T. Hellman, "Last of the Species—II," *New Yorker* (September 26, 1942), 24.

11. "When the Five O'Clock Whistle Blows in Hollywood," *Vanity Fair* (September 1921), 50.

12. "Self Portraits of the Great French Impressionists," *Vanity Fair* (November 1921), 36–37.

13. This drawing, *Ursa Major and Certain Particles of Cosmic Dust*, is owned by the Museum of the City of New York. The donor of the drawing stipulated that it could not be reproduced.

14. "A Typical First Night Audience in New York:—The Scene Which Invariably Confronts the Actor," *Vanity Fair* (April 1922), 52–53.

15. Cleveland Amory, *Who Killed Society?* (New York: Harper and Brothers, 1960), 111.

16. F. Scott Fitzgerald, "My Lost City," in Edmund Wilson, ed., *The Crack-Up* (New York: Charles Scribner's Sons, 1945; rpt., New Directions, 1993), 27. Amory, *Who Killed Society?* 132, 108.

17. Oliver M. Saylor, "The Strange Story of Balieff's Chauve-Souris," *Balieff's Chauve-Souris of Moscow* [theater program, 1923], 8. Balieff had started the Chauve-Souris in 1908 in a small Moscow cellar, offering a light, varied bill of fare that contrasted with the

more serious drama of the Moscow Art Theatre. After fleeing the Russian Revolution, he revived his innovative program in Paris, polishing the dances, songs, and skits into an artistically integrated whole. For the history of the Chauve-Souris, see Saylor, "Strange Story of Balieff's Chauve-Souris," 2–22; Frederic and Fanny Hatton, "Personality à la Russe," *Harper's Bazar* (July 1922), 38–39, 106; Merian C. Cooper, "From a Cellar in Moscow to a Roof in New York," *New York Times* (June 4, 1922), 6; Oliver M. Saylor, *The Russian Players in America* (New York: Bernhardt Wall, 1923). See also Chauve-Souris files of programs and clippings at the Free Library of Philadelphia and the Shubert Archives, New York.

18. *Vanity Fair* (April 1922), 26. "Chauve-Souris Anew on the Century Roof," *New York Times* (June 6, 1922).

19. Aline Fruhauf, *Making Faces: Memoirs of a Caricaturist*, ed. Erwin Vollmer (Cabin John, Md.: Seven Locks Press, 1987), 34; Willard Huntington Wright, "America and Caricature," *Vanity Fair* (July 1922), 55; Lynch, *History of Caricature*, 118; *Theatre Magazine* (September 1922), 162–163. See also Giles, "Ralph Barton—Death," 96, and Maybelle H. Klein, "The Star-Studded Audience That Night Was Staring Up at . . . Itself," *Christian Science Monitor* (January 2, 1986), 34.

20. Sister Natalie Barton to Karl Klein, February 1982, courtesy of Bruce Kellner. Merkin, *Jazz Age*.

21. The caption includes the notation "Drawn from Ralph Barton's Design for a Curtain Shortly to Be Installed at the Chauve-Souris." *New York Times* (May 7, 1922). This is only one of many pieces of evidence that the curtain was not installed for the opening of the Chauve-Souris program in February at the 49th Street Theater, as is often assumed, but later, when the show moved to the Century Roof.

22. Ralph Barton to Catherine Barton [late May/early June 1922], courtesy of Bruce Kellner.

23. Gai Saber, "Through the Eyes of Remisov," *Arts and Decoration* (June 1922), 124; "Chauve-Souris at the Wildenstein Galleries," *New York Times* (March 26, 1922).

24. Morris Gest, "A Statement by Morris Gest," Balieff's Chauve-Souris theater program, 1928–1929 season, 13. Janet Leckie, *A Talent for Living: The Story of Henry Sell, an American Original* (New York: Hawthorn, 1970), 74.

25. Fitzgerald, "My Lost City," 29. Lynch, *History of Caricature*, 118. Ralph Barton to Ethel Barton [Klein], March 27, 1924, courtesy of Bruce Kellner. 26. "The Pursuit of the Bridegroom," *Vanity Fair* (June 1923), 70–71.

27. Stehlisilks Corporation, *Americana Prints: A Collection of Printed Silks Designed by Six Contemporary American Artists* (New York: Stehlisilks Corp., 1926), 1.

28. Ibid., 2.

29. Ralph Barton to Ethel Barton (Klein), November 18, 1924, courtesy of Bruce Kellner.

30. For 1925 curtain, see Chauve-Souris files, Shubert Archives. "'Chauve Souris' Arrives with New Numbers," *Women's Wear* (January 15, 1925). Ralph Barton's curtain was also reproduced in the *New York Herald Tribune* on January 18, 1925, with the answers published the following week.

31. Lynch, *History of Caricature*, 118.

32. Fruhauf, *Making Faces*, 38. Updike, "Critic at Large," 116.

33. Giles, "Ralph Barton—Genius Destroyed Him," 36.

34. George H. Douglas, *The Smart Magazines: 50 Years of Literary Revelry and High Jinks at Vanity Fair, the New Yorker, Life, Esquire, and the Smart Set* (Hamden, Conn.: Archon Books, 1991), 141.

35. Updike, "Critic at Large," 113–114.

36. Ralph Barton, "The Graphic Section," *New Yorker* (August 15, 1925), 5.

37. Thomas Kunkel, *Genius in Disguise: Harold Ross of the New Yorker* (New York: Random House, 1995), 440.

38. Kellner, *Last Dandy*, 180–181.

39. Ibid., 190; Updike, "Critic at Large," 120, 117.

40. See Chauve-Souris theater program, 1929, Chauve-Souris files, Free Library of Philadelphia.

41. Giles, "Ralph Barton—Genius Destroyed Him," 36.

42. "'Pan America!'—The Cry of the Expatriates," *Literary Digest* (September 7, 1929), 46.

43. Kellner, *Last Dandy*, 213.

44. Giles, "Ralph Barton—Genius Destroyed Him," 36.

45. Fitzgerald, "My Lost City," 27.

CHAPTER SEVEN

1. Geoffrey Hellman, "That Was New York: Crowninshield," *New Yorker* (February 14, 1948), 80–81.

2. Geoffrey Hellman, "Last of the Species—II," *New Yorker* (September 26, 1942), 24.

3. "The Gentle Art of Concealing Beauty," *Vanity Fair* (February 1922), 46.

4. Willard Huntington Wright, "America and Caricature," *Vanity Fair* (July 1922), 54–55, 102.

5. "We Nominate for the Hall of Fame," *Vanity Fair* (November 1922), 72.

6. "Doll Portraits of People Who Deserve Better," *Vanity Fair* (January 1930), 45. Arthur Moss, "A Cubist Doll-Maker of Montparnasse," *Arts and Decoration* (May 1923), 18. Clara Wold, "Paris Presents the Portrait Doll," *New York Tribune* (April 2, 1922).

7. "Art Is Stealing into the Cabaret," *Vanity Fair* (March 1923), 41.

8. "See the Conquering Heroes!" *Vanity Fair* (May 1923), 46; "A Professional Reading at the Coffee House Club," *Vanity Fair* (August 1923), 40; "A Gallery of Friendly Caricatures," *Vanity Fair* (June 1923), 40; "The Pursuit of the Bridegroom," *Vanity Fair* (June 1923), 70; "Royalty and a Caricature," *Vanity Fair* (December 1923), 44; "Modern Napoleons Who Dominate the Present Fracas in Europe," *Vanity Fair* (December 1923), 45.

9. Aline Fruhauf, *Making Faces: Memoirs of a Caricaturist*, ed. Erwin Vollmer (Cabin John, Md.: Seven Locks Press, 1987), 114–118, 101–102. Her first *Vanity Fair* caricature, *George Jean Nathan*,

accompanied his series of comments about "talking pictures"; see George Jean Nathan, "The Holler Art," *Vanity Fair* (November 1929), 76.

10. Fruhauf, *Making Faces*, 75–76. "Doll Portraits of People Who Deserve Better," *Vanity Fair* (January 1930), 45.

11. Adriana Williams, *Covarrubias* (Austin: University of Texas Press, 1994), 6–15. Unless otherwise noted, biographical details on Covarrubias come from this source.

12. See Bernard Reilly, "Miguel Covarrubias: An Introduction to His Caricatures," in Beverly J. Cox et al., *Miguel Covarrubias Caricatures* (Washington, D. C.: Smithsonian Institution Press, 1985), 24–25.

13. "Covarrubias, 53, Illustrator, Dies," *New York Times* (February 6, 1957).

14. José Juan Tablada, "Caricature That Stings," *Shadowland* (April 1923), 54–55. Some of Covarrubias's caricatures also had appeared in an exhibition of Mexican popular arts in Los Angeles in 1922, and a couple of his drawings had been published in American magazines.

15. Robert Philippe, *Political Graphics: Art as a Weapon* (New York: Abbeville, 1980), 216.

16. Reilly, "Miguel Covarrubias," 28–29.

17. "Covarrubias Turns Scene Designer," *New York Times* (December 13, 1925); Carl Van Vechten, "Preface," *The Prince of Wales* by Miguel Covarrubias (New York: Knopf, 1925), n.p. Helen Sheehy, *Eva Le Gallienne: A Biography* (New York: Knopf, 1996), 108.

18. "I found this hieroglyphic—circa 1924—of Miguel at work," Al Hirschfeld wrote about this sketch to National Portrait Gallery Director Alan Fern at the time of the gallery's 1984 Covarrubias exhibition. "You may use this doodle for reproduction or set fire to it or dunk it in hot chicken fat—in short you may do anything with it except return it to me as the accumulation of paper in my studio threatens to engulf me"; Al Hirschfeld to Alan Fern, National Portrait Gallery, Smithsonian Institution. "Introducing Covarrubias,"

Screenland (December 1923), 49; Al Hirschfeld, "Recalling Miguel Covarrubias," in *Miguel Covarrubias Caricatures* (Washington, D.C.: Smithsonian Institution Press, 1985), 19.

19. *Vanity Fair* (January 1924), 37–38.

20. Ralph Barton, "It Is to Laugh," *New York Herald Tribune* (October 25, 1925).

21. William Murrell, *A History of American Graphic Humor*, 2 vols. (New York: Macmillan, 1938), 2: 207–208.

22. Miguel Covarrubias, "Six Derisions from a Mexican Pencil," *Vanity Fair* (March 1925), 46.

23. Henry McBride, "Ingratiating Art of Miguel Covarrubias: A Mexican Ambassador," *New York Sun* (December 24, 1927), 18. Miguel Covarrubias, *Negro Drawings* (New York: Knopf, 1927), preface.

24. Gilbert Seldes, "The Singular—Although Dual—Eminence of Ring Lardner," *Vanity Fair* (July 1925), 43. Miguel Covarrubias, "The Simplified Side of Some Theatrical Celebrities," *Vanity Fair* (August 1924), 40.

25. Alexander Brook, unpublished memoir, 1–6, Archives of American Art, Smithsonian Institution. Covarrubias had introduced Alexander Brook to José Juan Tablada, who showed him the drawings and watercolors of Orozco.

26. Williams, *Covarrubias*, 36.

27. Barton, "It Is to Laugh"; Bohun Lynch, *A History of Caricature* (London: Faber and Gwyer, 1926), 119.

28. Reilly, "Miguel Covarrubias," 27, 32–33. Frank Crowninshield, "Introduction," in *Negro Drawings*.

29. Barton, "It Is to Laugh."

30. Ibid.

31. Wright, "America and Caricature," 55, 102.

32. Corey Ford, *The John Riddell Murder Case, a Philo Vance Parody* (New York: Charles Scribner's Sons, 1930), title page, 77, 81–82.

33. Crowninshield, "Introduction," in *Negro Drawings*.

34. Lawrence E. Mintz, "American Humor in the 1920s," *Dancing Fools and Weary Blues: The Great Escape of the Twen-*

ties, Lawrence R. Broer and John D. Walther, eds. (Bowling Green, Ohio: Bowling Green State University Popular Press, 1990), 169.

35. Williams, *Covarrubias*, 37, 48. Covarrubias's image of a young girl in the illustration "Enter, The New Negro, a Distinctive Type Recently Created by the Coloured Cabaret Belt in New York," published in *Vanity Fair* (December 1924) influenced Parisian artist Paul Colin's famous first poster for *La Revue Nègre*. See Jean-Claude Baker and Chris Chase, *Josephine: The Hungry Heart* (New York: Random House, 1993), 112–113.

36. Archie Green, "Miguel Covarrubias' Jazz and Blues Musicians," *JEMF Quarterly* 13, no. 48 (Winter 1977): 187, 185; Williams, *Covarrubias*, 40. Marcet Haldeman-Julius, "Miguel Covarrubias," *Haldeman-Julius Quarterly*, January 1927, 62.

37. Williams, *Covarrubias*, 52.

38. Ibid., 138.

39. Ibid., 123.

CHAPTER EIGHT

1. Willard Huntington Wright, "America and Caricature," *Vanity Fair* (July 1922), 55.

2. Robert Baral, *Revue: The Great Broadway Period* (New York: Fleet Press, 1962), 119–121, 126; see also files on *Greenwich Village Follies*, Philadelphia Free Library. In *The Passing Show of 1922*, which opened in the fall, Fred Allen mocked the notion of comedy curtains with his own drop curtain, "Old Joke Cemetery"; Fred Allen, *Much Ado about Me* (Boston: Little, Brown, 1956), 258–279.

3. In 1924, Massaguer settled temporarily in New York, where he contributed to *Life*, the *New Yorker*, *Vanity Fair*, *New York World*, *Collier's*, *Town and Country*, and other periodicals. He returned to Havana the following year but maintained his American ties. He went to Geneva in 1929 as a caricaturist for King Features Syndicate and lived again in New York in the early 1930s. In 1933 he drew the caricatures for Cosmo Hamilton's book, *People Worth Talking About*. See Maria Luisa Lobo

Montalvo and Zoila Lapique Becali, "The Years of *Social*," *Journal of Decorative and Propaganda Arts* (1996): 104–131.

4. Carlo de Fornaro, "Impaling Celebrities on a Pen-Point," *Arts and Decoration* (April 1923), 22.

5. A leather album filled with Roland Young's drawings, which he gave to a friend, the actress Cornelia Otis Skinner, is now at the Harvard Theatre Collection. The Humanities Research Center at the University of Texas (Austin) also has a large collection of his drawings. *Literary Lights* (New York: Knopf, 1923); *Men about Town* (Chicago: Covici-McGee, 1924); Roland Young, *Actors and Others* (Chicago: Pascal Covici, 1925); Henry Major, *Portraits and Caricatures* (New York: Charles C. Morcand, 1927); Eva Herrmann, *On Parade: Caricatures by Eva Herrmann*, Erich Posselt, ed. (New York: Coward-McCann, 1929).

6. Waldo David Frank, *Time Exposures* (New York: Boni and Liveright, 1926), ix. The volume includes humorous portraits by Hans Stengel, V. De Pauw, George de Zayas (Marius's brother), Conrado Massaguer, James House, Jr., Miguel Covarrubias, A. E. King, and Henry Major, as well as several drawings by Hugo Gellert that were really not caricatures and a photograph of Georgia O'Keeffe by Alfred Stieglitz.

7. Carlo de Fornaro, "Celebrities of the Stage in Caricature," *Arts and Decoration* (December 1922), 21; *New York Evening Post* (December 16, 1922); "Caricatures by Frueh," *Brooklyn Eagle* (December 24, 1922).

8. *Shadowland* had started publishing caricature in 1920. Until its demise in November 1923 the magazine continued to experiment with portraiture, publishing caricatures by "Wynn," Robert J. Malone, Al Frueh, Bill Breck, John Decker, Dwight Taylor, Miguel Covarrubias, and others.

9. Carlo de Fornaro's caricature articles for *Arts and Decoration* include "Action Plus and Art that Pulsates" (November 1922); "Celebrities of the Stage in Caricature" (December 1922); "The Groping of Gropper" (March 1923); "Impaling Celebrities on a Pen-Point" (April

1923); "The Caricaturist Who Draws with a Scalpel" (September 1923); "A Famous Illustrator of French Manners" (October 1923); "The Man Who Tickled the World with a Pencil-Point" (November 1923); "Rich Delight in the Comedy Side of the Drama" (March 1924); "Oliver Herford: Poet, Wit, Caricaturist" (April 1924). Two volumes published in London in the 1920s set contemporary artists of the American press in an international context. Bohun Lynch's *History of Caricature* (1926) included illustrations by Ralph Barton and Miguel Covarrubias, while Geoffrey Holme's volume *Caricature of Today* (1928) featured several American artists, including William Auerbach-Levy, Oscar Berger, Miguel Covarrubias, James House, Jr., Al Frueh, and William Gropper.

10. Henry McBride, "Amusing Burlesques of the Player Folk at Anderson's," *New York Herald* (December 24, 1922). Wright, "America and Caricature," 55.

11. Richard Leonard, "Barney Gallant's 'Intellectual' Toy Cabaret,'" *New York World* (December 21, 1922); Allen Churchill, *The Improper Bohemians* (New York: E. P. Dutton, 1959), 221–223, 274; John McMullin, "The Fashions and Pleasures of New York," *Vanity Fair* (February 1923), 17; "Art Is Stealing Rapidly into the Cabaret," *Vanity Fair* (March 1923), 41.

12. Information on the early Sardi's comes from Vincent Sardi, Sr., and Richard Gehman, *Sardi's: The Story of a Famous Restaurant* (New York: Henry Holt, 1953); see also historical files, Sardi's Restaurant. Vincent Sardi, Jr., and Thomas Edward West, *Off the Wall at Sardi's* (New York: Applause, 1991), 67. Don Bevan was hired as in-house caricaturist after World War II and drew caricatures for Sardi's until his retirement in 1974.

13. *Bright Lights of 1944* Playbill, historical files, Sardi's Restaurant. *Forever Female*, Paramount Press Book, Film Archives, Library of Congress. Sardi and West, *Off the Wall*, 43. *Critics Choice* also had Sardi's scenes, and movies actually filmed in the restaurant include

No Way to Treat a Lady, *Made for Each Other*, *Please Don't Eat the Daisies*, *The Fan*, *The King of Comedy*, and *The Muppets Take Manhattan*.

14. James Wyman Barrett, *Joseph Pulitzer and His World* (New York: Vanguard, 1941), 327. Ely Jacques Kahn, Jr., *The World of Swope* (New York: Simon and Schuster, 1965), 19.

15. The best source of biographical information on Henry Major is his own collection of newspaper clippings, filmed by the Archives of American Art, Smithsonian Institution. See, for example, Derso, "Henry Major Kollegam, Sicu Pajtasom," *Az Ember* [New York] (September 25, 1948); "Noted Caricaturist Here," *Los Angeles Daily Times* (June 2, 1925); "Stalks Dynamic 'Game,'" *Detroit News* (November 9, 1925); "They Stand Out from the Crowd," *Literary Digest* (May 12, 1934), 11; Advertisement for Grumbacher Oil Colors, *Art Digest* (May 1, 1943), 31.

16. Ruth Brownlow, "Famous English Caricaturist Draws the Soul of His Subject Rather Than the Outer Man or Woman," *New York Evening Telegram* (March 22, 1923).

17. "Major Finds Some More Victims," *Evening News* [Harrisburg, Pa.], (March 25, 1926).

18. *Los Angeles Times* (June 7 and 9, 1925).

19. Alma Art Agency letterhead advertising Major's trip to Dayton, Henry Major papers, Archives of American Art, Smithsonian Institution.

20. Major had worked in a cabaret in Amsterdam, in 1921, where he developed his lightning-fast drawing style and ability to capture a likeness into a stage performance, but since newspaper artists were better paid, he concentrated on publishing his drawings. *Toronto Daily Star* (October 1, 1927). *Detroit News* (November 3, 1927).

21. William Auerbach-Levy, *Is That Me? A Book about Caricature* (New York: Watson-Guptill, 1947), 87.

22. Aline Fruhauf, *Making Faces: Memoirs of a Caricaturist,* ed. Erwin Vollmer (Cabin John, Md.: Seven Locks Press,

1987), 59–65.

23. Ibid., 60–62.

24. Ibid., 96.

25. Unpublished memoir by Irma Selz, owned by her son, Tom Engelhardt. See also Steven Heller, "New York's Girl Caricaturist: Irma Selz," *Upper and Lower Case: The International Journal of Typographics* 2, no. 2 (August 1984): 18–19.

26. For biographical material on William Auerbach-Levy, see Ernest W. Watson, "The Caricatures of William Auerbach-Levy," *Art Instruction* 2, no. 4 (April 1938) 4–10; Auerbach-Levy, *Is That Me?*; "William Auerbach-Levy," *Current Biography* (1948) (New York, 1948), 29–31.

27. Pennsylvania Academy of the Fine Arts, *Catalogue of the Twenty-Fifth Annual Philadelphia Water Color Exhibition, and the Twenty-Sixth Annual Exhibition of Miniatures* (Philadelphia, 1927), 9. Auerbach-Levy, *Is That Me?* 18–19.

28. Ibid., 18–23; Watson, "Caricatures of Auerbach-Levy," 7. The error that Auerbach-Levy became famous for his caricatures at the age of twenty-five has been frequently repeated. It was in 1925, when the artist was thirty-six, that his caricatures were first prominently featured in the *New York World*. See, for example, *National Cyclopedia of American Biography* (New York, 1969), 51: 495.

29. Auerbach-Levy, *Is That Me?* 115.

30. *New York World* (February 22, 1925).

31. Auerbach-Levy, "A Caricaturist Snitches on His Victims," *New York World* (October 18, 1925); Auerbach-Levy, *Is That Me?* 127–129.

32. Auerbach-Levy, *Is That Me?* 130.

33. Auerbach-Levy, "A Caricaturist Snitches."

34. Among the treasured possessions Woollcott kept at his island retreat on Lake Bomoseen, Vermont, were a drawing of Ruth Gordon by Auerbach-Levy and a poster of Minnie Maddern Fiske by Ralph Barton. See Ruth Gordon, *Myself among Others* (New York: Atheneum, 1971), 25. Samuel Hopkins Adams, *A.*

Woollcott: His Life and His World (New York: Reynal and Hitchcock, 1945), 4.

35. Unpublished memoir by Irma Selz. The card sent to Stein is now in the Collection of American Literature, the Beinecke Rare Book and Manuscript Library, Yale University. Auerbach-Levy, *Is That Me?* 25–26.

36. Auerbach-Levy, *Is That Me?* 145–149; *Vanity Fair* (June 1926), 47.

37. *New York Times*, [1947?]; the comment was quoted in an advertising brochure. The book was republished by the Art Book Guild of America under the title *The Art of Caricature*.

38. For information on Ross and the formation of the *New Yorker*, see Thomas Kunkel, *Genius in Disguise: Harold Ross of the New Yorker* (New York: Random House, 1995).

39. Kunkel, *Genius in Disguise*, 439–440, 92–93.

40. George H. Douglas, *The Smart Magazines* (New York: Anchor, 1991), 153; Kunkel, *Genius in Disguise*, 108.

41. "The Enquiring Reporter," *New Yorker* (August 29, 1925), 6.

42. Mae West, *Goodness Had Nothing To Do with It* (Englewood Cliffs, N.J.: Prentice-Hall, 1959), 43.

43. *New Yorker* (February 28, 1925), 20; (March 21, 1925), 16; (July 10, 1925), 24; (June 27, 1925), 16; (April 11, 1925), 18.

44. Barton, Covarrubias, Frueh, Major, Massaguer, Fornaro, and Gard all made caricatures for the *New Yorker*'s "Profiles" essays.

45. "Abe Birnbaum," *New Yorker* (July 2, 1966), 68; "Abe Birnbaum, 67, Illustrator, Dies," *New York Times* (June 20, 1966). The Hoover and Ziegfeld drawings were probably those published on October 20, 1928, and July 25, 1931, respectively. Birnbaum's portrait of Herbert Hoover was republished, in reverse, on January 3, 1931, 32. "Caricatures by Birnbaum," *New York Times* (January 31, 1932). Philip Hamburger, "Mr. Secretary—I," *New Yorker* (November 12, 1949), 39.

46. Alexander Woollcott, "Marc Connelly," *New Yorker* (April 12, 1930), 29.

47. Charles L. Bartholomew, *Chalk Talk and Crayon Presentation* (Chicago: Frederick J. Drake, 1922), 125. The lectures of Thomas Nast at the end of his career, Bartholomew pointed out, and the singing-drawing performances of Canadian caricaturist J. W. Bengough had played to packed houses. Advertising in the back of the volume, Bartholomew offered a correspondence course in illustrating and cartooning as well as the necessary art supplies.

48. James Thurber, *The Thurber Carnival* (New York: Harper and Brothers, c. 1945), 174–175.

CHAPTER NINE

1. On the decline of Nast's fortunes, Caroline Seebohm, *The Man Who Was Vogue: The Life and Times of Condé Nast* (New York: Viking, 1982), 300–370.

2. Geoffrey Hellman, "Last of the Species, II," *New Yorker* (September 26, 1942), 27.

3. Geoffrey Hellman, "That Was New York: Crowninshield," *New Yorker* (February 14, 1948), 80.

4. *Vanity Fair* (September 1932), 6.

5. Seebohm, *Man Who Was Vogue*, 227.

6. "A Note on Typography," *Vanity Fair* (March 1930), 31.

7. See Roland Marchand, *Advertising the American Dream: Making Way for Modernity, 1920–1940* (Berkeley: University of California Press, 1985).

8. *Business Builder* (April 4–June 6), 1933.

9. Marchand, *Advertising the American Dream*, xx.

10. Cotton's "clever interpretation of personalities that interest all," as the *Times* called them, hung in the Newport exhibition along with watercolors, drawings, and prints by Winslow Homer, John Singer Sargent, John Taylor Arms, and others; *New York Times* (August 21, 1927), sec. 2, 3. Marguerite B. Williams, "Here and There in the Art World," undated clipping, Archives, Art Institute of Chicago; *Chicago Daily Tribune* (June 12, 1927).

11. *Vanity Fair* (January 1931), 48.

12. William Murrell, *A History of Ameri-*

can Graphic Humor , 2 vols. (New York: Whitney Museum of American Art, 1938), 2: 134.

13. Ernest Boyd, "Theodore Dreiser," *Vanity Fair* (October 1931), 33.

14. *Vanity Fair* (February 1933), 13.

15. "Who's Who in Vanity Fair," *Vanity Fair* (May 1932), 6. "We Nominate for the Hall of Fame," *Vanity Fair* (October 1932), 37.

16. "The Editor's Uneasy Chair," *Vanity Fair* (February 1933), 9. Cotton's Stimson was published in *Vanity Fair* in December 1932, and his Borah appeared in January 1933.

17. Wolcott Gibbs, "Big Nemo—I," *New Yorker* (March 18, 1939), 24.

18. Charles Fabens Kelley, "Water Colors, All Styles," *Christian Science Monitor* (April 23, 1932).

19. Peter Hastings Falk, *The Annual Exhibition Record of the Art Institute of Chicago, 1888–1950* (Madison, Conn.: Sound View Press, 1990), 235; "Water Color Exhibition," *Bulletin of the Art Institute of Chicago* 31, no. 3 (March 1937): 50.

20. Paul Hyde Bonner, "Beerbohm and Caricature," *Saturday Review* (July 29, 1939), 9, 22.

21. For biographical material on Paolo Garretto, see Steven Heller, "Paolo Garretto: A Reconsideration," *Print* 44 (May–June 1990): 66–75. The article is based on the author's correspondence with the artist shortly before his death. See also Gianni Mazzocchi and Renzo Trionfera, *Paolo Garretto Story* (Milan, 1983) (in Italian). Heller, "Paulo Garretto," 75.

22. Garretto to Steven Heller, March 2, 1989. Steven Heller.

23. Garretto to Steven Heller, September 20, 1988. Steven Heller.

24. Elizabeth Hutton Turner, *Americans in Paris (1921–1931)* (Washington, D.C.: Counterpoint, 1996), 18; Elyce Wakerman, *Air Powered: The Art of the Airbrush* (New York: Random House, 1979), 16–45. Alan M. Fern, *Word and Image* (New York: Museum of Modern Art, 1968), 61.

25. Fern, *Word and Image*, 60.

26. Garretto to Steven Heller, September 20, 1988. Garretto letters, Steven Heller.

27. Wakerman, *Air Powered*, 42.

28. Ibid.

29. Ann Douglas, *Terrible Honesty: Mongrel Manhattan in the 1920s* (New York: Farrar, Straus and Giroux, 1995), 65. Marshall Smelser, *The Life that Ruth Built* (New York: Quadrangle/New York Times, 1975), 129.

30. Heller, "Paulo Garretto," 75. Paolo Garretto to Steven Heller, n.d. [circa 1989]. Steven Heller.

31. Seebohm, *Man Who Was Vogue*, 186.

32. "Fascist Artist," *Vanity Fair* (August 1934), 9; Heller, "Paulo Garretto," 162, 164.

33. Heller, "Paulo Garretto," 164.

34. Clare Boothe Brokaw, "The great Garbo," *Vanity Fair* (February 1932), 63.

35. "Imaginary Interviews—No. 1," *Vanity Fair* (December 1931), 56. The series title, "Impossible Interviews," appeared in the second caricature, published in January 1932.

36. Marchand, *Advertising the American Dream*, 145.

37. James R. Mellow, *Hemingway: A Life Without Consequences* (Boston: Houghton Mifflin, 1992), 420. Adriana Williams, *Covarrubias* (Austin: University of Texas Press, 1994), 73–74. See also Covarrubias correspondence, Universidad de las Americas, Puebla, Mexico.

38. "The Editor's Uneasy Chair," *Vanity Fair* (February 1935), 9.

39. "The Editor's Uneasy Chair," *Vanity Fair* (January 1933), 9–10.

40. Ibid.

41. Geoffrey Hellman, "Last of the Species—I," *New Yorker* (September 19, 1942), 24–25.

42. *Vanity Fair* (July 1933), 7.

43. Seebohm, *Man Who Was Vogue*, 320–329.

44. Ibid., 328.

45. Cynthia L. Ward, *Vanity Fair Magazine and Modern Style, 1914–1936* (Ph.D. diss., State University of New York at Stony Brook, 1983), 380.

46. "Vanity Fair's Own Paper Dolls—No. 1," *Vanity Fair* (September 1933), 36. "Vanity Fair's Own Paper Dolls—No. 2," *Vanity Fair* (November 1933), 38.

47. *Vanity Fair* (October 1935), 9; Frank Dunn, "Celebrated Faces of Our Time," *Vanity Fair* (October 1935), 14–15.

48. "The Editor's Uneasy Chair," *Vanity Fair* (January 1936), 9.

49. Mazzocchi and Trionfera, *Paolo Garretto Story*, 115–120.

50. *Vanity Fair* (February 1936), 28–29.

CHAPTER TEN

1. Henry McBride, "Some Portraits by Peggy Bacon," *New York Sun* (March 31, 1928).

2. William Murrell, *History of American Graphic Humor*, 2 vols. (New York: Macmillan, 1938), 2: 230. For biographical information on Bacon, see Roberta K. Tarbell, *Peggy Bacon: Personalities and Places* (Washington, D.C.: Smithsonian Institution, 1975).

3. McBride, "Some Portraits by Peggy Bacon"; Charles Demuth, "A Foreword: Peggy Bacon," *Peggy Bacon Exhibition* (exh. cat., New York: Intimate Gallery, 1928).

4. Henry McBride, "Peggy Bacon," *The Arts* 17 (May 1931): 584.

5. Edward Alden Jewell, "An Exhibition of Caricatures," *New York Times* (April 21, 1931); "Peggy Bacon," *Art News* (May 9, 1931), 9; Holger Cahill, "American Art Today," in Fred J. Ringell, ed., *America as Americans See It* (New York: Literary Guild, 1932), 259; Paul Rosenfeld, "Caricature and Peggy Bacon," *Nation* (June 3, 1931), 618; Tarbell, *Peggy Bacon*, 35.

6. "Portraits in Acid," *New York Times* (December 9, 1934). Peggy Bacon, *Off with Their Heads* (New York: Robert W. McBride, 1934), n.p.

7. Murrell, *History of American Graphic Humor*, 2: 234.

8. Dawn Powell was not included in *Off with Their Heads*. The notes were

written at the bottom of a quick, preliminary sketch of her owned by Kraushaar Galleries.

9. Josephine Nelson, "To the Faces I Love," *Independent Woman* (January 1935), 13.

10. Rosenfeld, "Caricature and Peggy Bacon," 617–618.

11. Quoted in Tarbell, *Peggy Bacon*, 38.

12. *Washington Star* (March 3, 1935). Tarbell, *Peggy Bacon*, 37.

13. Critics agreed that Howland had lampooned her subjects in a kindly fashion; *New York Times* reviewer Edward Alden Jewell considered the work "adroit and clever." See Jewell, *New York Times* (January 9, 1938); "Sculptural Jabs," *Art Digest* (January 15, 1938), 31; "Clay Caricature by I. Howland," *Art News* (January 15, 1938), 19; Downtown Gallery Press release (December 29, 1938) and other clippings, Isabella Howland papers, Archives of American Art, Smithsonian Institution, Washington, D.C. Howland returned to caricature portraits in 1950 with an exhibition of drawings at the Midtown Gallery. She also made caricature sculptures in bronze (including one of John Marin) in the early 1960s. Although both drawings and sculptures were well conceived, they did little for her career at this late date.

14. See Michele H. Bogart, *Artists, Advertising, and the Borders of Art* (Chicago: University of Chicago Press, 1995).

15. Ibid., 4.

16. For biographical references, see Albert Hirschfeld, *The American Theatre as Seen By Hirschfeld* (New York: G. Braziller, 1961); "Albert Hirschfeld," *Current Biography* (1970), 191–194; Albert Hirschfeld, *The World of Hirschfeld* (New York: Harry Abrams, 1971). After so many decades in the public eye, Hirschfeld and his career have generated considerable press coverage. Small biographical details differ in various sources.

17. Hirschfeld, *American Theatre*, n.p. Hirschfeld also began publishing in the *New York World* in 1927. See, for example, image of Eddie Cantor, *New York World* (August 14, 1927).

18. "The Al Hirschfeld 'Living Self Portrait Interview,'" videotape, June 1996, National Portrait Gallery, Smithsonian Institution.

19. Hirschfeld, *World of Hirschfeld*, 24–26.

20. Ibid., 30.

21. "Speaking of Pictures . . . These Are Photo-Doodles," *Life* (August 2, 1937), 6–9.

22. Hirschfeld, *World of Hirschfeld*, 39–40.

23. John Houseman, *Run-Through: A Memoir* (New York: Simon and Schuster, 1972), 253–278.

24. Lloyd Goodrich, Introduction to Hirschfeld, *World of Hirschfeld*, 8.

25. Arthur Miller, "Al Hirschfeld," *FMR* (October 1985), 41.

26. Aline Fruhauf, *Making Faces: Memoirs of a Caricaturist*, ed. Erwin Vollmer (Cabin John, Md.: Seven Locks Press, 1987), 151. "Black and Whites by Hirschfeld, Well Known Newspaper Artist," *Art News* (February 4, 1939), 14.

27. "Backstage with Esquire," *Esquire* (January 1934), 16. "Esquire in Quest of His Youth," *Esquire* (March 1934), 61–62.

28. When Henry Major depicted visiting monarch George VI in *Ken* as a sideshow for the New York World's Fair, a cartoon intended to satirize American celebrity exploitation, the British took offense. The magazine was banned in Canada, and the publishers were forced to apologize. It was not an auspicious sign. See *Ken* (April 6, 1939), 65; *Ken* (May 18, 1939), 6.

29. Thomas Kunkel, *Genius in Disguise: Harold Ross of the New Yorker* (New York: Random House, 1995), 219–223.

30. Jim Heimann, *Out with the Stars: Hollywood Nightlife in the Golden Era* (New York: Abbeville, 1985); "Original Hollywood Brown Derby Opens in Pasadena," *Brown Derby News* 3 (Fall 1986). The Brown Derby name has graced many restaurants throughout the Los Angeles area and elsewhere. It was the Hollywood restaurant that opened on Vine Street in 1929 that decorated its walls with caricatures in the mid-1930s and became a favorite gathering place for film industry notables. So great was its renown that the Disney-MGM Studios theme park in Orlando, Florida, has reconstructed the restaurant, complete with reproductions of its caricatures, to evoke the star-studded dining spots of 1930s Hollywood.

31. Decker's four panels start with the silent era's *Perils of Pauline* and the Keystone Kops, progress to *Ben-Hur* and *The Ten Commandants*, and conclude with such 1930s idols as Mae West, Shirley Temple, and W. C. Fields. Photographs at the National Portrait Gallery document the opening of John Murray Anderson's *The Silver Screen* at the Wilshire Bowl Restaurant in September 1941. The murals were unveiled on that occasion, and many of the stars portrayed attended.

32. See the clips "Teddy Roosevelt's Arrival in Africa" of 1909 and "Teddy Roosevelt's Reception by Crowned Heads of Europe" (circa 1910) in the Library of Congress's Motion Picture Division, and Pat Sullivan Studios's "Felix in Hollywood" (1923).

33. See, for example J. Michael Barrier, *Building a Better Mouse: Fifty Years of Animation* (Washington, D.C.: Library of Congress, 1978), 2–7; and Charles Solomon, *Enchanted Drawings: The History of Animation* (New York: Knopf, 1989), 40–41.

34. Biographical information on Joe Grant is based on "A Toon Man for the Ages," *Los Angeles Times* (January 19, 1995); Frank Thomas and Ollie Johnston, *Disney Animation: The Illusion of Life* (New York: Abbeville, 1981), 208–210, 376, 384; *14th Annual Annie Awards Program*, 9; and interviews with the artist.

35. The history of the "Parade of Award Nominees" is gleaned from conversations with Scott McQueen (who found the original footage in 1993), and other animation experts Mike Barrier, Stu Reisbord, and Joe Grant in 1994.

36. "'Toon Man for the Ages."

37. Thomas and Johnson, *Disney Ani-*

mation, 208–210. Although he retired in 1949 to pursue other artistic endeavors, Grant's remarkable first career at Disney was succeeded by a second. In 1987 he was invited back to the studio, and he has provided ideas for *Beauty and the Beast, Aladdin,* and *The Lion King.*

38. Norman Zierold, *Garbo* (New York: Stein and Day, 1969), 74.

39. John Tibbetts, "Of Mouse and Man," *American Screen Classics* (May–June 1978).

40. Jenny Wren was ultimately animated by Hamilton Luske. Thomas and Johnson, *Disney Animation,* 110–111. Mae West to Walt Disney, August 12, 1935. Walt Disney Archives, Burbank, California. London *Daily Express* (August 23, 1935); *New York Post* (July 1, 1935). See publicity scrapbook for "Who Killed Cock Robin," Walt Disney Archives, Burbank, California.

41. "Mickey's Polo Team," *Variety* (February 12, 1936).

42. Christopher Finch, *The Art of Walt Disney: From Mickey Mouse to the Magic Kingdoms* (New York: Harry Abrams, 1975), 54.

43. Early Warner Brothers cartoons with celebrity impersonations include "Crosby, Columbo and Vallee" (1932), "I Like Mountain Music" (1933), "Billboard Frolics" (1935), "I Love to Singa" (1936), "The Coo Coo Nut Grove" (1936), "Porky's Road Race" (1937), "Speaking of the Weather" (1937), "The Woods Are Full of Cuckoos" (1937), "Have You Got Any Castles" (1938). For other examples, see Jerry Beck and Will Friedwald, *Looney Tunes and Merrie Melodies* (New York: Holt, 1989).

44. Examples from the 1940s include "Malibu Beach Party" (1940), "Hollywood Steps Out" (1941), "Swooner Crooner" (1944), "Bacall to Arms" (1946), "Slick Hare" (1947). See Beck and Friedwald, *Looney Tunes.* Donald Crafton, "The View from Termite Terrace: Caricature and Parody in Warner Bros. Animation," *Film History* 5, no. 2 (1993): 214.

45. "Who *WAS* Mencken?" *Collier's* (November 19, 1949), 82.

46. The *American Mercury* caricature series began in January 1944 with a cover by Irma Selz. Sporadic in 1947 and replaced by photos in 1948, the caricature covers began again in February 1949 and ran through November 1950.

47. Richard Maney, *Fanfare: The Confessions of a Press Agent* (New York: Harper, 1957), 346–347.

48. Steven Heller, "Paolo Garretto: A Reconsideration," *Print* 44, no. 3 (May–June 1990): 164. Roland Marchand, *Advertising the American Dream: Making Way for Modernity, 1920–1940* (Berkeley: University of California Press, 1985), 149; Bogart, *Artists,* 137–143.

49. Demuth, "Foreword," *Peggy Bacon Exhibition.* Elizabeth Venant, "Hirschfeld's Who's Who—Still the Best Line on Broadway," *Los Angeles Times Calendar* (August 19, 1984).

50. "Life Goes to Lunch with Servicemen," *Life* (January 25, 1942), 106–109; "Speaking of Pictures . . . Mural Immortalizes Bronx Bar's Patrons," *Life* (December 5, 1949), 16–17; "Speaking of Pictures . . . These Are 'Table Top Photographs,'" *Life* (November 18, 1940), 12–13; "Pictures to the Editors," *Life* (October 6, 1941), 136–137; "The Latin Quarter," *Life* (September 20, 1943), 129.

51. "Speaking of Pictures," *Life* (September 26, 1949), 14–15.

52. "Vanishing Caricaturists," *National Observer* (October 24, 1966), 14.

53. Hirschfeld, *World of Hirschfeld,* 38.

54. "Radio Talent," *Fortune* (May 1938), 53–57, 122, and "That Evening Sun Goes Down," suppl. to May 1938 issue.

Bibliography

ARCHIVAL SOURCES

Barton, Ralph. Papers, Bruce Kellner.

Davis, Stuart. Scrapbooks, American Salon of Humorists, Archives of American Art, Smithsonian Institution, Washington, D.C.

De Zayas, Marius. Correspondence. Stieglitz Papers. Beinecke Rare Book and Manuscript Library, Yale University, New Haven, Connecticut.

De Zayas, Marius. The De Zayas Archive, Rodrigo de Zayas, Seville, Spain.

Frueh, Alfred J. Papers. Archives of American Art, Smithsonian Institution, Washington, D.C.

NEWSPAPERS AND PERIODICALS

As Others See Us, a Semi-Monthly of Comment and Caricature
The Bang
Brooklyn Eagle
Camera Work
The Critic
Esquire
Judge
Ken
Life
Life (Luce publication)
The Lion's Roar
New York Dramatic Mirror
New York Herald Tribune
New York Times
New York World
New Yorker
Photoplay
Puck
Shadowland
The Stage
Theater Arts
Vanity Fair
Variety

CARICATURE AND HUMOR (SELECTED WORKS)

Armitage, Shelley. *John Held, Jr.: Illustrator of the Jazz Age.* Syracuse, N.Y.: Syracuse University Press, 1987.

Auerbach-Levy, William. "A Caricaturist Snitches on His Victims." *New York World* (October 18, 1925).

————. *Is That Me? A Book about Caricature.* New York: Watson-Guptill, 1947.

Bacon, Peggy. *Off with Their Heads.* New York: Robert W. McBride, 1934.

Bailey, Craig R. "The Art of Marius de Zayas." *Arts Magazine* 53, no. 1 (September 1978): 136–144.

Barrier, J. Michael. *Building a Better Mouse: Fifty Years of Animation.* Washington, D.C.: Library of Congress, 1978.

Barton, Ralph. "It Is To Laugh." *New York Herald Tribune* (October 25, 1925).

Baury, Louis. "Wanted: An American Salon of Humourists." *Bookman* 40 (January 1915): 525–540.

Becker, Stephen. *Comic Art in America: A Social History of the Funnies, the Political Cartoons, Magazine Humor, Sporting Cartoons and Animated Cartoons.* New York: Simon and Schuster, 1959.

Beerbohm, Max. "The Laughter of the Public." *Living Age* 233 (April 5, 1902): 52–57.

————. "The Spirit of Caricature." *Pall Mall Magazine* (January–April 1901), 121–125.

————. *A Variety of Things.* New York: Knopf, 1928.

Bergson, Henri. *Laughter: An Essay on the Meaning of the Comic.* New York: Macmillan, 1937.

Blair, Walter, and Hamlin Hill. *America's Humor: From Poor Richard to Doonesbury.* New York: Oxford University Press, 1978.

Bohn, Willard. "The Abstract Vision of Marius de Zayas." *Art Bulletin* 62, no. 3 (September 1980): 434–452.

Brinton, Christian. "Sem, Cappiello, and Fornaro." *Critic* (December 1904): 545–556.

Bruhn, Thomas P. *The Art of Al Frueh.* Storrs, Conn.: William Benton Museum of Art, 1983.

Caricature and Its Role in Graphic Satire. Providence: Museum of Art, Rhode Island School of Design, 1971.

Clark, William Bedford, and W. Craig Turner. *Critical Essays on American Humor*. Boston: G. K. Hall, 1984.

Covarrubias, Miguel. *The Prince of Wales and Other Famous Americans*. New York: Knopf, 1925.

Cox, Beverly J., and Denna Jones Anderson, eds. *Miguel Covarrubias' Caricatures*. Washington, D.C.: National Portrait Gallery, Smithsonian Institution, 1985.

Crafton, Donald. "The View from Termite Terrace: Caricature and Parody in Warner Bros. Animation." *Film History* 5, no. 2 (May 1993): 204–230.

De Bois, Guy Pène. "Caricatures Are Difficult to Draw, Because They Must Be Devoid of All Malice." *New York American* (August 8, 1910).

De Casseres, Benjamin. "Caricature, and Max Beerbohm." *Metropolitan Magazine* (November 1906), 197–201.

———. "Caricature and New York." *Camera Work* 26 (April 1909): 17–18.

———. "The Psychology of Caricature." In Carlo de Fornaro, *Mortals and Immortals* (preface). New York: Hornet, 1922.

De Zayas, Marius. "Caricature: Absolute and Relative." *Camera Work* (April 1914), 19–21.

Eastman, Max. *Enjoyment of Living*. New York: Harper, 1948.

Feavor, William. *Masters of Caricature from Hogarth and Gillroy to Scarf and Levine*. New York: Knopf, 1981.

Flagg, James Montgomery. *The Well-Knowns as Seen by James Montgomery Flagg*. New York: George H. Doran, 1914.

Fornaro, Carlo de. "Caricature and Cartoon: A Distinction." *The Criterion* (October 1900), 6–7.

———. "The Caricaturist Who Draws with a Scalpel." *Arts and Decoration* (September 1923), 18–19.

———. "Celebrities of the Stage in Caricature: Satire in Simple Line Characterizes the Genius of Alfred Frueh." *Arts and Decoration* (December 1922), 20–21.

———. *Chicago's Anointed*. Chicago: Carlo de Fornaro, c. 1897.

———. "The Groping of Gropper." *Arts and Decoration* (March 1923), 14–15.

———. "Impaling Celebrities on a Pen: A Sketch of Conrado Massaguer, the Cuban Caricaturist Who Became a Successful Publisher." *Arts and Decoration* (April 1923), 22–23.

———. "The Man Who Tickled the World with a Pencil-Point." *Arts and Decoration* (November 1923), 18–19.

———. *Millionaires of America*. New York: Medusa, 1902.

———. *Mortals and Immortals*. New York: Hornet, 1911.

———. "Oliver Herford: Poet, Wit, and Caricaturist." *Arts and Decoration* (April 1924), 30–31.

Frueh, Alfred J., Jr., and Nancy Frueh. *Theatre Caricatures by Al Frueh: West End Meets Broadway*. London: The Theatre Museum, [1990?].

Fruhauf, Aline. *Making Faces: Memoirs of a Caricaturist*. Edited by

Erwin Vollmer. Cabin John, Md.: Seven Locks Press, 1987.

Gaines, James R. *Wit's End: Days and Nights of the Algonquin Round Table*. New York: Harcourt Brace Jovanovich, 1977.

Gard, Alex. *More Ballet Laughs*. New York: Charles Scribner's Sons, 1946.

———. *Stars Off Gard*. New York: Charles Scribner's Sons, 1947.

Giles, Dorothy. "Ralph Barton—Death." *College Humor* (April 1932), 76–77.

———. "Ralph Barton—Genius Destroyed Him." *College Humor* (February 1932), 34–36.

Gill, Brendan. "Alfred Frueh." *New Yorker* (September 28, 1968), 184.

Gombrich, Ernest H., and E. Kris. *Caricature*. Harmondsworth, England: Penguin, 1940.

Green, Archie. "Miguel Covarrubias' Jazz and Blues Musicians." *JEMF Quarterly* 13, no. 48 (Winter 1977): 183–195.

Hartmann, Sadakichi. "De Zayas." *Camera Work* 31 (July 1910).

Haviland, Paul. "Marius de Zayas—Material, Relative, and Absolute Caricatures." *Camera Work* (April 1914), 33–34.

Heller, Steven. "Paolo Garretto: A Reconsideration." *Print* 44, no. 3 (May–June 1990): 66–75.

———. "New York's Girl Caricaturist: Irma Selz." *Upper and Lower Case: The International Journal of Typographics* 2, no. 2 (August 1984): 18–19.

Hillier, Boris. *Cartoons and Caricatures*. New York: E. P. Dutton, 1970.

Hirschfeld, Al. *Hirschfeld Art and Recollections from Eight Decades*. New York: Charles Scribner's Sons, 1991.

———. *The World of Hirschfeld*. New York: Harry Abrams, 1970.

Holme, Geoffrey, ed. *Caricature of Today*. London: The Studio, Ltd., 1928.

Horn, Maurice, ed. *World Encyclopedia of Cartoons*. New York: Gale Research, 1980.

Hyland, Douglas. *Marius de Zayas: Conjuror of Souls*. Lawrence: Spencer Museum of Art, University of Kansas, 1981.

The Image of America in Caricature and Cartoon. Fort Worth, Texas: Amon Carter Museum of Western Art, 1976.

Kellner, Bruce. *The Last Dandy: Ralph Barton, American Artist, 1891–1931*. Columbia: University of Missouri Press, 1991.

Lent, John A., comp. *Animation, Caricature, and Gag and Political Cartoons in the United States and Canada: An International Bibliography*. Westport, Conn.: Greenwood, 1994.

Lucie-Smith, Edward. *The Art of Caricature*. Ithaca: Cornell University Press, 1981.

Lynch, Bohun. "Max Beerbohm." *Dial* (February 1921), 177–192.

———. *A History of Caricature*. London: Faber and Gwyer, 1926.

Lynn, Kenneth S. *The Comic Tradition in America*. New York: Doubleday, 1958.

Index

Clark, William Bedford, and W. Craig Turner. *Critical Essays on American Humor*. Boston: G. K. Hall, 1984.

Covarrubias, Miguel. *The Prince of Wales and Other Famous Americans*. New York: Knopf, 1925.

Cox, Beverly J., and Denna Jones Anderson, eds. *Miguel Covarrubias' Caricatures*. Washington, D.C.: National Portrait Gallery, Smithsonian Institution, 1985.

Crafton, Donald. "The View from Termite Terrace: Caricature and Parody in Warner Bros. Animation." *Film History* 5, no. 2 (May 1993): 204–230.

De Bois, Guy Pène. "Caricatures Are Difficult to Draw, Because They Must Be Devoid of All Malice." *New York American* (August 8, 1910).

De Casseres, Benjamin. "Caricature, and Max Beerbohm." *Metropolitan Magazine* (November 1906), 197–201.

———. "Caricature and New York." *Camera Work* 26 (April 1909): 17–18.

———. "The Psychology of Caricature." In Carlo de Fornaro, *Mortals and Immortals* (preface). New York: Hornet, 1922.

De Zayas, Marius. "Caricature: Absolute and Relative." *Camera Work* (April 1914), 19–21.

Eastman, Max. *Enjoyment of Living*. New York: Harper, 1948.

Feavor, William. *Masters of Caricature from Hogarth and Gillroy to Scarf and Levine*. New York: Knopf, 1981.

Flagg, James Montgomery. *The Well-Knowns as Seen by James Montgomery Flagg*. New York: George H. Doran, 1914.

Fornaro, Carlo de. "Caricature and Cartoon: A Distinction." *The Criterion* (October 1900), 6–7.

———. "The Caricaturist Who Draws with a Scalpel." *Arts and Decoration* (September 1923), 18–19.

———. "Celebrities of the Stage in Caricature: Satire in Simple Line Characterizes the Genius of Alfred Frueh." *Arts and Decoration* (December 1922), 20–21.

———. *Chicago's Anointed*. Chicago: Carlo de Fornaro, c. 1897.

———. "The Groping of Gropper." *Arts and Decoration* (March 1923), 14–15.

———. "Impaling Celebrities on a Pen: A Sketch of Conrado Massaguer, the Cuban Caricaturist Who Became a Successful Publisher." *Arts and Decoration* (April 1923), 22–23.

———. "The Man Who Tickled the World with a Pencil-Point." *Arts and Decoration* (November 1923), 18–19.

———. *Millionaires of America*. New York: Medusa, 1902.

———. *Mortals and Immortals*. New York: Hornet, 1911.

———. "Oliver Herford: Poet, Wit, and Caricaturist." *Arts and Decoration* (April 1924), 30–31.

Frueh, Alfred J., Jr., and Nancy Frueh. *Theatre Caricatures by Al Frueh: West End Meets Broadway*. London: The Theatre Museum, [1990?].

Fruhauf, Aline. *Making Faces: Memoirs of a Caricaturist*. Edited by Erwin Vollmer. Cabin John, Md.: Seven Locks Press, 1987.

Gaines, James R. *Wit's End: Days and Nights of the Algonquin Round Table*. New York: Harcourt Brace Jovanovich, 1977.

Gard, Alex. *More Ballet Laughs*. New York: Charles Scribner's Sons, 1946.

———. *Stars Off Gard*. New York: Charles Scribner's Sons, 1947.

Giles, Dorothy. "Ralph Barton—Death." *College Humor* (April 1932), 76–77.

———. "Ralph Barton—Genius Destroyed Him." *College Humor* (February 1932), 34–36.

Gill, Brendan. "Alfred Frueh." *New Yorker* (September 28, 1968), 184.

Gombrich, Ernest H., and E. Kris. *Caricature*. Harmondsworth, England: Penguin, 1940.

Green, Archie. "Miguel Covarrubias' Jazz and Blues Musicians." *JEMF Quarterly* 13, no. 48 (Winter 1977): 183–195.

Hartmann, Sadakichi. "De Zayas." *Camera Work* 31 (July 1910).

Haviland, Paul. "Marius de Zayas—Material, Relative, and Absolute Caricatures." *Camera Work* (April 1914), 33–34.

Heller, Steven. "Paolo Garretto: A Reconsideration." *Print* 44, no. 3 (May–June 1990): 66–75.

———. "New York's Girl Caricaturist: Irma Selz." *Upper and Lower Case: The International Journal of Typographics* 2, no. 2 (August 1984): 18–19.

Hillier, Boris. *Cartoons and Caricatures*. New York: E. P. Dutton, 1970.

Hirschfeld, Al. *Hirschfeld Art and Recollections from Eight Decades*. New York: Charles Scribner's Sons, 1991.

———. *The World of Hirschfeld*. New York: Harry Abrams, 1970.

Holme, Geoffrey, ed. *Caricature of Today*. London: The Studio, Ltd., 1928.

Horn, Maurice, ed. *World Encyclopedia of Cartoons*. New York: Gale Research, 1980.

Hyland, Douglas. *Marius de Zayas: Conjuror of Souls*. Lawrence: Spencer Museum of Art, University of Kansas, 1981.

The Image of America in Caricature and Cartoon. Fort Worth, Texas: Amon Carter Museum of Western Art, 1976.

Kellner, Bruce. *The Last Dandy: Ralph Barton, American Artist, 1891–1931*. Columbia: University of Missouri Press, 1991.

Lent, John A., comp. *Animation, Caricature, and Gag and Political Cartoons in the United States and Canada: An International Bibliography*. Westport, Conn.: Greenwood, 1994.

Lucie-Smith, Edward. *The Art of Caricature*. Ithaca: Cornell University Press, 1981.

Lynch, Bohun. "Max Beerbohm." *Dial* (February 1921), 177–192.

———. *A History of Caricature*. London: Faber and Gwyer, 1926.

Lynn, Kenneth S. *The Comic Tradition in America*. New York: Doubleday, 1958.

McBride, Henry. "Ingratiating Art of Miguel Covarrubias: A Mexican Ambassador." *New York Sun* (December 24, 1927).

Major, Henry. *Hollywood with "Bugs" Baer and Henry Major*. Hollywood: n.p., lithographed by Daniel Murphy and Co., Inc., 1938.

"Marius de Zayas: A Kindly Caricaturist of the Emotions." *Craftsman* 13 (January–March 1908): 385–395.

"Marius de Zayas: A Master of Ironical Caricature." *Current Literature* 44, no. 3 (March 1908): 281–283.

Markey, Gene. *Men about Town*. Chicago: Covici-McGee, 1924.

———. *Literary Nights*. New York: Knopf, 1923.

Maxwell, Perriton. "Frozen Jazz and the Soul of Man: About a New Caricaturist and the Art of Making People Squirm." *Arts and Decoration* (February 1923).

Merkin, Richard. *The Jazz Age, As Seen Through the Eyes of Ralph Barton, Miguel Covarrubias, and John Held, Jr.* Providence: Rhode Island School of Design, 1968.

Mintz, Lawrence E. "American Humor in the 1920s." In *Dancing Fools and Weary Blues: The Great Escape of the Twenties*, edited by Lawrence R. Broer and John D. Walther. Bowling Green, Ohio: Bowling Green State University Popular Press, 1990.

Mix, Katherine Lyon. *Max and the Americans*. Brattleboro, Vt.: Stephen Green, 1974.

Moss, Arthur. "A Cubist Doll-Maker of Montparnasse." *Arts and Decoration* (May 1923), 18.

Murrell, William. *A History of American Graphic Humor, 1865–1938*. 2 vols. New York: Whitney Museum of American Art, 1938.

Posselt, Erich, ed. *On Parade, Caricatures by Eva Herrmann*. New York: Coward-McCann, 1929.

Reilly, Bernard. *Drawings of Nature and Circumstance: Caricature Since 1870*. Washington, D.C.: Library of Congress, 1979.

Riewald, J. G. *Beerbohm's Literary Caricatures: From Homer to Huxley*. Hamden, Conn.: Archon, 1977.

Rosenfeld, Paul. "Caricature and Peggy Bacon." *The Nation* (June 3, 1931), 617–618.

Rourke, Constance. *American Humor: A Study of the National Character*. Garden City, N.Y.: Doubleday, 1931.

Sardi, Vincent, Sr., and Richard Gehman. *Sardi's: The Story of a Famous Restaurant*. New York: Henry Holt, 1953.

Schneider, Steve. *That's All Folks! The Art of Warner Bros. Animation*. New York: Henry Holt, 1988.

Shikes, Ralph. *The Indignant Eye: The Artist as Social Critic in Prints and Drawings from the Fifteenth Century to Picasso*. Boston: Beacon, 1969.

Silverman, Maxwell. *Frueh on the Theatre: Theatrical Caricatures, 1906–1962*. New York: New York Public Library, 1972.

Solomon, Charles. *Enchanted Drawings: The History of Animation*. New York: Knopf, 1989.

Tablada, José Juan. "Caricature That Stings." *Shadowland* (April 1923), 54–55.

Tarbell, Roberta K. *Peggy Bacon: Personalities and Places*. Washington, D.C.: Smithsonian Institution Press, 1975.

They Made Them Laugh and Wince and Worry and . . . Washington, D.C.: Library of Congress, 1977.

Treasures of Disney Animation Art. New York: Abbeville, 1982.

Updike, John. "A Critic at Large: A Case of Melancholia." *New Yorker* (February 20, 1989), 112–120.

Williams, Adriana. *Covarrubias*. Austin: University of Texas Press, 1994.

Wing, Francis M. *Amiable Libels*. Chicago: Reilly and Britton, 1916.

Wright, Willard Huntington. "America and Caricature." *Vanity Fair* (July 1922), 54–55.

Young, Roland. *Actors and Others*. Chicago: Pascal Covici, 1925.

GENERAL (SELECTED WORKS)

Adams, Franklin P. "It Was Originally the Thanatopsis Pleasure and Inside Straight Club." *Stage* (February 1935), 24–25.

Amory, Cleveland. *Who Killed Society?* New York: Harper and Brothers, 1960.

Amory, Cleveland, ed. Introduction to *International Celebrity Register*. New York: Celebrity Register, 1959.

Ashley, Sally. *F. P. A.: The Life and Times of Franklin Pierce Adams*. New York: Beaufort, 1926.

Baudelaire, Charles. "Peintre de la Vie Moderne." In *The Painter of Victorian Life*, translated by P. G. Konody. New York: William Edwin Rudge, 1930.

Benchley, Nathaniel. *Robert Benchley*. New York: McGraw-Hill, 1947. Reprint 1955.

Benchley, Robert C. "Mr. Vanity Fair." *Bookman* 50 (January 1920): 429–433.

Bogart, Michele H. *Artists, Advertising, and the Borders of Art*. Chicago: University of Chicago Press, 1995.

Boorstin, Daniel J. *The Image: A Guide to Pseudo-Events in America*. New York: Atheneum, 1971.

Braudy, Leo. *The Frenzy of Renown: Fame and Its History*. New York: Oxford University Press, 1986.

Churchill, Allen. *The Improper Bohemians*. New York: E. P. Dutton, 1959.

Covert, Catherine L., and John D. Stevens, eds. *Mass Media Between the Wars: Perceptions of Cultural Tension, 1918–1941*. Syracuse, N.Y.: Syracuse University Press, 1984.

DeCordova, Richard. *Picture Personalities: The Emergence of the Star System in America*. Urbana: University of Illinois Press, 1990.

Douglas, Ann. *Terrible Honesty: Mongrel Manhattan in the 1920s*. New York: Farrar, Straus, and Giroux, 1995.

Douglas, George H. *The Smart Magazines: Fifty Years of Literary Revelry and High Jinks at Vanity Fair, the New Yorker, Life, Esquire,*

and the Smart Set. Hamden, Conn.: Archon, 1991.

Erenberg, Lewis A. Steppin' Out: New York Nightlife and the Transformation of American Culture, 1890–1930. Westport, Conn.: Greenwood, 1981.

Ewen, David. George Gershwin: His Journey to Greatness. New York: Ungar, 1986.

Fitzgerald, F. Scott. "My Lost City." In The Crack-Up, edited by Edmund Wilson. New York: New Directions, 1945. Reprint 1993.

Flagg, James Montgomery. Roses and Buckshot. New York: G. P. Putnam's Sons, 1946.

Fowles, Jib. Starstruck: Celebrity Performers and the American Public. Washington, D.C.: Smithsonian Institution Press, 1992.

Gabler, Neal. Winchell, Gossip Power, and the Culture of Celebrity. New York: Knopf, 1994.

Gill, Brendan. Here at the New Yorker. New York: Random House, 1975.

Glackens, Ira. William Glackens and the Eight. New York: Horizon, 1984.

Harriman, Margaret Case. The Vicious Circle: The Story of the Algonquin Round Table. New York: Rinehart, 1951.

Hellman, Geoffrey T. "Last of the Species," Parts I, II. New Yorker (September 19, 1942), 22–26; (September 26, 1942), 24–31.

Hoare, Philip. Noel Coward: A Biography. New York: Simon and Schuster, 1995.

Homer, William Innes. Alfred Stieglitz and the American Avant-Garde. Boston: New York Graphic Society and Little, Brown, 1977.

———. Robert Henri and His Circle. Ithaca: Cornell University Press, 1969.

Hoyt, Edwin Palmer. Alexander Woollcott: The Man Who Came to Dinner. New York: Abelard-Schuman, 1968.

Kahn, Ely Jacques, Jr. The World of Swope. New York: Simon and Schuster, 1965.

Kery, Patricia Frantz. Art Deco Graphics. New York: Harry Abrams, 1986.

———. Great Magazine Covers of the World. New York: Abbeville, 1982.

Kimball, Robert. Cole. New York: Holt, Rinehart and Winston, 1971.

Kramer, Dale. Heywood Broun: A Biographical Portrait. New York: Current, 1949.

Kunkel, Thomas. Genius in Disguise: Harold Ross of the New Yorker. New York: Random House, 1995.

Laurent, Henri. Personality and How to Build It. New York: Funk and Wagnalls, 1916.

Levine, Lawrence W. Highbrow/Lowbrow: The Emergence of Cultural Hierarchy in America. Cambridge: Harvard University Press, 1988.

Macdonald, Dwight. "A Theory of Mass Culture." In Mass Culture, edited by Bernard Rosenberg and David Manning White. Glencoe, Ill.: Free Press, 1957.

Marchand, Roland. Advertising the American Dream: Making Way for Modernity, 1920–1940. Berkeley: University of California Press, 1985.

Meade, Marion. Dorothy Parker: What Fresh Hell Is This? New York: Villard, 1988.

Morris, Sylvia Jukes. Rage for Fame: The Ascent of Clare Boothe Luce. New York: Random House, 1997.

Norman, Dorothy. Alfred Stieglitz: An American Seer. New York: Random House, 1960, 1973.

O'Connor, Richard. Heywood Broun: A Biography. New York: G. P. Putnam's Sons, 1975.

Perlman, Bennard B. The Immortal Eight: American Painting from Eakins to the Armory Show (1870–1913). New York: Exposition Press, 1962.

Peterson, Theodore. Magazines in the Twentieth Century. Urbana: University of Illinois Press, 1956.

Reich, Sheldon. Graphic Styles of the American Eight. Salt Lake City: Utah Museum of the Fine Arts, 1976.

Schickel, Richard. Intimate Strangers: The Culture of Celebrity. Garden City, N.Y.: Doubleday, 1985.

"The Secret of Personality as Theodore Dreiser Reveals It." Current Opinion 66 (March 1919): 175–176.

Seebohm, Caroline. The Man Who Was Vogue: The Life and Times of Condé Nast. New York: Viking, 1982.

Sennett, Richard. The Fall of Public Man: On the Social Psychology of Capitalism. New York: Vintage, 1978.

Susman, Warren I. "Personality and the Making of Twentieth-Century Culture." In Culture as History: The Transformation of American Society in the Twentieth Century, edited by Warren I. Susman. New York: Pantheon, 1973.

Tebbell, John William. The American Magazine: A Compact History. New York: Hawthorn, 1969.

Teichman, Howard. George S. Kaufman: An Intimate Portrait. New York: Atheneum, 1972.

———. Smart Aleck: The Wit, World, and Life of Alexander Woollcott. New York: Morrow, 1976.

Thurber, James. The Years with Ross. New York: Penguin, 1984.

Turner, Elizabeth Hutton. American Artists in Paris, 1919–1929. Ann Arbor: UMI Research Press, 1988.

Varnedoe, Kirk, and Adam Gopnik. High and Low: Modern Art and Popular Culture. New York: Museum of Modern Art, 1990.

Ward, Cynthia L. "Vanity Fair Magazine and the Modern Style, 1914–1936." Ph.D. diss., State University of New York at Stony Brook, 1983.

Watson, Steven. Strange Bedfellows: The First American Avant-Garde. New York: Abbeville, 1991.

Yagoda, Ben. Will Rogers: A Biography. New York: Knopf, 1993.

Zurier, Rebecca. Art for the Masses. Philadelphia: Temple University Press, 1988.

Index

PHOTOGRAPHY CREDITS